709.2
usti

CR
STU

VICTORIAN
OUTSIDER

VICTORIAN OUTSIDER

A Biography of J. A. M. Whistler

BY

ROY MCMULLEN

MACMILLAN

To Simone

First published 1973 by E. P. Dutton & Co.
Inc., New York
First U.K. edition published 1974 by
MACMILLAN LONDON LTD.
London and Basingstoke
Associated companies in New York Dublin
Melbourne Johannesburg and Madras

SBN: 333 14116 4

Printed in the United States of America

OR 6.93

Contents

Illustrations

tesy of the Smithsonian Institution, Freer Gallery of Art, Washington, D.C.)

25. *Harmony in Blue and Gold: The Peacock Room.* 1876–77. (Courtesy of the Smithsonian Institution, Freer Gallery of Art, Washington, D.C.)

26. *The Palaces.* 1880. Etching, 10⅝ x 14⅛ inches. (Prints Division, The New York Public Library, Astor, Lenox and Tilden Foundations)

27. *Harmony in Flesh Color and Pink: Lady Meux.* 1881. Canvas, 75¾ x 36½ inches. (Copyright, The Frick Collection, New York)

28. *Arrangement in Flesh Color and Black: Théodore Duret.* 1883. Canvas, 76⅛ x 35¾ inches. (The Metropolitan Museum of Art, Wolfe Fund, 1913)

29. *Arrangement in Black: Pablo de Sarasate.* 1884. Canvas, 85½ x 44 inches. (Museum of Art, Carnegie Institute, Pittsburgh)

30. *Chelsea Shops.* 1880s. Panel, 5¼ x 9¼ inches. (Courtesy of the Smithsonian Institution, Freer Gallery of Art, Washington, D.C.)

31. *A Note in Green: Wortley.* Early 1880s. Panel, 5⁵⁄₁₆ x 9³⁄₁₆ inches. (Courtesy of the Smithsonian Institution, Freer Gallery of Art, Washington, D.C.)

32. *Dorsetshire Landscape.* 1895. Canvas, 12½ x 24⅞ inches. (Courtesy of the Smithsonian Institution, Freer Gallery of Art, Washington, D.C.)

33. *The Siesta* (Mrs. Whistler). 1896. Lithograph, 5⅜ x 8¼ inches. (Prints Division, The New York Public Library, Astor, Lenox and Tilden Foundation)

34. *Purple and Gold: Phryne the Superb: Builder of Temples.* 1898. Panel, 9¼ x 5⅝ inches. (Courtesy of the Smithsonian Institution, Freer Gallery of Art, Washington, D.C.)

Preface

Although this book is primarily a biography and an account of a personality, I have allowed it to become, at what seemed appropriate points, a description and an evaluation of Whistler's work. To have done otherwise would have been unfair, for the artist was often different from the man.

The notes and the bibliography should be read as grateful acknowledgments of what I have got from the other people. Two of my debts, however, deserve special mention. One is to Joseph and Elizabeth Pennell, the painter's most loyal, tenacious, and possessive friends during his last years. Their early biography of him and their *Whistler Journal* remain, in spite of some hero worship and a lack of historical perspective, the factual basis for all Whistler studies. My second large debt is to the University of Glasgow, which has an immense and admirably classified collection of Whistler papers, most of which were part of a bequest from the artist's sister-in-law, Rosalind Birnie Philip. The university authorities, as holders of the copyright, have granted permission to quote from letters, and I have received much patient help from Mrs. Margaret F. MacDonald, who for several years has been in charge of the documents.

R. M.

Paris, 1972.

Railroads and the Bible
1834-1843

James Abbott McNeill Whistler was born on July 11, 1834, in the Paul Moody House, a roomy, sober, vaguely Georgian clapboard residence set among tall trees on Worthen Street in Lowell, Massachusetts. His parents were Major George Washington Whistler, a thirty-four-year-old civil engineer, and Anna Mathilda Whistler, born McNeill, the major's twenty-seven-year-old second wife. The baby was baptized—with only two given names, the McNeill being added later on his own initiative—as an Episcopalian.

In England Turner was about to paint the *Burning of the Houses of Parliament*. At the Paris Salon Delacroix had just exhibited, and sold, his *Women of Algiers*. In isolated Tokyo, which was still called Edo, Hokusai was at work on his *Thirty-six Views of Mount Fuji*. Courbet was fifteen years old, Pissarro three, and Manet two. The French economist Michel Chevalier had just visited Lowell: canals, locks, water power, a booming textile industry, and a new locomotive works were already beginning to give the town a European reputation as "the spindle city" and "the Manchester of America."

The Whistlers were strangers in the place, as they were to some extent nearly everywhere. The family tradition on the paternal

side was mostly one of rootless, opportunistic professional soldiers and technicians, of people who belonged more to an itinerant caste than to one of the established layers of society. John Whistler, James's grandfather and the remotest ancestor of his on whom we have documents, had run away from home in Ireland around 1775, joined the British Army, sailed with his regiment to the rebellious American colonies, and surrendered with General Burgoyne at Saratoga. After being shipped back to England and discharged he had eloped with the daughter of a Sir Edward Bishop, returned with her to America, joined the United States Army, fought the British in the War of 1812, and served, among other places, at Fort Wayne, Indiana, and Fort Dearborn, the future Chicago. By the time of his death, in retirement in Missouri in 1817, he had risen to the brevet rank of major. Of his fifteen children, three sons became soldiers, and three daughters married soldiers.

George Washington Whistler was the most gifted, or the luckiest, of the patriarch's sons. He had gone to the West Point Military Academy, graduated into the field artillery, served as a surveyor in the Great Lakes region, taught for a while at the academy, and finally, with no wars to fight, turned to the promising business of railroading. With the approval of his military superiors, he had been sent to England in 1828 on a railroad study trip by the company that was planning the Baltimore and Ohio line. On his return he had helped to lay the first track for the B. and O. and had then found similar employment with the Baltimore and Susquehanna and the Paterson and Hudson River companies. In 1833, while working on the line from Stonington, Connecticut, to Providence, Rhode Island, he had resigned his army commission, keeping the courtesy title of major, and had become a full-time civil engineer. Early in 1834 he had come to Lowell as an expert for the locks-and-canal agency, his principal duty being the supervision of the machine shops, which included the locomotive works.

James's ancestors and relatives on the maternal side were Scottish, Old Southern, relatively sedentary, and definitely upper-class. Anna Mathilda Whistler's father was Dr. Charles Donald McNeill of Wilmington, North Carolina; he was the grandson of Donald

McNeill, chief of his clan, who had emigrated with some sixty Mc-
Neills from the island of Skye to North Carolina in 1746, after the
collapse of the Jacobite cause, and whose clansmen had later be-
come linked through marriage to the Fairfaxes and other Virginia
notables. By a first wife Dr. McNeill had two daughters who were
living in Lancashire, and Mrs. Whistler had once crossed the Atlan-
tic to visit them; she was thus almost as well traveled as the itinerant
major. She had an American brother, William McNeill, who was
an excellent civil engineer when he was not drinking and who had
been one of her husband's classmates at West Point.

Major Whistler was a resourceful and even daring railroad
designer; European observers were astonished by the steep rises
and sharp curves on lines for which he was partly responsible. The
same observers, however, could have wondered why he had had
so many jobs—no less than five in the six years preceding James's
birth—without turning any of them into a permanent situation for
himself. Clearly, he had much of the same restless temperament
that had brought old John Whistler from Ireland to die in remote
Missouri. He also had, as his painting son would eventually have,
the sort of imagination that finds conception a challenge and
realization something of a bore. In a portrait of around 1840, by
an unknown artist, he does not at all resemble a conventional image
of the hard-bitten army officer, nor of the rip-roaring pioneer
American railroader; his clothes are elegantly civilian, his long hair
fresh from the curlpapers used by the swells of the period, his
smooth-shaven face almost feminine, and the expression of the
mouth, possibly through the fault of the portraitist, quite irresolute.
At West Point he had been first in his class in drawing, and for a
while he had thought seriously of becoming a professional painter.
His classmates had called him Pipes, partly because the nickname
was thought to go well with Whistler, but also because he played
the flute well enough to perform with pianists at musical evenings.
He liked chess and Greek Revival architecture; at Lowell he gave
the shape of a Doric column to a double chimney he invented for a
Stephenson locomotive.

Anna Mathilda Whistler was not yet an appropriate subject

for a mother-cult icon in the Louvre. She was small, dark, rather pinched, and for a modern taste disagreeably, suspiciously devout. Her letters and the diary she kept for a few years are sprinkled with evidence of her Episcopal piety and with gloomy thoughts: "Be ye also ready. . . . She who liveth in pleasure is dead while she liveth . . . as you spend Sunday so will all your work in all the weekdays prosper or not." She enjoyed responsive recitations from the Bible before breakfast. She had married the major in 1831 in circumstances that suggest an ability to dissemble and an eye for the main chance; she had been a close friend of his first wife, Mary, and had won his gratitude after Mary's death by taking care of his three motherless children. But it would be unfair to mention only her less attractive side. She put her religious convictions into practice by serving frequently as an unpaid nurse, probably with considerable skill, since her father was a doctor. Everything indicates that she was devoted to her husband and her family, her three stepchildren included, and that she ran an efficient household under conditions that were just short of nomadic. She tempered her puritanism with a firm belief in culture, and even exhibited, when she had time, bluestocking tendencies; we learn from her comments that she liked to visit museums, knew more than a little about painting, studied French, took an interest in European events, and read Sir Walter Scott, James Fenimore Cooper, and the historian William Hickling Prescott. If she was somewhat lacking in humor, she compensated for the defect by being, in a world of irreverent soldiers and uncultivated railroaders, and later of Bohemian painters and poets, invariably sweetly, unassailably dignified. In sum, she was a not altogether unusual blend of Calvinist bigot, tender wife and mother, and Southern antebellum dame.

In 1836, two years after James's birth, another son, named William after Mrs. Whistler's engineer brother, was born; he was to occupy an important place in the life of James. Sometime during the next year the family moved from Lowell to the much smaller town of Stonington, Connecticut, where Major Whistler had accepted a position with the local railroad company. Here they lived, according to fond accounts by natives who remembered

them, in a pleasant house on Main Street; Sunday mornings they rolled to church at nearby Westerly on the new rails, in a horse-drawn buggy fitted with flanged wheels. In 1840 the major and his brother-in-law, William McNeill, became civil engineers for the Western Railroad of Massachusetts, and the family moved to Springfield, Massachusetts, where they lived on Chestnut Street in a place whose name, the Ethan Chapin Homestead, evokes something old, rural, and rambling. The town itself was old in the perspective of anyone who knew bustling, modern Lowell; it had been founded in the seventeenth century, and although by 1840 it was being rapidly industrialized it was still best known for its armory and its famous arsenal, the birthplace of the Springfield musket.

The next family move was of the sort that seals off one period and opens another in the life of a child. A Russian commission that had been inspecting the growing railroad networks in the United States offered the major the post of civil engineer—of chief executive, in effect, although without the title—for the construction of a line between St. Petersburg and Moscow. "I can return if I do not like it," he remarked in a letter to his brother-in-law, and he added, with his usual footloose optimism: "Of course I shall like it if they like me." So in the summer of 1842 he made the long journey from New England to the czarist capital. Anna Mathilda and the children lived at Stonington again until the following summer and then, reassured by his accounts of his situation in St. Petersburg, went over to join him.

The first nine years are important and often decisive in the development of an artist's, or of anybody's, personality; this is the time when the traumas, if there are to be any, are likely to occur and when the twig is bent. Concerning Whistler there are only a few really personal facts from this early period to go on, and none qualifies as a trauma. Some, however, when considered in the light of later facts and with a bit of common-sense psychology, do reveal that the twig was being bent.

More than half a century after the event an aged woman who had known the family at Lowell remembered finding the boy, who was not yet three years old, stretched out on a shelf under a dressing table. She had pulled him out by an arm and a leg, sat him on her knee, and asked what he was doing under there. Still clutching a pencil and a piece of paper, he had said, "I'se drawrin'." He later recalled that by the time he was in Russia he was "always doing that sort of thing." And by the time he was living in Paris and London he seldom went for a walk without a sketching pad, and sometimes a few plates for etching, in his pocket.

From the testimony of family friends and from two portraits of him as an adolescent, it is clear that he was a romantically handsome little boy, with a trim, well-proportioned body, large bluish-gray eyes, girlish features, and an angelic mass of dark, curly, unruly hair. In other words, he was in appearance the nineteenth-century upper-middle-class ideal child, an anticipation of Little Lord Fauntleroy. The woman who had found him drawing said her father used to say that "it was enough to make Sir Joshua Reynolds come out of his grave and paint Jemmie asleep." She also remembered that the boy had had a "very beautiful little hand." Although this kind of evidence should not be overworked, there is a connection between an early awareness of attention-getting good looks and the posturing, primping, hand-fluttering, overdressed vanity of the mature Whistler. The eccentric dandy who startled Paris and London might never have come into existence if Jemmie had been an Ugly Duckling instead of a Reynolds cherub.

The boy obviously adored his mother; forty years later he was still calling her mummy, and in a mood of affectionate professionalism he could refer to her as "a very pretty bit of color" (which did not prevent him from painting her as *Arrangement in Grey and Black No. 1* *). In sophisticated, unconventioned Chelsea he would always be ready to expel a red-headed mistress from his studio when Mummy arrived. And Mummy, in her letters and diary, makes it clear that he was always her favorite child. He was

* For locations of paintings see Museums and Collections, pp. 273–276.

her first-born, he was lively and beautiful, and he was fragile enough to require a good deal of coddling and the frequent exercise of her talent as a nurse. He had little competition from his brother Willie, who was a solid, healthy boy, and no competition at all from the stepchildren, who were approaching the status of adults.

Anna Mathilda was not, however, a woman who could be kept by sentiment from doing her duty as a Christian parent. She was "very strict," according to a family friend. Weekends were reserved for soap and God; on Saturday afternoon toys and books were stowed away, heads were washed, clothes were cleaned and repaired, and minds were tuned up for Sunday, when there were normally three trips to church and Bible readings between sermons. The boys were not exactly converted by all this; years afterward Willie, to the mystification of everyone except his brother, would express his dislike of something by observing that it was "like Saturday afternoon," and Jemmie would react to his mother's slogan-thoughts by becoming an ostentatious rebel against certain forms of conventional morality. But the grown-up Jemmie nevertheless preserved more than one trace of his early training in cleanliness and godliness. He amused his French and British painting acquaintances, who were not always well washed, by insisting on freshly laundered linen and by being, by their lights, a compulsive bather; in London he once kept a roomful of noon-breakfast guests waiting for two hours while he splashed audibly in his tub behind a thin partition. The Biblical prose style and the evangelical fervor of New England parsons can be found in some of his denunciations of British academic art; in fact, one of his best known denunciations opens with a presentation of himself "in the character of The Preacher." It is even possible, perhaps with a little straining, to see in his eventually ascetic painting, etching, and decoration the style of an essentially puritanical sensibility—the faint, transformed echo of Anna Mathilda's admonitions to avoid the sinful corporealness of earthly existence and to keep to the narrow way.

What the comparatively worldly major thought of his wife's religious enthusiasm and Saturday afternoons is not known; presumably he usually agreed with her child-training methods, and

could soothe his feelings by playing the flute when he disagreed. He himself did nothing specific about the education of his younger sons during this early period; he was busy with the problems raised by his own career. But he contributed in a general way to the formation of James's adult outlook simply by shifting to a different residence every two or three years and by being a glamorous and internationally successful example of the emerging *homo Americanus*, of the fellow who was perpetually on the move. ("It is good," said Simon Suggs, a popular fictional backwoodsman of the 1840s, "to be shifty in a new country.") The handsome, bright, Bible-reading little boy who left New England for Russia in the summer of 1843 was already used to adjusting quickly to strange places and already provided, by cultural inheritance, with his life-long status as a transient. After St. Petersburg there would be, stretching across the decades in a fashion that made a map a kind of calendar of his career, West Point, Baltimore, Washington, Paris, Cologne, Aachen, London, Brittany, Biarritz, Trouville, Valparaiso, Liverpool, Venice, Cornwall, Dordrecht, Dieppe, Bruges, Ostend, Brussels, Canterbury, Rome, Tangier, Gibraltar, Algiers, Marseilles, Ajaccio, Bath, The Hague, and scores of way stations. It would be said that the first object you were likely to encounter at one of his studios was a packed valise in the hallway.

The family sailed for Europe from Boston on August 12, 1843, aboard the paddle-wheel steamship *Acadia*, one of the first of the Cunard Atlantic liners and an expensive luxury vessel by comparison with the wind-driven packets of the period. In addition to James and William, Mrs. Whistler had with her a third son, Charles, who was still almost a baby, her stepdaughter Deborah, who was six years older than James, and a nursemaid who had helped to take care of the children at Stonington. George Whistler, the major's grown-up oldest son, went along to look after baggage and other details, with the intention of returning to America as soon as St. Petersburg was safely in view. The baggage was considerable; it included trunks of American clothes, boxes of Ameri-

can books and family silver, crates of family china, and a harp for
Deborah, who shared her father's passion for music. Anna Mathilda
was determined to make life in St. Petersburg as much like life in
Stonington as the foreign circumstances would permit.

The Atlantic part of the journey, which was interrupted for
an exciting moment when the *Acadia* rammed a barge off Halifax,
Nova Scotia, took seventeen days. At Liverpool the party left the
ship and went up to Preston for a stay of two weeks with Mrs.
Whistler's Lancashire half-sisters, Miss Alicia McNeill and Mrs.
Eliza Winstanley. Here appeared the first English elements in the
web of influences and accidents that would decide James's choice
of a career. Preston in 1843 was a newly independent port and the
site of many cotton mills, but it was still in many respects the
"Preston the Proud" that had been a center for cultivated and
fashionable society in the eighteenth century, and it had an art
gallery. Both of the boy's aunts were interested in painting, well
acquainted with artists, and ready to encourage his young talent.
Within a year, during a visit to Russia, Aunt Alicia would be sitting
patiently for one of his earliest attempts at portraiture.

From Preston Mrs. Whistler conducted her little band of
tourists to London for a few days of sightseeing, and then to
Hamburg by steamship. Out of Hamburg there was as yet no rail
line; so they took two private carriages for the all-night drive
across Denmark to Lübeck, and then went on by stagecoach to
Travemünde. (To think of such an expedition with three small
children in tow is to realize that Anna Mathilda must have been
on many occasions a formidable disciplinarian.) At Travemünde
they boarded a steamer for Kronstadt and St. Petersburg, and
George started back to the United States.

On the first day at sea the baby, Charles, became mysteriously
ill, and by the next morning he was dead. "He was so jolly, so full
of love," his mother wrote in her diary, "I ought to have been
warned . . ." He was the third child she had lost; in 1840 her
fourteen-year-old stepson Joseph had died, and in 1842, shortly
after the major's departure for Russia, her son Kirk had died at
the age of four. Three such losses in the space of only four years

might understandably have produced a weakening in her faith in the justness of her Calvinist God, but in fact they appear to have produced merely a deeper, more somber resignation in the face of His unfathomable behavior. They also increased her worries about James, who had developed an alarming susceptibility to colds and to what were diagnosed as bouts of rheumatic fever.

On September 28, she buried the baby temporarily at Kronstadt. Then she led her three surviving children and their nurse aboard a small boat that took them the remaining seventeen miles across the Gulf of Finland to the English Quay in St. Petersburg, where the major was waiting.

Palaces and Academies
1843-1849

This first phase of the artist's life abroad lasted six years, of which about four and a half were spent in Russia and the remainder in Great Britain. The boy picked up a working acquaintance with Russian, a slightly British accent for his American English, and an idiomatic fluency in French, which in the middle of the nineteenth century was still, as it had been in the time of Catherine the Great, the preferred language of polite society in St. Petersburg. The rest of his nonpainting education included dancing lessons, some piano instruction that did not go very far, and a spotty training in the humanities. The whole operation, in view of the fact that he was the son of a presumably democratic and modern-minded American technologist, looks surprisingly aristocratic and conservative. But by 1843 Major Whistler had moved up from the status of a wandering Irish-American soldier and railroader to that of a high functionary for Czar Nicholas I, with a houseful of servants and an annual salary that was the ruble equivalent of twelve thousand American dollars—four times the salary at Lowell and quite comparable, with money values adjusted, to the earnings of a twentieth-century corporation executive.

Mrs. Whistler's diary for 1844 mentions a Swedish tutor who

seems to have been anti-Russian; he instilled in James a fervent admiration for Charles XII that was "greatly to the prejudice of Peter the Great." By the spring of 1846 James and his brother William were studying Roman history, in French, with a new tutor, a Monsieur Lamartine, who in spite of his name and his language was a German. By early 1847 Monsieur Lamartine was out and a Monsieur Biber was in. Hiring a foreign tutor did not, however, mean an end to the educational program that had been started in New England. A diary entry for Ash Wednesday, 1845, reads: "I avail myself of this Lenten season to have my boys every morning before breakfast recite a verse from the Psalms, and I, who wish to encourage them, am ready with my response." For the same day there is a reference to attempts to counteract the effect of instruction exclusively in French: "Here comes my good boy Jemmie now, with his history in hand to read to me, as he does every afternoon, as we fear they may lose their own language . . ."

The tutoring was interrupted during the winter of 1846–47, when the major placed both James and William, who were then respectively twelve and ten years old, in a St. Petersburg boarding school run on German military lines by a Monsieur Jourdan. Everything, according to Anna Mathilda's diary, went well at first: "My dear boys almost daily exchanged billets-doux with mother, since their absence of a week at a time from home. James reported everything 'first-rate,' even to brown bread and salt for breakfast, and greens for dinner . . ." Soon, however, things began to go less well. By November the older boy had demonstrated that he was not, after all, a little soldier: "Jamie was kept in until night last Saturday, and made to write a given portion of French over twenty-five times as punishment for stopping to talk to a classmate after their recitation, instead of marching back to his seat according to order. . ." Two months later he was "drooping from the close confinement," and the experiment with Monsieur Jourdan was halted.

The drooping was not faked. Unlike the solid Willie, Jemmie did not adjust well to the notorious St. Petersburg climate, to the long, damp, cold, dark winters, the brief, violent springs and

autumns, and the hot summers with their "white nights." He caught cold during the thawing season, he suffered in 1846 from an acute sore throat that may have been due to a streptococcus infection, and early in 1847 he provoked a family crisis by having a long attack of rheumatic fever—which was possibly related to the throat infection and which was almost certainly the initial cause of the heart trouble he had during the last years of his life. Anna Mathilda's concern over these illnesses was increased, if an increase was possible, by the death in 1846 of still another son, her fourteen-month-old "Russian" baby. That made four young Whistlers, all boys, who had been taken, and she must have found it hard not to wonder who would be next.

Illness and bad weather did not, however, keep her beloved first-born from enjoying his stay in Russia and from being, much of the time at least, a normally active boy. There are diary glimpses of him skating on the Neva, running wild in the countryside near St. Petersburg, celebrating the Fourth of July with fireworks and musket practice, getting himself drenched in a neighbor's pond, getting himself caught out in a small boat during a storm, attending a street-booth puppet show, and watching a review of eighty thousand of the czar's most spectacular hussars, dragoons, Cossacks, grenadiers, Polish lancers, Bashkirs, Kalmuks, and Circassians, all attired in uniforms that were evidently intended more for the eye of a painter than for service on a battlefield.

There are also glimpses of Whistler's later personality in the making. Shortly before Palm Sunday in 1844 Anna Mathilda took Willie and Jemmie along on an expedition up St. Petersburg's most famous avenue, the Nevski Prospekt, to the vast, arcaded, eighteenth-century bazaar, Gostinny Dvor, and she could not help noticing that "Jemmie's animation roused the wonder of many." In August of that year the family saw some paintings of birds that were attributed to Peter the Great, and "our Jemmie was so saucy as to laugh at them." In May, 1845, we are given to understand that at the age of eleven the artist already had some of his extraordinary later ability to get on people's nerves: "Jemmie's eagerness to attain all his desires for information and his fearlessness often

makes him offend, and it makes him appear less amiable than he really is."

Meanwhile, the habit of drawing was growing, and in the summer of 1844 it provoked the sort of chance remark that can affect the course of a life. The Scottish historical painter Sir William Allan, a member of the British Royal Academy and a celebrated creator of exotic scenes on a grand-opera scale, was in St. Petersburg with the intention of depicting some of the exploits of Peter the Great. On July 1, in the company of one of Aunt Alicia's Scottish friends, he called on Mrs. Whistler "in the nick of time for our excellent homemade bread and fresh butter, but above all the refreshment of a good cup of tea." The conversation turned to Sir William's picture of Peter teaching the *muzhiks* (Russian peasants) to build ships. "This," Mrs. Whistler writes, "made Jemmie's eyes express so much interest that his love for art was discovered, and Sir William must needs see his attempts. When my boys had said good night, the great artist remarked to me, 'Your little boy has uncommon genius, but do not urge him beyond his inclination.' I told him his gift had only been cultivated as an amusement, and that I was obliged to interfere, or his application would confine him more than we approved."

Years later James said that his mother had wanted him to be a clergyman, and certainly the phrase "cultivated as an amusement" does not suggest that when he was ten years old she took his drawing very seriously. But the major did take it seriously, and she did not feel "obliged to interfere" when, in the first week of April, 1845, he took the boy across the ice to Vasilyevski Island and enrolled him in the Imperial Academy of Fine Arts. The school's archives for that year mention the new student as "belonging to the drawing class, heads from nature," although it is probable that, in line with the practice in other European academies of the period, he began by working from plaster casts instead of from live models. Anna Mathilda comments in her diary entry for April 5: "Jemmie began his course of drawing lessons at the Academy of Fine Arts, just on the opposite side of the Neva, exactly fronting my bedroom window. He is entered at the second room. There are two

higher, and he fears he shall not reach them, because the officer who is still to continue his private lesson at home is a pupil himself in the highest, and Jemmie looks up to him with all the reverence an artist merits. He seems greatly to enjoy going to his class . . ." He worked hard; on March 2, 1846, there were examinations, and he was listed as first in a group of twenty-eight students.

The academy was, and still is, in spite of the Revolution of October and World War II, an impressive piece of architecture, both palatial and reasonably functional. On the gray and pink granite quay of the Great Neva the major and James would have walked past two grandly Egyptian sphinxes, which had been brought from Thebes a dozen years earlier to flatter the eclectic taste of Czar Nicholas. The long main facade of the building, which reflected the early Neoclassical tendencies of Catherine the Great, consisted of a simple, rusticated basement, two stories of dressed stone and carefully rhythmical windows, and three projecting pavilions. The interior, according to a report by one of the art-minded friends of Aunts Alicia and Eliza, was usually unrepaired, untidy, and malodorous. But it had scale, dignity, and geometry in its favor. The main entrance opened onto a large vestibule dominated by columns and a double flight of stairs; the plan in outline was a square around a circular courtyard with four outlying rectangular courtyards. On the upper floors there were long galleries for temporary exhibitions, special rooms for painting and drawing, a Russian Orthodox chapel, and a circular hall for lectures and official ceremonies. The whole conception was essentially eighteenth-century French, but French with a hint of a Slavic accent and more than a hint of the traditional Russian liking for bigness. It must have made the small American who encountered it in 1845 feel immensely important and feel also that the fine arts themselves were immensely important.

The kind of drawing and painting that was liked by the professors at the academy was even more international in style than the building, and as remote from the native icon tradition as the St. Petersburg court and aristocracy were from the masses of the Russian people. Early in the eighteenth century, shortly after the

founding of the city, Peter the Great had begun the local custom of importing foreign artists and sending promising young Russians abroad for long periods of study. At first the studios of Venice and Amsterdam had been favored. By the third quarter of the century, when the academy was being organized, the court had discovered Van Dyck poses, Louis XIV gestures, and Rococo bosoms. During the reign of Catherine the Great there had been a wave of interest in English painting; for a while both Reynolds and Gainsborough had been influential. In the first part of the nineteenth century a thoroughly academic variety of French Neoclassicism, modified sometimes by the old lure of Italy, had tended to prevail. By the time Jemmie was crossing the Neva for his lessons a certain amount of Romanticism, in treatment if not always in subject matter, had begun to creep in, and by then the best-known Russian painters were Alexander Ivanov and Karl Briullov, both of whom had worked in Rome. Ivanov, who still lived mostly in Italy, had ideas about a revival of medieval religious art that were somewhat like those of the later Pre-Raphaelite Brotherhood in England and of the earlier German Nazarenes. Briullov was a disciple of Raphael, David, and Poussin, a member of the academies in Milan and Bologna as well as the one in St. Petersburg, a fashionable portraitist, and a social lion in the Russian capital during the 1840s. His chief claim to glory, however, was his huge, melodramatic *Last Days of Pompeii*, which he had finished painting in 1830 after visiting the excavated town, reading Pliny, and listening to Giovanni Pacini's opera, *L'ultimo giorno di Pompei*. The picture had been exhibited in Rome and Paris, and had been pronounced one of the wonders of the modern era. Bulwer Lytton had found in it the inspiration for his best-selling novel with the same title, and Sir Walter Scott had sat mesmerized in front of it for an hour.

Briullov the painter of grand historical "machines" was exactly the sort of artist whom the mature Whistler would go out of his way to insult. But the young student, in spite of his recorded tendency to be saucy about the bird pictures of Peter the Great, was as ready as his elders were to admire the current artistic heroes of the St. Petersburg establishment. After all, he was himself a kind

of satellite of a satellite of the academy's center of admiration, since the private instructor whom he looked up to "with all the reverence an artist merits"—and who has been identified as a Russian named Alexander Ossipovich Koritsky, or Karitzky—was an assistant to Briullov and a collector of the master's works. Also, there was always Briullov the portrait painter to be considered, and here the boy, who had already begun to draw portraits of members of the family, felt himself a competent judge. In July, 1846, his mother mentions a visit to the czar's new palace during which permission was granted to see the apartment of the late Grand Duchess Alexandra: "On one side is the lovely picture painted by Buloff [*sic*], so like her in life and health, though taken after death, as representing her spirit passing upwards to the palace above the blue sky. . . . No wonder James should have thought this picture the most interesting of all the works of art around us." His interest in portraits in general was keen, and on at least one occasion it was combined with an interest in his own handsome appearance: in May, 1846, he went to the Triennial Exhibition at the academy "almost every day for a week," part of the attraction being "a boy's portrait said to be *his* likeness . . . although the eyes were black and the curls darker."

Oddly, the diary in all its talk about art makes no reference to the Hermitage, where the czar's collection, largely of Western European works, had grown to more than four thousand paintings and an almost uncountable number of drawings. Nor is James recorded mentioning this most fabulous of all Russian galleries. Since the major clearly had enough influence at court to get permission to visit the collection with his family, he probably failed to do so simply because of the very special circumstances of the period. In 1837 the Winter Palace had been ravaged by a fire, and between 1840 and 1849 the New Hermitage was being built. Officially, Nicholas I did not open his treasures to the view of the general public until 1852, by which time the Whistlers' stay in Russia was sadly in the past. Possibly that fire of 1837 deflected the whole tendency of James's pictorial vision, for it is easy to imagine that he would have been a different painter if his young

eyes had been nourished occasionally on Titian, Watteau, and Velázquez at the Hermitage instead of on Briullov and Karitzky and company at the Imperial Academy of Fine Arts.

He was not quite exclusively, however, on an academic diet. In 1847 during his attack of rheumatic fever he was given a massive volume of Hogarth's engravings—probably the popular series reproducing *A Rake's Progress* and *Marriage à la Mode*, unsuitable as they may seem for a nineteenth-century adolescent—and Anna Mathilda was much taken by his reaction: "We put the immense book on his bed, draw the great easy-chair close up, so that he can feast upon it without fatigue. He said, while so engaged yesterday, 'Oh, how I wish I were well; I want so to show these engravings to my drawing master; it is not everyone who has a chance of seeing Hogarth's own engravings of his originals . . .'" We may want to believe that the conversational style of Jemmie was a little less stilted, but there can be no doubt about the permanent effect of the gift. Many decades later an acquaintance would recall hearing the strident voice of the Whistler of around 1885 crackling through the silence of the Hogarth room in the London National Gallery: "Why! Hogarth! He was a great painter!" This opinion was never shaken by the inconvenient fact that Hogarth had been a leading exponent of the kind of English storytelling painting which in theory the mature Whistler wanted to badger out of existence.

His visual education in Russia included not only his lessons in drawing, his experience of the palatial academy, his visits to art shows, and his discovery of Hogarth, but also his daily views of streets, squares, waterways, monuments, and, during the summer, a remarkably civilized surrounding countryside. St. Petersburg was not an environment of the neutral sort that can be ignored. It was one of the urban masterpieces of the world, created by the labor of millions of serfs, by the sheer willfulness of a few autocrats, most of them women, and by the imaginations of a series of brilliant architects whose names read like a roll call of European talent. The whole thing, which in the 1840s was a metropolis of about five hundred thousand inhabitants, had been set down, apparently but

not actually with the absurdity of a tipsy peasant, on what in 1703 had been a bleak marsh crossed by the shifting branches of the mouth of the Neva. It was Russian in its vistas and scale, frequently Baroque and Neoclassical in its forms and details, and for the most part, at least in the historical center, rigorously, heartlessly beautiful. Looking at it for four and a half years was excellent training for an artistic sensibility that would one day be the inventor of quasi-abstract visual "arrangements" and "symphonies."

From September, 1843, when Anna Mathilda and the children arrived, until the next spring the Whistlers lived a short distance south of the main branch of the river, in what is now Red Street and was then called the Galernaya; the quarter was one of embassies, and the house had just been vacated by the American envoy. When Jemmie went outdoors he was within a few minutes of several of the most celebrated sights in the city. Immediately to the south was the domed pile of the French architect Monferran's uncompleted Cathedral of St. Isaac, loaded with sumptuous marble and granite and visibly indebted to St. Peter's, St. Paul's, and the Paris Panthéon. Immediately to the north were the public gardens and the French sculptor Falconet's Bronze Horseman. To the east, near the beginning of the Nevski Prospekt, lay the golden spire and the strongly geometrical, Romantic-Classical silhouette of the Russian Zakharov's admiralty building; still farther east was the long Baroque facade of the Italian Rastrelli's Winter Palace. To the west the boy could see the Italian-Russian Rossi's recently completed Roman-looking senate and synod.

In May, 1844, the family rented a house for the summer in an area called Dom Drury, three and a half miles southwest of St. Petersburg on the road to the palaces and resort towns near the shore of the Gulf of Finland. On August 23, Mrs. Whistler took the children on a sightseeing trip to Peterhof (now Petrodvorets), where the czars and especially the czarinas had created a Russian version of Versailles: "Jemmie was delighted with the figure of Samson tearing open the jaws of the lion, from which ascends a *jet d'eau* one hundred feet. . . ." On August 28, with stepdaughter

Deborah and Aunt Alicia, they visited Tsarskoye Selo (now Pusn-kin), where they enjoyed the fake Gothic ruins, the Turkish kiosk, the Chinese village, and the palace rooms, which the Scottish architect Cameron had decorated in a blend of Chinoiserie and lightweight Palladianism.

That fall the Galernaya house was given up for a large flat on the English Quay (Red Fleet Quay in modern Leningrad), a section of the Great Neva waterfront west of the Bronze Horseman and opposite the most monumental part of Vasilyevski Island. From the windows of the flat could be seen not only the French architect Vallin de la Mothe's Academy of Fine Arts, but also, strung out toward the east like a man-made archipelago, the German Schädel's rust-red Menshikov Palace, the Italo-Swiss Trezzini's massive university building, the Italian Quarenghi's nobly Neoclassical Academy of Sciences, and perhaps the roofs of the French Thomon's many-columned Bourse, a splendid marriage of First Empire refinement with the Doric rudeness of the Greek temples at Paestum. Confronted by so much stony magnificence and by such a list of internationally illustrious designers, Anna Mathilda' began to muse, according to the evidence of one of her letters, on the possibility that Jemmie would become, if not a parson or an engineer, the first architect in the family.

When Major Whistler, on his arrival in 1842, had asked Nicholas I how the railroad from St. Petersburg to Moscow should be laid out, the czar had taken a ruler and drawn a straight line on the map between the two cities. This piece of imperial nonsense had turned out to be only the first of a long list of unexpected differences between working in Russia and working on the Baltimore and Ohio or the Stonington line. A labor force of illiterate, frequently drunken peasants had had to be trained for the new technological era with the help of serfmasters and whips. The murderous northern winters had sometimes undone part of what had been accomplished during the previous summers. Official assistants and supervisors had been better at court intrigue than at

building railroads. There had been unbelievable errors: when some rolling stock had finally arrived, it had turned out to be of a different gauge from that of the rails. The czar, eager to get his money's worth out of his American civil engineer, had asked for assistance on such matters as the building of an iron bridge over the Neva and the improvement of the docks, arsenal, and fortifications at Kronstadt. The harassed major regularly had to absent himself from his wife and children for days at a time. But somehow the construction of the line was well under way by the spring of 1847, and he was therefore decorated with the Order of St. Anne of the Second Degree. Fortified by this evidence that his affairs were in shape, he sent Anna Mathilda, Deborah, James, and William off for a holiday in England, and joined them there briefly at the end of the summer.

The principal event of the year for the family was the marriage of Deborah, in Preston on October 10, to Dr. (later Sir) Francis Seymour Haden, a tall, sober, prosperous, twenty-nine-year-old surgeon whom she had met during a visit with some friends in Switzerland. Seymour Haden, as he was usually called, had much to recommend him as a brother-in-law. Although English, he was the nephew of a leading citizen of Lowell. He had inherited a fine house at 62 Sloane Street, London. Like his bride, he was interested in music. He was a knowledgeable collector of pictures, and an expert, sensitive etcher, destined to play a respectable role in the nineteenth-century revival of engraving in the British Isles. He was ready to give useful advice to James, and willing to provide what the boy may have already been looking for—a base of operations in London. Nevertheless, relations between the brothers-in-law got off to a slightly strained start, and James later recalled an immediate dislike that was provoked by the doctor's alleged pomposity. "Haden," he said, "patted me on the shoulder and said it was high time the boy was going to school."

The Hadens went to Wales on a wedding journey before settling down at 62 Sloane Street, and the Whistlers, minus Deborah, arrived back in St. Petersburg on the last boat before ice closed the approaches to Kronstadt. The flat on the English

Quay was waiting, freshly papered and painted. Life in Russia was soon back to normal, with the major frequently away on inspection trips, Willie skating on the Neva, Anna Mathilda watching the servants and writing her diary, and Jemmie, with the help of Karitzky, working at his drawing. But in June, 1848, there was an outbreak of cholera in the city, and so the two boys and their mother returned to England for another summer holiday. This time the major did not feel that he would be able to join them.

They picked up Deborah in London, and by the last week in July they were on the southern coast of the Isle of Wight, enjoying the clean sea air and exploring the steep, picturesque gullies, known as chines, created by the ancient action of small streams on the soft rock. Mrs. Whistler mentions one "lovely bright morning" when they took the classic tourist drive along the top of the cliffs to the celebrated Blackgang Chine: "Jamie flew off like a sea-fowl, his sketchbook in hand . . ." Here he sounds in perfect health, but when the time came to go back and face another St. Petersburg winter his mother decided that it was wiser to leave him in the relatively mild climate of England. He was installed in a school at Portishead, near Bristol, in the autumn of 1848, but he was no more suited to school life in England than he had been to life under Monsieur Jourdan in Russia. By the following January he was in London, staying with his half-sister and getting some tutoring from a clergyman.

Encouraged by such cultivated relatives as Deborah, Seymour Haden, and Aunts Alicia and Eliza, he continued his drawing. He met the painter William Boxall, who had studied in Italy and at the school run by the British Royal Academy, who had done portraits of Landor, Coleridge, Wordsworth, and Prince Albert, and who would one day be a member of the Royal Academy and director of the London National Gallery. Commissioned by the major from the distant banks of the Neva, Boxall painted a romantic likeness of the boy, and in the course of the work developed a lasting interest in the future of his sitter.

On January 24, 1849, a desire that had evidently been discussed in St. Petersburg was brought firmly, if a trifle incidentally,

up to the level of a decision. James wrote from 62 Sloane Street to his father:

"Have you been to any exhibition at the Academy lately? I wish you would tell me all about it (if you have) in your next. Did I mention in my last, that Mr. Boxall is going to take me to Hampton Court, where Raphael's cartoons are? I shall tell you what I think of them then. Fancy being so near the works of the greatest artist that ever was! I wish you could go with me! And Karitzky, too, how much we should enjoy it! I hope, dear Father, you will not object to my choice, viz: a painter, for I wish to be one so *very* much and I don't see why I should not, many others have done so before. I hope you will say *Yes* in your next, and that Dear Mother will not object . . ."

The major had had a mild attack of cholera earlier that winter, and although he had apparently recovered he was still not his old energetic self. Also, for probably the first time in his life, he was seriously discouraged. Work on his railroad, which was only about a year from completion, became bogged down because of the epidemic and because the Russian government, frightened by the European revolutions of 1848, was diverting funds from rails to cannons. On February 12, he wrote to a friend in the United States to say that he was thinking of giving up and going home. Perhaps because of all this, or perhaps because he remembered the strength of his own early desire to be a painter, he may not have felt up to answering James's letter. In any event, it was Anna Mathilda who, on February 15, wrote the answer:

"And now, Jamie, for your future calling! It is quite natural that you should think of all others you should prefer the profession of an Artist, your father did so before you. I have often congratulated myself his talents were more usefully applied and I judge that you will experience how much greater your advantage, if fancy sketches, studies, etc. are meant for your hours of leisure. I have hoped you would be guided by your dear father and become either an architect or engineer—but do not be uneasy, my dear boy, and suppose your tender Mother, who so desires your happiness,

means to quench your hopes. Try to enlarge your views by improving your mind first, be governed by the daily direction of dear Sis and Seymour till you can be with Father again."

The refusal revealed essentially the same attitude that had come out when she had told Sir William Allan in St. Petersburg that the boy's gift "had only been cultivated as an amusement." In spite of her visits to museums she was incapable of anything except a condescending appreciation of art. But the refusal was not quite flat, and James's activities during the next few weeks, as revealed in his letters to his parents, show that he was far from having his hopes quenched. He visited the art gallery in Preston and the Vernon Gallery in London. On March 17, 1849, he says he has been reading the *Memoirs of the Early Italian Painters*, recently edited by Mrs. Anna Jameson. In the same letter he mentions a Fuseli print given to him by Haden and announces that he has been attending lectures at the Royal Academy. The lecturer was Charles Robert Leslie; the subjects were Thomas Bewick, Thomas Stothard, William Hogarth, Benjamin West, and Sir Joshua Reynolds; and each of these six artists could have stirred an intimation, or a daydream, of a possible future. Leslie was an American who had studied in London, achieved election to the Royal Academy, taught drawing for a while at West Point, and written a well-known life of Constable. Bewick, Stothard, and Hogarth had demonstrated that one could become famous through prints. West was another American who had succeeded in London; he had even captured the presidency of the Royal Academy. Reynolds had been solid evidence of what Dear Mother did not yet understand: the dignity of the painter's profession.

All thoughts, however, of a painting career in London were soon extinguished, temporarily at least, by the news that the major, exhausted and demoralized, had died on April 9 of an undiagnosed illness. Anna Mathilda, accepting the offer of Nicholas I's private barge, took the body of her husband from the English Quay to Kronstadt and put it on the steamer for America, where it would be buried alongside the four young Whistlers who had died since

1840. She rejected a suggestion from the czar that her sons be left in Russia to complete their education at the school for imperial pages. After farewell visits in Britain and a trip to the Royal Academy show to see the Boxall portrait, she and James and William boarded a liner for New York at Liverpool. By the middle of August they were back in Stonington.

CHAPTER III

The Southern Cavalier
1849-1855

The major's estate provided his widow with an annual income of
about fifteen hundred dollars, which was not very much in com-
parison with the twelve thousand of the St. Petersburg period.
A girl cousin of Jemmie and Willie said afterward that the boys
"were brought up like little princes until their father's death, which
changed everything." Shortly after the return to America Mrs.
Whistler gave up the pleasant residence on Main Street in Stoning-
ton and rented part of a farmhouse at Pomfret, Connecticut. But
it would be wrong to conclude from such information that she
was impoverished after 1849. In the first place, fifteen hundred
dollars a year was a respectable lower-middle-class income in the
middle of the nineteenth century. In the second place, financial
help was available from some of the major's numerous brothers and
sisters, from members of the McNeill family in the United States
and England, and from stepson George, who by the early 1850s
had married a sister of the railroad industrialist Thomas Winans
and had entered the Winans locomotive works in Baltimore as
partner and superintendent. Although Anna Mathilda no longer
had the houseful of servants she had had on the English Quay, she
was able to continue the education of both of her sons and eventu-

40

ally send William to a medical school. Later on she was prosperous enough to offer herself three voyages across the Atlantic. And her principal reason for moving to Pomfret was to put the boys in a local private school, Christ Church Hall, which was run by a stern master who, being both a parson and a West Point civil engineer, combined in himself the two careers she thought most suitable for bright male Whistlers.

If James was conscious of having suddenly become a ruined ex-prince, he gave no indication of it. The above-mentioned cousin, who was a student at Christ Church Hall in 1850, remembered him as "tall and slight, with a pensive, delicate face, shaded by soft brown curls, one lock of which fell over his forehead. . . . He had a somewhat foreign appearance and manner, which, aided by his natural abilities, made him very charming even at that age. . . . He was one of the sweetest, loveliest boys I ever met, and was a great favorite." His tallness must have been an illusion due to his slightness, for when he was fully grown he was only five feet five. But he was clearly an attractive adolescent; another girl schoolmate at Pomfret remembered him as "fascinating . . . with a charm which from the beginning everyone who knew him recognized." He was also "full of fun," she recalled, and one day he was caned after coming to class in a stiff collar and a tie that mocked those of the engineer-parson headmaster.

He was still drawing, although now without the help of a private tutor, and he impressed his fellow students with his caricatures, portraits, landscapes, and maps. He continued to recite Bible verses before breakfast. He dutifully took his turn with the chores around the farmhouse; his mother remarks in one of her letters that he has been shoveling snow from a path. She also says, however, that "Jemmie is still an excitable spirit with little perseverance."

After two years at Christ Church Hall he decided, or Anna Mathilda decided, that the proper thing for a son of Major Whistler and a nephew of William McNeill was to enter the military academy at West Point. His half brother George went up from Balti-

more to Washington and talked to Senator Daniel Webster about the possibility of being enrolled. Perhaps the fact that the young aspirant to a military career was also an artist had some effect on the senator, who a few months later was leading an unsuccessful oratorical battle to persuade Congress to purchase for the nation George Catlin's gallery of portraits of Indians. In any event, the senator applied the necessary political pressure, and President Millard Fillmore ordered the appointment of James as a cadet at large— as one not included, that is, in the quota of students from any particular state.

The official history of the new cadet's academy exploits exists in the form of a laconic report by a West Point colonel: "He entered July 1, 1851, under the name of James A. Whistler, aged sixteen years and eleven months. . . . At the end of his second year, in 1853, he was absent with leave on account of ill health. On June 16, 1854, he was discharged from the Academy for deficiency in chemistry. At that time he stood at the head of his class in drawing and No. 39 in philosophy, the total number in the class being forty-three."

The anecdotal history of these three years is more bulky. James spent a lot of his time falling off horses, being absent from roll call on cold mornings, wearing nonregulation boots, and going off limits for buckwheat cakes or pretty girls, both of which he would continue to like for the rest of his life. He accumulated 218 demerits, which was eighteen more than the law allowed. Like many students who fail and rebel, he was popular with his classmates, one of whom remembered him as "a vivacious and likeable little fellow" who was known as Curly. He was difficult to shame. Once a professor, shocked because Cadet Whistler did not know when the battle of Buena Vista had been fought, tried to be worldly about the matter: "Suppose you were to go out to dinner, and the company began to talk of the Mexican War, and you, a West Point man, were asked the date of the battle. What would you do?" "Do," Curly replied, "why, I should refuse to associate with people who could talk of such things at dinner." One of the questions in his final chemistry examination concerned silicon, which he con-

fidently announced was a gas. "Had silicon been a gas," he re-marked later, "I would have been a major general."

He was taken seriously only in his drawing class. The pro-fessor was Robert W. Weir, a middle-aged civilian who was mostly a genre and portrait painter, but who had studied the grand man-ner in Italy and had executed, among other historical works, *The Embarkation of the Pilgrims* as a mural for the new Capitol rotunda in Washington. A self-portrait depicts him as a nonchalant, round-faced, bold-eyed man, disheveled in a fashion halfway from Byron to Baudelaire. He devoted special attention to gifted cadets, for he was interested in something beyond the mere training of civil en-gineers and military mapmakers. But how much James actually learned from him is debatable, partly because the boy had already received some solid academic instruction from Karitzky and the St. Petersburg faculty, and also because Weir had a habit of re-touching his students' exercises. On the whole, the small number of Whistlers, or supposed Whistlers, surviving from this period are very disappointing things from a nearly grown-up artist with several years of training behind him. As examples of his classwork there are drawings that are evidently copies of unidentified originals used by Weir for teaching. Among the sketches done outside the class are scenes from *Pickwick Papers* and a series showing a cadet getting sleepy on guard duty. There is also the cover for the sheet music of *Song of the Graduates*, which shows two young soldiers shaking hands in front of what is presumably the Hudson River valley near West Point. Although the cover is credited to Cadet Whistler, the style is that of a mid-nineteenth-century professional, and sentimental, lithographer.

In addition to the surviving sketches there were, according to the recollections of classmates, many humorous drawings of cadets, teachers, and visitors, at least one painting, and some illustrations for the novels of Dumas and Hugo. The illustrations suggest that James was not neglecting his St. Petersburg French, and so does a West Point story that has him referring habitually to his room-mate, whose name was Childs, as Les Enfants.

On the record, then, the three years at the military academy

were a humiliating failure in everything except art, and in art they were only an ordinary schoolboy success. They were, however, of considerable importance in the development of the Whistlerian lifestyle, a development that, here as elsewhere, is best perceived in the light of a combination of early hints and later facts.

We can start with a curious affair of names. The boy entered West Point under his baptismal James Abbott. This was the name of a Detroit man who had married the major's oldest sister; at Lowell in 1834 the name was perhaps regarded as a sign of a warm tribal togetherness that embraced everybody from Anna Mathilda's first-born to the remote uncle-in-law. James must have long regarded the names as simply his own emanation, as something that could not be otherwise; at least most children appear to regard their names in this way. But at the military academy in 1851 he suddenly adopted a different attitude. He began to insert his mother's maiden name, McNeill, before the Whistler. Eventually he dropped the Abbott altogether except for legal documents and a few formal occasions. Why did he thus partly rechristen himself? The operation, which can scarcely be called usual among seventeen-year-olds, must have had some kind of symbolic, perhaps incompletely avowed, perhaps liberating, significance for him. What was it?

A Freudian answer is possible, although it must remain in the realm of speculation. We can suppose that by taking the name McNeill the young cadet, who was sinking, however waggishly, into a bad defeat for his ego, symbolically rekilled his army-officer father and married his dear mummy. To be sure, this Oedipal interpretation is flawed by the fact that the boy finally eliminated the Detroit uncle-in-law's name instead of the major's. But he could not have dropped the Whistler without provoking awkward questions and facing up to his secret reasons for his action; and guilt-inspired substitutions in such situations are familiar to depth psychologists. Moreover, the rest of the supposed evidence, past and future, can be made to fall into place like the data in a textbook case history. We can imagine the long days and nights in St. Peters-

burg when the handsome, frail child was being nursed and caressed by Anna Mathilda, his servant and his love object; we can imagine, too, his hot jealousy when the major came home from an inspection trip and took husbandly possession of the love object. We can imagine the months at West Point when the son was failing where the illustrious father had succeeded, and when the cadet was being disciplined by officers who were like omnipresent reincarnations of the father. Then came the change of name and, in 1853, what the military academy called absence with leave on account of ill health—in other words, a flight home to mummy. In the textbook case histories the son often winds up as a homosexual, and James did not. He did, however, in his voice, his walk, his gestures, his dress, and his tastes, reveal a good deal of latent effeminacy. (One day in Paris the mordant Degas, watching him prance into a restaurant, called out: "Whistler, you've forgotten your muff.") He did keep house with his mother, with his "pretty bit of color," for what might be called an abnormal length of time. He made her the subject of what is universally recognized as his most deeply felt, most personal painting. And he did not marry until she was in her grave and he was fifty-four.

Psychoanalytic speculation, however, although all right as far as it goes, leaves out of consideration a mass of evidence that shows that the rechristening as a McNeill was a symbolic rejection not only of the major as father and sexual rival, but also of the major as the representative of certain American cultural elements—in particular, of Irish-immigrant drive, New England technology, and Yankee, or at any rate northern, egalitarianism. Sometime around 1851 James decided to make himself over into an entirely Scottish, entirely Southern, dashingly aristocratic West Point cavalier, with a touch of Russian princelet for exotic effect. Since he was not entirely Scottish, since he never got farther south than Baltimore, since his West Point years were a fiasco, and since his Russian princeliness was as American as the Fourth of July, his decision meant that he was committed to an extraordinarily elaborate, strenuous piece of role-playing. From sometime around 1851 can

be dated the emergence of a disconcertingly double Whistler, of an attractive, serious, artistic Whistler and a frequently absurd stage Whistler inside the same skin.

With the passage of time the Scotch, Southern, West-Point-cavalier, Russian-princelet role had to share billing with a number of other roles, but it remained, as some sampling across decades can demonstrate, the core of the stage Whistler's performance. In Washington he promenaded in a Scotch cap and with a plaid shawl draped over his shoulder. Later on, having discovered the name "Francis Whistler, gentleman" in a list of early Virginia settlers who were in fact not related to his family, he remarked: "There is an ancestor, with the hallmark F.F.V. [First Families of Virginia], who . . . washes out the taint of Lowell." Once when an American in England observed that he too was born in Lowell, the Southern cavalier fairly spurted venom: "Most interesting, no doubt, and as you please. But I shall be born when and where I want, and I do not choose to be born in Lowell . . ." There exists a proof of a *Who's Who* notice on which he crossed out both "Abbott" and "Lowell," inserted "of Baltimore" after his name, and added: "Mother's family, McNeills of S. Carolina." Asked in London about the possibility of his returning to the United States, he said, "When I go to America, I shall go straight to Baltimore, then to West Point, then sail . . ." He constantly referred to himself as "a West Point man." He liked to deliver little sermons about "correct West Point principles" and "our deference to the unwritten law of tradition." He admired the wars of the nineteenth century that were fought, in his opinion, according to the West Point code, "with the most perfect courtesy and dignity on both sides, and the greatest chivalry." As for his fancying himself as a Russian princelet, the best evidence is that at the time of his conflict with Ruskin he solemnly affirmed in a London lawcourt that his birthplace was St. Petersburg.

In view of his wit, his attested charm when he wished to be charming, and his shrewdness about his personal publicity, chroniclers of his progress through the art worlds of Paris and London have been inclined to treat his role-playing as something of a run-

ning joke. Could the sharp, sophisticated, tasteful Jimmy Whistler have actually been that far, and that obtusely, out of touch with reality? Alas, while there were certainly flashes of humor and irony in his performance of the cavalier role, there were none in his attachment to the set of values that went with the role. He did not limit himself to foolishness about chivalry and fictitious birthplaces; he was always ready to exhibit the uglier aspects of his notion of himself as a purebred member of a master race from somewhere below the Mason-Dixon line, or from the banks of the Neva. He frequently expressed his loathing for "niggers," and would not listen to any suggestion that perhaps they had not had the same chance as white men. Influenced possibly by what he called "my Russian cradle," he was also violently anti-Semitic. His friends and early biographers Joseph and Elizabeth Pennell remark in passing (and with seeming approval): "How he hated Jews!"

Oedipus the Southern cavalier refused at first to accept as irrevocable his expulsion from the military academy. "Well, you know," he mused long afterward, "it was not a moment for the return of the prodigal to his family or any slaying of fatted calves . . . I went to Washington and called at once on Jefferson Davis, who was the secretary of war, a West Point man like myself. He was most charming, and I—well—from my Russian cradle, I had an idea of things and the interview was in every way correct, conducted on both sides with the utmost dignity and elegance. I explained my unfortunate difference with the professor of chemistry, represented that the question was one of no vital importance, while on all really important questions, I had carried off more than the necessary marks. My explanation made, I suggested that I should be reinstated at West Point, in which case, as far as I was concerned, silicon should remain a metal." Davis sent the request to Robert E. Lee, who was then superintendent of the military academy, but neither was sufficiently impressed by the young Southerner from New England to order his reinstatement. An application for an appointment to the naval academy at Annapolis was also rejected.

For a moment there was the possibility of an appointment in the Marine Corps, which Whistler himself apparently ruled out as an adequate substitute for a return to West Point. These last-minute maneuvers are proof that at no time did the painter at the military academy suffer the pangs of frustration generally supposed to afflict artists when they find themselves trapped in nonartistic careers. Although he had no aptitude for the process of actually becoming an army officer, he was delighted with the prospect of somehow being one. He always looked back with pleasure at his appearance as a cadet, "very dandy in gray."

During the summer of 1854 he was in and out of Baltimore, where in theory he was being tried out as an apprentice draftsman in the Winans locomotive works under his half-brother George. According to the recollections of a fellow draftsman, the experiment was marked only by "flightiness," some "loitering" in the workrooms, and a large amount of very random drawing: "We all had boards with paper, carefully stretched, which Jem would cover with sketches, to our great disgust . . ." By the end of the summer, the family had decided that the only thing to be done with the loiterer was to turn him into a professional painter. But he was to wait until money was available to send him abroad to study, and in the meantime he was to do some work. So on November 7, 1854, he entered the drawing division of the United States Coast Survey (now the Coast and Geodetic Survey) in Washington, at a salary of a dollar and a half a day. Jefferson Davis had suggested the appointment, and the arrangements had been facilitated by the fact that Captain Henry Benham, the assistant chief of the survey, had known Major Whistler. The principal activity of the division was the designing and etching of maps and topographical plans.

"I was apt to be late," James recalled. "I was so busy socially. I lived in a small room, but it was amazing how I was asked and went everywhere—to balls, to the legations, to all that was going on." Acquaintances remembered him as "rather hard up," "painfully nearsighted" (which may explain a few of his troubles as a cadet), and "witty and paradoxically amusing." Again he was al-

ways sketching, even on the walls of the survey building. Also, he talked about Paris. He resigned on February 12, 1855, obviously to the relief of his superiors; office records show that he worked less than six full days that month and less than seven in January. Yet he cannot be said to have wasted his time at the survey, for under the guidance of the agency's expert cartographers he learned at least the rudiments of the technique of etching. Two of the plates on which he worked have been preserved; on one of them, which was given to him as a beginner for experimenting, there are views of part of the Boston harbor combined with sketches of a mother and child and five vaguely romantic heads. Once more a modern viewer is likely to be disappointed if he looks for signs of genius. Although the etching is competent enough, the drawing reveals no more promise than the surviving production of the West Point years.

George Whistler made another offer of a position in the locomotive works at Baltimore, but without success. By April James was installed in a Washington studio, where he painted a few portraits, all of which have been lost; all appear to have been likenesses of friends and of members of the family, and can scarcely be called the beginning of a professional career. He also tried his hand at lithography, a medium he would not take up again until 1878. By autumn the financial arrangements for his period of study in Europe were agreed upon; he was to have his passage paid to France and three hundred and fifty dollars a year, to be sent to him in quarterly payments by George, acting as one of his guardians. In October he left the United States, never to return. He stayed for a while with Deborah and Seymour Haden in London, and on November 3, 1855, he reached Paris.

The Bohemian Dandy
1855-1859

Paris in 1855 was for most foreigners the city of the Exposition
Universelle, the first of the international fairs staged by Napoleon
III as evidence that the France of the Second Empire was capable
of becoming as modern as England and Germany. Between the
official opening on May 15 and the closing ceremonies on Novem-
ber 15, less than two weeks after Whistler's arrival, the show
attracted five million visitors, including such illustrious ones as
Queen Victoria, Prince Albert, and the kings of Sardinia and
Portugal. A total of forty thousand lovers of Romantic music
appeared at the three Berlioz concerts, conducted by the composer
himself. Deborah and Seymour Haden came over from London in
time for the final events. Day after day the crowds in stovepipe
hats and crinolines walked past the agricultural exhibits and the
new machines in the Palais de l'Industrie, an up-to-date construc-
tion of masonry, glass, and iron—partly a classical temple and
partly a copy of Paxton's four-year-old Crystal Palace—situated in
the green belt between the Avenue des Champs-Elysées and the
Seine.

When you tired of corn and gadgets you could walk over to
the fine arts section, and here, for a young American painter hoping

to find his way among world contemporary trends, the spectacle must have been at once exhilarating and discouraging. More than five thousand pictures from twenty-eight nations were jammed onto the walls frame against frame in several tiers; those favored by the exposition jury were at eye level, "on the line" in Royal Academy slang, while the unfavored were mercilessly "skyed" at nearly ceiling level. British tendencies were well represented by the work of such artists as Millais, Maclise, Holman Hunt, and Leslie, the Royal Academy lecturer of 1849. But the French easily dominated. The older kind of Romanticism was represented by Delacroix, with thirty-five major works that spanned his career. What could still be called Neoclassicism was represented by Ingres, with forty paintings and a large number of drawings. Some unconventional landscapes were supplied by such precursors of the Impressionists as Corot, Daubigny, and Jongkind. Expertly conventional historical and genre works were contributed by such academic stalwarts as Couture, Gérome, Cabanel, and Meissonier. Down near the river stood the Pavillon du Réalisme, defiantly erected by Courbet at his own expense after the official jury had refused to hang two of his submitted pictures. The little building drew more laughs than visitors; alongside the imposing Palais it looked, a hostile journalist wrote, "like a puppet theater alongside La Scala." But its lonely one-man show had the seeds of Whistler's and several other young artists' future rejection of institutionalized taste.

Paris in 1855 was also the city of Baron Haussmann, the emperor's new prefect of the Seine Department and chief urbanist. Under the efficient Baron's direction whole quarters were being demolished, thousands of buildings were going up, street lamps were proliferating, and long, wide, straight avenues, winding up at landmark monuments or converging in *ronds-points*, were being laid out. The new metropolis that was emerging was a convenience for gendarmes shooting at mobs, an unquestionable progress in terms of public health, a source of regret for romantic lovers of the old Paris, and a source of pleasure for admirers of Versailles-like vistas and scholarly architectural styles. Almost as remarkable as the nature of the change was the speed with which it was being

carried out. In 1853 the new Boulevard de Strasbourg had been inaugurated. In 1854 the Bois de Boulogne had begun to be the parade ground for fashionable people. In 1855 the extension of the Rue de Rivoli was being completed, and the Boulevard de Sébastopol was under way. The next year would bring the opening of the racetrack at Longchamp, the reconstruction of the Pont Saint-Michel, and the beginning of the Boulevard Saint-Michel. Excavations and scaffolding were everywhere; Parisians, playing on the name of a general who had just been made the Comte de Palikao, referred to Haussmann as Paris-Chaos.

That Whistler felt much grief at the destruction of the jumbled old quarters can be doubted. He had been conditioned by the vistas of St. Petersburg, he had little bent for nostalgia of any sort, and he would soon demonstrate that he could distill a poetic mood from such unromantic motifs as warehouses, waterfronts, shopfronts, and factory chimneys. In any event, the quarter into which he immediately plunged on his arrival in Paris, and in which he lived for most of the next four years, was relatively neglected by the imperial razers and straighteners. He began by renting a room in the Hôtel Corneille, a ramshackle boardinghouse for students near the Théâtre de l'Odéon, in the center of the Latin area. After that he changed lodgings frequently, without leaving the Left Bank. For a time he was in the Rue Saint-Sulpice near the church of the same name; most of the buildings in the street dated back at least to the eighteenth century and offered (as several still do) views of picturesque mansard roofs, carved doorways, and ornamental ironwork. Another of his addresses was No. 1 Rue Bourbon-le-Château, back of the Church of Saint-Germain-des-Prés; here the atmosphere was seventeenth-century and even medieval, with a gloomy prison occupying part of the tangled tract through which the Boulevard Saint-Germain would eventually be cut. Later on he moved up the hill to No. 3 Rue Campagne Première, and here he was practically out in the country. He was also in the middle of one of the more disreputable amusement areas of the Second Empire. A few blocks to his south, in a setting best described as dismally rural, stood the huge shed of the partly open-air restaurant

called La Californie; it was frequented by thieves, ragpickers, prostitutes, failed artists, and jobless workers, and the daily consumption of cheap stew was such that cattle and sheep were brought in on the hoof and butchered on the premises. A few blocks to the north, in another partly rural setting, was the legendary dancing, eating, and drinking establishment known officially as La Closerie des Lilas and more familiarly as the Bal Bullier, from the name of its proprietor. Its lilac-decorated aisles were crowded every evening with students accompanied by their favorite female companions, the young seamstresses and apprentice milliners, sometimes of easy virtue, who because of their gray workdresses had acquired the label *grisettes*.

To have followed Anna Mathilda's middle-class and puritanical precepts on the Left Bank in the 1850s would have required very firm intentions, and Whistler did not meet the requirement. He had read—possibly in America, for the book had appeared in 1851— and even partly memorized Henry Murger's popular *Scènes de la vie de Bohème*, and he was soon determinedly imitating, with the help of his command of French, the amorous adventures, the wit, the poverty, and the carefree outlook of Murger's Rodolphe, Marcel, Colline, and Schaunard. (In the book, it can be noted in his defense, the four heroes are not quite the cardboard figures they became in Puccini's opera.) He made a point of getting to know Murger himself, and remained steadfast in his admiration when the supposed king of Bohemia, by then in his middle thirties, turned out to be a dirty, popeyed, timid little man with a discolored beard and frankly bourgeois literary aspirations.

It was important, of course, to have a real-life equivalent for Rodolphe's erring, seductive Mimi, and this want was fulfilled, perhaps as early as 1856, in the person of a Latin Quarter *grisette* named Héloise. She was a milliner's assistant whom Whistler met at one of the garden dancing places, probably the Bal Bullier. According to the recollections of a student friend, she "seemed madly in love with Jimmy and would not allow any other woman to talk to him when she was present." According to another account, she was an ambitious, although sentimental, girl who had a

reputation in the Latin Quarter for attaching herself to young men she considered out of the ordinary. Whatever her motives were, she became Whistler's recognized mistress and lived with him for two or three years. Because of her fiery behavior, he called her Fumette, and the other students referred to her as La Tigresse. During one of her fits of jealous rage she tore up a large number of the drawings in his studio and reduced him to unmanly blubbering—the only occasion in his life on which he is known to have actually shed tears. In a portrait he etched in 1858 she is a very small, very pretty animal, gazing warily out from under a mass of undone hair and half crouching in her large skirt, as if to leap. In a drypoint he did in 1859 she looks wistful and remote; in this mood she might well have evoked, in spite of her apparently robust health, Murger's ethereal, tubercular Mimi, or *la dame aux camélias*, or some other heroine of the current weak-chest school of literature. At any rate, she was not an ordinary *grisette*. She was constantly reciting the poetry of Musset. She had a good singing voice, and one of the songs she sang suggests that she had a music-hall knack for mixing irony with light sentiment:

> *Voulez vous savoir, savoir,*
> *Comment les artistes aiment?*
> *Ils aiment si artistement,*
> *Ils sont de si artistes gens . . .*

(Do you want to know, to know, how artists love? They love so artistically, they are such artistic people . . .)

Sometime in 1859, to judge from another drypoint portrait done during that year, a quite different sort of woman took Whistler's eye. She was a Creole dancer who was known professionally as Finette; during the late 1850s she became a minor celebrity as one of the *entraineuses*, or pacemakers, for the crowds that patronized the Bal Mabille, an extremely fashionable Champs-Elysées ballroom and garden. Eventually she had a London engagement, during which she was billed as "Madame Finette in the Cancan, La Danse Nationale Française." In the drypoint, which from details appears to have been executed in her dressing room

at the Bal Mabille, she looks like a languid lady of fashion; in a photograph taken in London she looks like a trollop. Probably she found the young American painter amusing; nearly everybody did during these early years in Paris. His relationship with her did not last very long; it may have been merely a temporary reaction to the end of his affair with Fumette. It may also have been another instance of life imitating the *Scènes de la vie de Bohème*, for when Rodolphe breaks up with Mimi he too goes to the Bal Mabille, where he drinks too much and allows himself to become briefly involved with an aggressive demimondaine. As for Fumette, she must at about this time have found another out-of-the-ordinary lover who liked Musset, for there are no more Whistler portraits of her. She is said to have finally gone to South America.

Murger, in the preface to his *Scènes*, observes that there are three categories of Bohemian artists. There are "the naives," who lack either talent or initiative and who end their days in misery; there are "the authentics," who regard Bohemian poverty as just a stage in their careers as serious artists; and there are "the amateurs," who come from affluent families and choose to play at being vagabonds and spongers on the Left Bank. Whistler was certainly an "authentic" in terms of gifts and ultimate ambitions. But in other respects he was pretty much an "amateur." His annual allowance of three hundred and fifty dollars, about two thousand francs, was roughly the income of a minor French government clerk. His fees as a student in a group atelier were only ten francs a month. He could dine in a decent Latin Quarter restaurant for less than two francs, wine included, and at La Californie, if he could stand the stew, for thirty centimes. A small apartment on the Left Bank could be rented for less than two hundred francs a year. His tobacco, although he was a heavy smoker of cigarettes, could not have cost him more than fifty francs a year. He added to his income, as did most of the young painters in Paris, by turning out copies of the masterpieces in the Louvre; for a while he had a commission from a Captain Williams of Stonington for as many copies as he wished to do, at twenty-five dollars apiece. Nevertheless, he managed to play the role of the penniless, constantly im-

provising Bohemian very well, simply by spending each quarterly payment of his allowance long before the next one arrived. Soon there were stories of how *le petit américain* had exchanged his jacket for a cool drink in the Rue Bourbon-le-Château, how he had tried to pawn a worthless straw mattress, how he moved to cheaper and cheaper lodgings toward the close of each three-month period, and how he adroitly stole paint from neighboring palettes at the Louvre. He became, and remained all his life, an unabashed borrower of money and an unabashed commentator on his borrowing; on one occasion, after getting three hundred francs from another American painter, he remarked: "And do you know, he had the bad manners to abuse the situation, he insisted on my looking at his pictures." He also developed, and retained, an exceptional talent for obtaining credit; when he left Paris for London in 1859 he owed Lalouette's, a Left Bank restaurant known for its wine cellar, three thousand francs. (In this branch of Bohemian activity he was outdone, however, by his friend Murger, who died owing a Right Bank restaurant fourteen thousand.)

In addition to not being as hard up as he seemed, he differed from most of the young painters in Paris by being eccentric in his dress and general personal appearance. By the 1850s the vogue for Bohemian waistcoats, berets, cloaks, and hairiness was twenty years in the past; the average French artist or poet, if he was not too threadbare, was indistinguishable from a bank clerk. Whistler, drawing on a variety of sources and on his own imagination, went back to the sartorial protests and shock tactics, although not to the actual styles, of the peacocky 1830s. During the cool months he perched on the side of his head a soft, wide-brimmed felt hat, like the one worn by Velázquez's dwarf El Primo; during the summer he substituted for this a strangely flat-crowned, extremely wide-brimmed, Venetian straw boater, decorated with a long, trailing ribbon. When the weather was relatively warm he donned a white duck suit, of a sort never seen on the streets of Paris but favored by plantation owners in the American Deep South. Winter and summer, for all occasions, he wore tight, thin, patent-leather shoes that were little more than dancing pumps. He let his

dark, curly hair grow into two thick clumps that framed his face and almost brushed his shoulders; he had a hint of a military moustache and a dab of a beard under his nether lip. In the self-portraits of this period he looks sometimes like a mid-nineteenth-century West Point colonel fresh from fighting the Indians, and sometimes like the Velázquez self-portrait in *Las Meninas*, a painting he had never seen, but which, basing himself on copies and engravings, he often mentioned as if he had. By the end of his period as a Paris student he had acquired for his right eye a large monocle, which he used as a remedy for his nearsightedness and also, by suddenly screwing it into place or by letting it drop dramatically from its socket into his hand, as a device for adding emphasis to witticisms.

Thus the role-playing continued, with the difference that now he was getting beyond such simple attention-attracting tricks as wearing a Scotch cap and a plaid shawl on the streets of provincial Washington. Now he was playing in Europe, on the big stage, and attending carefully, as he would for the rest of his life, to every detail of his appearance and performance. He was modifying his basic Southern-cavalier role, visible as it still is in parts of his Latin Quarter getup, by grafting onto it at least two other roles. One was that of the gay, impecunious, Mimi-keeping, scrounging Bohemian, extremely young and, being an artist, extremely exempt from the rules that govern ordinary philistine society. And the other role was that of a dandy in the manner of Barbey d'Aurevilly and Baudelaire, which in Paris in the 1850s meant playing Beau Brummell with some new overtones.

Brummell had died in exile at Caen in 1840, half mad and, what was worse, carelessly dressed, but his last sad state had not dimmed the brightness of his heyday and had not kept him from becoming a hero in the minds of many French men of letters. To Barbey d'Aurevilly, who had published his *Du dandysme et de George Brummell* in 1844, the great English fop had been a rebel against mediocrity and standardization, a social philosopher who saw that to seem is to be, and a wit who perceived the need to astonish and wound rather than please—in sum, an aristocratic soul eminently

worthy of imitation in an era when the sea of bourgeois banality was rising everywhere. A little later Baudelaire developed similar notions, with a focus on the situation of poets and painters in nineteenth-century materialistic, conformist society; he urged the "cult of self," defended what he called "the customary insolence of genius," affirmed that an artist had to have "a great deal of the dandy in him," and argued, with an untranslatable play on words, that the true, spiritual dandy adorned himself only in order to cut himself off from the herd: "*Le dandy ne se pare que pour se séparer.*" Both writers practiced what they preached. Barbey d'Aurevilly dazzled contemporaries with his tailored splendor, bound his books in colors that went with his costumes, and carried fastidiousness to extreme lengths in his choice of writing materials. Imprisoned in 1855 for three days for having refused to serve in the Garde Nationale, he explained on his release that he had been upset chiefly by the sheets of ordinary stationery his jailer offered him: "The soul of old Brummell reared up in my soul and forbade me to touch these bourgeois horrors." Baudelaire, besides indulging in the spiritual dandyism apparent in his poetry and prose, spent hours every day on his personal appearance; normally he chose to defy the herd by adopting an outrageous simplicity in his attire, but he used cosmetics heavily, and on one occasion he had asserted his proud isolation by shaving his head and painting it green.

Whistler read Baudelaire and eventually got to know him personally. Although a similarly direct connection with Barbey d'Aurevilly cannot be documented, it need not be; the ideas and the flamboyant personality of this leading French dandy were well known, and Whistler demonstrated on many occasions a gift for picking up things through conversation, for absorbing what was in the cultural air of a dinner party or a café terrace. It is safe, then, to assume that his notion of himself as a dandy, although to some extent already present in the Reynolds cherub at Lowell, in the narcissistic adolescent who admired "his" portrait in the gallery at St. Petersburg, and in the cadet who wore nonregulation boots at West Point, was influenced by French literary attitudinizing. This element in his role-playing, in his construction of an imagi-

nary Jimmy Whistler, can therefore be regarded as something slightly more serious, at at least more defensible, than his Southern-cavalier and Left-Bank–Bohemian poses. It gave a measure of philosophical and social justification to the antibourgeois sentiments that the phony cavalier and the phony Bohemian had in common; it put Whistler the painter on common ground with the French writers, mostly poets, who were fighting to dissociate art from the contaminating concerns of the new, cocksure bourgeoisie of the Second Empire. It would be an important part of his offensive and defensive equipment in the decades ahead, when he would be battling almost alone to dissociate British painting from the concerns of the British middle class, the Royal Academy, a cocksure corps of journalists, and mad John Ruskin.

Dandyism was also for him a pointer toward another French literary attitude, art for art's sake, which he picked up in the Paris of the late 1850s. To the notion of the artist as a dandy, as an artificial, self-created aristocrat, as the triumph of seeming over being, there corresponded the notion of art as a pure, willed, artificial order divorced from morality and utility. The latter notion had been formulated energetically by Théophile Gautier as long ago as 1835, in the famous preface to his novel *Mademoiselle de Maupin:* "Things are beautiful in inverse proportion to their utility. The only thing that is truly beautiful is the thing that serves no purpose at all. Everything useful is ugly." In 1856, a few months, after Whistler's arrival on the Left Bank, Gautier returned to the attack with a leading article in the magazine *L'Artiste.* "Art," he proclaimed, "is not a means, but an end. Any artist who sets out to produce anything except beauty is not an artist." Years later in London, twitching his moustache and brandishing his monocle, Whistler would be defending one of his nocturnes from a similar premise—as "an arrangement of line, form, and color first."

In brief, he acquired some effective stances in France. And yet, looking at and listening to the amateur Bohemian in the big straw hat, you could have had misgivings. In the best of examples dandyism cannot stand much examination, and little Jimmy was not

one of the best examples. Whereas the ideal dandy is nerveless and cold, Jimmy was a bundle of nerves and a quick reactor to insults, real or fancied; one of his Latin Quarter friends described him as *un petit rageur*. Whereas the ideal dandy delivers a witticism cleanly and drily, Jimmy would usually deliver one of his with a prefatory "do you know" and a concluding, braying "eh what" accompanied by a loud, falsetto "ha, ha." Whereas the ideal dandy is a master of understatement in dress, Jimmy could seldom resist the temptation to add the extra detail that made him look like a vaudeville caricature of a Beau Brummell. Finally, whereas the ideal dandy works at nothing except dandyism, Jimmy was supposedly committed to the business of becoming a painter.

During the Second Empire the French system for the training and public recognition of painters was dominated, as it had been since the breakdown of the old system of apprenticeship at the beginning of the nineteenth century, by two institutions. One was the Ecole des Beaux-Arts, on the Rue Bonaparte and only a short distance from Whistler's rooms on the Rue Bourbon-le-Château; here a ferociously conservative faculty, strongly influenced by Ingres, extinguished individuality and, in the words of Delacroix, "taught beauty as one teaches algebra." The other institution was the biennial (annual after 1861) government-sponsored exhibition, the Salon, which from 1855 onward was held in the Palais de l'Industrie, left standing after the close of the Exposition Universelle; commonly between seven and eight thousand pictures were submitted to the jury, and less than half were accepted.

It was dishearteningly difficult for a painter to get a reputation or even sell his work without appearing in the Salon; privately owned galleries were few, a venture like Courbet's Pavillon du Réalisme was usually impossible, and the average collector was likely to be reluctant to invest in something that had not won the approval of the official jury. It was thoroughly possible, however, to study art in Paris without being enrolled in the Ecole des Beaux-Arts. There was a government drawing school, the Ecole

Impériale et Spéciale de Dessin, located on the Rue de l'Ecole-de-Médecine not far from the Hôtel Corneille in which Whistler first settled. There were also several *académies*, presided over by well-known painters, which were more or less satellites of the august institution on the Rue Bonaparte; in a typical *académie* the students, between thirty and forty in number, paid small monthly fees for the use of the atelier, the services of a model, and the opinions of the master. Normally the daily operation was supervised by a dele-gated older student, the *massier*, and the distinguished artist who lent his prestige to the place appeared only once or twice a week to comment on work in progress.

Whistler, for reasons he never gave, did not even attempt to enter the Ecole des Beaux-Arts. In November, 1855, immediately after reaching Paris, he began attending drawing classes, including evening ones when he was not at the Bal Bullier, in the Ecole Impériale et Spéciale de Dessin. Either then or later on in publica-tions and conversations, he got to know the theories of Horace Lecoq de Boisbaudran, a professor at the Ecole Impériale and one of the great French art teachers of the nineteenth century. Lecoq de Boisbaudran believed in working, not with an eye on the motif, but from memory. The supposed advantages of this procedure were once explained by Degas: "It's a transformation in which your imagination collaborates with your memory. You reproduce only what has impressed you, which is to say only what is necessary. Your recollections and your fantasy are liberated from the tyranny of nature." While Whistler would never adopt the method for his oil portraits and his etchings, he would find it useful for painting night views of the Thames.

In June, 1856, he entered the *académie* of Charles-Gabriel Gleyre, where he remained enrolled, if not always actually study-ing, for the next two years. Gleyre, then in his early fifties, was a Swiss artist who had established himself in Paris after spending ten years in Italy and the Near East. He had triumphed at the Salon of 1843 with his *Illusions perdues*, which shows an aging, archaic bard, his lyre cast aside, sitting disconsolately on the bank of the Nile while a bevy of gay maidens, presumably representing

the dreams of his youth, glides away in an Egyptian bark. This
success had not been repeated, and finally the painter himself had
become the victim of lost illusions: by 1856, although still widely
respected, he had stopped sending his pictures to the Salon. He was
described by a disciple as "an antique man" who "never jested about
that holy thing that is called art." In subject matter his work was
a sentimentalization of the remote past in general, and at its most
typical an *embourgeoisement* of ancient Greece. In his painting
style he was a timid eclectic who tried to combine the line of
Ingres with the color of Delacroix. Yet he can scarcely be called
an unsuccessful teacher; among the graduates from his atelier in
the 1860s would be Monet, Renoir, Bazille, and Sisley. And
Whistler, with results that would be both good and bad, learned
three things as a Gleyre student which he would always cling to
—and which would separate him from the majority of con-
temporary French innovators. One was an immense respect for
the art of the past; another was the idea that ivory (or bone)
black, the most intense of the black pigments, was a good base for
a scale of tonal values; and the third was the practice of arranging
a choice of colors on a palette before starting to work. Gleyre
favored this last practice because he felt it left the artist relatively
free to concentrate on drawing; Whistler would favor it as a way
of establishing in advance a "harmony" or a "symphony" for a
given picture.

Although the age was one of heavy-handed practical jokes and
savage student baiting, and although the walls of every Paris atelier
were covered with graffiti and caricatures, the atmosphere at
Gleyre's was generally serious and even dignified. A newcomer was
expected to provide some musical entertainment and a round of
cakes and drinks, and after this brief initiation he was likely to be
accepted as one of the regulars. "If a man was a decent fellow,"
Whistler recalled, "and would sing his song and take a little chaff,
he had no trouble. I only remember one performance of the kind,
and that was when a student, who had already been there some
time, seemed too pleased with himself, too certain he was going
to be made *massier*. And one morning when I came to the studio

late, I found them all working very hard, the unpopular one among them, and there at the end of the room on the model's stand was an enormous catafalque, a wonderful construction, the unpopular one's name on it in big letters."

No coffin was erected for Jimmy. By the end of his life he would have lost more friends than anyone has a right to lose, even in the jealousy-torn and infighting world of art. But he always had, when he chose to exercise it, a remarkable ability to make new friends, and during these first years in Paris he chose to exercise it a great deal. He was constantly introducing himself to strangers who looked interesting, amusing, or useful.

Among his non-French friends were people at the American Embassy, who procured him invitations to good dinners, and a well-to-do Baltimore railroad representative and art collector, George A. Lucas, who had settled in Paris and would be for thirty years a source of loans, services, and encouragement. Close to the amateur-Bohemian category was a group of art-minded young Londoners, some of them students at Gleyre's *académie*, who often gathered in a large studio four of them had rented at 53 Rue Notre-Dame-des-Champs, two thirds of the way up the Montparnasse slope. The most articulate member of this Paris Gang, as they would afterward call themselves in England, was George du Maurier, future cartoonist for *Punch* and future author of *Trilby*. Other members were Thomas R. Lamont, a minor painter and du Maurier's close friend; Thomas Armstrong, future director of the South Kensington Museum, which became the Victoria and Albert at the end of the century; Edward J. Poynter, whose carefully managed future would include knighthood, the presidency of the Royal Academy, and the directorship of the London National Gallery; and the brothers Luke and Alecco Ionides. The last two were not artists, but their wealthy Anglo-Greek family and their home on Tulse Hill, London, were to prove invaluable to Whistler during the 1860s.

Luke Ionides once suggested that du Maurier had created Trilby out of memories of Whistler's mistress Fumette; this seems unlikely, since Fumette was small and musical while Trilby is "a

very tall and fully-developed young female" who is "absolutely tone-deaf" without the help of Svengali. But about the originals of other characters in the novel there is no question. Lamont appears as "Sandy, the Laird of Cockpen," Poynter as "Lorrimer, the industrious apprentice," and Alecco Ionides as "the Greek," who has a "lordly parental abode" in London. In an early serial-version installment, which ran in *Harper's Monthly Magazine* for January, 1894, Whistler also is easily recognizable:

> "Then there was Joe Sibley, the idle apprentice, the King of Bohemia, *le roi des truands*, to whom everything was forgiven. . . . Always in debt, like Svengali; like Svengali, vain, witty, and a most exquisite and original artist; and also eccentric in his attire (though clean), so that people would stare at him as he walked along—which he adored! But, unlike Svengali, he was genial, caressing, sympathetic, charming; the most irresistible friend in the world as long as his friendship lasted—but that was not forever. . . . Sometimes [his] enmity would take the simple and straightforward form of trying to punch his ex-friend's head; and when the ex-friend was too big, he would get some new friend to help him. And much bad blood would be caused in this way—though very little was spilt. And all this bad blood was not made better by the funny things he went on saying through life about the unlucky one who had managed to offend him . . ."

Whistler protested violently to the editor of *Harper's*, and so in the book version du Maurier replaced "Joe Sibley" with "yellow-haired Antony," who is pointedly "void of any self-conceit" and "the warmest, staunchest, sincerest, most unselfish friend in the world.'

Du Maurier had not been unfair, nor even hostile. He had, however, been slightly anachronistic and slightly inaccurate. Whistler in the 1850s, although by common accord a waspish *rageur* when aroused, was not yet the pugilist implied by the description of Joe Sibley. When he found the Englishmen in the big studio in the Rue Notre-Dame-des-Champs practicing fencing and boxing he suggested, in his best dandyish manner, that they "hire the concierges to do their fighting for them." He was not

quite "the idle apprentice" either; a few paintings and etchings have been dated back to around 1857, and the story of Fumette's destructive rage shows that he was still drawing regularly. But he certainly gave the impression of being idle. The sessions at the *académie* began at eight in the morning, and he, according to one of his fellow apprentices, "was every evening at the students' balls and never got up until eleven or twelve." The industrious Poynter remarked, in a speech to the Royal Academy, that "during the two or three years when I was associated with him [he] devoted hardly as many weeks to study."

Eventually the English friends in Paris were outnumbered by French ones. Among the first of the latter were several Bohemian students at Gleyre's whom Whistler, in order to distinguish them from the gang in the Rue Notre-Dame-des-Champs, referred to as his "no-shirt" friends. Among the shirted was Henri Martin, whose father had just won the first prize of the French Academy for his fifteen-volume *Histoire de France*. In a special department of the Parisian picturesque was La Mère Gérard, an aged and partly blind woman who sold flowers and matches at the entrance to the Luxembourg Gardens. She was believed to have been in her youth a prosperous poetess. Whistler did an oil portrait of her and an etching, and carried on with her a mild flirtation, without mockery, for he was always tender toward the very old and the very young. She thought she had a tapeworm, and when asked what she wanted to eat or drink would reply, "Milk. He likes it."

Ancients and Moderns
1855-1859

That the allegedly idle apprentice had his moments of seriousness can be deduced from what is known of his work as a copyist in Paris museums between 1855 and 1859—from what is known in words, for the canvases he produced have been lost. His own account of this activity was offhand, but by no means deprecatory: "I copied a picture, I cannot remember whom it was by, of a snow scene, with a horse and a soldier standing by it and another in the snow at his feet; a second of Saint Luke, with his halo and draperies; a third of a woman holding up a child toward a barred window and a man seen looking through the bars; and a fourth of an inundation. I have no doubt I made something very interesting out of them. There were wonderful things even then, the beginning of harmonies and purple schemes. I suppose it must have been intuitive. Then . . . I painted—copied—Ingres' *Andromeda*, chained to the rock." The snow scene suggests something from the First Empire, possible a detail from Gros' wintry *Battle of Eylau*, which had long been in the government's collection. The Saint Luke with draperies sounds Baroque. The woman showing a child to a prisoner must have been an example of nineteenth-century sentimental genre on view in the Luxembourg Museum, which

housed contemporary works supposedly destined to hang in the Louvre someday (as a rule, ten years after the death of the artist). The flood could have been Girodet's *Deluge,* or Paul Huet's much-admired *Inundation of Saint Cloud,* which had been awarded a medal at the Salon of 1855 and purchased for the Luxembourg. The reference to Andromeda should be read as one to Ingres' *Ruggiero Freeing Angelica,* which had been in the Luxembourg since 1824 and whose subject, drawn from Ariosto's *Orlando furioso,* was easily confused with the Perseus-Andromeda motif. Whistler, according to friends who were there, copied the picture, or at least the figure of the naked maiden, in 1856, working alongside James Tissot—another painter who was to have a worldly career in London.

Although the first four of these copies were paid for by Captain Williams, otherwise known as Stonington Bill, and the naked maiden by another Stonington man, the young copyist seems to have been left free to pick the originals, and so the list has some slight value as an indication of his taste. Evidently he liked a little of everything, but liked the Italian Renaissance less than other periods. Although this impression has to be corrected a bit by the fact that he is said to have once copied Veronese, it is largely confirmed by the earliest oils he executed on his own in Paris. The earliest of all, in his recollection, was *La Mère Gérard,* of which there were apparently three versions. Not much later, to judge from the style, was *Head of an Old Man Smoking.* Both pictures, in their broadly applied impasto and their objective, although sympathetic, treatment of old age, are thoroughly Dutch in inspiration; both are proof that Joe Sibley was learning as much from Hals and Rembrandt as he was from listening occasionally to Gleyre.

He was not, however, learning from any master exclusively. During his Paris stay he copied at the Louvre two particularly significant pictures which he himself did not list; one was Boucher's *Diana Leaving the Bath* and the other a seventeenth-century Spanish work that is usually referred to in English as *Thirteen Cavaliers.* Boucher, helped by the Second Empire's general lightheartedness,

was emerging into favor again after a nearly total eclipse that had
begun with the first triumphs of David's moralizing Neoclassicism
over Rococo eroticism; to copy the *Diana*, which had been acquired
by the Louvre as recently as 1852, was thus to show that one meant
to move with the more sophisticated currents of Parisian artistic
opinion. To copy the *Thirteen Cavaliers*, which had been acquired
in 1851, implies a similar intention, although the sophisticated
currents were not the same. Today this not very distinguished little
painting, a depiction of booted men talking, perhaps quarreling, in
an oddly undefined pictorial space, is usually hidden in the
Louvre's reserves, where it is either ignored by art historians or
assigned to Velázquez's son-in-law, Mazo. But in the 1850s it was
attributed to Velázquez himself, and this was enough to provide it
with an immense prestige in the eyes of a whole generation of van-
guard artists. The ardently Hispanicizing young Manet, for ex-
ample, made a copy about when Whistler did, and painted two free
variations a few years later.

French interest in the work of Velázquez and his countrymen
had been awakened by Louis Philippe, who between 1835 and
1842 had accumulated in the Louvre, largely at his own expense,
some six hundred Spanish pictures, one of the best collections of
the kind then in existence. When the king had fled into exile after
the revolution of 1848 the government of the short-lived Second
Republic, displaying a scrupulousness rare in the political history
of art, had let his collection follow him, but in Paris the interest
had continued to grow. Much of it, especially after the marriage of
Napoleon III to the Spanish Eugénie de Montijo in 1853, was
modishness, and much was concentrated on subject matter; a
Velázquez, or a supposed Velázquez, was enjoyed in the same
way as the troupes of Spanish dancers, singers, and guitarists that
appeared regularly in the popular theaters on the boulevards. Many
painters were happy merely to aim at the market thus created; in
Trilby one of the members of the Paris Gang keeps "a complete
toreador's kit" in the studio and does fairly well with small pictures
of bullfighters serenading ladies of high degree. Even the inde-

pendent Courbet was not above turning out an *espagnolade* for fanciers of the picturesque.

Many French artists, however, including Courbet at his best, were attentive to Velázquez for reasons less superficial than a supposed folkloristic appeal. They were fascinated by the courtly Spaniard's unblinking gaze at human beings, idiots not excepted, and by his free brushwork, rich tonal values, and evocatively sketchy backgrounds. They found in his style, even when filtered through works not from his own hand, two ideas that were also in the styles of the Dutch masters and that were to become the springs of the painterly future. One idea, which was already motivating Courbet's Realism and would go on to motivate Impressionism and several other sorts of Naturalism, was to paint facts, in opposition to the Neoclassical, Romantic, and academic tendencies to paint idealizations, myths, legends, reveries, and prettiness. The other idea, which was already partly implicit in the doctrine of art for art's sake, and would go on to motivate partly such diverse movements as expressionism, symbolism, and abstractionism, was that what the Beaux-Arts faculty tended to regard as mere technique—brushwork, shading, and coloring—could be as meaningful as the representational and literary content of a picture. Was Whistler thinking of all this when he went to the Louvre to copy the *Thirteen Cavaliers?* Obviously he was not. He was still strongly under the influence of the Dutch combination of factualness with broad handling, and he would take several years to absorb and to adapt to his own needs, particularly in his portraits, the Spanish variety of the same combination. Further in the future was the day when, goaded by the attacks of London critics and by his awareness of a conflict between literary content and painting technique, he would decide, in words if never entirely in practice, that "arrangements" and "harmonies" were all-important and that nonpainterly content was mere "claptrap." But there can be little doubt that during his Paris years he was already eager to learn from Velázquez.

The eagerness was one of his reasons for making a special trip to England during the summer of 1857, with his friend Henri

Martin and of course on borrowed money. The occasion was an exhibition at Manchester entitled Art Treasures of the United Kingdom, the "of" meaning belonging to British collections, and much of it seemed to have been arranged with the express purpose of stimulating a Whistlerian sensibility. There were some four hundred British portraits, including one by an old friend and counselor, William Boxall; photography, although attracting more customers every day, had not yet killed what had once been the major branch of painting in the realm. In the section devoted to "modern masters" there was an admirable series of Hogarths. Among the treasures labeled "ornamental art" were specimens of Chinese blue-and-white porcelain, which Whistler would be enthusiastically collecting within a few years. In the rooms allotted to "ancient masters" were eleven hundred paintings representing important European artists from the Middle Ages up to the middle of the eighteenth century, Hals and Rembrandt prominently included. The star of the show, however, was Velázquez, who was on hand with no less than fourteen presumed works. The majority of these were wrongly attributed, as were scores of "Velázquezes" that turned up in northern Europe during the first half of the nineteenth century. (A recent study dismisses as mistaken all except one of a hundred and forty-seven attributions to the Spanish master made in Paris salesrooms between 1821 and 1850.) But what was close enough to Velázquez to deceive the experts who organized the Manchester exhibition was good enough to influence a student artist; and at least two of the works, the *Toilet of Venus* and the *Lady With a Fan*, were authentic.

By 1858 the apprentice was ripe for starting out on his own. He was twenty-four, he was no longer learning much from Gleyre, he was provided, mostly through looking at the art of the past, with the elements of a personal style, and he was the creator, in *La Mère Gérard, Head of an Old Man Smoking*, and some self-portraits, of works that revealed an undeniable if still not independent talent. He chose, however, to make his professional debut, his first unmistakably personal manifestation, as an etcher rather than as a painter; and, as he nearly always did when he turned a

corner in his life, he began the operation by taking a trip. This time the trip was a tour of eastern France and the Rhineland, an abbreviated *Wanderjahr* appropriate for the end of a somewhat idle apprenticeship. The pretext was an invitation to visit the family home of a Gleyre student who lived at Saverne, in Alsace, and to see something of the verdant countryside around the town. (Not that Whistler was ever much interested in verdant countrysides; he shared the attitude of Boucher, who complained that they were "too green and badly lit.") Included in the invitation was a young painter, Ernest Delannoy, who was one of the most Murgeresque of the "no-shirt" friends.

The two wanderers left Paris by train in August, 1858, clearly with no intention of roughing it in Alsace. Ernest was wearing a cotton summer suit, a straw hat, and short gaiters of the kind sported by Courbet in the painting *Bonjour, Monsieur Courbet;* James was equipped with his flat Venetian boater, his patent-leather shoes, and two hundred and fifty francs, a little more than the going rate for two copies for Stonington Bill. Possibly as a concession to the supposed spirit of the expedition, or as a reminder that he came from a nation of frontiersmen, James did have a knapsack, but he used it principally to carry a set of small copper plates grounded in advance for on-the-spot etching. At Saverne there were some gently lurching old gabled houses, a partly Romanesque parish church, and the eighteenth-century château, whose long facade and projecting pavilions must have brought back to the ex-St. Petersburg boy the Imperial Academy of Fine Arts. In the environs the tourists visited the ruins of fortresses and took in the view across the crests of the Vosges. Then they proceeded down the Rhine, probably by boat, to Cologne, where they installed themselves in a small hotel; and there the last of the two hundred and fifty francs was spent almost immediately.

From this point the story can be told partly in Whistler's words: "Then I wrote for money to everybody—to a fellow student, a Chilean I had asked to look after my letters in Paris—to Seymour Haden—to Amsterdam where I thought letters had been forwarded by mistake. We waited. Every day, we went to the post

office, and every day the officials said, 'Nichts, Nichts!' and finally we got to be known, I with my long hair, Ernest with his brown holland suit and straw hat now fearfully out of season. The boys of the town would be in wait to follow us to the post office, and hardly would we get to the door before the official would shake his head and cry out 'Nichts, Nichts!' and all the crowd would yell 'Nichts, Nichts!' At last, to escape attention we spent the day sitting on the ramparts outside the town." In the meantime they were eating at the hotel on credit, and Ernest was becoming gloomy. When it finally became apparent that no money was to be expected from the Left Bank or 62 Sloane Street, Whistler talked the landlord into accepting the knapsack and the copper plates as a guaranty that the bill would be paid: "Then, with a supply of paper and pencils, we started off for Paris on foot. It was the time of the autumn fairs and we paid our way by making portraits for a few *sous*. We even joined a lady who played the violin and a gentleman who played the harp, and we gave entertainments in all the villages we passed through, sleeping in the straw, and tramping it on off days. My little patent-leather shoes were all in bits and had to be patched together in the evening at every town and village. . . . When we got to Aix-la-Chapelle, it was all right again. I went to see the American consul, got some money, and did the rest of the journey in comfort. And the landlord was paid, and the knapsack of etchings returned . . ."

The story may have acquired some flourishes with repeated telling. Since the distance from the Cologne dinner table to the American consul's pocketbook was only about fifty miles, there need not have been many nights in the straw and days with the lady violinist. In any event, Whistler and the knapsack were both back in Paris by the beginning of October, and there he immediately set about harvesting the artistic fruits of the adventure. He made a selection of the etchings done during the trip, added enough plates from his existing Left Bank and London work to bring the total to a dozen, and in November published the resulting miscellany as a series entitled *Douze eaux-fortes d'après nature*. Eventually the series came to be known among print collectors

as the French Set, to distinguish it from such other Whistler series as the Thames Set and the First and Second Venice Sets. The printer was the capable and subtle Auguste Delâtre, whose workshop at 171 Rue Saint-Jacques, near the Panthéon, had for several years been a meeting place and information center for French etchers.

The set was a rebuke to the members of the gang in the Rue Notre-Dame-des-Champs who had formed a hasty opinion of their American friend's future. The title page carries a mild caricature of the long-haired, odd-hatted author—in gaiters, Ernest having posed for the figure—at work in a village street surrounded by a band of solemnly curious children. Beyond this there is no sign of Joe Sibley, nor of the Bohemian dandy, nor of the Oedipal Southern cavalier; the stage Whistler is replaced by a competent, meditative, deeply compassionate artist. Among other excellent plates are the sharp *Fumette Seated;* the full-length *La Mère Gérard,* in which the old flower-seller is even more Rembrandtesque than in the oil portrait; *La Vieille aux Loques,* in which another old woman, herself scarcely more than a *loque,* a rag, sits dozing in a tiny, dark kitchen; and the contrasting *En Plein Soleil,* in which a picknicking Second Empire belle, defending herself against the "full sunlight" with a small parasol, anticipates one of the familiar motifs of the Impressionists. Equally arresting are the sinister *Street at Saverne,* in which the Whistlerian fascination with darkness broken by spots of light is already present, and *The Kitchen,* in which a tunnel of brightness recedes dramatically from a dark foreground. Not all the plates are as good as these; some are marred by awkward drawing or faulty biting. Toward the end of his career Whistler was apt to make disparaging remarks about the set as a whole, and one can see why: the style is in general densely explicit rather than allusive in his later manner. But this is simply to say that these etchings were done in 1858 and not in 1880. Judged without preconceptions, their quality warrants saying that he had become, almost at a single stroke, one of the major etchers of the nineteenth century.

Nothing in the history of art, of course, has ever really hap-

pened at a single stroke. The French Set shows that Whistler, during his years of supposed idleness, had learned to record his impressions rapidly; each print—with the possible exception of the nocturnal *Street at Saverne*, which may have been done by the memory system of Lecoq de Boisbaudran—was drawn directly on the plate with the needle. The set also shows that the ex-employee of the United States Coast Survey had quickly become aware of the engraving revival that was under way in Paris in the 1850s. Especially evident, in such a print as *La Vieille aux Loques*, is the influence of Charles Jacque, a pioneer of the revival and a habitué of Delâtre's workship; much in Whistler's work that suggests Rembrandt's humanity and play of light and shade could have come through Jacque, or through Jacque's friends in the Barbizon group of artists. Delâtre himself was an influence; from him Whistler learned to conceive a plate in terms of the tone that could be achieved during the printing process by the quality of the ink, by the delicate wipe of a hand across the plate, and by the hazardous coaxing of ink from the lines with a piece of muslin. Before leaving Paris the young etcher was capable of doing his own printing.

The series is dedicated to *"mon viel [sic] ami Seymour Haden,"* and this is an acknowledgment of another debt. Haden had done his first etchings as far back as 1843, using a technique he had learned for the purpose of making anatomical studies while in medical school; then, busy with his career as a surgeon, he had contented himself with building up a collection of prints by other artists. In 1858, however, he had begun to engrave again, and he produced during the year nineteen plates, some of them executed alongside Whistler. Plainly the older man was stimulated by the example of the younger. But the stimulation was not a one-way affair, for Haden was not an ordinary spare-time artist. He was good at capturing, in a style quite different from that of his brother-in-law, the changing aspects of English skies, waterways, and foliage, and he was full of information about the history of his art. (Later on he wrote several treatises on printmaking, including a study of Rembrandt's work.) Although academic in his drawing, he was frequently unorthodox in his etching method; he

possibly invented the comparatively slow-biting mordant called the Dutch bath, and he sometimes had the audacity to work outdoors from nature with the plate already in the bath, a procedure calling for a quick eye for tone and a sure knowledge of the effects of the acid.

Perhaps one of the reasons for Whistler's concentration on etching was simply the fact that during his first three years on the Left Bank he met no young French artists who could stimulate him in the oil medium. One of his earliest French friends, the painter Henry Oulevey, is remembered today merely because he knew the American artist. The Bohemian Ernest Delannoy, although amusing, belonged to Murger's category of the untalented "Naïves"; he struggled on in poverty after his student days, and died insane. Another early friend, the sculptor Charles Drouet, is known mostly as the somewhat Mephistophelian subject of a Whistler print. Another, the sculptor and cellist Becquet, did not leave behind him even a discoverable first name. He is remembered partly as the subject of another Whistler print and partly as the possessor of a reportedly unearthly kind of masculine beauty; in middle age he once had to resist the determined advances of Sarah Bernhardt.

The situation, however, changed abruptly for Whistler on October 7, 1858, just after his return from the Rhineland. On that day, during a copying session at the Louvre, he met Henri Fantin-Latour, and the two became close friends almost at once. One explanation for the mutual attraction is that at their first meeting Whistler warmly admired the copy of Veronese's *Marriage Feast at Cana* Fantin was working on, and Fantin liked Whistler's big hat. A more elaborate explanation is that the two were extremely unlike each other, in nearly every respect except a high level of artistic intelligence and an interest in Dutch and Spanish old masters. Fantin, who was then twenty-two, was round-bodied, full-bearded, gentle, unassuming, and conscientious; he had studied at both the Ecole des Beaux-Arts and the small atelier organized by Lecoq de Boisbaudran, and among the other students he had a reputation as a man of learning. Although in 1858 he was something

of a Courbet Realist and therefore something of a rebel against
the Paris art establishment, he would ultimately subside, without
becoming stodgily academic, into a successful Salon exhibitor of
group portraits, flower pieces, allegories, and mythologies.

On the evening of the day of the Louvre encounter he took
his new American friend, who brought along some proofs of the
French Set by way of introduction, around to the Café Molière,
a rendezvous near the Théâtre de l'Odéon for a circle of painters
and intellectuals who shared some advanced opinions. Among the
members of the circle were Zacharie Astruc, who was both a
painter and a sculptor but more significant as an art critic; Otto
Schölderer, a German painter who would later be close to Manet;
and Carolus-Duran, who was beginning to display some of the slick-
ness that would make him one of the most fashionable portraitists
of the century. A more important member, however, from
Whistler's point of view, turned out to be Alphonse Legros, who
had been a classmate of Fantin's in the atelier of Lecoq de Boisbau-
dran. Legros, although only twenty-one, already had a considerable
body of work behind him. He had been etching since 1855, in a
style marked by sensitive draftsmanship reminiscent of Ingres and
fifteenth-century Italy. (Poynter, in du Maurier's words, once
"nearly bust a gut" in his enthusiasm over some Legros prints.)
In 1857 he had brought off the coup of which every young Paris
painter dreamed: he had had a picture, a Holbeinish portrait, ac-
cepted by the jury of the Salon. In 1858 he was under the
influence of Courbet and the Spaniards—Zurburan rather than
Velázquez—and was at work on a major canvas destined for the
Salon of 1859. With his long hair, earnest gaze, and Christ-like
beard he looked like a figure out of the Middle Ages; and in
his devout, French-provincial Catholicism he was indeed almost
medieval. He had the kind of mind that feels no need for more
than a few things in a given category; throughout his long career
he would continue to paint with a repertory of somber, pietistic
motifs drawn from the Burgundy of his boyhood, and although he
would live in Great Britain for nearly half a century he would
never learn English.

Whistler formed with Fantin-Latour and Legros, his two *nonsemblables*, a mutual-aid group he referred to as *La Société des Trois*. Partly because the circle at the Café Molière overlapped with other circles, he soon got to know a number of other talented Parisians who, without being of the first rank, have their places in the artistic history of the period. By early 1859 he had met Félix Bracquemond, one of the principal animators of the etching revival; Théodule Ribot, who because of his painting style and favorite subjects was called "the Velázquez of the kitchens"; Guillaume Régamey, an attractive painter of military scenes; Louis Ottin, who later exhibited with the Impressionists; the novelist and art critic Edmond Duranty, who advocated the painting of everyday life; another novelist and art critic, Champfleury, who had been one of the early defenders of Courbet; and the painter François Bonvin, an *intimiste* in the Dutch seventeenth-century manner, an old friend of Courbet, and one of the kindest men in France. Some of these people gathered regularly on the lower slopes of Montmartre at the Brasserie des Martyrs or the Restaurant Dinochau, where Murger ran up his epic bill. In the Latin Quarter the center of the whole web was the Brasserie Andler, on the ground floor below Courbet's studio in the Rue Hautefeuille; here Courbet himself, when he was in town, sat at the head of a large table in a cloud of tobacco smoke and roared his opinions at the assembled painters and critics.

Courbet was in Germany from September, 1858, until February, 1859, and so Whistler did not have a chance to meet him right away. But Courbet's Realism, in one form or another, was to be encountered in the Café Molière and the other centers simply by sitting down and listening. Nobody, of course, could define Realism with much precision. In philosophical minds, warmed by an evening of drink and talk, it could be connected with the supposedly scientific Positivism of Comte, in literary minds with the supposed objectivity of Flaubert, and in political minds with various sorts of radicalism, partly because of the known affection of Courbet for the socialist leader Proudhon. In many minds it was regarded as a cult of the low and the ugly. The Comte de

Nieuwerkerke, imperial director for the fine arts, thought that the entire production of the Realists was disgusting and subversive: "It's the painting of democrats, of these men who don't change their linen, who want to impose themselves on people of good society . . ." Courbet, in his manifesto of 1855, had remarked that "the title of Realist" was one that "nobody, I should hope, can really be expected to understand." On other occasions he had made it clear that he regarded his doctrine as a kind of self-advertisement combined with a drastic secularization, debunking, updating, and reifying of art. He had scoffed at metaphysical, mythological, and historical subjects, had maintained that artists should not prettify, had called for a contemporary outlook, and had insisted that painting was a physical operation, a way of slapping juicy chunks of pigment onto canvas.

Not surprisingly, practice lagged somewhat behind theory. In a Courbet picture Realism often meant a carefully composed contemporary genre subject painted in an essentially conservative, although vigorous, manner on a canvas of the large size traditionally reserved for idealized historical, religious, and mythological subjects; what shocked many Second Empire viewers was not so much the naturalism as a felt discrepancy between ends and means, between the ordinary scene and the noble dimensions. In the work of less intransigent artists even this kind of shock was avoided; with them Realism often became merely an impulse toward plausibility strengthened perhaps by a desire to paint the everyday life of the lower classes. Other artists confused the issues and the public by veering from Realism into a modernism that did not exclude a certain amount of idealization; they responded, without always being aware of the fact, to a summons Baudelaire had issued as far back as 1845: "To the wind that will blow tomorrow no one lends an ear, and yet the heroism of modern life surrounds us. . . . The painter, the true painter, will be the one who will be able to wrench from contemporary life its epic aspect and make us see and understand, with color or with drawing, how grand and poetic we are in our cravats and our little patent-leather boots."

For several reasons, then, the revolutionary phase of Realism,

the phase that frightened traditionalists, did not last very long. Academic painters soon sentimentalized contemporary subject matter and tamed Courbet's vigorous technique. Rich people discovered that, if not unduly alarmed, they loved looking at pictures of poor people. The movement slowed down. Nevertheless, the revolutionary phase had its importance. The barrel figure of Courbet, doubling up with hilarity at the very thought of painting such nonexistent creatures as angels and ancient Greeks, made a formidable symbol of artistic independence; even his conceit and his vulgarity were liberating in their effect on younger artists. And his doctrine, mostly untenable as it was in practice and condemned as it was to rapid academic absorption, served well as a bridge from Romanticism to Impressionism and to several other kinds of dissent.

By November 1858, Whistler was advancing over that bridge, heading toward the first stage of his own kind of dissent. He was neither a Positivist nor a political radical, he liked to change his linen often, and in the long run he would find the ebullient refractoriness of Courbet as unacceptable as the melancholy orthodoxy of Gleyre. But in his role as a Bohemian, a dandy, a partly Russian aristocrat, a Scottish Southern cavalier, and a West Point man he had, or believed that he had, a lively contempt for the conformism of bourgeois artists. Moreover, he was already a Realist to a considerable extent in his etchings and such pictures as *La Mère Gérard* and *Head of an Old Man Smoking*—in part perhaps from having studied Courbet's work, although the evidence of other influences make the assumption superfluous. With the publication of the French Set he had made his professional debut as a printmaker; now he decided to attempt his debut as a painter, with a canvas aimed at the Salon of 1859. He began, as might have been predicted, by taking a trip, this time to London and the encouragement to be found at 62 Sloane Street.

Music, Water, and Hair
1859-1860

Seymour Haden's house was on the corner of Hans Street and Sloane Street, a suitable location for a man who was both a fashionable surgeon and an artist. To the north lay the ribbon of smart society along the edge of Hyde Park. To the east were the Georgian squares and crescents of Belgravia, prime territory for a physician to the well-off; in Belgrave Square alone at the end of the 1850s there resided three dukes, thirteen other peers, and thirteen members of Parliament. Half a mile to the south began the modest, often dilapidated, occasionally picturesque facades of Chelsea, which was becoming an urban village favored, like Montparnasse and Montmartre, by painters and writers; Turner had spent his last days there, and Carlyle had been living there since 1834. Sloane Street, which in the time of George III had been partly transformed by an estate development, had not yet lost, as had many Victorian streets, an eighteenth-century air of architectural good sense and confident taste. It was still genteel. Although a bridge across the Thames to Chelsea had been opened in 1858, most of the heavy wagon traffic still rumbled into the center of town over the main roads to the north. Through an opened window at No. 62 one was likely to hear nothing except

the brisk jingle of a light carriage, or the wail of a barrel organ trying to cope with the Miserere from *Il Trovatore*, which had been added to the street repertoire after the success of the opera at Covent Garden in 1855.

The house was a narrow, dignified, four-story structure of red brick, with few ornaments; from the outside it suggested a private clinic. Inside, with a stairway that was like a vertical corridor, it exhibited the predilection for up-and-down living that is evident in much of the older domestic architecture of London. On the top floor Haden had created an etching studio and personal sanctum; here he would lock himself in and work on his plates, "glorying," in the opinion of his disrespectful brother-in-law, "in the artist who let the surgery business slide." On lower floors there were several bedrooms and a very efficient bathroom; the fresh sheets, gas water heater, and modern shower were undoubtedly welcome changes for an amateur Bohemian tired of trying to keep to Anna Mathilda's cleanliness rules in Left Bank student lodgings. The focus of the house was the music room, where filtered sunlight and shaded gaslight managed to unify maroon carpeting, green-tinted walls, pictures in heavy gold frames, a large mirror, a grand piano, and a profusion of chintz drapery, cream colored with a floral pattern in green and deep pink. Here Deborah, who had become a competent pianist, continued the musical evenings that had been about the only relaxation of her flute-playing father in New England and St. Petersburg; here also, as several etchings by her husband and her half-brother testify, the household might assemble after dinner to read, look at pictures, or simply wait for bedtime, in a ticking silence almost visible in the prints. (Deborah, incidentally, is always depicted with her book a few inches from her nose; nearsightedness seems to have run in the Whistler family.)

It was in the music room, in this Victorian island of middle-class reverie set in the Sloane Street sea of gentility, that Whistler, after all the revolutionary talk at the Café Molière, found his personal style as a painter. Here, in November, 1858, he conceived *At the Piano*, the picture he hoped to get past the jury of the 1859 Paris

Salon. The work is not, of course, entirely personal. It is a variation
on the conversation-piece portrait that had been popular in England
in the eighteenth century; the sitters are Deborah and her ten-year-
old daughter, Annie, and the conversation is the music, easily
imagined as a Chopin nocturne, which Deborah is playing for her-
self and Annie. A hint of Spain and Velázquez can be seen in the
austere design, the low-keyed tonality, and the fairly bold brush-
work. A lot of seventeenth-century Holland shows in the general
arrangement and the intimate, domestic subject; Vermeer's *Concert*
has been suggested as a compositional source. French influence is
also present; the quiet atmosphere is shared with Fantin-Latour's
Two Sisters and Degas' *Bellelli Family*. Although Whistler could
not have seen the *Bellelli Family*, which was painted in Italy and
then forgotten for many years, he certainly knew what Fantin was
doing. Nevertheless, when all the possible influences have been
noted, *At the Piano* remains strikingly Whistlerian. Here are
prominent for the first time such traits as a background grid of
rectangles, a tendency to keep things parallel to the picture plane,
a liking for the profile view that idealizes a sitter, an association
with music, a preference for muted light, and a readiness to be
pensive.

　　In brief, *At the Piano* is the first important example of an ulti-
mately characteristic combination of pattern with mood. The com-
bination was tricky; it called for an alert elimination of inessential
elements, and it needed a genuinely felt yet not too strong source
of emotion. It could decay into empty pattern, or formless moodi-
ness, or a thin mixture of the decorative with the sentimental. At
unhappy moments in his career Whistler would be tempted to
abandon it for a less exacting, or ostensibly more vigorous, ap-
proach, and he would finally be forced to admit tacitly that, his-
torically considered, it was an impasse. But when it worked as well
as it had in this first experiment it seemed to justify the brightest
of hopes. It also pointed up, even more than had the generous
humanity of some of the etchings in the French Set, the differences
between the monocled, overdressed, wisecracking, role-playing
stage Whistler and the Whistler who produced works of art. While

the former could be unconsciously vulgar, the latter was intuitively tasteful, almost to a fault. Where the one was painfully emphatic, with a bony elbow figuratively in everyone's ribs, the other was ingratiatingly allusive. Where the one was full of brittle vanity, the other was full of self-doubts, often to the point of having his talent disabled by them. Was there a third man in the affair, a Whistler who was neither a public pose nor merely the style of an etcher and painter? Clearly there was; he was the one who obtained the fierce loyalty of mistresses, immediately charmed new acquaintances, impressed people who were neither foolish nor insensitive, formed the *Société des Trois* with Fantin and Legros, and behaved with knightly deference toward little girls and old women. At the same time he was the alien who lacked a country, a social class, and even the solid cultural baggage that could substitute for a country or a social class; in the complex, rigid system for providing identity that existed in nineteenth-century Europe he was almost a nonperson, and so he had use for the stage Whistler and the quiet painter of *At the Piano*.

The picture was finished during the winter in Paris, and in the spring of 1859 it was submitted to the Salon, along with two prints from the French Set. There was reason to be hopeful, since the antiacademic Delacroix was a member of the jury for the first time. The hope turned out to be unfounded in its major section, for although the prints were hung, *At the Piano* was not. But Whistler finally had cause to feel consoled and to want to keep trying. In the first place, he was by no means alone in his disappointment; the jury, in spite of the presence of Delacroix, was one of the most severe in the history of the Salon, to such a point that after its decisions become known the police had to be called to disperse a crowd of indignant painters who gathered to boo and whistle under the windows of the imperial director for the fine arts. In the second place, the kindhearted Bonvin, who knew from rough personal experience what the struggle for official recognition, and for the livelihood that depended on it, could be like, decided to organize in his studio in the Rue Saint-Jacques a small salon of his own where the public, in particular the public

that frequented the Brasserie Andler and the Café Molière, could see for itself how unfair the jury had been. Here *At the Piano* was exhibited, along with canvases by Fantin, Legros, and Ribot that had also been rejected for the big official show, and the result was a Latin Quarter consecration. Courbet, among other visitors, singled out Whistler's picture for praise. Whistler at last met the famous leader of the Realists, and reacted by shouting: "He's a great man!" Soon the two were on intimate terms which the older painter regarded, without much warrant, as those of a teacher and a pupil.

Thus by April, 1859, when he was still only twenty-four, Whistler had accomplished what he could only have dreamed about when he was in Washington planning his invasion of Europe. In less than three and a half years he had become a known Murgeresque Left Bank figure, an admired participant in the Paris etching revival, a publicly, if not yet officially, recognized Paris painter, and a friend of the chief agitator in contemporary French art. He had demonstrated with *At the Piano* that he had the talent and sensibility required for creating a truly personal style, a little pictorial universe of his own. If futures in the School of Paris had been examined that spring, his might have looked more brilliant than those of such comparatively unknown young men as Manet and Degas, both of whom had been developing along lines somewhat parallel to his. (Monet, Renoir, and Cézanne were too young to be considered at all, and Pissarro, who had arrived in Paris the same year as Whistler, was getting off to a timid start.) His prospects would have certainly looked more brilliant than those of the majority of his comrades in conversation at the Café Molière, to whom he had been introduced as an amusing foreigner as recently as the previous October.

His immediate response to this Paris success was to make what was perhaps one of the major mistakes of his life. In May he transferred his headquarters from the Left Bank to London, where he would remain, with his usual breaks for travel, during most of the rest of his career. He had solid reasons for making the move initially, and he shortly had solid ones for persisting in it. London

was a city he had got to know well ten years earlier, when he had
met Boxall, had listened to Leslie's lectures at the Royal Academy,
and had decided to accept what his mother might have described
as "the call" to become a painter. The place offered the English
language and, for apparently as long as he wished, a home at 62
Sloane Street, with cultivated relatives and a gas water heater. It
provided, in the music room and on the Thames waterfront, con-
genial subject matter for painting and etching. Soon it would pro-
vide him with a beautiful new mistress, clever new friends, generous
patrons, and temporary approval by the British academic world.
Nonetheless, he might have suspected he was making a mistake. He
had concocted, in his role-playing and his aesthetic outlook, an
infallible recipe for irritating the upper middle class whose strong-
hold was London. Having managed to become an insider in the
art capital of the European nineteenth century, he now chose to
risk becoming an outsider in what, from the viewpoint of a
sophisticated Continental artist, could have been dismissed, unfairly
but understandably, as merely a large provincial capital where
painting was confused with literature. He chose to leave the main
stream of modernism and to cut himself off, although not right
away, from the comradeship, the friendly rivalry, and the sense
of a shared stylistic enterprise which in Paris could help innovators
to survive without crippling bitterness the hostility and, what was
often worse, the laughter of the public.

An interest in the Thames was not, in the period context, at
all unusual. Sketching tours of the river were for English landscap-
ists a tradition dating back to the eighteenth century and bearing
the authority of Turner. Water was becoming a favorite motif in
all the European arts and would remain so for the next fifty years;
it would flow through music from Wagner to Debussy, recur in
the imagery of English and French poets, and serve as the principal
inspiration for the flickering, fleeting-moment effects of the Im-
pressionists. When Monet and Sisley got to England, they too
would do the Thames. Still, there was something special about
Whistler's attitude in the summer of 1859. He had looked at such
famous rivers as the Neva, the Potomac, the Seine, and the Rhine

without seeing anything particularly seductive about them. This time he feel deeply in love, and for good. Moreover, he fell in love, not with the rural Thames favored by artists like Seymour Haden, but with the presumably unlovable Thames of working London, the stretch where, in T. S. Eliot's often Whistlerian account of the city,

> The river sweats
> Oil and tar
> The barges drift
> With the turning tide . . .

In 1859 this stretch could have functioned even better than in the twentieth century as part of the symbolic décor for a *Waste Land*. Although the Smoke Nuisance Act of 1853 had begun to thin out the blackness of the bad old days of laissez-faire, the atmosphere was far from clear; and although the board of works, spurred by cholera, had begun in 1855 to alter London's ancient drainage system, the stench of sewage was enough, on days with an inshore breeze, to keep members of Parliament from using their new Gothic waterfront terrace. The putative Realist from the Café Molière could scarcely have asked for more suitable territory in which to try out his tenets.

He maintained a base at the house in Sloane Street, but lived elsewhere most of the time. For long periods he stayed at a small inn in Wapping, in the heart of the great dock area downstream from the Tower of London; he worked sometimes from a skiff and sometimes from the Angel, a pub on the south bank, in Rotherhithe, with a balcony jutting out over the water. Here, where the river sweated more oil and tar than almost anywhere else, he etched the crisp, sharply shadowed *Black Lion Wharf*, *The Pool*, and *Rotherhithe: Wapping*; these three plates were among the series of sixteen that would be known as the Thames Set after their publication together in 1871. Parts of the set were published separately right away in the Bond Street shop of Serjeant Thomas, a lawyer and port-wine connoisseur turned print dealer; and Delâtre was brought over from Paris to supervise the printing. Although sales, at the rather stiff price of one and two guineas apiece, were not

high, the general critical reaction was flattering. Three of the prints, along with two done in Paris, were accepted for the annual show of the Royal Academy, the English equivalent of the French Salon, in the spring of 1860. Baudelaire saw some of them a year or so later in the gallery of Louis Martinet in the Boulevard des Italiens and wrote praising their "marvelous jumble of ship's gear, yardarms, ropes; chaos of fog, furnaces, and spiralling smoke; profound and complicated poetry of a vast capital."

The Royal Academy show of 1860 brought an even more important triumph, for *At the Piano* was accepted and was immediately purchased for thirty pounds by academician John Phillip, who was known as Spanish Phillip because of his Iberian genre pictures and his enthusiasm for Velázquez. Not all the critics were kind; the *Daily Telegraph* mentioned "an eccentric, uncouth, smudgy, phantom-like picture of a lady at a pianoforte, with a ghostly-looking child in a white frock looking on." But the *Athenaeum*, after condemning the "recklessly bold manner and sketchiness," went on to praise the "feeling for atmosphere and judicious gradation of light." And private reactions were extremely encouraging. Du Maurier, who was back in London, wrote to his mother: "I must now tell you about Jemmy. . . . I have seen his picture, out and out the finest thing in the Academy. I have seen his etchings, which are the finest I *ever* saw. The other day at a party where there were swells of all sorts he was introduced to Millais, who said: 'What! Mr. Whistler! I am very happy to know —I never flatter, but I will say that your picture is the finest piece of color that has been on the walls of the Royal Academy for years.' What do you think of that, old lady? And Sir Charles Eastlake took the Duchess of Sutherland up to it and said 'There Ma'am, that's the finest piece of painting in the Royal Academy.' But to hear Jemmy tell all about it beats anything I ever heard." These were compliments from men who counted in the Victorian art world. John Everett Millais was on his way to becoming one of the most prosperous painters of the century and a grouse-shooting baronet. Eastlake was the president of the Royal Academy and the director of the National Gallery, where the academy shows

were then being held, and he was also the husband of Elizabeth Rigby, a writer on art who was at the time nearly as influential as Ruskin.

The bravos suggested an encore, which took the form of the painting finally entitled—when Whistler had begun to stress the abstract aspects of his work—*Harmony in Green and Rose: The Music Room*. Annie Haden, in the white dress she wears in *At the Piano*, sits reading a large book in the center of the picture, while around her the ritual of a Victorian morning visit comes to a close. On the right a tall woman in a black habit, who has been identified as a Miss Boot, is taking leave of Deborah, who is outside the direct field of vision but reflected in the mirror on the left. Nearly a third of the area is occupied by the cream, green, and deep pink chintz drapery. The total effect includes a busyness that would eventually be eliminated from Whistler's pictorial universe. But the combination of flat pattern with deep space, the anticipation of Degas' much later use of unfamiliar viewpoints and snapshot composition, the reminder of Velázquez's *Las Meninas* in the mirror that makes Deborah a ghostly presence outside the frame, and the odd presentiment (it could have been nothing more than that) of Japanese influence in the silhouette of Miss Boot make the whole performance extraordinary for a twenty-six-year-old artist in the London of 1860. By November of that year, when the painting was apparently finished, all talk about the idle apprentice was beside the point.

By November, however, Whistler had been struggling for weeks with another piece of complexity, which on completion—probably late in 1863, after much repainting—would be called *Wapping*. The picture is mentioned by du Maurier in a letter dated October, 1860: "Jemmy . . . is working hard & in secret down in Rotherhithe, among a beastly set of cads and every possible annoyance and misery, doing one of the greatest chefs d'oeuvres—no difficulty discourages him." The painter himself, in an undated letter in French to his Paris friend Fantin, supplies further documentation:

"I'd like to have you here in front of a picture on which I'm counting a devilish lot and which ought to become a master-

piece. . . . At last, believe me! I've succeeded in getting an EXPRESSION! Silence, my friend! a real expression. Ah! but let me tell you about the head: there is a quantity of hair, the most beautiful you've ever seen! of a red not gilded, but *coppered*—like everything Venetian you have dreamed about! a white skin that's yellow, or golden, if you like. And with this first-rate expression I'm talking about, an air of saying to her sailor: 'All that's very fine, fellow, but I've seen others of your sort!' You know, she winks, and she's making fun of him. Now, all this *against* the light and consequently in a half-tint that is atrociously difficult. . . . Ssh! don't talk about it to Courbet!"

After such a description, accompanied apparently by a fear that Courbet would steal the idea, Fantin could have expected a harshly Realistic picture of a red-headed London waterfront prostitute bargaining with a client. In fact *Wapping* is mostly a translation into oil, with a Spanish nuance, of the "marvelous jumble of ship's gear, yardarms, ropes . . . and spiralling smoke" previously rendered in the Thames etchings. When the work was shown at the Royal Academy in 1864 the *Times* remarked: "If Velázquez had painted our river he would have painted it something in this style." What was conceived as an anecdotal lowlife scene is in the finished version simply a group of three strangely uncommunicative people sitting on the river balcony of the Angel pub in Rotherhithe. On the left is an apparently quite respectable, if slightly blasé, young woman with reddish hair; facing her is a man in a seaman's hat who could have dropped in for a beer on his way home to the wife and little ones. In the middle, looking earnest and saintly, is Alphonse Legros. Although Whistler was willing to be shocking in many ways, he was too much of a puritan, and too little of a narrative painter of the Hogarth sort, to depict the incident his theoretical commitment to Realism had led him to imagine. He was also too much inclined toward understatement, in paint although not in words, to achieve "expression" in the somewhat histrionic fashion called for by the traditional instruction at the Ecole des Beaux-Arts.

His hymn to hair in the letter to Fantin would nonetheless

have its sequels, and here again there would be anticipations and echoes of the period context. The erotic hair motif was about as common as the water motif in European art during the second half of the nineteenth century. Baudelaire combined the two by thinking of his mistress's locks, in this instance black, as a sea that would carry him to a harbor where his soul might drink "scent, sound, and color in great waves." The women designated as "stunners" by the painters and poets of the Pre-Raphaelite Brotherhood (PRB) and its circle were equipped with heavy masses of glistening hair, often reddish or blond, and for Rossetti even the evil Lilith was just a PRB "stunner" gone wrong: when she had finished off a bewitched youth she

> . . . left his straight neck bent
> And around his heart one strangling golden hair.

The cult can be traced randomly in the long tresses lovingly rendered by such diverse painters as Courbet, Lord Leighton, Renoir, Degas, and Burne-Jones. For Wilde around 1880 a proper heroine had "bright golden hair" that in the grave was "tarnished with rust." The young Yeats returned to Baudelaire's liquid analogy, although on a smaller scale:

> And his neck and his breast and his arms
> Were drowned in her long dim hair . . .

One sort of climax was reached in Art Nouveau designs that were almost entirely undulating hair, and another sort was reached when Debussy's Pelléas, accompanied by an orchestral fortissimo, stood in ecstasy below the bedroom window of Mélisande with her ripe-corn hair filling his hands and mouth and winding around his arms and neck. Whistler never went that far; he was not much interested in ecstasy. But he remained a worshiper of hair, especially undone hair, until the end of his career.

A principal reason for his liking the motif in the summer of 1860 was the young woman who appears, for the first time in his work, in the foreground of *Wapping*. She was Joanna Heffernan (or Hiffernan, as she once signed herself) and was usually

called Jo. She was Irish, poor, and largely self-educated; her family may have been part of the migration that followed the potato famine in Ireland in 1845 and 1846. Her father was a sometime teacher of penmanship and was disreputable in some undefined way, perhaps because of drunkenness; du Maurier refers to him as "an impulsive & passionate Irishman" whom Whistler thought capable of disgracing the family at a funeral. Jo had become a professional model, in spite of the tendency of British painters to prefer the nonchalant posing of Italian girls; she had in her favor copper hair, long, trim legs, high breasts, and a look of recently awakened, possibly unorthodox sensuality which, for young men who had read *Les Fleurs du Mal* and would shortly be reading Swinburne's fleshly *Poems and Ballads*, was difficult to resist. By the time of the letter to Fantin she was already Whistler's mistress; by 1861 she was his wife in every sense except the legal and, for some Victorians, the social. She served as his regular model, managed what household affairs he had, accompanied him on his trips, made herself knowledgeable about painting and etching, and helped to sell his work. With what may have been a half-humorous, half-rueful assertion of her rights, she picked up his mostly discarded middle name and presented herself to strangers as Mrs. Joanna Abbott. Her father, not a man for half-measures, referred to Whistler as "me son-in-law."

Keeping a mistress, even one as commonsensical as Jo was on most occasions, required money. But for an optimistic painter who had already exhibited at the Royal Academy there was little cause to doubt that the requirement would somehow be met. Victorian England, once you got above the poverty line, was plainly getting richer and richer. If Whistler had had a mind for statistics he could have discovered that the economic growth rate had been high for more than a generation, that the value of British exports had nearly quadrupled since 1840, that British rail mileage was seven times that of France or Germany, that British shipping tonnage was more than half the world total, and that the affluent in Britain were

numerous enough to provide employment for more than a million domestic servants. The result was a golden age for painters who could produce what the market wanted. By 860 a Millais picture might bring a thousand pounds (the equivalent of about five or six thousand in the money of a century later). A source of huge profits, for both artists and dealers, had been found in the reproduction of copyrighted paintings, since the improved technique of steel engraving made it possible to publish editions mounting into thousands. In 1860 William Powell Frith, whose cheerful, crowded, John Bully *Derby Day* had been the sensation of the academy show of 1858, was paid forty-five hundred pounds by a London dealer, Louis Victor Flatow, to turn out a similar success; the result was *The Railway Station*, which the enterprising Flatow exhibited to twenty thousand paying viewers and then sold for sixteen thousand pounds to a print merchant. At about the same date Holman Hunt received fifty-five hundred guineas for *Finding the Saviour in the Temple* from another dealer, Ernest Gambart, who got more than ten thousand pounds through exhibitions, engravings, and the resale of the painting.

Whistler could not have counted on breaking into this realm of bestsellers right away, aggressively sure of himself though he was. Not was he obliged to achieve immediate financial success, for a comparison of his known sales with his known way of life— his trips to the Continent, his good dinners, his clothes, and his gifts to Jo—shows that he certainly continued to receive money from his family during these first years of residence in England. But he was not slow to make himself available in the right places. Luke and Alecco Ionides, of the Paris Gang, introduced him to their wealthy father, Alexander Ionides, who bought etchings and after the success of *At the Piano* at the Royal Academy commissioned a portrait of Luke. Soon the inimitable Jimmy was a regular Sunday guest at the Ionides house on Tulse Hill, out in the still partly rural southeastern suburbs of London. Here he made useful connections with many other members of the lively, prosperous Greek commercial colony: the Coronios, the Cassavettis, the Cavafys, the Lascardis, and—an important family for his future—the Spartalis.

By 1860 he had acquired enough of a reputation to attract a pupil, M. W. Ridley, who was interested in etching. Ridley brought about an introduction to the Edwardses, one of the most attractive art-minded couples in the London area. Edwin Edwards, then in his middle thirties, was a beaming little man with a Santa Claus beard who was in the course of retiring from a successful legal career in order to devote himself to playing the flute, studying German and French literature, collecting prints, and etching English landscapes in a style which, although a trifle scratchy, was acceptable at Royal Academy shows and the Paris Salon. His wife, a lanky woman with hot, intelligent eyes, shared his enthusiasms and helped to operate their equipment, which eventually included a printing press, a boat for sketching tours, and a tiny, transportable greenhouse in which, dressed in the costume of a polar explorer, Edwin executed his winter scenes. During the 1860s their house at Sunbury, on the upper Thames, became what Courbet's friend Duranty, who arrived occasionally from the Brasserie Andler, described as "an etching sanctuary." Whistler would sometimes drive down from London to Hampton Court and take their boat for the rest of the way, thus obtaining a complete holiday from the oil, tar, hard work, and "beastly cads" of Rotherhithe and Wapping.

He continued, with the same ease as in Paris, to make acquaintances among other artists. He got to know Frederic Leighton, whom he had possibly seen on the Left Bank. The introduction during which Millais had so gratifyingly praised *At the Piano* developed into a lasting, although never intimate, relationship. One of the most important encounters was with the modest, eccentric Charles Keene, who had been contributing his admirably nervous drawings to *Punch* since 1851, who knew influential people, who had helped to found the Junior Etching Club, and who became a faithful member of the circle around the Edwardses. Although Whistler, in spite of some fairly successful attempts, never became a magazine illustrator, and although he profited little from belonging to the etching club, he obtained from Keene the kind of encouragement that made a London future look desirable. He also

got, in the long run, a rare thing in his life: a friendship that was never broken.

He did not—not immediately—drift away from the friends he had made in France; on the contrary, he drifted closer to them for a while. The incorrigibly Bohemian Ernest Delannoy was among the first to be invited to 62 Sloane Street; he pretended to be frightened by the servants and the shower bath. Fantin, profoundly discouraged by the fact that one of his still lifes had just been knocked down for two francs at a Paris auction, came over in July, 1859; he disapproved of Verdi's Miserere on a barrel organ, but enjoyed Deborah's piano version of the barcarole from *Oberon* and wrote home praising the food and drink: "At lunch or for an afternoon snack I devour two or three slices of roast beef. I'm eating quantities of meat, of excellent meat! It's a good religion that has no fast-days. Everything washed down with sherry. . . . And what dinners, always with champagne!" Haden gave him lessons in etching, took him to museums, art shows, and concerts, bought two of his pictures, and sent him back to Paris with a commission for a copy of a work in the Louvre. Legros, whose poverty at the moment was such that, in Whistler's opinion, "it needed God or a lesser person to pull him out of it," arrived in Sloane Street late in 1860 and sold his painting *The Angelus* to Haden. When the latter, who could be quite professorial, undertook to correct the perspective in his purchase, there was a small crisis, for the author and Whistler promptly restored the work to its original condition. But Legros enjoyed his stay, made a number of other sales, met the Edwardses, did a painting and etching of their drawing room at Sunbury, and returned to France with the idea of settling in England. Whistler was taking the *Société des Trois* seriously.

Du Maurier was at this time also in need of assistance, for he was struggling to get started as a *Punch* cartoonist and trying to recover his morale after a shattering experience for a young artist: in the summer of 1858 he had lost the sight of his left eye and had seemed in danger of going totally blind. Whistler helped with an introduction to the patiently hospitable Hadens, with extravagant praise for sometimes mediocre drawings, and by sharing, during

the summer of 1860, a small apartment he had rented at 70 Newman Street, a few blocks from the British Museum. For ten shillings a week Kicky, as du Maurier was known to his intimates, had a roof, a bed, a table, two chairs, some of Deborah's sheets and towels, the constant view of etchings from the French and Thames series, and the frequent use of a dress coat and an almost new waistcoat.

His opinion of his American friend, as expressed in letters to the du Maurier family and to Thomas Armstrong of the Paris Gang, was for many months quite different from what would appear thirty-four years later in the first version of *Trilby;* in fact, it was a schoolboy crush for a while. Whistler is described as "an enchanting vagabond" and "the grandest genius I ever met, a giant." He is "the pet of the [Ionides] set," and as such gets away with only a mild reproof from Kicky for what appears to have been a serious flirtation with Alecco Ionides' sister, Mrs. Aglaia Coronio. Although "the Greeks" are pointedly mentioned as "very *useful acquaintances*" for an artist who is trying to make a living, there is scarcely a trace of envy at Whistler's success with them: "I am beginning to be a little lion and the big lion Jemmy and I pull together capitally dans le monde—no rivality whatever, both being so different. Jemmy's bon mots which are plentiful are the finest thing I ever heard; and nothing that I ever read of in Dickens or anywhere can equal his *amazing* power of anecdote. He *is* a wonder, and a darling—we are immense chums . . ." Not until October is there a hint of awareness of the chum's harsh ego: "I think I am more *liked* than he though, being d'une nature plus sympathique as the french novels say . . ."

On the Road
1860-1863

The close of 1860 and the beginning of 1861 saw Whistler getting more and more caught up in social activity, to a point that suggests a drug that induced in him a need for increasingly frequent doses. When he was not at the Ionides place on Tulse Hill he was apt to be with the Edwardses in Sunbury-on-Thames, or at the London home of the Majors, a lively satellite family of the Ionides set. Between the bigger social occasions he could have been found having a midnight supper in the Haymarket with Poynter and other veterans of the Paris Gang, or presiding in his Wapping inn at a dinner whose guest list included both waterfront acquaintances and slumming gentlefolk. Christmas was celebrated with the Hadens in Sloane Street. A week later he was much less decorous, at least in the opinion of Kicky du Maurier: "New Year's Eve at the Majors where it was most uproarious fun and jollity I must say. . . . Such splendid embroidered costumes the Greeks had— national you know . . . Jimmy was magnificent, but unfortunately got awfully drunk at supper and misbehaved himself in many ways." The misbehavior, however, was clearly not quite a social disaster, for on January 14, 1861, according to a program that has been preserved, Jimmy appeared on Tulse Hill in a theatrical

entitled *The Thumping Legacy*, playing opposite the flirtatious Mrs. Coronio. He also, perhaps during this winter or possibly a little later, began to appear and to perform at the stag parties given on Campden Hill by the wealthy West End draper Arthur Lewis. The painter Arthur Severn, who had met Jimmy in Sloane Street, preserved vivid memories of these parties: ". . . towards the end of the evening, when we were all in accord, there were yells for Whistler, the eccentric Whistler! He was seized and stood up on a high stool, where he assumed the most irresistibly comic look, put his glass in his eye, and surveyed the multitude, who only yelled the more. When silence reigned he would begin to sing in the most curious way, suiting the action to the words with his small, thin, sensitive hands. His songs were in argot French, imitations of what he had heard in low cabarets on the Seine when he was at work there." Fumette would probably have recognized some of the songs as evidence that she had not been entirely forgotten.

His theatricality was not restricted to parties: he continued to wear odd suits and hats, and for a while he startled Londoners by carrying two umbrellas, one white and the other black. But he also continued to work hard. Among the prints executed in 1860 is the drypoint of Annie Haden wearing a cape over her short crinoline and looking like a dainty, pouting version of a Terborch burgher; the rigorous geometrical construction, the linear economy, and the rather Chinese passage from upper explicitness to lower sketchiness justify Whistler's own opinion of the work as "one of my very best." On Christmas Day, looking from the balcony of the Angel, he finished painting *The Thames in Ice*, in which can be seen for the first time, along with some free brushwork, some typically Whistlerian outdoor light, a silvery, foggy, unifying luminousness that owes nothing to Courbet but something possibly to Corot, something to the Great Neva, the Seine basin, and London winters, something to nearsightedness, something to a secret pensiveness, and something to the fairly simple trick of rendering even relatively near things in the aerial-perspective technique reserved by academic painters for distant things.

In May, 1861, one of the versions of the oil *La Mère Gérard*
was hung at the Royal Academy show; British juries were turning
out to be decidedly less stuffy than those of the Paris Salon. Again
the *Athenaeum* was kind, describing the picture as "powerful-
toned." The *Daily Telegraph* felt that it would have been more
appropriately "hung over the stove in the studio than exhibited
at the Royal Academy," but granted that it was "replete with
evidence of genius," and then went on to give the young painter
some advice: "If Mr. Whistler would leave off using mud and
clay on his palette and paint cleanly, like a gentleman, we should
be happy to bestow any amount of praise on him, for he has all
the elements of a great artist in his composition. But we must
protest against his soiled and miry ways." The tone of this would
soon become familiar to Whistler; for many years he would be
regarded by London critics, not entirely without reason, as a man
who was failing to fulfill his promise.

In July he had an attack from his old childhood enemy,
rheumatic fever, severe enough to start rumors in the Ionides set
that he was dying. His illness did not, however, keep him from
continuing the mutual-aid work of the *Société des Trois*. Fantin-
Latour came over from Paris at the beginning of the month and
promptly sold all the pictures he had brought with him, including
a large copy of the *Marriage Feast at Cana* for which Haden paid
a thousand francs—a price that made Stonington Bill look like a
grinder of the faces of the poor. With Haden, Fantin stayed for a
while in Surrey at the country home of James Clarke Hook, a
pleasantly Victorian painter whom both Whistler and Baudelaire,
to the surprise of twentieth-century art historians, greatly admired.
Then came a stay of several weeks with the Edwardses at
Sunbury, where the young Frenchman soon found himself prac-
tically a member of the family. He enjoyed the music, painted a
number of still lifes with flowers, and started a portrait of Mrs.
Edwards. He resisted, nonetheless, the temptation to imitate his
American friend and remain in England, and in November, three
months after his return to France, he wrote to Edwin Edwards
explaining his attitude: "Paris is liberty in art. You sell nothing,

but you have freedom to reveal yourself, and people who are seeking, who are struggling, who are applauding; you have partisans, you found a school; the most ridiculous of ideas has its partisans, along with the most elevated of ideas . . ."

Whistler may have listened to similar praise of Paris during the summer, for he decided to accompany Fantin when the latter left for the Continent at the end of August. The departure was a welcome one to du Maurier, who wrote to his mother a sharp letter revealing that the schoolboy crush was over: "Jimmy Whistler gone to Paris—bon débarras; j'en devenais las; nothing is more fatiguing than an egotistical wit . . ." The same letter, as if to prove how fatiguing the wit could occasionally become, relates a sequel to the unfortunate New Year's Eve party: "I must tell you a very funny thing he said to Rosa Major; at their theatrical, he wore her pork-pie hat (that was the evening he got so drunk); afterwards it appears, Rosa M. found that somebody had spat in the hat and didn't wear it any more; and the other day she gave it to him, saying that he might have it as it had been spit in, and thinking that he would be much ashamed, but he took the hat quite delighted, and said:—'By jove, Miss Rosa, if that's the way things are to be obtained in your family I only regret I didn't spit in your hand!' (If Miss Rosa knew whose head her hat adorns at present, she would have kept it in spite of the spit.)"

The other head was of course that of Jo, whom Whistler took with him to France. Kicky had developed an intense dislike for her, out of motives that apparently included jealousy, snobbery, and a not unjustified belief that she was the kind of woman who caused quarrels between male chums. His letters from this point forward refer to her as the "red-haired party," the "duchess," the "grande dame," and "an awful tie."

In Paris at the close of the summer of 1861 the situation was changing rapidly and, from the point of view of the younger men, for the better. At the Salon that spring Fantin had had no less than four pictures accepted. Legros, although attacked by conser-

vative critics, had been awarded an honorable mention by the jury
for his Courbet-like *Ex-Voto*. Manet had scored his first triumph
with his Velázquez-like *Le Guitarrero*, and after the opening of
the Salon a delegation of artists including Fantin, Legros, Carolus-
Duran, and Bracquemond had called on this obviously rising leader
of the vanguard to express their admiration and solidarity. These
signs of a shift in the art climate of the city were being ac-
companied by a noticeable geographical drift; although nothing
was made explicit, the drift implied an obscure feeling that the
Latin Quarter, with its ancient literary associations, was not the
proper center for a kind of painting that was becoming increasingly
nonliterary and visual in its emphasis. The elegant, non-Bohemian
Manet was very much a Right Bank man; his studio was near the
Parc Monceau in the Batignolles quarter, a petit-bourgeois su-
burban village recently annexed by the City of Paris, and his
favorite meeting place, where he could be found nearly every
afternoon between five and seven, was the Café de Bade, in the
fashionable Boulevard des Italiens. Fantin himself had just moved,
although not permanently, across the Seine into his parents' apart-
ment in the Rue Saint-Lazare, a long way both in distance and in
outlook from the Café Molière and the Brasserie Andler.

Whistler took in the situation with his usual osmotic swiftness.
He went to the Café de Bade with Fantin. He met Manet, whom
Fantin had known for several years through copying sessions in
the Louvre. Soon the Bohemian dandy of the years on the Left
Bank was installed with his red-headed mistress in a rented studio
in the Boulevard des Batignolles. He spent the considerable sum of
fifty francs on the creation of a new bonnet for Jo, and proudly in-
formed Kicky that all the Parisians on the smart boulevards were
"aghast" at her beauty. But he decided that before settling into a
new Paris phase he would make use of the remaining warm
weather by taking a trip, this time to Brittany.

In September he was at Perros-Guirec, a small fishing port on
the north Breton coast that lists among its attractions a partly Ro-
manesque church and two sandy beaches. Here he did the dry-
point *The Forge*, in which his liking for darkness shot with

dramatic light is again evident. Three miles away, near the hamlet of Ploumanac'h, he was struck, as have been generations of tourists, by the chaos of pink-granite rocks that covers much of the beach, and here he painted his first major seascape, *The Coast of Brittany*. As the sentimental original title, *Alone with the Tide*, can suggest, this picture is arguably the most Victorian thing he ever produced; its human-interest motif, a ragdoll-like Breton girl in folk costume reclining dreamily against a boulder near the sounding sea, could have been inspired by the admired J. C. Hook, or by a postcard. In fact, the whole work, with its flooding, slightly artificial color and its wonder-of-nature content, has a troubling postcard quality. The best features are the treatment of the strip of ocean, which both recalls and anticipates some of Courbet's effects, and the flat patterning of the mass of rocks, which anticipates some of the mature Whistler's effects, in his etchings especially.

He spent most of the following winter in the Boulevard des Batignolles. Jo was introduced to Courbet, Whistler pulling her hair down to her shoulders in order to make the expected impression on the Realist leader. Ernest Delannoy, as Bohemian as ever, moved into the studio for a while and quarreled regularly with Jo. Whistler himself appears to have grown more quarrelsome during this period; on one occasion he shifted from the quarrel of Jo and Ernest into a fistfight with a hackney coachman. He also developed a new edge to his wit. Called to London by the death of Thomas, his print publisher, he commented with a gag formula he would employ more than once in the future: "I wrote to the old scoundrel, and he died in answer by return of post— the very best thing he could do." Told by an admirer of Turner that the great man was so unpretentious "he'd leave his pictures in his courtyard to be pissed against," Whistler replied: "Well, that accounts for some of the damned peculiarities . . ."

The most discussed artistic event of the Paris season was the opening by Courbet of an *académie*, in response to a petition issued by a group of rebellious students at the Ecole des Beaux-Arts. The atelier was a barnlike place in the Paris Gang's old Rue Notre-

Dame-des-Champs, and the models included such unusual ones as a chained bull, a horse, and a peasant to control the bull. The experiment lasted only from the end of the year to the following spring, partly because Courbet insisted all along that he was not a professor and that anyway art could not be taught. He did, however, with the help of his friend the critic Castagnary, write an open letter to his students on December 25, 1861, and in it he reaffirmed the tenets of Realism. "Imagination in art," he said among other observations, "consists in knowing how to find the most complete expression of an existing thing, but never in inventing or creating that thing itself. . . . Beauty, like truth, is a thing which is relative to the time in which one lives and to the individual capable of understanding it. The expression of the beautiful bears a precise relation to the power of perception acquired by the artist. . . . It is not possible to have schools for painting; there are only painters." The loyal, conscientious Fantin was enrolled in the new *académie*, or antischool, for a while. Whistler was not; in general he was cool toward animals. But he must have looked in now and then, for visiting the enterprise became a Parisian pastime, and he certainly read the open letter, which was published immediately in one of the Sunday papers. He could easily have agreed with many of its assertions, including especially the one about "the power of perception acquired by the artist." He could scarcely have agreed, however, with the prohibition against "inventing or creating," for at that very moment he was struggling to finish a picture, *The White Girl*, that owed a great deal of its quality to invention, something to art for art's sake, and practically nothing to Courbet's Realism.

For the occasion Jo and a corner of the studio in the Boulevard des Batignolles had been thoroughly aestheticized, Jo by means of undone hair, a white gown, a sprig of a lily, and a mysterious stare, and the studio by means of white drapery and a bearskin rug. The result, which ten years later was called *Symphony in White No. 1*, is a seductive, dashingly painted tour de force that teeters between spiritual symbolism and sexual comedy; and it is also a complex illustration of the way the Whistlerian sensibility functioned. Close

historical correspondences for the more striking features are not hard to discover. In France in the eighteenth century studies in white against white had not been uncommon; a still life by the expert Jean-Baptiste Oudry might include, for example, a white goose, a white candle, a while porcelain cup, and a piece of white paper. In England the Pre-Raphaelites had condemned the bitumen favored by the academic brown school, and as early as 1850 Rossetti had painted his Annunciation, *Ecce Ancilla Domini*, almost entirely in white. There were precedents, too, for the stare. In France during the 1850s the Romantic portraitist Gustave Ricard had had an immense success with large, enigmatic eyes, and in England Millais had painted young women, including a nun, with fixed stares that were at once erotic and soulful. Finally, the *femme fatale*, the girlish harpy, the recent virgin, and the lady of pain were stock figures, frequently fused, for nineteenth-century painters and writers. But all this is not to say that every correspondence can be set down as a direct influence. Since the *Ecce Ancilla Domini*, for instance, had long been in an Irish collection, there is only a remote possibility that Whistler had seen it before painting *The White Girl*. That he had seen an Oudry cannot be proved. Although he had seen and admired the work of Millais, he may not have had it in mind when he gave Jo her stare. He had, beyond question, a flair for absorbing the trends of his time. Often, however, he absorbed them because of already existing affinities, or simply because, faced by problems similar to those faced by his contemporaries, he arrived at solutions similar to theirs. In brief, he was himself, to a degree that would be more apparent around the end of the century, one of the taste-makers of his period.

He returned to London in the spring of 1862, not in the best of health. He had painted *The White Girl* with white lead (zinc white was just coming into use), a poisonous compound if inhaled or ingested, and had had in consequence a touch of the then familiar malady called painter's colic, or plumbism. He soon had

cause to feel more out of sorts, for the picture stirred up more controversy than he seems to have expected. On April 9, Jo wrote to George Lucas, the still friendly Baltimore man who had settled in Paris: "I note the *White Girl* has made a fresh sensation—for and against. Some stupid painters don't understand it at all while Millais for instance thinks it splendid, more like Titian and those of old Seville than anything he has seen—but Jim says that for all that, perhaps the old duffers may refuse it altogether." The old duffers, who were the jury for the Royal Academy show, did refuse it altogether, although they softened the refusal by accepting both *The Coast of Brittany* and *The Thames in Ice*, along with the etching *Rotherhithe*.

The critics were indulgent about the two exhibited paintings, praising the Breton one as "perfectly expressed" and the London on as "broad and vigorous." Whistler was not satisfied, however, with this incomplete success, and so in June he accepted an invitation to exhibit *The White Girl* at the recently opened Berners Street Gallery. F. G. Stephens, the critic for the *Athenaeum*, commented: "It is one of the most incomplete paintings we ever met with. A woman in a quaint morning dress of white, with her hair about her shoulders, stands alone in the background of nothing in particular. . . . The face is well done, but it is not that of Mr. Wilkie Collins' *Woman in White*." This complacent assumption that the work was intended as an illustration provoked from the painter the first of what would one day swell into a flood of letters to the press. He confessed that he had not read the popular Collins novel, asserted that the gallery had entitled the picture *The Woman in White* without his approval, and added, a bit disingenuously: "My painting simply represents a girl dressed in white, standing in front of a white curtain."

He spent part of the summer painting *The Last of Old Westminster*, working from a window in the apartment of Arthur Severn's brother in Manchester Buildings, which became the site of New Scotland Yard. Young Arthur, who finally became a Ruskin protégé, later recalled the technique of his American

friend almost with awe: "It was the piles with their rich color and delightful confusion that took his fancy, not the bridge, which hardly showed. He would look steadily at a pile for some time, then mix up the color, then, holding his brush quite at the end, with no maulstick, make a downward stroke and the pile was done. I remember his looking very carefully at a hansom cab that had pulled up for some purpose on the bridge, and in a few strokes he got the look of it perfectly." The actual subject of the picture was not, as the title implies, the final demolition of the lovely eighteenth-century bridge, on which Wordsworth had felt that "earth has not anything to show more fair" than London on a September morning; it was rather the removal of the scaffolding from the new span. And this actual subject probably explains the surprising resemblance between *The Last of Old Westminster* and Hiroshige's popular view of the Nihonbashi bridge in Tokyo, for there is not much reason to suppose that Whistler was being influenced by Japanese prints in mid-1862. He was merely getting his affinities tuned up.

He was also extending his circle of acquaintances in ways that would be important for his art as well as for his social life. He met Swinburne, who was in public simply the author of two unsuccessful plays but in private the extraordinary creature whom another American, Henry Adams, encountered at a country party in Yorkshire the same year: ". . . a tropical bird, high-crested, long-beaked, quick-moving, with rapid utterance and screams of humor, quite unlike any English lark or nightingale." On July 28, at Swinburne's lodgings in Newman Street, Whistler met Rossetti, who within three weeks was arranging contacts for his new friend with possible buyers of pictures. Also present at the July gathering were the landscapist George Price Boyce, whom Whistler already knew; the amiable, muscular Val Prinsep, who had studied with Gleyre and would be partly the original for Taffy in *Trilby;* the second-wave Pre-Raphaelite Burne-Jones; and the gifted, constantly penniless portraitist Frederick Sandys, whom Rossetti referred to as "the tomb of loans."

John Cavafy, a relative of the Ionides family, bought *The Last of Old Westminster*. Other orders for river pictures came from "the Greeks." The London magazines *Once a Week* and *Good Words* bought half a dozen drawings for woodcut illustrations, at nine pounds each. There were sales of etchings. More importantly, there were apparently some American railroad securities available for cashing in, for du Maurier, in a letter dated July, 1862, remarks: "Jimmy . . . is going at last, so he says, to realise the Wabash bonds, and will start for Venice with Jo on the proceeds." In sum, by autumn Whistler had money in his pockets, and to him that meant an opportunity to take a trip. He finally decided, however, to substitute Spain for Venice: his doctors had recommended the Pyrenees for his health, and he had a more lively interest in Spanish painting than in Venetian.

By early October he and Jo were at Biarritz, the favorite Atlantic resort of the Empress Eugénie. Here he painted *The Blue Wave*, an uncharacteristic but solid piece of work. His first letters to Fantin were full of boyish enthusiasm for the Spanish master- pieces ahead of him: "You must be waiting impatiently for my trip into Spain. You're right, I'll be the first person capable of looking at the Velázquezes for you. I'll give you a full account, I'll tell you about everything. What great luck for both of us . . ." From Guéthary, a few miles south of Biarritz, he wrote, with his cus- tomary relish for storytelling, about being nearly drowned: "The sun was setting, everything was ready for the occasion. I saw the land get further away. A fifteen-foot wave absorbed me. I drank a barrel of salt water and went through the wave, only to be swallowed by a twenty-foot one, in which I whirled like a wheel and got engulfed by a third one. I swam, I swam, and the more I swam the further from shore I got. Ah, my dear Fantin, to feel how futile one's efforts are, and to hear the spectators on the beach saying, 'But this Monsieur is having fun, he must be terribly strong!' I screamed, I howled with despair . . ." At last he was pulled out by a bather who "leaped into the sea like a Newfound- land dog."

By late October the fun had gone out of the expedition. He

reported to George Lucas that the weather was "precious cold" and that Jo was "very full of coughs." His projects for pictures, with the exception of *The Blue Wave*, did not work out. He confessed to Fantin that he was "almost demoralized by lost days" and that he was having doubts about the principle of doing landscapes and seascapes straight from nature, in the manner that would be adopted by the Impressionists: "Anyway, these pictures done outdoors after nature can be nothing except large sketches. It isn't there! a bit of floating drapery, a wave, a cloud, it's there for a moment and then gone forever. You catch the pure and true tone in flight as you kill a bird in the air—and the public asks you for finished work!" He even confessed to doubts about the wisdom of traveling: "There's the arrival in an unknown land, there are the models to train, the natural ones who pose only after a lot of wheedling, and finally there are weeks before a picture gets under way." He began to indulge in the reverie of the sailor who wants to come home for good from the sea: "Actually, I don't know quite what I'm dreaming about, but for the moment it seems to me that a place in the country, near London or Paris, would do for my happiness. A large room for a studio, and then a bedroom, a small living room, etc." He and Jo went on an excursion across the border to the picturesque fortified town of Fuenterrabia, and that was all he ever saw of Spain.

On his way back to England he stopped off in Paris for some dining and theater-going with members of the Winans family of Baltimore, who were spending the winter in Europe. He also had to settle a lawsuit in the French capital, for earlier in the year, when he was in the studio in the Boulevard des Batignolles, he had got heavily into debt with a laundry woman and several other tradespeople. It was December and he was feeling rheumatic when he at last found himself again in London—more precisely in Chelsea, at 7A Queen's Road West (now Royal Hospital Road), where he had rented rooms during the summer. Two months later the nesting impulse he had had on the road to Spain became irresistible, and so, helped by three hundred pounds worth of commissions from the Greek colony, he leased a house on the Chelsea waterfront at 7

Lindsey Row (now 101 Cheyne Walk). For the first time in his life, he had a home of his own.

In March he was on the road again, with *The White Girl* rolled up under his arm and with the tropical bird Swinburne fluttering along as a traveling companion. They went to Paris first, where the poet was introduced to Manet and the painting was deposited in Fantin's studio, with instructions that it was to be submitted to the Salon jury and, if rejected for the Salon, exhibited in a show that was being organized at the Martinet gallery in the Boulevard des Italiens. Whistler then dropped Swinburne, picked up Legros, and set out for the Netherlands to see Rembrandt's *Night Watch* in the Rijksmuseum and do some etching. In a show at The Hague his prints won a gold medal, and he immediately wrote to Fantin to arrange for the proper Parisian publicity: "Now here is what you're going to spread around everywhere with all the rascally finesse of which you're perfectly capable—for we know that each of us is worthy of the other. I have received the Dutch gold medal. You are to slip this news into the ear of the Commandant [Lejosne, a relative of the painter Bazille] at the Café de Bade, in such a way that the others will hear you and that the news will naturally get to be known everywhere . . ."

As anticipated, *The White Girl* was refused by the Salon jury. So were more than four thousand other works, including those submitted by Manet, Fantin, and Legros. In fact, the jury had been more severe than that of 1859, and this time the protests were loud enough to reach the ears of Napoleon III, who was in many ways less conservative than the faculty of the Ecole des Beaux-Arts. On April 24, a week before the scheduled opening of the Salon, a sensational item in the government paper gave the Imperial answer: "His Majesty, wishing to let the public judge the legitimacy of these protests, has decided that the works of art that have been refused should be exhibited in another part of the Palais de l'Industrie. This exhibition will be optional, and the artists who do not wish to take part have only to inform the administration . . ." Thus was created the historic show that soon came to be known as the Salon des Refusés. Some of the rejected artists felt that they

had been trapped by the Emperor: if they exhibited, the public might decide that the jury had been right, while if they did not exhibit they would seem to be tacitly admitting that the jury had been right. Some of the more timid were afraid that exhibiting would anger the jury and spoil any future chance of getting into the official Salon. A large number, however, saw that they had been given an opportunity to challenge academic stupidity and advertise their own conceptions of contemporary art, and Whistler was among these braver spirits. From Holland he sent his instructions to Fantin: "This exhibition of the refused is delightful for us! My picture must certainly be in it! And yours too. It would be madness to withdraw them in order to show them in Martinet's gallery."

The Salon des Refusés opened on May 15, and from the first day the crowds, alerted by the press, were huge. Most of the visitors found nearly everything sidesplitting; they laughed at the efforts of the naïve and the incompetent, at whatever was non-academic, at Manet's *Le Déjeuner sur l'herbe*, and especially at *The White Girl*. The English critic P. G. Hamerton reported in the *Fine Arts Quarterly:* "The hangers must have thought her particularly ugly, for they have given her a sort of place of honor, before an opening through which all pass, so that nobody misses her. I watched several parties, to see the impression. . . . They all stopped instantly, struck with amazement. This for two or three seconds, then they always looked at each other and laughed." More than twenty years later Zola, in his novel *L'oeuvre*, recalled the same reaction: "It was the contagious hilarity of a crowd that had come with the intention of being amused, exciting itself little by little, bursting out over nothing, getting merry over beautiful things as well as over the very bad. . . . The *Lady in White*, she also, entertained people: they jabbed each other with their elbows, and went into convulsions; there was always a group gathering in front of the picture, mouths open from ear to ear."

Why did they laugh? Many undoubtedly did so, as Zola noticed, simply because they were confident, rather brutal people whose risibility thresholds were low; they had read the papers

and they had come to the Salon des Refusés prepared to laugh, as they would have been at a zoo or a madhouse. Others may have found, as one can still find, something absurd in the combination of the strapping Jo, the bearskin rug, the sprig of lily, and the wounded-little-girl look; Hamerton may have had this in mind when he wound up his account by remarking: "Here, for once, I have the happiness to be quite of the popular way of thinking." Some viewers, conditioned by Second Empire humor and affected by the undone red hair, may have snickered at the boudoir implications; Castagnary, who was friendly to Whistler but could never-theless have smiled as he wrote, suggested that the scene represented a bride's morning after, the moment when she realizes she is no longer a virgin. Finally, there remains a strong possibility that many people laughed because, unlike Castagnary, they could dis-cover no anecdotal, allegoric, or symbolic content at all. Hence the painting looked foolish to them. Unsophisticated in art for art's sake, they were utterly incapable of supposing that Jo was standing on the bearskin mostly to let Jimmy work on his tonal values and on the basic pictorial problem of figure and ground.

Castagnary's reaction, however, was not the only favorable one. In a pamphlet on the Refusés the poet Fernand Desnoyers, an ardent defender of the Realists, described *The White Girl* as the most original work that had been submitted to the Salon jury. The Paris critic Paul Mantz, in the *Gazette des Beaux-Arts*, praised the return to the French eighteenth-century light palette and called the picture a "symphony of white," a phrase that would have a considerable posterity. Fantin rounded up private opinions for Whistler, who was still in Holland: "Now you are famous. Your picture is very well hung. You have won a great success. We find the whites excellent; they are superb, and at a distance (that's the real test) they look first class. Courbet calls your picture an apparition, with a spiritual content (this annoys him); he says it's good; this will annoy someone who does badly. Baudelaire finds it charming, charming, exquisite, absolutely delicate, as he says. Legros, Manet, Bracquemond, de Balleroy, and myself we all think it admirable." These were people—with the possible exception of

the now forgotten painter Albert de Balleroy, a close friend of Fantin—whose judgments were more important than the guffaws of the crowd.

Once more, then, Whistler had an opportunity to become an insider in the modern School of Paris that was emerging, and this time his situation was far more brilliant than the one he had occupied in 1859 after his Left Bank success with the French Set and *At the Piano*. That by staying in France he would have gone on to become something of a Monet or a Cézanne is of course unlikely, even on the supposition of equal talent, for although he was an outdoor sketcher and etcher he had revealed in Brittany and on the road to Spain that he was mostly a studio artist in his attitude toward painting. There existed, however, a recognizable group of Paris painters who can be referred to as simply the "dissidents," with the intention of distinguishing them from the historical and mythological academics, from the Courbet Realists, and eventually from the Impressionists. Although some of the dissidents, like Fantin, were not far from the academics, and some, like Legros, not far from the Courbet Realists, the more typical ones were neither solemn nor somber. They liked doing picnics, the racetrack, boulevard society, and portraits of their contemporaries, often elegant women, in contemporary settings. They occasionally updated into Second Empire terms such genres as the Van Dyck full-length court portrait, the Dutch group portrait, the British conversation piece, the Renaissance open-air nude, and even the Renaissance allegory. The typical dissident palette excluded the close, brownish harmonies of the academics in favor of a combination of clear colors with rich blacks; the brushwork was generally striking, either because of a photographic smoothness or because of a certain *brio* or sketchiness. In the 1860s the group included such artists as Carolus-Duran, James Tissot, and Alfred Stevens, all of whom twentieth-century critics, sometimes a bit hastily, have been inclined to dismiss as men who lost their way, or their nerve. Later on the dissident tendency exhausted itself in the chic virtuosity of portraitists like Giovanni Boldini. But an art tendency should not be judged only in the light of its weaker representatives; both Manet

and Degas, in spite of their connections with the Impressionist group, remained dissidents in many respects throughout their careers. And their achievement is a measure of what Whistler might have done in Paris, if he had chosen to follow up the dissident success scored by *The White Girl* at the Salon des Refusés.

He chose not to follow it up. By early summer he was back in Chelsea at 7 Lindsey Row. In the affair of the Refusés he had tasted the pleasure of provoking an art scandal, and he would not forget the taste. But he felt, he told Fantin, a need for "the familiar all about me," and that meant London, the Thames, Jo, Deborah, Seymour, the Greek colony, and the Royal Academy. Soon it would mean Mummy, who was planning on coming to England after having been caught by the Civil War in Richmond, where Willie was serving as a surgeon in the Confederate Army. It would also mean money, for London at the moment seemed indeed to be the place where the "tin," in Rossetti's personal slang, was to be found. Legros came over again, stayed at 7 Lindsey Row until the end of the year, and did so well he decided to become a British subject.

Chelsea and the Orient
1863 - 1865

In 1834 Thomas Carlyle, having just found the house in Cheyne Row, Chelsea, where he would pursue his career as an essayist and historian for the next forty-seven years, had written to his wife: "Chelsea is a singular, heterogeneous kind of spot, very dirty and confused in some places, quite beautiful in others, abounding with antiquities and the traces of great men: Sir T. More, Steele, Smollett, &c., &c. Our Row (which for the last three doors or so is a *street* and none of the noblest) runs out upon a beautiful 'Parade' (perhaps they call it) running along the shore of the River: shops, &c., a broad highway, with huge shady trees; boats lying moored, and a smell of shipping and tar; Battersea bridge (of wood) a few yards off: the broad River . . ." By 1863, when Whistler and Jo, plus Legros for several months, were settling down at 7 Lindsey Row, there had of course been some changes. Half a mile upstream the broad prospect of the Thames had just been interrupted by the completion of Battersea Railway Bridge. Real-estate development had filled in outlying areas and reduced the sense of isolation from the rest of London. Victorian Gothic had left its mark here and there. But on the whole the borough had been too poor to indulge in anything like urban renewal. It was still a

heterogeneous kind of spot, very dirty and confused in some places, quite beautiful in others. Poultry cackled in back yards and skittered across streets that were often pretty much those of the eighteenth-century village. There was still a smell of shipping and tar along the waterfront, which still sloped, as it had for hundreds of years, down to the river through rocky fill-in and low-tide mud. Still in place was the wooden Battersea Bridge, which looked even more Japanese than had the scaffolding around the new Westminster span.

The heterogeneity of the spot became particularly evident when, starting from the eastern edge of the "village," one walked along the riverside promenade that became in part the Chelsea Embankment after shoring-up operations in the early 1870s. Standing behind a noble sweep of greensward and trees was Wren's Royal Hospital, commonsensical in its brickwork, dignified in its classical portico, witty in its cupola, and fussy nowhere—"the work of a gentleman," Carlyle thought. Further west, sheltered from vulgar waterfront bustle by a strip of shrubbery, was stately Cheyne Walk, which included a row of red-brick Georgian houses garnished with wrought-iron railings and small flower gardens. Then came the resolutely English squareness of Chelsea Old Church, which sheltered monumental memories of Sir Thomas More and other eminent early residents of the borough. At this point, however, you were already into a zone of taverns and what Carlyle had designated as "shops, &c.," most of which were installed in undistinguished little buildings that could have reminded an American of a small-town Main Street. Beyond Battersea Bridge you were in definitely unfashionable Lindsey Row; here the principal landmark was Lindsey House, a fine seventeenth-century mansion that had once belonged to the Earl of Lindsey, had served for a while as the headquarters of the Moravian evangelical movement in England, and had finally suffered division into five separate houses. The promenade straggled on past the establishments of Thames boatmen to the cottage where Turner had lived, mostly on a diet of milk and rum, from 1846 to his death in 1851. At the southward bend of the river lay Cremorne Gardens, which had

begun its career as a ladies' and gentlemen's sporting club and had long since become an amusement park for the lower classes, specializing in band concerts, mammoth public balls, balloon ascents, and firework displays.

The house at 7 Lindsey Row was a narrow, whitish building with a rather cramped ground level and two more spacious stories above. It was situated next door to Lindsey House on the side looking toward the Turner cottage and Cremorne Gardens, and could therefore lay no claim to being a stylish address. In an etching done by Seymour Haden in 1863 the place looks a trifle decayed and the immediate neighborhood more than a trifle seedy; in the back of the house there is something that appears to be a shanty, and in front there is a picket fence beyond which some small boats lie in the Thames-side mire. There was no proper studio, nor even a room with a skylight. But Whistler at the moment had no need for a stylish address of the sort useful to the academic painters up in Kensington, and he had got used to decaying lodgings and seedy neighborhoods during his years on the Left Bank. Also, throughout his career he preferred the relatively subdued illumination provided by ordinary windows to the light of a conventional studio, falling through an expanse of slanting panes at the orthodox angle of forty-five degrees. And finally whatever defects the house may have had were more than compensated for by a first-rate view of the river and the nearness of amusing friends.

During these first months in his new home he completed his long-pending revision of *Wapping*, probably without bothering to return to the balcony of the Angel. He also did some prints; from 1863 dates the drypoint *Weary*, in which Jo, her undone hair artfully flung into an erotic halo, looks remote, soulful, and Pre-Raphaelite. He did not neglect, however, his fresh opportunity to indulge his fascination with the Thames. "On a brilliant autumn evening" in 1863, according to one of his letters, he painted *Battersea Reach*. Then came *Grey and Silver: Old Battersea Reach*, the designation "grey and silver," like all the abstract elements in his titles, being added later. On a freezing day of the following winter he produced, or at least began, *Harmony in Grey: Chelsea in Ice*. Some-

time during this period he painted *Brown and Silver: Old Battersea Bridge*. All these pictures show a preoccupation with liquid paint, muted colors, gray light, mistiness, and simplified forms; they can thus be regarded as one of the transitional clusters between the earlier, more detailed, more Realistic views of the London dock area and the night views of the river that would appear in the next decade. Two of the paintings are also evidence of continuing good relations with the local Greek colony: *Old Battersea Reach* was bought by Mrs. Aglaia Coronio, the sister of Luke and Alecco Ionides, and *Old Battersea Bridge* was commissioned by their father.

Among the amusing new friends were members of the Greaves family, who lived two doors away in Lindsey Row, in the direction of Cremorne Gardens. The father was the owner of a flourishing boat-building and boat-renting business, and a veteran Thames waterman; fifteen years earlier he had rowed Turner to good points from which to study sunsets. The mother was a kind-hearted woman who always laughed at Whistler's jokes. The six children included two boys, Walter and Harry, who in 1863 were respectively seventeen and nineteen years old; both were assiduous amateur painters in the detail-crowded, brick-by-brick style favored by the untrained nearly everywhere, and Walter was quite serious about his art. Whistler appropriated them as devoted companions, Chelsea guides, expert oarsmen, loyal disciples, and to a considerable extent ordinary servants; they functioned as his claque, initiated him into the delights of Cremorne Gardens, taught him to row with the special Thames "waterman's jerk," imitated his gestures and dress, carried his equipment, stretched his canvases, helped to prepare his colors, and played the piano while he danced with one of the Greaves daughters. He in turn taught them to draw and paint in a pseudo-Whistlerian manner—disastrously, for Walter's splendidly naïve *Hammersmith Bridge on Boat-Race Day*, painted in the late 1860s during a moment of emancipation, reveals a talent that in an unmolested condition might have gone on to rival that of the Douanier Rousseau.

At the fashionable eastern end of the Chelsea waterfront there

were friends of a quite different sort. In October, 1862, Rossetti had rented No. 16 Cheyne Walk, a big, brick Queen Anne house with ivy-covered walls, nineteenth-century bay windows, and almost an acre of unkempt garden in the back. The original idea had been to share the place with George Meredith, Swinburne, and William Michael Rossetti, Dante Gabriel's brother, and by 1863 this was not exactly working out. Meredith had withdrawn from the project almost immediately, in part because his gentleman-novelist's nerves could not stand the morning spectacle of Rossetti devouring poached eggs. William Michael was too busy as a civil servant and an art critic to put up with the irregular daily life of a Bohemian fraternity. For the time being only Swinburne was a fairly constant co-resident; his masochistic aberrations, his delight in being stark naked, his tendency to have fits, and his habit of exceeding his very small capacity for alcohol made him dependent on the protection of a companion. The defection of the other residents, however, had not kept 16 Cheyne Walk from developing into a sort of writers' and artists' informal clubhouse and party-giving center. Meredith and William Michael came round regu-larly. So did Whistler, Jo, Legros, the impecunious Frederick Sandys, and many high-spirited men and women who had been in or on the fringes of the Pre-Raphaelite movement of the previous decade. The house encouraged a sense of belonging and hence one of separateness from the uninitiated; in October, 1863, du Maurier wrote to Thomas Armstrong: "Jimmy & the Rossetti lot, i.e., Swinburne, George Meredith, & Sandys, are as thick as thieves. . . . Their noble contempt for everybody but themselves envelops me I know. Je ne dis pas qu'ils ont tort, but I think they are best left to themselves like all Societies for mutual admiration of which one is not a member."

By 1863 the Pre-Raphaelite Brotherhood as such had long since broken up, and its never coherent doctrine had generated a diffused set of stylistic tendencies that could be called Pre-Raphaelite only because there was no other convenient term. Truth to nature was supposedly a PRB heritage, but so were unnaturally bright colors, middle-class moralizing, Tennysonian medievalism, meticulous

brushwork, cluttered pictorial space, and the predilection for ripe, staring young women with heavy hair. Rossetti at the moment was becoming something of a specialist in staring-women pictures, with the peculiarly exotic-looking Jane Morris, the wife of the arts-and-craft evangelist William Morris, as an increasingly favorite model. Hence it can scarcely be said that Whistler was strongly influenced by the paintings he saw in Cheyne Walk: although with *The White Girl* he had made a gesture in the direction of the "stunner" genre, he was now moving in a different direction, and in any case his liking for broad handling and simply patterned, relatively empty pictorial space was not at all Pre-Raphaelite. Nevertheless, he was obviously fond of Rossetti, for he saw him almost daily for several years. He was amused by the Rossetti backyard zoo, which at various times during the 1860s included salamanders, lizards, peacocks, parrots, a raccoon, owls, rabbits, dormice, wombats, woodchucks, kangaroos, wallabies, a jackass, and a Brahmin bull whose eyes were supposed to resemble those of Jane Morris. He admired the strange, paunchy little man's jocularity, effrontery, and generosity, and seems not to have noticed that behind the entertaining eccentricities a desperate personality was slowly sinking into paranoid morbidity and heading toward an existence rendered tolerable only by chloral with whisky chasers. Whistler's final opinion, pronounced at a time when his opinions of old friends were seldom charitable, would be that Rossetti had been "the only white man in all that crowd of painters, not an artist, you know, but charming and a gentleman."

Part of the charm was financial. Among the early buyers of PRB pictures were many members of the new class of British industrialists, self-made, practical men who had amassed fortunes outside London, who cared little about academic aesthetic opinions, and who liked canvases that bore fresh paint and the signatures of living artists. Such patrons were the provincial equivalent of the Ionides set, and they were well known, through years of high-pressure selling, to Rossetti. He introduced Whistler to three of them, James Leathart of Newcastle, William Graham of Glasgow, and Frederick R. Leyland of Liverpool, and all three became

purchasers of the American's work. Rossetti was also acquainted with the London dealer Gambart, of whom he had written:

> There is an old he-wolf called Gambart,
> Beware of him if thou a lamb art
> Else thy tail and thy toes
> And thine innocent nose
> Will be ground by the grinders of Gambart.

Soon Gambart, too, was being beguiled into investing in Whistler.

For a moment there was a possibility of Baudelaire's appearing in Chelsea. On October 10, 1863, the poet, who by this date was well acquainted with Whistler, Legros, and Swinburne, addressed a letter to 7 Lindsey Row mentioning a project, already discussed with Whistler in Paris, for a London engagement as a lecturer and a reader of verse. Unfortunately perhaps for the history of literature, the letter was entrusted for delivery to the photographer Nadar, who tucked it into his briefcase and found it forty years later. Baudelaire went to Belgium for the lecture tour.

Mrs. Whistler, however, did arrive in London at the end of 1863, and after a visit with Deborah and Seymour in Sloane Street came to live in Lindsey Row with her favorite child. She was now fifty-six and was having trouble with her eyesight and with her health in general, but in the important features of her character and personality she was exactly what she had been in 1855, when Whistler had last seen her. She had made her way from the blockaded Confederate States to England with the same quiet efficiency and fearlessness she had always displayed in her travels. Her principles were intact; Walter Greaves remembered her from this early Chelsea period as "a very religious lady [who] used to say that she liked being up in her bedroom because there she felt nearer her Maker." She developed, as many people did, a protective affection for the brilliant, dissolute, childlike Swinburne, called him Algernon, and nursed him back to his always very relative wellness after he had had one of his fits. He responded by sitting at her feet

when visitors were present, as if to proclaim that he had never in
his life been anyone but her Algernon.

Her arrival involved the departure of Jo for separate lodgings,
and this provoked from Haden some extremely Victorian behavior.
He knew Jo well, he had traveled with her and Whistler, and he
had dined and worked in her voluptuous, copper-haired presence at
7 Lindsey Row. He had not, however, allowed Deborah to
appear in a house in which an irregular sexual relationship existed,
and now that Jo was gone he decided to continue his prohibition,
on the grounds that a house in which such a relationship had
formerly existed could never become a place, not even with Anna
Mathilda there, in which a respectable woman like Mrs. Seymour
Haden could afford to be seen. One result of this theory of per-
manent environmental pollution by fornication was that Deborah
could not visit her mother in Chelsea, and another was a loud
quarrel between Haden and Whistler that began in the etching
room on the top floor of 62 Sloane Street, spiraled down the
stairs past the music room to the ground level, and then nearly
spiraled back up again, for on being turned out of the front door
Whistler discovered that he had left his hat in the etching room.
Although the brothers-in-law went on seeing each other, they
ceased to be the comrades in art they had been in the days of their
early prints.

During the winter there was a quarrel, too, with Legros, whom
Jo had found as undesirable in Lindsey Row as she had found
Ernest Delannoy undesirable in the Boulevard des Batignolles.
Perhaps, aware of how uncertain her hold on Whistler was, she
was excessively ready to be irritated by his attachment to the
Société des Trois and his tendency to invite his male friends to share
the home she had been trying to create. But the quarrel was patched
up, at least temporarily, and by late February, 1864, both Legros
and Whistler were in Paris again, posing for Fantin-Latour's revival
of the Dutch group portrait, his *Hommage à Delacroix*. The pic-
ture, which was completed in time to be accepted for the Salon
that spring, might be described as less a homage to the late
Romantic master than a manifesto of the new dissidents, or even

a homage to Jimmy Whistler. The latter, spruce and proud, stands near the center of the composition with the air of a man contemplating himself complacently in a mirror. Behind him are the other two members of the *Société des Trois;* opposite him stands Manet, looking diffident. The others in the group are the etcher Bracquemond, the novelist-critics Duranty and Champfleury, the painter de Balleroy, the sculptor Charles Cordier, and Baudelaire, looking old and ill. There had been a suggestion by Whistler that Rossetti, described on this occasion to Fantin as "a great artist," be included, but Rosseetti had been unable to come over in time to pose. His inclusion, as things turned out, would have been embarrassing to everyone concerned, for when he did get to Paris later in the year he reported to his family that the *Hommage à Delacroix* was "a great slovenly scrawl," that Manet's pictures were "of the same kind," that Courbet's were "not much better, and that in general the new French school was "simply putrescence and decomposition." Rossetti was not a man for broad handling, and at bottom he was more a poet than a painter.

The "slovenly scrawl" nevertheless drew favorable comment at the Salon, and this served Whistler as a point of departure for another display of his talent for friendship. He immediately wrote to Fantin from London: "I'd like to be with you in your success and see you at last take the place in Paris which you have deserved for such a long time. It makes me happy to think of all that we would have to tell each other, of those good long evening conversations in which we would understand each other so closely—you must feel a great need to talk to me during the Salon. It makes me happy to think that we need each other for that true exchange of sympathy which we cannot have with other people. I at least never experience that complete confidence in the sympathy of somebody except with you." Does such a declaration of affection, coming from a thirty-year-old man, seem a little effusive? If it does, the effect may be due merely to the fact that such declarations, which were not uncommon in the correspondence of men in the middle of the nineteenth century, have gone out of style. In any case, the letter was followed at the beginning of the summer

by another mobilization of the *Société des Trois*. A month of
working together at 7 Lindsey Row was accompanied and followed
by the now customary round of profitable visits to the Ionides set,
the Edwardses at Sunbury, and other patrons.

In July Fantin wrote from Chelsea: "We are leading an
impossible life, all three of us, in Whistler's studio. We might be at
Nagasaki, or in the Summer Palace . . ." In other words, by this
time Whistler, exhibiting his usual sensitivity to trends, was well
into an Oriental phase in his tastes and work. He had been a col-
lector of Chinese blue and white porcelain for about a year; a du
Maurier letter dated October, 1863, says: "Jimmy . . . has bought
some very fine china; has about sixty pounds worth, and his
anxiety about it during dinner was great fun." He was also buying
Oriental furniture, kimonos, lacquer work, Japanese fans, and
Japanese prints. His mother, writing from 7 Lindsey Row on
October 2, 1864, remarks that "this artistic abode of my son is
ornamented by a very rare collection of Japanese and Chinese. . . .
You will not wonder that Jemmie's inspiration should be (under
such influences) of the same cast."

As a collector of Chinese blue and white porcelain he may
have been initially influenced by the fact that several people in
the Pre-Raphaelite circle were interested in willow-pattern ware,
but this purely English Chinoiserie could at most have been only
a stimulus for him. He may have made his first purchases in Paris
when he took *The White Girl* over, or later that spring in Holland,
which had long been the principal country through which Chinese
blue and white entered the European market. Another source could
have been London itself, where he was introduced by Rossetti to
the marvels of the Oriental Department of the Great Cloak & Shawl
Emporium and to the department's alert young manager, Lasenby
Liberty (whose later commercial activity would make his name
one of the synonyms, especially in Italy, for Art Nouveau). What-
ever or whoever the first causes may have been, one thing is certain:
Whistler rapidly became one of the leading promoters of the
blue and white craze that swept England in the 1860s and 1870s and
developed—along with the crazes for sunflower motifs, red brick

houses, peacock feathers, anything Japanese, and words like "utterly"—into an ingredient of the Aesthetic Movement. Although he was generally eclectic, buying Japanese as well as Chinese pieces, he appears to have been especially fond, as were many artists and connoisseurs in the nineteenth century, of the technically brilliant blue and white wares produced during the reign of Louis XIV's Chinese contemporary, K'ang Hsi. In Chelsea the chief rival collector was for a long while Rossetti, who applied to the acquisition of porcelain the same guile and energy he applied to the acquisition of art patrons; at friends' homes he had a habit of turning Chinese plates upside down in order to sneak a look at the reign marks, and on one oft-recounted occasion he failed to notice that the plate contained the fish course. Both Whistler and Rossetti eventually had as their principal supplier of blue and white the London dealer Murray Marks, who was also an expert on bronzes, a student of Schopenhauer and Spinoza, and the husband of a beautiful woman Rossetti enjoyed painting.

Japanese art was by no means unknown in England when Whistler became fascinated by it. There were occasional contacts with Nagasaki through Dutch and Chinese traders long before Commodore Perry's opening-up expedition of 1853. By 1857 there were Britons actually residing in Edo, which was on its way to becoming Tokyo. During the 1850s the Gothic Revival architect William Burges was already collecting Japanese prints; in 1854 in London the Old Water Colour Society staged a show of Japanese applied art. After 1858, when the new Japan concluded commercial treaties with Great Britain, the United States, and France, what had been occasional began to become almost regular. In 1861 a British book appeared with reproductions of Japanese color woodcuts, and at about the same time the architect and decorator E. W. Godwin, with whom Whistler became friendly two years later, boldly severed a previously firm attachment to Ruskinian medievalism, stripped the interior of his house in Bristol nearly bare, and adorned it with a few Japanese prints asymmetrically hung. At the International Exhibition in South Kensington in 1862 there was a fairly large Japanese section, which was discussed in an

article by William Michael Rossetti. Whistler would have had to have been a great deal less osmotic than he actually was to have failed to absorb something of all this.

The full impact, however, of Japanese art, and of the Japanese print in particular, on Western painting occurred in France rather than in England. The standard anecdote is that in 1856 Delâtre, the printer, acquired a copy of one of Hokusai's sketchbooks, the *Mangwa,* in a shipment of porcelain, that the etcher Félix Bracquemond acquired the volume in 1858, and that after that *le japonisme* spread like wildfire through Paris studios. This seems a little neat and a little early, in view of the dates of the Japanese commercial treaty and of the first clear signs of *japonisme.* What actually happened was an infiltration like the one in England, the important difference being that French writers and painters, including especially the dissidents, reacted more swiftly, more intensely, and finally more seriously than did their British counterparts. By 1861 the Goncourt brothers, advancing not illogically from their enthusiasm for the French eighteenth century, were buying Japanese prints in a shop called La Porte Chinoise, situated near the Bibliothèque Nationale. Baudelaire, in a letter written in December of that year, remarks that since "long ago" he has owned "a bundle of *japonaiseries,*" including some "not bad" prints. A few months later a couple named Desoye opened a shop called La Porte Japonaise, situated under the arcades of the Rue de Rivoli at No. 220, and then *le japonisme* did indeed spread like wildfire. Among the early customers of the Desoyes were Bracquemond, Baudelaire, the Goncourts, the museum director Frédéric Villot, the art historian Philippe Burty, Fantin, and Whistler; and they were soon followed by Manet, Degas, Monet, James Tissot, Carolus-Duran, Alfred Stevens, Champfleury, Zola, and the critic Zacharie Astruc. Competition between customers was often fierce; Stevens remembered a dinner that nearly turned into a boxing match because Whistler appeared carrying a fan which Mme. Desoye had supposedly set aside for Astruc—at the peak of the argument the latter, who was more Romantic in his prose than in his taste for painting, roared that

he was ready to "uproot the whole Forest of Fontainebleau and throw it at your head," to which Whistler replied: "Me, I'm going to give you a good punch in the eye."

Japanese art appeared in Paris at exactly the right historical moment; it provided fresh, exotic subject matter, it answered a felt need for a new aesthetic, and in its less noble, bric-a-brac forms it satisfied a Second Empire yearning for decorative kitsch. But it might not have had its impact without the help of the evidently extraordinary Mme. Desoye. (M. Desoye is seldom heard of; he must have frequently been away on buying trips, or in the back of the store repairing bibelots.) She was an immense, loud, bejeweled, goodhearted Jewish woman with a remarkably white skin, a genius for selling, and a shrewd willingness to let her shop become a meeting place for idle, talkative artists who might not at the time be in the market for anything at all. She had reportedly lived for a while in Japan, astonishing the natives with her complexion. Another story was that she had distributed quinine to malaria victims in the Far East and had passed as the Virgin Mary among the local Christians. Whistler, in the numerous orders he sent from London via Fantin, refers to her as *la japonaise*. When Rossetti appeared, at the end of 1864, she promptly sold him four Japanese books and delighted him "with a great deal of laughing about Whistler's consternation at my collection of china." Edmond de Goncourt speaks of spending hours examining the treasures at 220 Rue de Rivoli, "in the midst of the chatter, the laughter, the wild guffaws of the droll, ribald creature, circling around you, rubbing up against your chest, and questioning you with a jostling of her potbelly." Some of the customers, he adds, were almost as much in love with the merchant as with her merchandise.

Whistler may have have been slightly influenced by Japanese prints in some of his early Chelsea river scenes. The first, however, of his definitely Orientalizing works was *Rose and Silver: La Princesse du Pays de la Porcelaine*, which was begun in 1863 and finished sometime during the next year, after an interruption due to the illness of

the model. The picture is a variation on the staring-woman motif, a fancy-dress remake of *The White Girl*, done with the help of a costume and a screen that probably came from 220 Rue de Rivoli. Although the long curve of the young woman's body and robe implies an acquaintance with the Japanese artist Utamaro, it could also have been suggested by the sway of a figure on a blue and white pot, for the robe is Chinese and the "land of porcelain" referred to in the title is of course China. Whistler, who at this date was rather stuffed with undigested influences, may even have been half remembering a similar sway in certain Pre-Raphaelite work: put the "princess" in a proper medieval dress and setting and she could be Queen Guinevere. In real life she was Christine Spartali, a daughter of the Greek consul in London and a member of the Ionides set. She and her sister Marie, who had the same full red lips and mass of black hair, were favorites from Tulse Hill to Lindsey Row and Cheyne Walk; Swinburne, seeing them at a garden party, pronounced them "so beautiful I feel I could sit down and cry."

The next Orientalizing work, under way by early 1864, was *Purple and Rose: The Lange Lijzen of the Six Marks*. The title refers to the Delft term for the elongated figures, the "long Lizzies," found on blue and white porcelain and to the potter's marks; the picture is another fancy-dress number in which a young Western woman, who may be Jo slightly transformed, is wearing Oriental clothes and painting a Chinese vase—all of which suggests that in 1864 Whistler, in spite of his enthusiasm as a collector, did not have the foggiest notion of how Chinese porcelain was manufactured. In much the same vein as *The Lange Lijzen* is another picture dated 1864, *Caprice in Purple and Gold No. 2: The Golden Screen;* here a Nipponized Jo, in a décor that includes a large Japanese screen and a folding chair that may be Chinese or Korean, is examining some Hiroshige prints. Both these paintings, the Oriental costumes and props aside, are thoroughly Victorian in conception and execution. Although charming enough as patterns of bright color, their chief interest springs from the vivid documenta-

tion they provide on what was being accumulated in the house Mrs. Whistler referred to as "this artistic abode."

Another letter of Anna Mathilda's from 7 Lindsey Row, dated February 10, 1864, reports: "During a sharp frost of a few days, I think for two days, ice was passing as we looked out upon the Thames. He could not resist painting, while I was shivering at the open window, two sketches which all say are most effective; one takes in the bridge. Of course, they are not finished; he could not leave his Oriental pictures." One of the sketches was undoubtedly *Chelsea in Ice;* one of the other pictures, which the letter refers to as "a group in Oriental costume on a balcony, a tea equipage of old China," was the beginning of *Variations in Flesh Color and Green: The Balcony*, which was completed some three or four years later. Of all the oddly eclectic works which Whistler undertook during this period of assimilation of the art of the Far East, *The Balcony* is easily the most odd and the most eclectic—and the most impressive as a piece of painting. The background is the same wintry Thames and Battersea industrial skyline that appear in *Chelsea in Ice;* the foreground is occupied by a flower-decked balcony (a studio construction, there being no real balcony on the house), on which four Anglo-Japanese maidens have gathered to drink tea, listen to the music of the three-stringed samisen, or simply look at the river. The background is an embryonic Whistler nocturne; the foreground is largely a borrowing from Kiyonaga's *Twelve Months in the South,* a series devoted to scenes in the Shinagawa brothels of eighteenth-century Edo. Particularly evident is the debt to the print called *The Fourth Month* (or, because of the view of the beach and the bay, *Gathering Shellfish at Low Tide*). Here, for the first time, Whistler seems to be grasping something of the Japanese way of making the structure of a picture stand out from the details; he even employs the trick of the foreground screen that calls attention to verticals and horizontals.

Late in 1864 he sent his mother to Torquay for her health and brought Jo back to live at 7 Lindsey Row. Partly as a result of

these events, and partly perhaps because he had begun to have misgivings about his hybrid Western-Eastern experiments, he painted what has deservedly become one of his most popular pictures, *Symphony in White No. 2: The Little White Girl*. Here the Oriental accessories are reduced to a Japanese fan, a Chinese blue and white vase, and sprays of flowers; Jo has discarded kimonos for her familiar white dress, and stands in front of the thoroughly Occidental fireplace and mirror of a Chelsea living room. The undone copper tresses and the gown, which can be imagined as bridal, still carry some of the erotic overtones that had helped to make the first *White Girl* a sensation in Paris, and the mirrored face has the expression of the mirrored Velázquez Venus seen at Manchester in 1857. But this time Jo is not merely a "stunner," and certainly not a goddess of love; she is a very human and slightly sad domestic companion, painted with husbandly tenderness. Swinburne was inspired by the painting to compose his poem *Before the Mirror*, and Whistler was so pleased with this tribute he had stanzas four to six printed on gold paper and pasted to the frame:

> Come snow, come wind or thunder
> High up in air,
> I watch my face, and wonder
> At my bright hair;
> Nought else exalts or grieves
> The rose at heart, that heaves
> With love of her own leaves and lips that pair.
>
> She knows not love that kissed her
> She knows not where.
> Art thou the ghost, my sister,
> White sister there,
> Am I the ghost, who knows?
> My hand, a fallen rose,
> Lies snow-white on white snow, and takes no care.
>
> I cannot see what pleasures
> Or what pains were;
> What pale new loves and treasures
> New years will bear;

What beam will fall, what shower,
What grief or joy for dower;
But one thing knows the flower—the flower is fair.

The fact that the lines tell the reader more about Swinburne than about *The Little White Girl* seems not to have been noticed.

The Valparaiso Crisis
1865-1871

The year 1865, on the surface at least, was a pleasant one for Whistler. He continued his relationship with Jo. He danced and watched the fireworks at Cremorne Gardens; he explored his beloved Thames with the Greaves brothers and did his best to indoctrinate them with the principles of true Whistlerian art. (Walter Greaves once summarized the difficulties in the latter operation: "To Mr. Whistler a boat was always a tone, to us it was always a boat.") Early in the spring he went to Paris again, where he posed in a Chinese robe for another group portrait by Fantin, entitled *Le Toast*, or *Hommage à la Verité*. Fantin later destroyed the picture, but he exhibited it at the Salon of 1865 and thus announced that his American friend was still to be considered one of the Paris dissidents. Among the other figures portrayed were Bracquemond, Manet, Duranty, Astruc, and a naked woman representing Truth.

The round of parties at 16 Cheyne Walk went on, and now they were often enlivened by the presence of Charles Augustus Howell, a man of extremely uncertain profession who had been abroad for several years, presumably in Portugal. A Rossetti limerick begins:

> There's a Portuguese person named Howell
> Who lays on his lies with a trowel . . .

Actually, the "person" was at most only half Portuguese, but he

does seem to have been a brilliant and prolific liar, and in general the sort of half-cultivated, half-honest, fast-talking operator often found in the border zone where art turns into business. He had the battered look of an unsuccessful prizefighter—"the face of a whipped cab-horse," in the opinion of Rossetti's friend Hall Caine —and at the same time the born swindler's gift for inspiring confidence. He lived in a big house upstream in Fulham, usually surrounded by women whose exact relationship to him was not clear. He knew a good deal about paintings, etchings, rare furniture, and Chinese blue and white pots, and even more about how to make a living as a go-between for writers, painters, collectors, and dealers. Although in 1865 he was only twenty-five, he was already a secretary and financial handyman for Ruskin, and by the next year he was an agent for both Swinburne and Rossetti. Swinburne finally referred to him as "the pole-cat Howell." Rossetti relished in him an entertaining, swashbuckling Munchausen, a human addition to the Cheyne Walk zoo. Whistler found him a fascinating combination of villainy and charm: "He was the real hero of the picaresque novel, forced by modern conditions into other adventures and along other roads. He had the instinct for beautiful things. He knew them and made himself indispensable by knowing them. . . . He introduced everybody to everybody, he entangled everybody with everybody, and it was easier to get involved with Howell than to get rid of him."

At the end of the summer Anna Mathilda went to Coblenz, West Germany, to consult an eye specialist; Whistler accompanied her and took the occasion to make a pilgrimage down the Rhine valley to the hotel in Cologne where he had temporarily left his knapsack and etching plates seven years before. Then, gathering up Jo in Chelsea, he embarked on a lengthy painting expedition to Trouville, which during the Second Empire was one of the most fashionable of the French Channel beach resorts and a favored source of avant-garde pictorial subjects. Courbet, the young Monet, the veteran sky expert Boudin, and the even more veteran water expert Daubigny were already on hand, and soon a small artists' colony was functioning merrily and productively, with sea-

food delicacies, music at the casino, dips in the icy ocean of October, and some serious concern, according to Courbet, with the problems posed by horizons and empty maritime space. Whistler turned out notably three fluid, atmospheric seascapes: *Crepuscule in Opal: Trouville, Grey and Green: The Silver Sea*, and *Harmony in Blue and Silver: Trouville*. All three reveal the influence of Courbet, and the third named is a direct tribute to him: it shows him standing on the beach and copies the disposition of his own earlier *Edge of the Sea at Palavas*.

The reaction to the tribute may not have been entirely what was expected by its author, for although Courbet in his letters from Trouville grants that "my pupil" has talent he also remarks in passing that "little Whistler . . . always makes the sky too low, or the horizon too high." Moreover, there is plain evidence that at the moment the Realist leader, although now forty-six and getting more barrellike every year, was far more interested in Jo than in seascapists, talented or not; in fact, he was developing for her a lasting, touching, and possibly not altogether innocent case of middle-aged romantic sentiment. She posed for him several times. In the portrait often referred to as *La Belle Irlandaise*, or simply as *Jo*, he painted her with her undone copper hair nearly filling the canvas, and after leaving Trouville he did three other versions of the picture. In 1877, an exile and a drunkard after having been imprisoned and financially ruined for his part in the Paris Commune, he sent Whistler a painful, begging letter that evoked those happy autumn weeks on the Normandy coast: ". . . remember Trouville and Jo, who played the clown to cheer you up and who in the evening sang Irish songs so well. She had artistic distinction and spirit . . . I still have her portrait, which I'll never sell . . ." He apparently kept his promise in spite of his money worries: on the day of his death, a few months later, what was almost certainly a version of *La Belle Irlandaise* was seen hanging in his studio.

As late as November 11, 1865, Whistler and Courbet, if the latter's epistolary boasts are to be believed, were still plunging into the

icy ocean at Trouville; the weather must have been miraculously
good, and they must have been the last beach athletes of the sea-
son. Whistler and Jo did not get back to Chelsea until late that
month. Did he still need her clowning to cheer him up? Perhaps he
did, for within a few weeks he was getting himself into the mood
for one of the strangest episodes of his career, an episode that
would occupy most of 1866.

The historical circumstances can be found, in solemn detail,
in the *Times*, of which he was a reader. By January, 1866, the
paper was carrying frequent columns of news and comment about
the worsening situation in South America, where Spain was bicker-
ing with her former colonies over matters of protocol that reflected
a continuing struggle between old imperialism and new nationalism.
The Spanish Admiral Pareja had demanded that Chile humbly
apologize for allegedly hostile acts and pay homage to the Spanish
flag by firing a twenty-one-gun salute. Chile had refused. Pareja
had retaliated by announcing a naval blockade of Chile. The Chil-
ean government had then declared war, although without doing
any actual fighting. By February Pareja was becoming more men-
acing, and Bolivia, Peru, and Ecuador had joined in the declaration
of war against Spain. That Whistler, an American living in Europe,
should have followed these events with interest is understandable;
the Monroe Doctrine was involved, and Spain was not regarded by
the United States as a very friendly nation. Also, the unnamed
Chilean student who had looked after letters in Paris during the
Rhineland tour of 1858 may have created some sympathy for the
South American cause.

What Whistler did about the events, however, went beyond
any usual expression of interest and sympathy. In February he too,
in appearance at least, joined in the declaration of war against
Spain. After revising his will and entrusting his mother to the care
of the Greaves family he took a steamer from Southampton to
Panama, crossed the Isthmus, and proceeded to Chile. He went to
Santiago, presumably to talk to government officials, and then
established himself in Valparaiso, living for a while in a club or-
ganized by English residents of the city. He was there on March

24, when the Spanish fleet, following the rejection by Chile of another Pareja ultimatum, shelled the port, killed a few people, and inflicted considerable damage on houses and dock facilities. In spite of this taste of real war he appears to have remained in Valparaiso for several months; at any rate he did not turn up again in London until November.

He told stories about the trip for the rest of his life, and many of the stories can be accepted as approximately true, with allowances for Whistlerian jokes and irony. But he never got around to clearing up the central mystery in the episode: namely, the exact nature of the emotional stresses that suddenly and absurdly led him to abandon a beautiful mistress, a loving mother, stimulating friends, reliable patrons, and a London career and take off for South America as if he were a child running away with the gypsies. He could not have been all that interested in the Monroe Doctrine, nor all that partial to Chile. Nor could he have gone merely for the pleasure of the voyage, as he once pretended. Nor could he have had in mind a painting expedition; going to Valparaiso was not like going to Biarritz or Trouville. What, then, were his real motives? What was he running away from? He himself may not have known the answers to these questions, or may not have wanted to know them, and so guessing at them from the outside more than a century afterward may be presumptuous in a couple of senses. There are good reasons, however, for asserting that the Valparaiso crisis was merely the most striking manifestation of a complex, many-stranded crisis that had been building up for some time in his life and work and would continue until the end of the 1860s. The strands in this general crisis were of course interwoven; as experienced by their troubled victim they must have often constituted a single, aching conviction that something had gone wrong. But they can be presented separately, each with its own chronology, as a convenience for discussion.

The strand that became the immediate, although not the only, reason for the Valparaiso trip concerned, naturally, the Southern cav-

alier. One might suppose that Whistler had found playing the role rather awkward during the last years of the American Civil War, when he was practicing the waterman's jerk in peaceful Chelsea and so many real Southern cavaliers were dying gallantly for their lost cause. Actually, he seems to have gone on much as before, and even to have received, on two occasions, encouragement from what he considered the other world. The Victorian mania for table-turning and séances with mediums was at its height during the 1860s, and he had become—and would remain all his life—a firm, serious believer in the possibility of communicating with spirits. He and Jo had had an apparently convincing experience by putting their hands on a table at Rossetti's house, and after that they had worked on the technique at 7 Lindsey Row. "One day," he told his friends the Pennells, "I and the White Girl went into her room and just the two alone tried the same experiment, and a cousin from the South talked to me and told me the most wonderful things. Again by holding a lacquer box, a beautiful Japanese box, one of the many wonderful things in the Chelsea house, between us, we had the same sort of manifestation."

The play-acting, however, must have become decidedly awkward after April, 1865. His younger brother, now Dr. William Whistler, had arrived from Richmond with dispatches for the British government and, caught by the fall of the Confederacy, had decided to remain in London. (He eventually established himself as a successful doctor in Wimpole Street, and married Helen Ionides, a cousin of Luke and Alecco.) Willie was no more a Southern cavalier than Jimmy was, but he was an authentic war veteran who had distinguished himself both as a surgeon for the Confederate Army and as a brave soldier attached to Orr's Rifles, a famous South Carolina regiment. Moreover, he was not the only Southern veteran to turn up in England, for British sympathy for the Confederate States had been well known. And each veteran made the difference between fantasy and reality a little more evident.

There cannot be much doubt, then, that in the Valparaiso adventure Whistler was moved partly by the seeming chance, combined with a growing emotional need, to prove himself in action,

to justify his windy talk and his posturing with some Southern-cavalier deeds. He himself made the situation quite clear in one of his later accounts of the trip: "It was a moment when many of the adventurers the war had made of many Southerners were knocking about London hunting for something to do, and, I hardly knew how, but the something resolved itself into an expedition to go and help the Chileans and, I cannot say why, the Peruvians, too. Anyhow, there were South Americans to be helped against the Spaniards. Some of these people came to me, as a West Point man, and asked me to join—and it was all done in an afternoon."

Unfortunately, however, for the welfare of his ego, he did not conduct himself very heroically during the shelling of Valparaiso, the only action he saw, and the fact that he was able to joke about his behavior did not change things: "The people all got out of the way, and I and the officials rode to the opposite hills, where we could look on. The Spaniards . . . sent a shell whizzing over toward our hills. And then I knew what a panic was. I and the officials turned and rode as hard as we could, anyhow, anywhere. The riding was splendid, and I, as a West Point man, was head of the procession. By noon the performance was over . . . and I and the officials rode back into Valparaiso. All the little girls of the town had turned out, waiting for us, and as we rode in called us cowards."

Another strand in the general crisis concerned aggressiveness. The period around and during the Valparaiso journey was marked by a series of ugly quarrels and by fits of meanness that contrasted sharply with displays of irresistibly winning behavior. It was during these years that Whistler began his lifelong process of losing friends. And at one point he even took boxing lessons from a London professional pugilist.

As early as February, 1864, du Maurier, in a letter to Armstrong, had noticed a change: "As for Jim . . . I met him lately and he certainly wasn't very nice to me, and seemed to have grown spiteful and cynical et pas amusant du tout." At the end of 1864 there had been a break with Legros, who had prospered and had

married a fifteen-year-old English girl—all of which the apparently resentful Whistler had chosen to regard as screamingly funny. Kicky's correspondence is again the source: "Legros . . . called here the other day, and talked bitterly of Jimmy, whom he says he can never see again. There has been some money quarrel between them and according to Legros Jimmy's conduct has been most shabby. . . . But he was especially bitter about Jimmy's conduct à propos of his (Legros') marriage, for it appears Master Jim chaffed him on all occasions in a very disagreeable manner . . ."

Aboard ship on the way back from South America Whistler found an opportunity, in the person of an inoffensive little Negro whom he called "the Marquis de Marmalade," to correct the weak impression made during the Spanish shelling of Valparaiso, avenge the defeat of the Confederate States, and demonstrate the superiority of the white man. This time the Southern cavalier is himself the source: "[There was] a nigger from Haiti who made himself—well, obnoxious to me, by nothing in particular except his swagger and his color. And one day I kicked him across the deck to the top of the companion way and there sat a lady who proved an obstacle for a moment. But I just picked up the Marquis de Marmalade, dropped him down the steps below her, and finished kicking him down stairs." One result was that the aggressor was confined to his cabin for the rest of the voyage, and another was that when he got off the train at Waterloo Station in London he found somebody, possibly a friend of "the Marquis," waiting for him: there was another round of violence, the outcome of which is obscure. Such exploits, duly recounted at 16 Cheyne Walk, led Rossetti to compose another limerick:

> There's a combative artist named Whistler,
> Who is, like his own hog's-hair, a bristler;
> A tube of white lead
> And a punch on the head
> Offer varied attractions to Whistler.

Rossetti's brother, however, had the courage to remark that the attack on the Negro had been "scandalous."

The return to Europe did not calm the aggressiveness. Early

in April, 1867, in the London office of Luke Ionides, Legros and Whistler ended forever the little that was left of their once warm friendship: they quarreled about a copying commission Whistler had obtained for Fantin, Ionides heard Legros say "You lie," and in the ensuing fight Whistler, after having some of his hair pulled out, finally floored Legros with a hard blow in the face. Whistler went to Paris a few days later and promptly continued his career as a pugilist. First he punched a workman for accidentally dropping some plaster on him in a narrow street in the Latin Quarter; the American minister to France had to be called to smooth out the affair with a French magistrate. Then, also in a Paris street, the once warm friendship with Seymour Haden ended forever in a vague dispute that turned into an undignified brawl, which Whistler won by knocking his brother-in-law through a plate-glass window. This time *le petit américain*, who had the bad luck to be hauled before the same judge who had handled the plaster-dropping case, was fined as a recognized, chronic disturber of the peace. When he got back to London he was punished again by being expelled from the Burlington Fine Arts Club, of which both he and Haden had long been members.

The change that was under way in the personality of the formerly charming animator of the *Société des Trois* was noticed even by Fantin, although in this instance there was not a definite break in friendship. In July, 1866, during the long mail blackout that had accompanied the Valparaiso adventure, Fantin had written to Edwin Edwards: "It would give me great pleasure to see him again, and I can say right now that his silence has grieved me a great deal. For to me Whistler is like a wife, like a mistress whom one loves in spite of all the troubles she gives you. . . . He is, after all, seductive . . ." Six months later another letter to Sunbury-on-Thames adopted a quite different tone: "I have found Whistler very American, very amiable, but as for me, I have not been too amiable. I have a feeling that our happy days are over. . . . He believes too much in money, in the cut of a coat, in making a stir, and not enough in quality, which is the only way to success."

The sudden decision to play the Southern-cavalier role to the hilt, the repeated outbursts of aggressiveness, and the new cynicism noticed by Fantin all imply some sort of disappointment, disillusionment, or frustration—a secret malaise that was in contrast with the gaiety and self-assurance Whistler usually manifested in public. Could Jo have been one of the sources of the trouble? That she was a principal or an immediate source looks unlikely, if only because of her morale-building efforts at Trouville. But that she was somehow a strand and even a covictim in her lover's complex crisis is probable. Her dislike for Legros may have been one of the factors behind the final blowup in Luke Ionides's office. Her visible sweetness as *The Little White Girl*, her clowning and singing, and her irregular status as Mrs. Abbott did not keep her from indulging in the Victorian wife's tendency to henpeck; du Maurier, in the letter of 1864 that calls Whistler spiteful, reports having heard that "he stands in mortal fear of Jo, and that he is utterly miserable." Finally, while the Southern cavalier was away in Valparaiso she was engaged with Courbet in a small adventure of her own, one that suggests a woman quite different from the loyal Jo of Chelsea.

Courbet had returned from Trouville to Paris, where he was soon enjoying one of the most successful years of his career, partly because he softened the harshness of his Realism and exhibited at the Salon what he himself called "proper" pictures, "the kind they like." Among the commissions that came in was one from Khalil Bey, a wealthy, libidinous art collector, possibly Egyptian in origin, who had been the Turkish ambassador to St. Petersburg and had then retired to Paris in order to cultivate his taste for erotica. Khalil Bey was vexed because he had just missed a chance to buy a sensuous study of Venus and Psyche, and he was now in the market for something special. The result, painted in Courbet's studio above the Brasserie Andler during the summer of 1866, was *Le sommeil*, which is also referred to as *Paresse et Luxure*. The "sleep" and the "laziness and lechery" mentioned in the titles are those of two provocatively naked, entwined lesbians, exhausted after what appears, from the way their jewelry is scattered on the bed, to have

been a particularly ardent session of lovemaking; the scene evokes, without being an illustration, Baudelaire's poem, *Femmes damnées*, on the initiation of a virgin into the Sapphic passion. Courbet's treatment of buttocks, breasts, and undone hair makes the wan ambiguities of the Pre-Raphaelites look like calendar sentimentality. And not the least remarkable thing about the picture is the fact that one of the lesbians is unmistakably Jo Heffernan, alias Mrs. Abbott of Chelsea.

What Whistler thought about this otherwise undocumented escapade in Paris, if he knew about it, can only be supposed. When he returned from Valparaiso at the end of 1866 he moved to more elegant quarters at 2 Lindsey Row (now 96 Cheyne Walk), a section of the seventeenth-century Lindsey mansion near Battersea Bridge, and a letter of that date reveals that Jo was still living with him. Shortly after that, however, they broke off their love affair, without fireworks and without refusing to see each other occasionally. The last pictures in which she appears are things he was apparently working on in 1867, but which he had begun two years earlier. By 1869 he was involved with a woman named Louisa Fanny Hanson, who on June 10, 1870, bore him a son and then disappeared from history. The boy, whom the father once referred to as "an infidelity to Jo," was christened Charles James Whistler Hanson but was often called John by people who knew him. Even more oddly, he was practically adopted and mostly raised by Jo. Perhaps she felt she was thus preserving at least something of the man who had once been incapable of going anywhere in Europe without her as his companion and inspiration. Or perhaps she felt she was preserving, in however indirect a fashion, a claim to his old husbandly tenderness which he would one day acknowledge; if she did feel that, she was mistaken.

There was a painting strand interwoven with the other strands in the general crisis of which the Valparaiso trip, or flight, was the central incident, and here there is no need to seek directions by indirections: Whistler was obviously feeling frustrated about his art

between roughly 1865 and 1871, and his feeling was largely justi-
fied, in spite of the production of some interesting pictures.

He had exhibited *Wapping* and *The Lange Lijzen* at the
Royal Academy in the spring of 1864 and had attracted favorable
comment. At the academy show of 1865 his *Old Battersea Bridge*
and *The Gold Screen* were praised for their colors and tone values,
but he was referred to as only "half a great artist" and the *Athe-
naeum* was severe enough to describe the Jo of *The Little White
Girl* as one of the "most bizarre of bipeds." At the Paris Salon of
that year his *Princesse du Pays de la Porcelaine* was dismissed, not
altogether unfairly, as a study of costume. This apparently grow-
ing critical coolness was accompanied in France by a tendency to
regard him as one of several young dissidents who had got lost in
the labyrinth of contemporary painting movements. The *Gazette
des Beaux-Arts* gave him a backhanded slap in a general comment
on the followers, or former followers, of Courbet: "The enthu-
siasm is evidently dying down, the group is getting worried and
dispersed. . . . M. Fantin, having had the idea of gathering the last
friends of nature in an *Hommage à la Vérité*, has had a world of
trouble finding some Realists, and since he could not leave his can-
vas empty he has been obliged to grant a place in it to M. Whistler,
who lives in intimate communion with fantasy, and one to M.
Manet, who is the prince of chimera fabricators."

One way out of the discouraging confusion touched on by the
critic in the *Gazette*, a way that was beginning to be adopted by
the Monet circle, was to go forward into the optical naturalism
that in 1874 would be derisively labeled Impressionism. Another
way was that of Manet, who went to Spain in the summer of 1865
and rediscovered the autonomy of brushwork, color, and tonal val-
ues: "Velázquez," he wrote to Fantin, "is decidedly the painter's
painter." Whistler, with a courage that looks like desperation,
chose to experiment off and on for several years with a way that
combined *japonisme* and classicism, his manifest hope being that on
some marvelous morning he would break through into a serene,
ideal, timeless sort of art. His *japonisme* reflected his continuing in-
terest in the flowing silhouettes of Edo prostitutes, particularly

those drawn by Kiyonaga. His classicism harked back, insofar as it harked back at all, mostly to the Hellenistic era, to the Greece of minor friezes, Tanagra figurines—collected by Alexander Ionides—and the pastoral convention; it also to some extent partook of the classicizing neo-Greek mode of the mid-nineteenth century, represented in England with immense success by Leighton. Possibly Whistler was even having, very much in his own fashion, a delayed reaction to the teaching of Gleyre.

The major influence, however, came from Albert Moore, whose *Marble Seat* was one of the noticed pictures in the Royal Academy show of 1865, and who became friendly with the exhibitor of *The Little White Girl* at about the same time. Moore, a frail but attractive aesthete now usually ignored outside England, specialized in the painting of statuesque, often sleepy young women whose sweet Victorian faces contrasted pleasantly, if anachronistically, with the Grecian drapery that swathed their athletic bodies; typically he posed them on a divan before a wall so as to create a decorative frieze, and he sometimes added a bit of *japonisme* in the form of a fan or a spray of flowers. He avoided anecdotal subject matter and tried to give the impression that his pretty girls were merely pretexts for his studiously worked out designs, his flattened pictorial space, and his high-keyed color arrangements, in which pink and blue were frequent. By August, 1865, he was being nominated by Whistler, in a letter to Fantin, as a replacement in the *Société des Trois* for Legros, who was dismissed as "falling behind" and inferentially as lacking the right breeding for an artistic Derby: "It's the pure-blooded who win! I think we can be sure of that now. . . . In us the pure race reappears."

Swinburne noticed that Moore was a then rare phenomenon, an English practitioner of the French doctrine of art for art's sake. "His painting," he wrote, "is to the artists what the verse of Théophile Gautier is to the poets: the faultless and secure expression of an exclusive worship of things beautiful." From Swinburne's, Moore's, and Gautier's notion of art for art's sake it was easy to move on to the neighboring notion of resemblances between arts, and Whistler did so; by 1867 he was using musical terminology for

his current work and beginning to retitle earlier pictures on the basis of musical analogies. He could scarcely have been unaware of the possible objections. He was opening himself to the charge of bluffing and posing once again, for he was not a musician and not a particularly serious listener to music; he liked popular songs, hurdy-gurdy tunes, band concerts, Meyerbeer's operas, and especially the sprightly numbers of Offenbach, to which he responded with insistent foot-trotting and sometimes a final little cancan kick. He was also opening himself to the charge of cliché-peddling, for Baudelaire, drawing on Swedenborg and E. T. A. Hoffmann, had developed a widely known theory of "correspondences," Murger had had a Bohemian character compose a *Symphony on the Influence of Blue in the Arts*, Gautier had written a poem entitled *Symphony in White Major*, the critic Paul Mantz had called *The White Girl* a white symphony and even Ruskin, in a nonmoralizing mood, had once referred to color as "visible music." And finally, of course, the whole analogy, cliché or not, could not be pressed very far without stirring up a swarm of absurdities; it was, after all, at least in its nineteenth-century form, just a synesthetic metaphor. Against these objections, however, there had to be weighed, in the situation in which Whistler found himself during these years of the Valparaiso crisis, several advantages: the metaphor offered him a highfalutin explanation for his already demonstrated decision to abandon what he had left of Courbet's Realism, it offered a convenient approach to and a language for the problem of abstract color arrangements, and it provided him with a challenging, publicity-getting way of announcing to the complacent British that subject matter was by no means the most important thing in a picture.

His letters to Fantin during 1864 and 1865 reveal that he was frequently unhappy about the direction his work was taking. On one occasion he writes: "There are times when I think I've learned something, and then I am strongly discouraged." On another occasion: "I've just had a bad day. How unhappy one is after doing badly! When will I have more knowledge?" On another: "I'd like to talk to you about me and my painting, but at the moment I'm

too discouraged. It's always the same thing, always work that's so painful and uncertain! I am so slow. . . . I produce very little, because I rub everything out." In August, 1865, however, in the same letter that nominates Moore for the *Société des Trois*, there is a new note of cheerfulness: "I'd like to show you my latest things, for I have really made enormous progress. At last I think I am reaching the goal I have proposed for myself. . . . Also, day by day everything becomes simpler, and now I am concerned especially with composition." The reason for the optimism, made clear by an accompanying sketch, was a painting very much in the Moore manner, showing Jo and another woman wearing white dresses and posing rather awkwardly on and below a sofa. Work on it was interrupted by the Trouville and Valparaiso trips and not completed until early in 1867. When the picture was exhibited at the Royal Academy that spring it bore the first of Whistler's musical titles, *Symphony in White No. 3*, and provoked from Hamerton, the critic who had laughed at *The White Girl* in Paris in 1863, the solemn comment that some dashes of color made it "not precisely a symphony in white." To this Whistler replied, in a letter which was not published until twenty years later but which he preserved for his own delectation: "*Bon Dieu!* did this wise-person expect white hair and chalked faces? And does he then, in his astounding consequence, believe that a symphony in F contains no other note, but shall be a continued repetition of F F F? . . . Fool!"

During the nine months of the South American expedition he managed to produce, or begin, four seascapes that survived the voyage; after some changes in titles they became *Nocturne: The Solent, Symphony in Grey and Green: The Ocean, Crepuscule in Flesh Color and Green: Valparaiso*, and *Nocturne in Blue and Gold: Valparaiso*. In these works he can be seen advancing toward the poetic vision of water and night he would make peculiarly his own. But after his return to London he resumed, still under the influence of *japonisme*, classicism, Moore, art for art's sake, and musical analogies, his attempt to break through into an ideal art; and soon he was bogging down in hopelessly ambitious projects for large figure compositions and decorative panels. He was further

dismayed by unfavorable criticism in Paris, where in the spring of 1867 he showed a selection of his earlier work at the Salon and in the American section of the International Exhibition of that year. The *Gazette des Beaux-Arts* went so far as to dislike even his etchings, which he was in the habit of seeing singled out for praise by the most savage denouncers of his paintings. One of the magazine's critics also visited the Royal Academy show, and described *Symphony in White No. 3* as something that could scarcely get by as a prelude.

In September, 1867, in a long letter to Fantin, all the pent-up discouragement exploded into a tirade of accusations, disavowals, regret, pride, and self-doubt:

"Ah, my dear Fantin, what an education I have given myself! Or rather, what a terrible lack of education I feel in myself! With the fine qualities I was born with, what a painter I would now be if, vain and content with these qualities, I had not scorned everything else. . . . No, you see, the time when I arrived [in Paris] was very bad for me. Courbet and his influence were disgusting. The regret, the rage, and even the hatred I now feel for all that will perhaps astonish you. But here's the explanation. It's not poor Courbet that I find repugnant, nor his works. I recognize, as always, their qualities. I'm not complaining either about the influence of his painting on me. There hasn't been any, you won't find any in my pictures. It couldn't have been otherwise, for I have a very personal manner and I was rich in qualities which were enough for me and which he did not have. But here's why all that was pernicious for me. It's that this damned Realism appealed *immediately* to my painter's vanity and, making fun of all the traditions, yelled loudly with the assurance of ignorance: 'Long live Nature!' Nature, my dear fellow. That yell was a great misfortune for me. Where could one have found a disciple more ready to accept a theory that was so convenient for him, and so calming for every worry? Why, he had only to open his eyes and paint what was in front of him, lovely Nature and all the rest of the paraphernalia. That's all there was to it! Well, that remained to be seen. And one saw *At the Piano, The White Girl*, the Thames series, the seascapes—in sum, pictures produced by a naughty

child all puffed up over being able to show to other painters
some splendid gifts, some qualities that needed only a strict
education to turn their possessor into a master instead of
what he is at the moment: a corrupted schoolboy. Ah, my
friend, our little group was a very vicious society. Oh, if only
I had been a pupil of Ingres. I don't say that at all with the
intention of rhapsodizing about his pictures. I like them only
so so. I think that several of his works, which we have seen
together, are in a thoroughly questionable style, not at all
Greek, as people like to say, but very incorrectly French. I
feel that one can go much further, that there are much more
beautiful things to be done. But, I repeat, if only I had been
his pupil . . ."

Page after page the tirade rolled on, becoming more and more
insistent on the need to return to a classicizing style, to a style
based on drawing. The painter who had once posed proudly in a
homage to Delacroix now spoke of color as merely a wife who had
to be "firmly guided" by her lord and master, drawing, and who
in the absence of such guidance quickly became "a jaunty whore"
responsible for "a chaos of drunkenness, trickery, regrets, and in-
completeness." The idle apprentice of Gleyre's atelier now referred
to himself, in a hopeful if melancholy conclusion to his discourse,
as having become a model of academic industriousness with a pro-
gram of "enormous work" designed to give him "that education"
he had neglected: "I'm sure I'm going to make up for badly used
time. But how painful it all is!"

Fortunately, for the moment he had some money (evidently
from relatives, his inheritance, and advances on commissions, since
he was earning very little); one of his letters of 1867 mentions "my
two French servants." His mother having gone to the United States
to visit her family, he decided in November to pursue his new edu-
cation in Paris for a while. "I have a great deal of very hard work
to do," he wrote from 2 Lindsey Row to his friend George Lucas,
"and must be more quiet than I can be here. Also care but little to
meet the old café set just now, as I have no time for talk." The un-
expected return of Mrs. Whistler in December upset his plans for

France, but he did succeed, apparently during 1868, in getting away from Lindsey Row for seven months, which he spent living with the architect Frederick Jameson, who had an apartment and servants at 62 Great Russell Street, in the middle of a Bloomsbury which, although no longer fashionable, was respectable and tranquilizing—the exact opposite of randy, exciting Chelsea. Jameson remembered these months as an "unproductive" period during which Whistler was struggling with some "Japanese" pictures: "I have seen large portions . . . apparently finished, but they never satisfied him, and were shaved down to the bed-rock mercilessly. . . . His talk about his own work revealed a very different man to me from the self-satisfied man he is usually believed to have been. He knew his powers, of course, but he was painfully aware of his defects—in drawing, for instance." After one particularly discouraging session with *japonisme* and classicism the two men left the studio and roamed disconsolately through London until, before a Velázquez in the National Gallery, Whistler suddenly found the courage to go back and try again.

The "Japanese" pictures were probably part of the series of oil sketches called the *Six Projects*, one of which was enlarged into the version called *Three Figures: Pink and Grey;* they are frieze-like arrangements of Greco-Oriental female figures remarkable chiefly for fluid, rhythmic brushwork and decorative pinks, blues, and greens. A related, although more static, study is *Harmony in Flesh Color and Red*, or *Symphony in Red*, in which the women wear European dresses. At about the same time work, or painful thinking, was under way on a Fantin-like group portrait, projected as early as 1865 and entitled *The Artist's Studio;* two sketches, in which Jo makes her farewell appearance as a model, have survived. To around 1868 can also be dated an insipid study of a nude, *Venus Rising From the Sea;* here it can be safely said that there is no evidence of Courbet's influence, although there may be some of Anna Mathilda's. These efforts in oil were accompanied by a large number of pastel, chalk, and pen and ink drawings, which show how seriously the doctrine, if not at all the style, of Ingres was

being followed. All the efforts, however, added up to a disappoint-
ment; the marvelous morning of the breakthrough into an ideal,
timeless sort of art never dawned, and the projects remained pro-
jects. Between early 1867 and late 1870 the new, reformed Whist-
ler, working harder than he had ever worked in his life, did not
produce a single finished painting.

Precarious Balance
1871–1876

The 1870s were an unhappy time for many people on both sides of the English Channel. Frenchmen were afflicted with the Franco-Prussian War, the fall of the Second Empire, the massacre of the Communards, and then the struggle to recover from these disasters. Englishmen were beset, less dramatically and less severely, by the Irish question, urbanization, strikes, and the first symptoms, after about 1873, of what came to be known as the great Victorian depression. There was unhappiness of a more personal kind among Whistler's acquaintances. The war trapped Fantin and Manet in a Paris that had no leisure for art, and exiled Monet and Daubigny to London for a while. Participation in the Commune destroyed Courbet. Chloral and whisky began to destroy Rossetti. A fierce critical attack further demoralized Rossetti and nailed Swinburne as "this Dandy of the brothel, this Brummel of the stews." Yet, with only a little of the distortion common in cultural history, these years can be made to look like an era of liberation and modernization, one that in many sectors seemed to herald the triumph of sophistication over Mrs. Grundy, of wit over sententiousness, of form over content, and of art over pseudo-art. Philistines were still powerful, of course, and still cocksure. But during the decade the Impressionists managed to stage their first group show. Mallarmé

published *L'Après-midi d'un faune*, with illustrations by his friend Manet. In England Walter Pater, the critic and novelist, was telling young men that ecstasy was success in life and arguing, with a Legros etching as an example, that all art aspired toward the condition of music. The Aesthetic Movement was beginning to affect interior decoration and architecture. Gilbert and Sullivan began their series of hits. Wealthy, cultivated men and women were creating "art houses," spending money more freely, dressing less conventionally, talking more amusingly, dining out more often, and worrying less about the salvation of their souls.

Whistler benefited from this shift in the *Zeitgeist*. In practice if not in his wounded inner self he drew from his period of frustration and attempted reeducation the only conclusion possible, which was that he lacked the draftsmanship, the compositional skill, the inventiveness, and the peculiar, complacent ordinariness required to compete with academic painters of mammoth neo-Greek "machines" for exhibitions. Judged by widely accepted nineteenth-century criteria for pictorial size and complexity, his work was the product of an incurably "minor" talent. Judged by official juries, he himself was a troublemaking outsider, and there was no use pretending otherwise. Instructed by his bad reception in 1867, he did not send another picture to the Paris Salon until 1882. After 1872 he stopped sending pictures to the Royal Academy show for the rest of his life. At the beginning of the 1870s he withdrew into his own sensibility and turned toward the newly rich art-conscious British public, which was about the only public he had ever had anyway. He abandoned his big, unrealizable projects and his classicism, although he retained from the latter a liking for economy of means. He also abandoned the more obvious sorts of *japonisme*, retaining an occasional motif, a certain Oriental flavor, some structural principles, a continuing enthusiasm for Japanese decoration, and again a liking for economy of means. He kept his musical analogy and, as a second weapon against British anecdotal painting, his commitment to a personal variety of art for art's sake. Although he was still opposed to Courbet's Realism and still not at all interested in the naturalism and flickering brushwork of the

French Impressionists, he took another look at the great Spanish and Dutch masters, tacitly reconsidered his belittling remarks about *At the Piano*, and renewed his love affair with the Thames in a fashion which many of his contemporaries, because of the absence of details and sharply defined forms, regarded as "impressionistic." The result of this elaborate set of eliminations and recuperations was that he emerged at last from the long crisis of which the Valparaiso trip had been the most prominent sign.

He emerged brilliantly with his most famous picture, *Arrangement in Grey and Black No. 1: The Artist's Mother*, and during the next few years produced the series of portraits and landscapes on which his reputation as a painter mainly rests. He also cultivated his relations with party-giving patrons, dined out regularly, played the eccentric dandy, and entertained stylish people in his own art house at 2 Lindsey Row. Although he never succeeded in getting into the exclusive circles which Londoners referred to as "society," he joined several clubs and met some titled personages. In brief, this was in many respects the most satisfactory period of his career. For an extended instant, with the poise of a Cremorne Gardens ropedancer, he kept his balance on the dangerously narrow aesthetic path that was left after his successive eliminations of other paths. Although he frequently relapsed into his recent inability to finish a picture, he managed some of the time to reconcile production requirements with his perfectionism, his fits of discouragement, or whatever else might paralyze him. Keeping a remnant of the humility he had suddenly displayed in the depths of his despair in 1867, he checked temporarily his egotism and his tendency to overween, his hubris, his reliance on what the cautious Fantin had once defined as "insolent luck." Somehow he even managed, with the help of loans, advances, and a mounting pile of unpaid bills, to maintain a fictive balance between his income as an artist and his expenses as an increasingly public figure.

Since his portrait of his mother was the first important result of his emergence from his crisis, one can suppose that working on it was

in some way salutary for him. Exactly how and when the salutariness began are not, however, very clear. The picture was painted on the back of a canvas, on the face of which was a portrait of a child; such a procedure, besides yielding an oddly ribbed surface that is still visible, strongly suggests an unplanned action, an impulse. The date of the impulse must have been sometime later than November, 1866, after the return from Valparaiso and the move into 2 Lindsey Row, for the picture shows a room at the new address that was used in portraits executed in the 1870s. Another clue is provided by an undated letter to Fantin which from internal evidence appears to have been written early in 1867; here Whistler remarks in passing: "I'll have the portrait of my mother photographed and will send you a print. Also I am thinking of perhaps sending the canvas to Paris for the next Salon." The time span involved might support a neat and psychologically plausible theory in which the crestfallen cavalier, troubled artist, and unsuccessful lover comes back from his South American evasion, finds immediate solace with his sweetheart-mother, regresses a bit toward his adolescence, gratefully paints her portrait, and then gets rid of Jo, the other woman. That he did indeed find solace with his mother is probable; her correspondence for these early years in Chelsea reveals that she took a lively interest in his work, tried hard, in her words, "to render his home as his father's was," and also attempted to re-create for him the happy security of the times they had spent alone together in St. Petersburg—"it is so much better" she wrote, "for him generally to spend his evenings tête-à-tête with me, tho I do not interfere with hospitality in a rational way." That he did indeed feel suddenly grateful for this maternal solace is likewise probable; at least his decision to paint Anna Mathilda right after the Valparaiso adventure can scarcely have been accidental. But reality is seldom as neat as theory, and shortly after the letter to Fantin it became thoroughly untidy. The portrait was not sent to the Paris Salon, and apparently it was not finished until four or five years later. (There is no reason to assume that the letter to Fantin refers to a different and subsequently lost or destroyed painting.) Presumably it underwent during this period the process

which Frederick Jameson described as being "shaved down to the bed-rock mercilessly," for what was finally ready for exhibition was in a style unlike anything the artist was attempting, in 1867. In any event, the next document in the case is a letter of April 10, 1872, in which the subject herself reports that she has just had visitors wishing to see the now completed picture before its departure for submission to the Royal Academy jury. She felt that the occasion was solemn: "I was up in my Japanese bedroom seated in my armchair and refused not the particular friends and admirers of my son's work."

The jury at first rejected the portrait for the annual show, and changed its mind only after Boxall, still loyal to his young protégé of 1849, threatened to create a scandal by resigning from the academy. Other viewers were quick to see the qualities that would make the picture a sentimental symbol, a maternal *Mona Lisa*. Swinburne saw in it an "intense pathos." One of Mrs. Whistler's visitors commented: "It has a holy expression. Oh, how much sentiment . . ." Soon Whistler recognized the danger to which he had exposed his art-for-art position, and tried to stem the tide of easy emotion. In 1878, in the little essay he called "The Red Rag," he would write: "Art should be independent of all claptrap—should stand alone, and appeal to the artistic sense of eye or ear without confounding this with emotions entirely foreign to it, as devotion, pity, love, patriotism, and the like. . . . Take the picture of my mother, exhibited at the Royal Academy as an *Arrangement in Grey and Black*. Now that is what it is. To me it is interesting as a picture of my mother; but what can or ought the public to care about the identity of the portrait?" Yet at a slightly later date, in a private conversation and with just a hint of his usual air of listening to his own phrases, he himself came close to taking the side of "claptrap," and an alert friend noted the betrayal with relish: ". . . we were looking at the *Mother*. I said some string of words about the beauty of the face and figure, and for some moments Jimmy looked and looked, but he said nothing. His hand was playing with that tuft upon his nether lip. It was, perhaps, two minutes before he spoke. 'Yes,' very slowly, and very

softly—'Yes, one does like to make one's mummy just as nice as possible.' "

Among the unexpected admirers of the picture was Carlyle, who was persuaded to meet Whistler by Mme. Emilie Venturi, a mutual friend and one of the many unconventional residents of Chelsea. (She was also a friend of the Italian revolutionary leader Giuseppe Mazzini, who had often called on her during his periods of exile.) Carlyle knew little about painting, but he liked the simplicity of *The Artist's Mother* and finally agreed, at Mme. Venturi's urging, to let himself be painted in the same pose and the same surroundings. The long-term result was *Arrangement in Grey and Black No. 2: Thomas Carlyle*, a subtle variation on the underlying geometry, the flat black silhouette, the Calvinist austerity, and the tender humanity of the *Mother*. The short-term result, during sittings that dragged on at 2 Lindsey Row until well into 1873, was one of the best comic duos of the nineteenth century. At one end of the room sat the grumpy, bitter, seventy-seven-year-old Sage of Chelsea, the anti-dandy incarnate. At the other end of the room, skipping toward and back from the canvas like a combination dancer and fencer, was the dapper artist. The lack of communication was nearly total, and it was manifest, according to Whistler, at the very first session: ". . . he sat down, and I had the canvas ready and the brushes and palette, and Carlyle said: 'And now, mon, fire away!' That wasn't my idea how work should be done. Carlyle realized it, for he added: 'If ye're fighting battles or painting pictures, the only thing to do is to fire away!' " Later on there was trouble because the sitter thought that the use of small brushes was the cause of the slowness of the proceedings, and so the artist had to pretend to use larger ones. Further troubles were recorded in a diary kept by the poet William Allingham: "Carlyle tells me he is sitting to Whistler. If C. makes signs of changing his position, W. screams out in an agonized tone: 'For God's sake, don't move!' C. afterwards said that all W.'s anxiety seemed to be to get the coat painted to ideal perfection; the face went for little. . . . He used to define W. as the most absurd creature on the face of the earth."

Carlyle, as often during his career, was being deliberately unfair. After hours of watching the battle he must have realized that it took nerve and tenacity to keep firing away until a picture like *Arrangement in Grey and Black No. 2* was completed. And a good deal of nerve and tenacity, along with a hint of the violent aggressiveness of the 1860s, can be discovered in the face of the Whistler who, sometime around 1872, squinted nearsightedly into a mirror for the execution of the self-portrait he called *Arrangement in Grey*. Many painters have tended to look like Rembrandt when they painted themselves; here the artist, intent on presenting himself, properly hatted, in the full historic dignity of his calling, brought off the tour de force of looking like Sir Joshua Reynolds looking like Rembrandt.

The picture is noteworthy also as the first one in which Whistler has the feathery white forelock that soon became—along with his monocle, patent-leather shoes, long cane, strange clothes, even stranger hats, and falsetto laugh—part of his equipment for role-playing. Presumably the tuft of hair turned white during the crisis of the late 1860s; du Maurier attributed the sudden bleaching, almost certainly mistakenly, to a bullet or sword wound received at Valparaiso. Whatever the cause may have been, the lock made a fine panache for the Southern cavalier and put him in excellent dandyish company: Barbey d'Aurevilly had a somewhat similar lock, and Georges Selwyn, the perverse dandy in Edmond de Goncourt's novel *La Faustin* (published in 1882, but based on much earlier documentation) "acquired an additionally strange character from the fact that in the middle of his hair, which was very black, a white lock . . . was arranged and thrust into prominence with a certain affectation."

Another Whistler trademark, the butterfly signature, also appeared in the early 1870s, after an evolution of several years from a monogram composed of the interwoven initials JMW. The idea came first from Rossetti, who himself used a monogram signature and sketched one in 1864 for Whistler after a patron had balked at buying *La Princesse du Pays de la Porcelaine* because of the size of the signature. A second source was undoubtedly Albert Moore,

who signed pictures with a stylized neo-Greek anthemion motif. The most important sources, however, were Oriental: the inscriptions, cartouches, and collectors' seals on Japanese prints, the potters' marks on blue and white porcelain, and possiby, through prints or Mme. Desoye's textile department, the strikingly formalized emblems on Japanese banners and the costumes of kabuki actors. The half-abstract insect continued to change through the years, and Whistler employed it as a recurring compositional element—by no means a minor one, in his opinion—as well as a signature. It also became his totem and heraldic symbol; as such it appeared on his cards, letters, brochures, and linen, at his exhibitions, and in every situation in which he went forth to joust with his enemies. He never explained why he chose this rather foppish blazon instead of one of the other winged devices his JMW could have suggested and which could have served his desire for personal publicity just as well. But of course he had nothing against foppishness when it was his own brand, and the butterfly, being at once pretty and futile, can be considered one of nature's better examples of art for art's sake. It is simply an arrangement, without claptrap.

The year 1873 was a particularly promising one for Whistler the portraitist. In addition to finishing *Arrangement in Grey and Black No. 2* he was engaged on four major commissioned works, all of which were completed, or nearly so, by the beginning of the following year. The most seductive, and arguably his masterpiece in the genre, is *Harmony in Grey and Green: Miss Cicely Alexander;* the dainty, sulking, butterflylike subject was the nine-year-old daughter of William C. Alexander, a prominent London banker and collector of blue and white porcelain who had just purchased an art mansion, Aubrey House, on Campden Hill. The most regal of the four is certainly *Arrangement in Black No. 2: Mrs. Louis Huth,* perhaps because Mrs. Huth owned a magnificent black velvet gown. Her husband, a London businessman, was a collector not only of Chinese poreclain but also of European

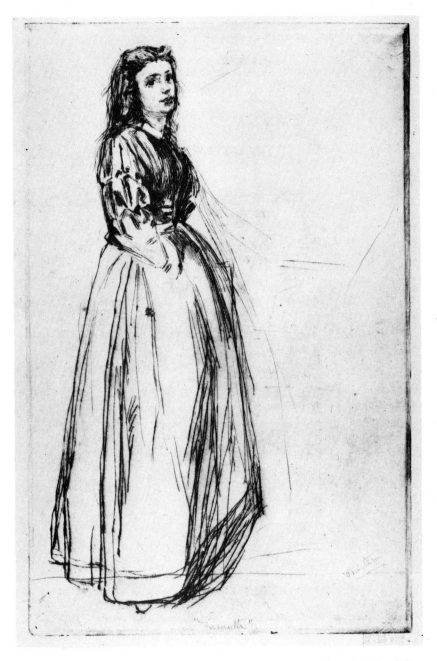

1. *Fumette Standing.* 1859. Drypoint, 13⅜ x 8½ inches. (Prints Division, The
New York Public Library, Astor, Lenox and Tilden Foundations)

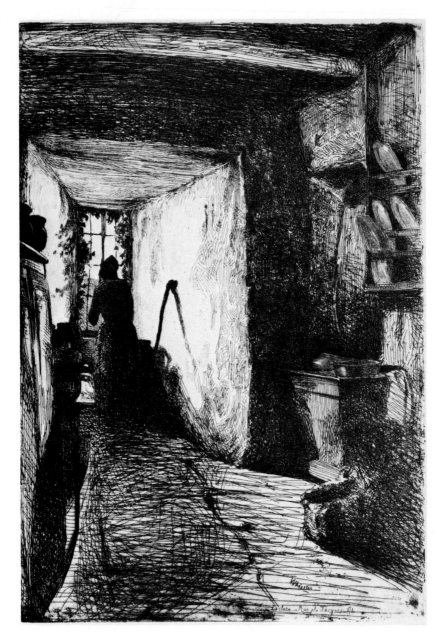

2. *The Kitchen.* 1858. Etching, 8⅞ x 6¼ inches. (Prints Division, The New York Public Library, Astor, Lenox and Tildon Foundations)

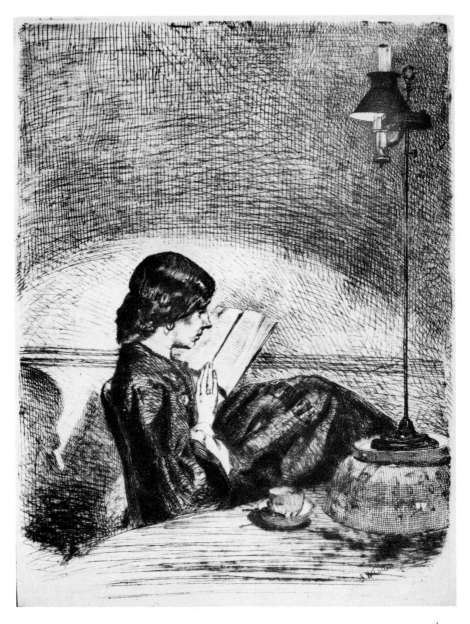

3. *Reading by Lamplight* (Mrs. Haden). 1858. Etching and drypoint, 6³⁄₁₆ x 4⁹⁄₁₆ inches. (Prints Division, The New York Public Library, Astor, Lenox and Tilden Foundations)

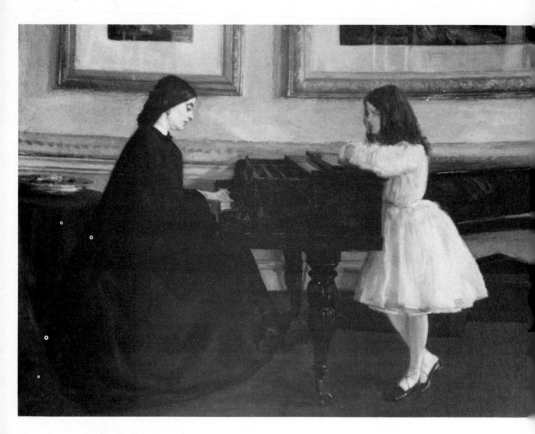

4. *At the Piano.* 1858–59. Canvas, 36⅜ x 26¹⁄₁₆ inches. (Taft Museum, Cincinnati, Ohio, U.S.A.)

5. *Harmony in Green and Rose: The Music Room.* 1860. Canvas, 37⅝ x 27⅞ inches. (Courtesy of the Smithsonian Institution, Freer Gallery of Art, Washington, D.C.)

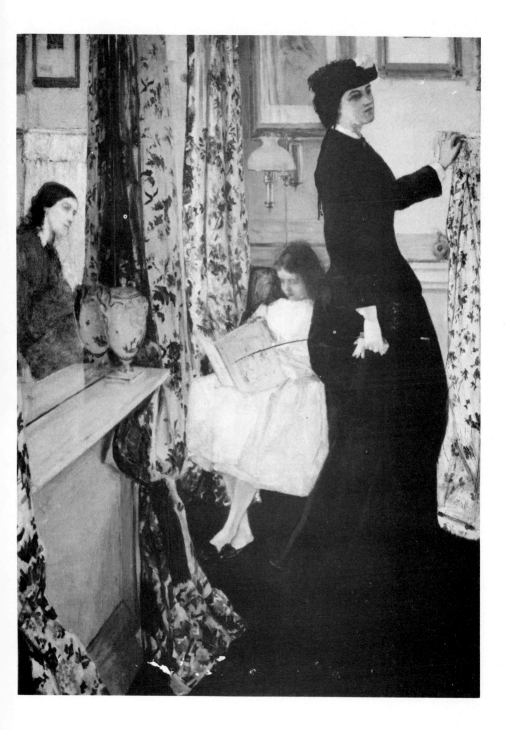

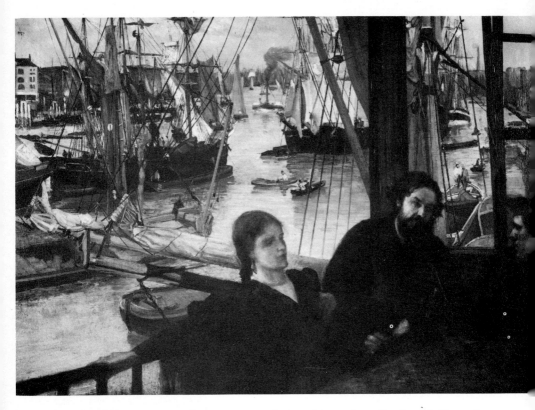

6. *Wapping*. 1860–64. Canvas, 28 x 40 inches. (From the collection of Mr. and Mrs. John Hay Whitney)

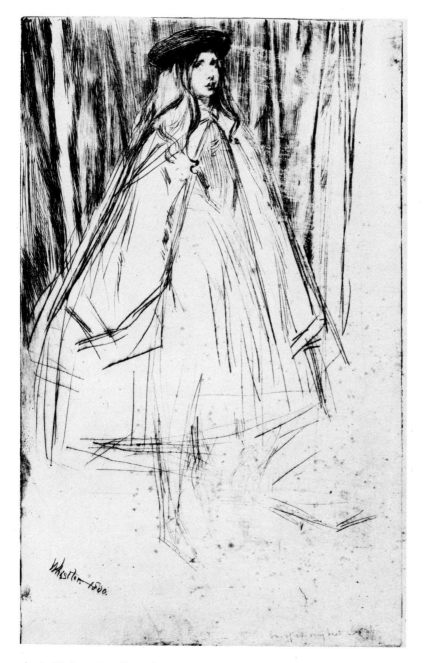

7. *Annie Haden.* 1860. Drypoint, 13¾ x 8⅜ inches. (Prints Division, The New York Public Library, Astor, Lenox and Tilden Foundations)

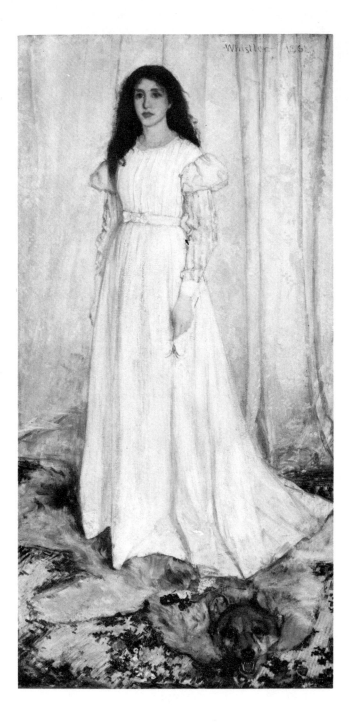

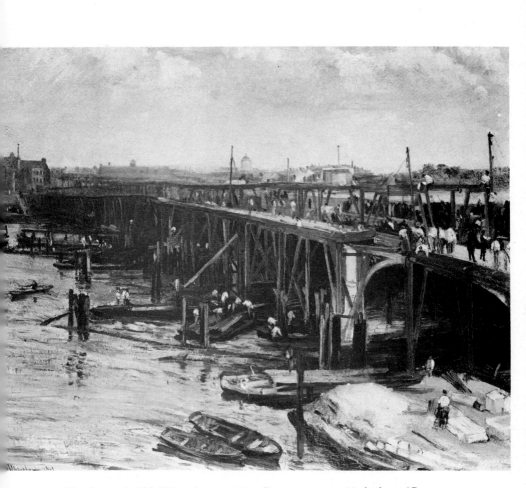

9. *The Last of Old Westminster.* 1862. Canvas, 24 x 30½ inches. (Courtesy Museum of Fine Arts, Boston, Abraham Shuman Fund)

8. *Symphony in White No. 1: The White Girl.* 1862. Canvas, 84½ x 42½ inches. (National Gallery of Art, Washington, D.C., Harris Whittemore Collection)

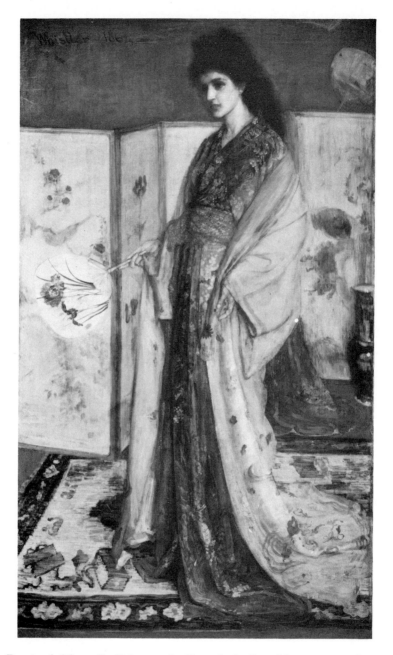

10. *Rose and Silver: La Princesse du Pays de la Porcelaine.* 1863–64. Canvas, 78¾ x 45¾ inches. (Courtesy of the Smithsonian Institution, Freer Gallery of Art, Washington, D.C.)

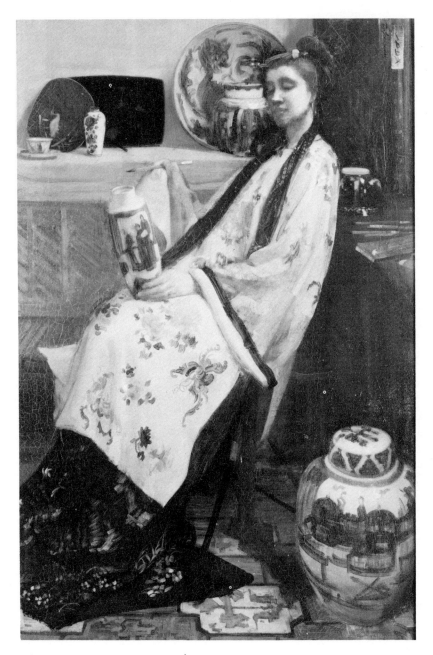

11. *Purple and Rose: The Lange Lijzen of the Six Marks.* 1864. Canvas, 36¼ x 24¼ inches. (Courtesy, John G. Johnson Collection, Philadelphia)

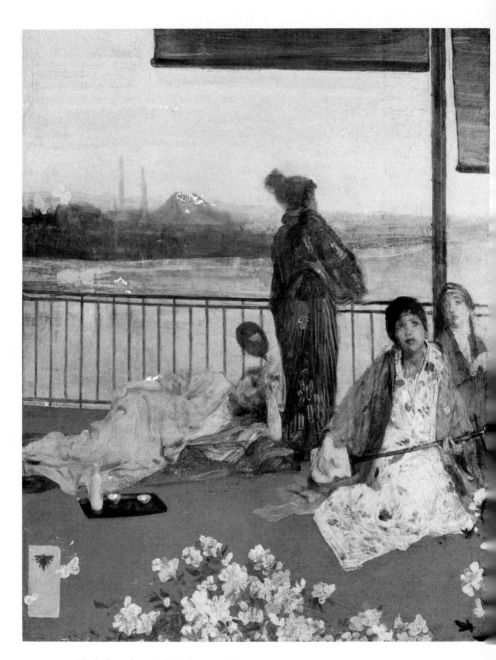

12. *Variations in Flesh Color and Green: The Balcony.* 1864–67. Panel, 24¼ x 19⅜ inches. (Courtesy of the Smithsonian Institution, Freer Gallery of Art, Washington, D.C.)

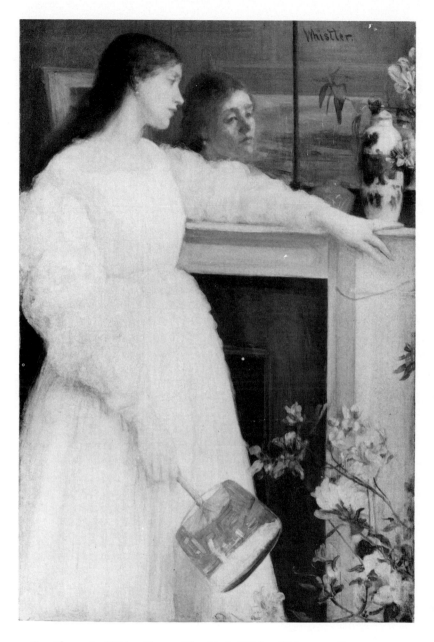

13. *Symphony in White No. 2: The Little White Girl.* 1864. Canvas, 30 x 20 inches. (The Tate Gallery, London)

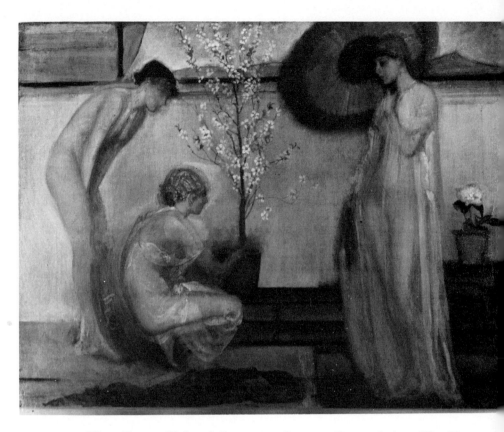

14. *Three Figures: Pink and Grey*. 1868. Canvas, 55½ x 72 inches. (The Tate Gallery, London)

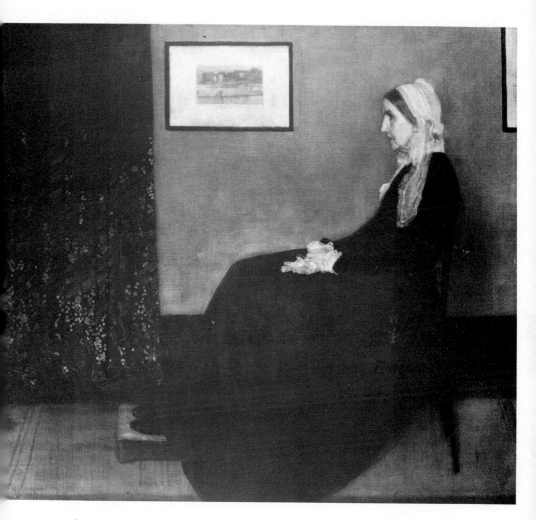

15. *Arrangement in Grey and Black No. 1: The Artist's Mother.* Exhibited in 1872. Canvas, 56 x 64 inches. (Louvre, Paris. Photo/AGRACI)

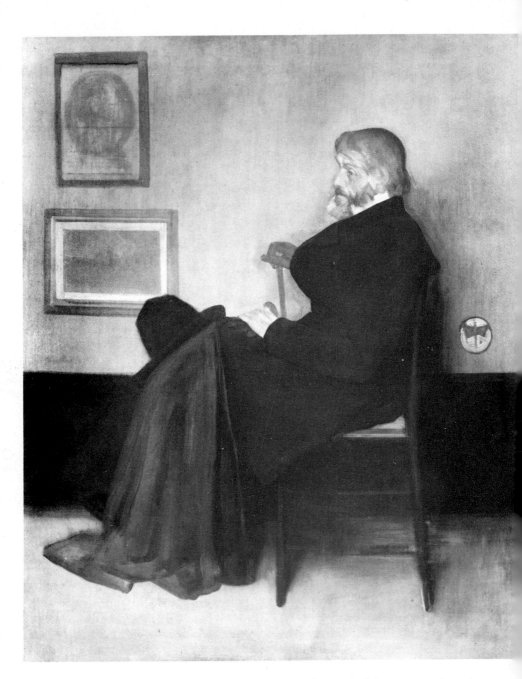

16. *Arrangement in Grey and Black No. 2: Thomas Carlyle.* 1872–73. Canvas, 67⅜ x 56½ inches. (Glasgow Art Gallery)

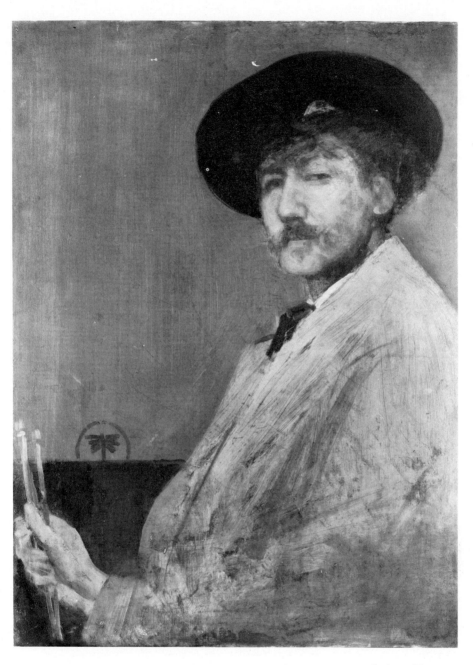

17. *Arrangement in Grey: Self-Portrait.* 1871–73. Canvas, 29½ x 21 inches. (From the collection of The Detroit Institute of Arts. Bequest of Henry G. Stevens)

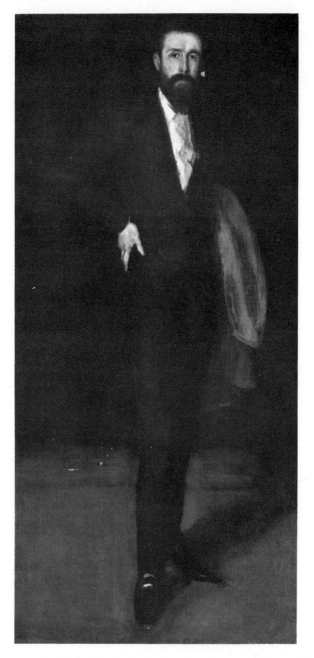

18. *Arrangement in Black: F. R. Leyland.* 1873. Canvas, 75⅞ x 36⅛ inches.
(Courtesy of the Smithsonian Institution, Freer Gallery of Art, Washington, D.C.)

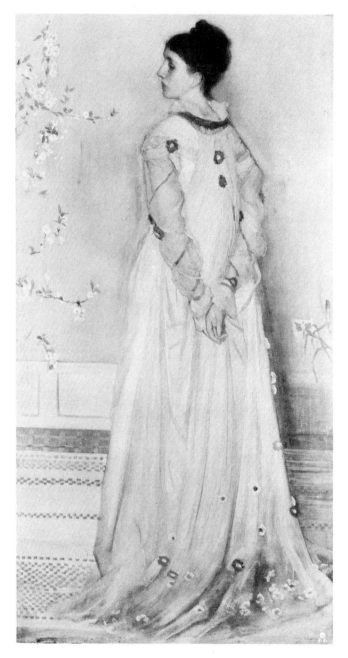

19. *Symphony in Flesh Color and Pink: Mrs. F. R. Leyland.* 1873. Canvas, 82½
x 36½ inches. (Copyright, The Frick Collection, New York)

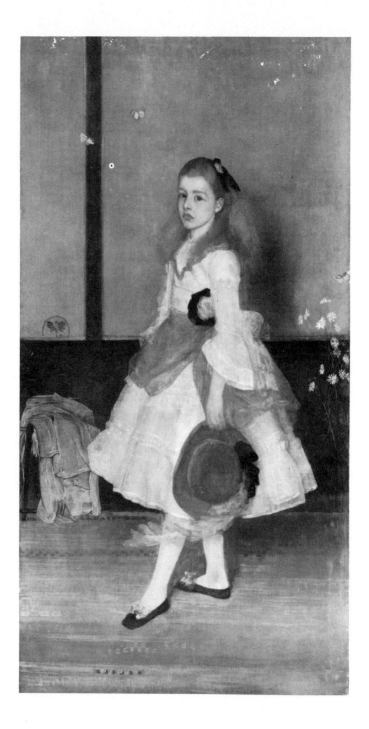

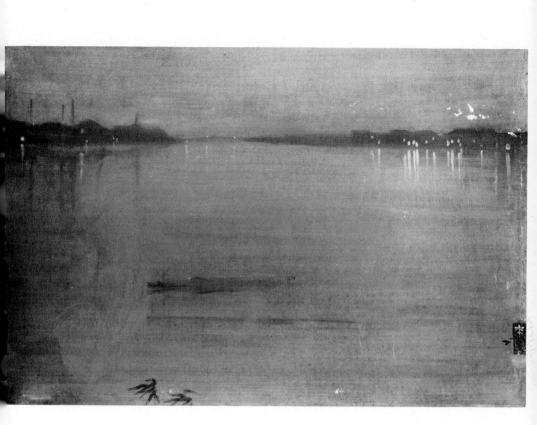

21. *Nocturne in Blue and Silver: Cremorne Lights.* 1872. Canvas, 19½ x 29¼ inches. (The Tate Gallery, London)

20. *Harmony in Grey and Green: Miss Cicely Alexander.* 1872–74. Canvas, 74 x 39 inches. (The Tate Gallery, London)

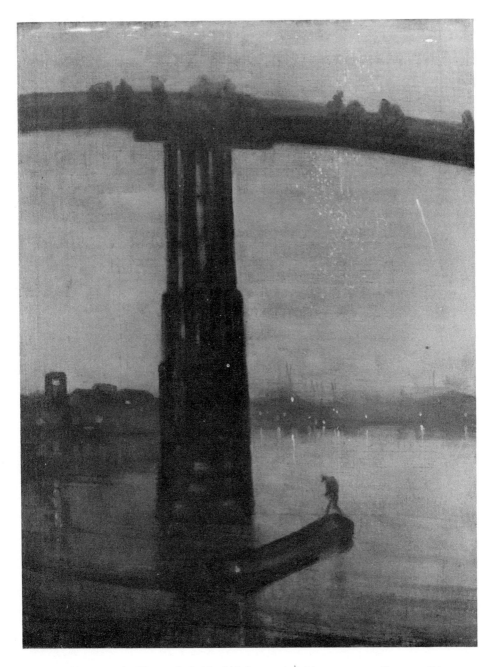

22. *Nocturne in Blue and Gold: Old Battersea Bridge.* 1872–75. Canvas, 26¼ x 19¾ inches. The Tate Gallery, London)

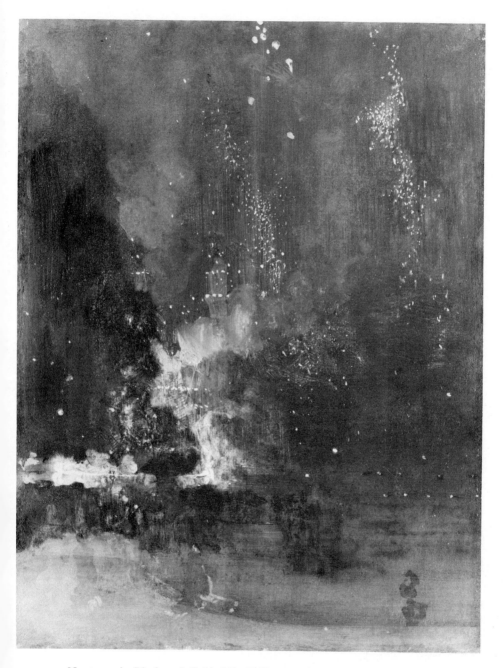

23. *Nocturne in Black and Gold: The Falling Rocket.* 1874. Panel, 23¾ x 18⅜ inches. (Purchase, The Dexter M. Ferry, Jr. Fund)

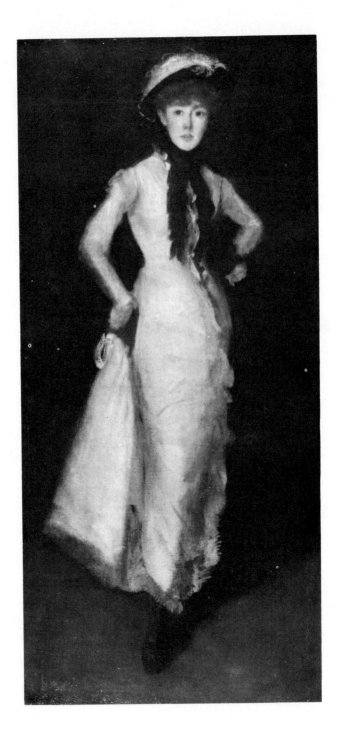

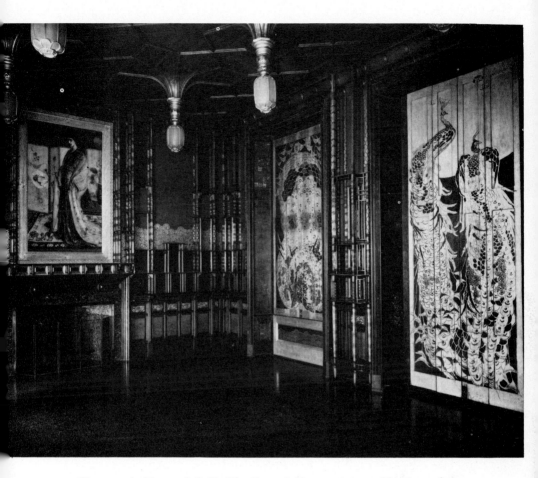

25. *Harmony in Blue and Gold: The Peacock Room.* 1876–77. (Courtesy of the Smithsonian Institution, Freer Gallery of Art, Washington, D.C.)

24. *Arrangement in Black and White: The Young American* (Maud Franklin). Exhibited in 1878. Canvas, 75¾ x 34¾ inches. (Courtesy of the Smithsonian Institution, Freer Gallery of Art, Washington, D.C.)

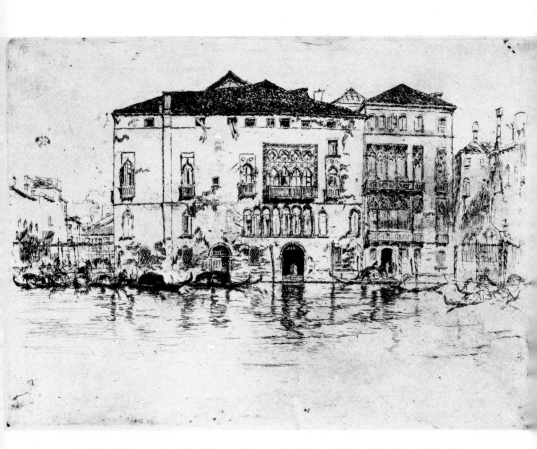

26. *The Palaces*. 1880. Etching, 10⅝ x 14⅛ inches. (Prints Division, The New York Public Library, Astor, Lenox and Tilden Foundations)

27. *Harmony in Flesh Color and Pink: Lady Meux*. 1881. Canvas, 75¾ x 36½ inches. (Copyright, The Frick Collection, New York)

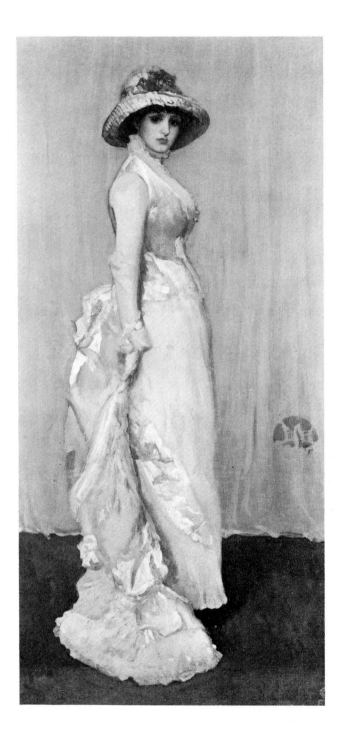

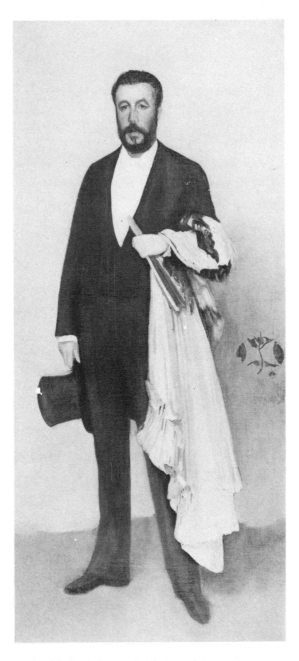

28. *Arrangement in Flesh Color and Black: Théodore Duret*. 1883. Canvas, 76⅛ x 35¾ inches. (The Metropolitan Museum of Art, Wolfe Fund, 1913)

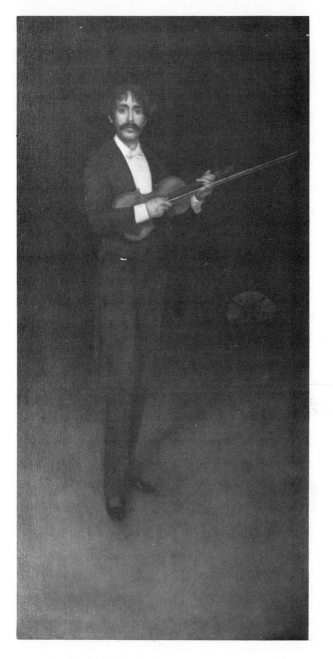

29. *Arrangement in Black: Pablo de Sarasate.* 1884. Canvas, 85½ x 44 inches.
(Museum of Art, Carnegie Institute, Pittsburgh)

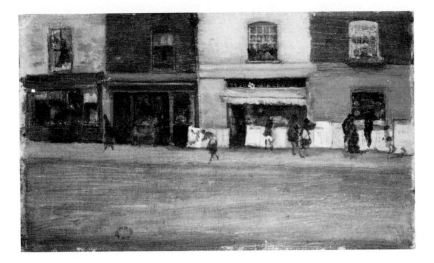

30. *Chelsea Shops.* 1880s. Panel, 5¼ x 9¼ inches. (Courtesy of the Smithsonian Institution, Freer Gallery of Art, Washington, D.C.)

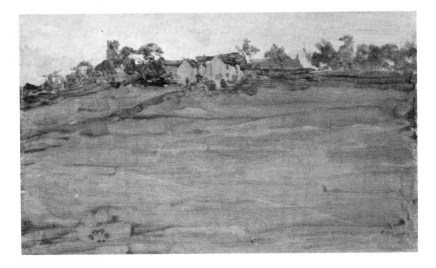

31. *A Note in Green: Wortley.* Early 1880s. Panel, 5⁵⁄₁₆ x 9³⁄₁₆ inches. (Courtesy of the Smithsonian Institution, Freer Gallery of Art, Washington, D.C.)

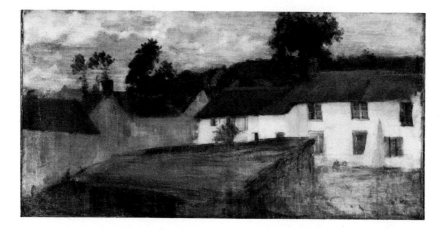

32. *Dorsetshire Landscape*. 1895. Canvas, 12½ x 24⅞ inches. (Courtesy of the Smithsonian Institution, Freer Gallery of Art, Washington, D.C.)

33. *The Siesta* (Mrs. Whistler). 1896. Lithograph, 5⅜ x 8¼ inches. (Prints Division, The New York Public Library, Astor, Lenox and Tilden Foundations)

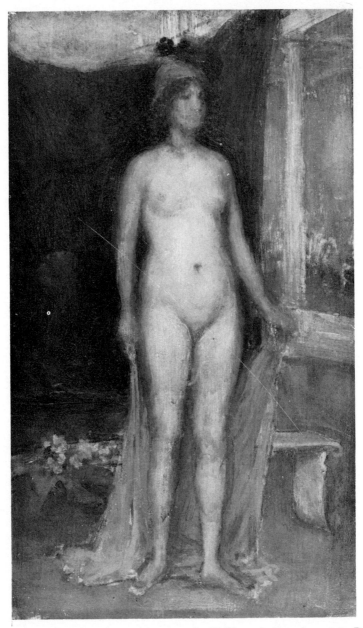

34. *Purple and Gold: Phryne the Superb: Builder of Temples.* 1898. Panel, 9¼ x 5⅜ inches. (Courtesy of the Smithsonian Institution, Freer Gallery of Art, Washington, D.C.)

old-master paintings. The most interesting of the four, in terms of the portraitist's career, are *Arrangement in Black: F. R. Leyland* and *Symphony in Flesh Color and Pink: Mrs. F. R. Leyland.* Leyland, the Liverpool shipping magnate whom Rossetti, the super picture salesman, had introduced to the Chelsea colony some ten years earlier, was by 1873 one of Whistler's staunchest supporters, frequently good for a loan, an advance on a commission, or a welcome invitation to stay for an indefinite period at Speke Hall, a large, many-gabled, half-timbered country place, near Liverpool, where the Leyland family lived much of the year.

Advancing money on commissions meant that the patron was willing to gamble, for Whistler continued to promise more than he delivered, and he was often very late in delivering. Projects for portraits of other members of the Alexander family never got beyond sketches. Commissions for oil portraits of the four Leyland children finally yielded only some pastels, etchings, drawings, and botched canvases; and the *Leyland* and *Mrs. Leyland*, although practically finished in 1873, were not delivered until several years later. When the artist finally got down to work, his attention to every detail of the "arrangement," "harmony," or "symphony" could be a constant threat to progress. He gave precise instructions to Mrs. Alexander for the design of each of Cicely's frills, ruffles, and ribbons, and even specified how the girl's dress was to be laundered; he refused to let Mrs. Leyland wear a favorite black gown, and invented for her instead a loose, flowing, pink muslin robe that faintly echoed the reddish tint of her hair, owed something to the costumes in Pre-Raphaelite pictures, and anticipated the aesthetic lady's attire of the 1880s. On the canvas he was ruthless both with himself and with the client, partly because he had become convinced that the success of his mood-evoking patterns of forms, colors, and tonal values depended on continuity of execution, which meant that if a detail went wrong it could not be repaired without doing practically the whole picture over again (at the risk, as time would show, of often leaving the paint in bad condition). On several occasions Mrs. Leyland went home thinking her portrait was nearly finished, only to find the next

morning that it had been wiped out with a rag dipped in benzine. If Cicely Alexander wound up looking sulky for eternity, one reason was that she had to endure some seventy sittings, or standings rather, while her picture went through cycles of destruction and re-creation. (Carlyle, seeing her enter 2 Lindsey Row one day as he was leaving, shook his head and muttered: "Puir lassie. Puir lassie.") At one point Mrs. Huth flatly refused to continue posing. Leyland was more patient during his particular ordeal, but was finally willing to let a professional model come in and pose nude so that Whistler, who according to Walter Greaves was in "an awful mess," could go on trying to get the legs right.

Was so much trouble justified? One can feel that in several ways it was not and even that it was a sad diversion of artistic energy. By the 1870s photography was turning hand-painted portraits into anachronistic luxury products and status symbols, tainted slightly by *nouveau-riche* vulgarity. Moreover, Whistler was not a natural portraitist; he lacked the requisite skill in drawing (he never did get Leyland's legs and feet quite right), and he frequently failed to find the requisite sharpness of focus on individuality (his Carlyle is an appealing, weary old man, not the irascible Sage of Chelsea). Also, as he seemed to acknowledge in his comment on the *Mother*, he got himself tangled in an awkward conflict between his theory and his practice, for among the traditional pictorial genres portraiture is probably the least amenable to the art-for-art's-sake approach, the least inclined to aspire toward the condition of music. Given his aesthetic premises, and a little less of his naïve desire for a worldly sort of success, he should have been interested in still life. But when the complaints have been registered the fact remains that these portraits of the early 1870s add up to an achievement unmatched in the production of any other mid-Victorian painter. Influences are of course visible. Somewhere behind the black dress of Anna Mathilda and the black coat of Carlyle there is the black robe of a Japanese official or actor. Behind Cicely Alexander there are Velázquez's little princesses. Behind Mrs. Huth there are court portraits and again Velázquez, who was represented in Louis Huth's collection by a full-length

version of the *Queen Elizabeth* of the Vienna Kunsthistorisches Museum (the Huth picture is now in a German private collection). For Mrs. Leyland the possible references range from *japonisme* and the Aesthetic Movement to the English type of half-aristocratic, half-theatrical glamour turned out by Sir Thomas Lawrence. For Leyland there are the full-length portraits of tall and thin courtiers common in England since Van Dyck and earlier, and once more Velázquez, not only for the figure but also for the sketchy, enveloping background—a feature Whistler would emphasize in later work, under the spell of a photograph he owned of the Spanish master's *Pablo de Valladolid.* (Manet had seen the original *Pablo* at the Prado in 1865, had pronounced it "perhaps the most astonishing piece of painting ever created," and had reported to Fantin, in a letter Whistler may have seen: "The background disappears; it is air that surrounds the fellow, all dressed in black, alive.") All these influences, however, are assimilated; Anna Mathilda, Carlyle, Cicely, Mrs. Huth, Mrs. Leyland, and Leyland all inhabit the Whistlerian universe.

Even more Whistlerian are the night landscapes of the 1870s. They too can be attached to precedents and traditions: in England the line of painters of moonlit scenes went back through Whistler's younger contemporary Atkinson Grimshaw to the Pether family (one member of which was known as Moonlight Pether), Old Crome, Wright of Derby, and various watercolorists; in Holland the line went back from Jongkind to the seventeenth century and Aert van der Neer; in Japan an almost exactly parallel line was well represented by Hokusai and Hiroshige in their so-called "blue prints." But it would be difficult to prove that Whistler drew direct inspiration from any of these artists except the Japanese, and it is scarcely too much to say that he reinvented the specialty, taking as his starting point a personal transformation of the European marine-painting tradition. The transformation may be said to have begun in 1863, when he began to paint, and to explore with the Greaves brothers, the relatively empty Thames at Chelsea instead of the

busy river at Wapping; further stages were accomplished by the work and talk at Trouville in 1865, and by the long Atlantic and Pacific voyages of 1866. He learned to eliminate obtrusive details or integrate them into the fluid, low-keyed, atmospheric substance of the picture as a whole. By a quite logical movement of his sensibility, he proceeded from the wintry, foggy Thames to twilight views of the ocean and on to the decisive moment when, apparently from the window of the English club, he painted the port of Valparaiso shrouded in darkness. What he was after, he once said, was "the mystery of it all," and he added that he was thoroughly aware that a large section of the Victorian public was impervious to the charm of visual mystery: "What they like, is when the east wind blows and everything is sharp and hard and awful—they like the sort of day when, if you look across the river, you can count the wires in the canary bird's cage on the other side."

Perhaps the earliest of the series of mature studies in darkness is *Nocturne in Blue and Green: Chelsea*, which is dated 1871 and was bought by Cicely Alexander's father. Closely related to it in style is the *Nocturne in Blue and Silver: Cremorne Lights* of 1872. Possibly as early as 1872, although more probably a little later, is *Nocturne in Black and Gold: Entrance to Southampton Water*. These three pictures are examples of what can be called the basic nocturne: an almost monochromatic waterscape with a high horizon, few details, long horizontal brush strokes punctuated by short vertical ones, and an ambiguous, Oriental sort of space that can be viewed as mysteriously deep one second and decoratively flat the next. In the general dimness and fuzziness there can be no question of counting the wires in the canary's cage, nor of identifying anything with precision; that long smudge in the water might or might not be a boat, and that mass on the horizon might or might not be a building. What the viewer is confronted with is a nearly abstract pattern which, largely because of the distribution of tonal values, contrives to function, like many pieces of music, as a metaphor for an indefinable mood; and so, all things considered, it was not surprising that a large section of the Victorian public

should have been baffled—to the point of suspecting a joke or a fraud. Whistler himself seems to have taken a good while to realize how far he had strayed from the idea of painting as a representational art, for at first he referred to his night scenes as "moonlights." But when, around 1872, his friend Leyland, who was an amateur pianist, came up with the term "nocturne," the reaction was a eureka letter: "I can't thank you too much for the name Nocturne as the title for my Moonlights. You have no idea what an irritation it proves to the critics, and consequent pleasure to me; besides it is really so charming, and does so poetically say all I want to say and *no more* than I wish."

With the basic formula and the terminology established, variations became possible. One of the most striking, datable to sometime around 1873, is *Nocturne in Blue and Gold: Old Battersea Bridge;* here the massive T-section of the bridge, seen from below in the very near foreground, deepens the fireworks-lit space behind the picture plane in a way that is nonetheless effective for being plainly borrowed, without acknowledgment, from a fine Hiroshige print, the *Kyobashi Bamboo Market* (in the series *One Hundred Views of Famous Places in Edo*). Fireworks, in each instance at Cremorne Gardens, figure again in *Nocturne in Black and Gold: The Falling Rocket* and *Nocturne in Black and Gold: The Fire Wheel;* both date from around 1874, and both, to a twentieth-century viewer, can suggest that Whistler by this time was about ready to go over the edge from figurative painting into something like Abstract Expressionism—thirty-five years before Kandinsky, in much the same situation in regard to both practice and theory, actually did go over the edge. What held Whistler back? The answer, clearly, is that he was not nearly as ready as he may seem to have been: his theory was never as rigorous as he liked to pretend, and the abstract look of *The Falling Rocket* and *The Fire Wheel* was partly an accidental effect of the subject matter. The pictures he painted at about the same period as these two show that a complete break with representation was as unthinkable to him as it was to any royal academician. But to grant all this is not to deny his right to some kind of medal from speculative art historians

for coming closer than any of his contemporaries to the unthinkable.

Many of his best effects in his nocturnes, and some of his less happy ones, were due to his technique, which was even less orthodox than his theory. Often he would spend an entire night on the Thames in one of the Greaves brothers' skiffs, sometimes taking notes or making crude sketches in the darkness, but mostly just observing the scene and practicing the memory method advocated by Lecoq de Boisbaudran. The next day, if he felt he could "see" his picture, he went to work, out of sight of the river in the back room he normally used as his studio at 2 Lindsey Row. He remade his brushes, melting the glue at their bases and pushing the bristles into the forms he wanted. His surfaces were occasionally mahogany panels obtained from the Greaves boat-building establishment, but generally they were pieces of extremely absorbent canvas covered with preliminary coats of red, gray, or black. In line with Gleyre's teaching, the finishing colors—usually dominated by a cobalt blue, a blue-gray, or a blue-green, with some warm hues for lights and fireworks—were laid out in advance on a large table palette; eventually they were mixed with a medium of copal, mastic, and turpentine so as to create a thin liquid which the artist, borrowing a term used in the Left Bank *académies* of the 1850s, referred to as his "sauce." The execution normally involved a good deal of wiping to get the desired tonal values, or of scraping to remedy a defect that had been allowed to dry, and sometimes the canvas had to be snatched from the easel and laid flat on the floor to keep the "sauce" from running. When things went right, a picture might be finished in a couple of sessions; when things went wrong, the wiping and scraping might continue until the canvas was a dark, frayed ruin. At any moment a tender touch might succeed marvelously in evoking "the mystery of it all," and at the next moment an intended refinement might turn into an impoverishment beyond repair. With the passage of time the color of the underpainting could work its way up and modify the foggy harmony, with unpredictably poetic or sour results. The whole

process was an oddly unprofessional and wildly hazardous com-
bination of the methods of traditional oil painting with those of
watercolor.

The fact that the nocturnes and the major portraits of the
1870s, with the notable exception of *The Artist's Mother*, were not
exhibited at the Royal Academy was less important than it would
have been a few years earlier, for private enterprise was beginning
to compete seriously with the annual academy show for public
attention. The Berners Street Gallery, where *The White Girl*
had been hung in 1862, had been one of the pioneers in the new
trend, and had been followed by two other art shops, the Dudley
Gallery and the French Gallery. During the Franco-Prussian War
the Paris dealer Durand-Ruel, a partisan of the Barbizon land-
scapists and increasingly of the not-yet-labeled Impressionists, had
organized shows in London that had developed into a gallery called
the Society of French Artists—which did not mean that only
French artists were admitted. Whistler took part regularly in
group exhibitions at the Dudley, French, and Society galleries,
and during the summer of 1874 he persuaded the Flemish Gallery,
at 48 Pall Mall, to give him a one-man show, his first and a rare
occurrence for any painter in the nineteenth century. For the
occasion he chose fifty etchings, thirty-six drawings, a painted
screen, and thirteen oils that included *Carlyle, Mrs. Huth, Leyland,
Mrs. Leyland, Cicely Alexander*, and some nocturnes, all supplied
with his fancy new titles. He prepared a special catalogue, sent out
butterfly-inscribed invitations, repainted the walls of the gallery
with a suitable gray tint, hung his works with plenty of space
around them, and decorated the premises with flowers, palms, small
bronzes, and blue and white porcelain. The result was a disappoint-
ing lack of lengthy comment in print and some shocked reactions
from viewers accustomed to the dowdy disorder of Victorian exhi-
bitions. But at least he had the satisfaction of seeing some of his
best things outside the studio, and he was probably not greatly
distressed by the thought that he had increased his reputation for
showmanship and dandyism. Four years later in "The Red Rag,"

he wrote, "I know that many good people think my nomenclature funny and myself 'eccentric.' Yes, 'eccentric' is the adjective they find for me."

He was content not only to be allegedly eccentric, but also to be isolated as an artist. A few weeks before the opening of his one-man show the first group exhibition of the Impressionists had taken place in Paris, and that he could have participated in that historic event if he had wanted to is practically certain. He had long known some of the leading Impressionists, he had exhibited at Durand-Ruel's Paris gallery, he had recently been in touch with Degas, one of the most active organizers in the French group, and Degas had turned out to be an enthusiastic admirer of the early nocturnes: "This Whistler," he remarks in a letter of 1873 to Tissot, who was then in London, "has really got something in these views of the sea and of water which he has shown me." Moreover, Degas from the beginning of the Impressionist project for a show had been eager to corral as many participants as possible, without worrying much about their stylistic tendencies, in order to share costs and to avoid suggesting that the affair concerned merely a small avant-garde clique. The conclusion can only be that Whistler had not wanted to participate, that once again he had preferred the risk of being a lonely outsider in London to the possibility of being an insider in Paris.

Not that he was ever in much danger of being physically alone in London. Sometime during the early 1870s he acquired a new mistress, an artist's model named Maud Franklin, who was destined to remain with him for approximately fifteen years—many of them extremely trying years. She appears in a pen and ink sketch dated 1873, again in the perhaps deliberately mistitled *Arrangement in Black and White: The Young American* of about the same date, again in the slightly later *Arrangement in Black and Brown: The Fur Jacket*, and again, this time disguised as a character in Scott's *Heart of Midlothian*, in the *Arrangement in Yellow and Grey: Effie Deans* of 1876. When one thinks of the exasperating hours of posing required for each of these pictures it becomes evident that she was a thoroughly professional model and also that Whistler,

at least during these first years of their love affair, did not easily tire of looking at her. Like Jo, she was red-headed, intelligent, and fiercely loyal, but there the resemblance ended. Whereas Jo was large, languid, soft, and Irish, Maud was small, quick, rather fragile looking, and English; one of Whistler's friends remembered her as "not pretty, with prominent teeth, a real British type." Whereas Jo, in the pictures for which she posed, looks like a Romantic and partly PRB woman of the 1850s and 1860s, Maud looks like a product of the *Zeitgeist* shift, a stylish young woman of the 1870s. Above all, whereas Jo, in spite of her temper and her possessiveness, was socially humble and ultimately self-effacing, Maud was ambitious: as soon as she felt herself the permanent mistress she began introducing herself as Mrs. Whistler and had the name engraved on calling cards. Although she could not live at 2 Lindsey Row when Anna Mathilda was there, she might appear when Whistler entertained and she accompanied him to as many proper homes as Victorian decorum permitted. Depending on the company he was in to catch his nuances, he referred to her variously as Mrs. Whistler, Madame, and "my pupil."

He had begun to entertain formally in the late 1860s, borrowing for his first big evening Mme. Venturi's pots and pans and Mrs. Leyland's butler. By the mid-1870s he was no longer improvising, and his dinners, particularly the more intimate ones, appear to have been models of nineteenth-century low-pressure sociability, well supplied with aesthetic decor and stimulating conversation. Alan Cole, whose family had known Whistler since 1849 and whose father, Sir Henry Cole, was director of the South Kensington Museum, captured some of the quality of these dinners in diary entries made during the winter of 1875–76. On November 16, he notes: "Dined with Jimmy; Tissot, A. Moore. . . . Lovely blue and white china, and capital small dinner. General conversation and ideas on art unfettered by principles. Lovely Japanese lacquer." On December 7: "Dined with Jimmy. . . . Talked Balzac . . ." On January 6: "With my father and mother to dine at Whistler's. . . . My father on the innate desire or ambition of some men to be creators, either physical or mental. Whistler considered art had

reached a climax with Japanese and Velázquez. He had to admit natural instinct and influence, and the ceaseless changing in all things." On March 12: "Dined with Jimmy. Miss Franklin there. Great conversation of Spiritualism, in which J. believes. We tried to get raps, but were unsuccessful, except in getting noises from sticky fingers on the table."

Around 1873 the routine of dinner parties began to be varied with Sunday breakfasts, which were actually what later came to be called Sunday "brunches," for the hour was noon and the menu was apt to be an extraordinary Franco-American combination of Burgundy with buckwheat cakes and green corn. On some Sundays there might be as many as twenty guests at 2 Lindsey Row, and the amusement might include singing as well as talking. Whistler, all in white when the weather was suitable, bustled about telling a stream of stories and emphasizing his points by pouring wine into a glass at the right moment. Or he might recite some of Rossetti's limericks, a favorite being one that began:

> There is an old painter called Sandys
> Who suffers from one of his glands . . .

Probably a part of his high spirits can be attributed to the Burgundy, for although he was a light drinker he was also a notoriously unresistant one; a single sip, it was said, and his laugh grew louder.

His less sophisticated social activity included expeditions to Cremorne Gardens, where he painted, probably in 1875, the dashingly handled and strikingly French *Cremorne Gardens No. 2.* He saw less and less of Rossetti and 16 Cheyne Walk, but continued to be fascinated by the shady, fast-talking Howell, who after about 1873 dispensed hospitality and sharp business advice part of the year from a beach property at Selsey, on the English south coast. The friendship with Howell yielded, among other things, the undated *Beach at Selsey Bill* and in the mid-1870s *Arrangement in Black and Brown: Rosa Corder.* Rosa Corder, a painter and a Howell mistress who specialized in pictures of horses and who sometimes assisted her lover in his ventures by copying old paintings and drawings, proved to be one of the least strong

of Whistler's tortured subjects: she fainted twice during the long sessions of posing and finally, after some forty sessions, refused to put up with any more retouching. Howell nevertheless bought the picture as a finished work and, quite uncharacteristically, promptly paid for it. "I was amazed," Whistler commented, "when I got the check, and I only remembered some months afterwards that he had paid me out of my own money which I had lent to him the week before."

The night scenes painted shortly after the show at the Flemish Gallery reveal a growing tendency to be as inexplicit as possible, accompanied by a growing disdain for the nature of canvas and for the chemistry of oil painting. An example of both the tendency and the disdain, and beyond question one of the most un-Victorian works of the Victorian era, is *Nocturne: Cremorne Gardens No. 3*; the only identifiable motifs are four small-paned windows, a rectangle of light that can be read as a sort of portico, and a reddish diagonal streak that can be read as a path. Inside the rectangle of light there are half a dozen dabs of relatively thick paint, but the bulk of the picture is simply a vibrant gray-green blur produced by a "sauce" that must have been of about the consistency of water, and also by a wiping and a scraping energetic, or reckless, enough to let the warp and woof of the canvas show through. Here Whistler was close to a point where conception precluded realization, where execution became destruction, and he seems to have accepted the situation with an ominous, perverse sort of courage: during these years he went all the way with several nocturnes, ripping them from their stretchers and slashing with a knife what was left of the canvases.

His continuing fascination with the pictorial possibilities in young girls led, probably in 1876, to *Harmony in Yellow and Gold: The Gold Girl, Connie Gilchrist*, one of the rare large pictures in which he attempted to depict movement. Connie Gilchrist, then eleven years old, was at the moment being featured at the Gaiety Theatre in London in the rope-skipping dance she is doing, rather solemnly and stiffly, in the portrait; and she was also something of a professional model, posing notably for Leighton in *The Music*

Lesson and for Frank Holl, "the English Velázquez" and society portraitist. (She went on to star in light comedy and burlesque, to marry the Earl of Orkney, and to survive World War II.) Whistler was never very satisfied with the picture, and years later made determined efforts to get it back from its owner and destroy it.

He did succeed in destroying three important commissioned portraits that were under way in 1876 and were never brought to states he regarded as finished. One, which was finally burned, was a nearly life-size study of Sir Henry Cole. Another, which was slashed, represented the future Lord Redesdale, a Lindsey Row neighbor since the year before, dressed in a Van Dyck costume. Another, also slashed, showed the future Lady Redesdale in a special costume of Chinese blue silk. But these setbacks, which might have broken for good the morale of another painter, seem only to have persuaded Whistler that solutions for all his problems were just around the corner. He began work on *Arrangement in Black No. 3: Sir Henry Irving in the Character of Philip II of Spain in Tennyson's "Queen Mary,"* and Alan Cole, visiting the Lindsey Row studio on May 5, 1876, found him "quite madly enthusiastic about his power of painting such full-lengths in two sittings or so." The word "madly" was about right, for in fact the familiar cycle of rubbing out and re-creating set in almost immediately, and soon the celebrated actor, who had not commissioned the portrait, decided that he had more urgent things to do than changing into his stage clothes every day and posing in a Chelsea back room. When the picture was exhibited the following year no less than three ghostly outlines of the figure were visible under the successive repaintings. Around 1885 Irving was persuaded to return for more sittings, and the rubbing out and re-creating continued until, as a photograph of the early version reveals, many changes were effected. Even then, however, Whistler presumably considered the work unfinished or somehow unsuccessful, for he did not add his butterfly signature.

The Peacock Crisis
1876-1877

In 1875 *The British Architect* described the previous twenty-five years as "the most memorable quarter of a century in the annals of Art which this country has known since the brilliant periods of the Middle Ages." In 1876 the *Furniture Gazette* declared that "there has assuredly never been since the world began an age in which people thought, talked, wrote and spent such inordinate sums of money and hours of time in cultivating and indulging their tastes." Although the qualitative judgment can be questioned, the quantitative one was pretty close to the facts—especially the facts concerning interior decoration. The London Great Exhibition of 1851, the Paris Exposition Universelle of 1855, the London International Exhibition of 1862, the Paris Exposition Universelle of 1867, and a long series of smaller but similar shows had interested British home furnishers and the British public in the problems posed by mass production, stylistic revivals, new living habits, and the lack of any taste-defining authority comparable to the old aristocracy. Scores of handbooks and periodicals had stimulated further interest. Men like Henry Cole and William Morris had pleaded, with missionary fervor if not always with convincing examples, for a more rational approach to design, and had helped

to make "applied" art quite as respectable as the "fine" variety. Japanese influence and a fresh look at the once-scorned eighteenth century had countered the High Victorian love of clutter and coincided with a growing suspicion that Gothic might not be the ideal style for a domestic interior of the nineteenth century. By the mid-1870s the collecting of fine porcelain had become prevalent enough to be satirized in *Punch*, with a drawing by du Maurier, as "chronic chinamania," and not to have an opinion on dadoes and Art Furniture was to be excluded from tasteful table talk throughout polite society in the British Isles.

Whistler was in no danger of such exclusion. His dandyism, his *japonisme*, his art-for-art's-sake notions, and his emphasis on abstract, supposedly musical "arrangements" and "harmonies" all inclined him toward the decorative arts. So did his staginess, which involved a concern, when possible, with domestic interiors regarded as sets for his performances. So did a sort of aesthetic imperialism, or annexationism, which is fairly common among painters with abstract tendencies and which in him was aggravated by egocentrism; he could not resist, that is, the feeling that in a properly organized world everything would naturally be incorporated into systems of forms and colors controlled by his pictures. Beginning with specially designed frames for his oils and prints, he was usually prepared to take over as much surrounding territory as the circumstances permitted; it was typical of his attitude that he should have attempted to annex the entire Flemish Gallery to the *Arrangement in Grey and Black No. 2* by painting the walls gray. In a conversation with the Pennells he once insisted "that the painter must also make of the wall upon which his work hung, the room containing it, the whole house, a Harmony, a Symphony, an Arrangement, as perfect as the picture or print which became part of it." That in some situations this theory, if strictly applied, might have meant only one picture to a room, or to a house, seems not to have worried him, perhaps because he did not foresee many opportunities for strict application.

He was for many years on more or less friendly terms with several of the most brilliant and fashionable of the new Victorian

decorators and designers. In the 1860s, through the Rossetti circle, he got to know Morris, Burne-Jones, and other men connected with the firm Morris had founded to defend neo-medieval styles and neo-medieval work methods. Later on there were encounters with Walter Crane and Lewis F. Day, who can be regarded, in spite of their eventually firm refusal of the honor, as precursors of Art Nouveau. A continuing, close relationship existed from the mid-1860s to the mid-1880s with E. W. Godwin, who in 1874, in a London house occupied by himself, his mistress Ellen Terry, and their children Edith and Gordon Craig, developed the Anglo-Japanese mode to an unprecedented degree of uncluttered exoticism and chromatic refinement: floors were covered with straw-colored matting or simply waxed and left bare, walls when not left plain white were done in delicate shades of yellow, blue, or umber, curtains and cushions were gray-blue, ornaments were mostly Japanese fans, furniture was lightweight and scarce, and the children were dressed in kimonos when indoors.

Another important, although less close, relationship was with Thomas Jeckyll, whom Whistler met through du Maurier as early as 1862 and whom he continued to see regularly into the 1870s. Jeckyll crops up in the young du Maurier's letters as "a little lying snob" who "talks so beastly big about his friends Wales and St. Albans," and some ten years later he appears in accounts by other acquaintances as "a pale little man with a bald head and a dark beard" who "wore knee-breeches and buckle-shoes, and was looked upon as peculiar." His peculiarities did not, however, keep him from exercising a considerable talent as a designer. In addition to working as an architect he created, mostly in the Anglo-Japanese manner, cast-iron gates, stoves, and lawn ornaments that attracted international praise at exhibitions in London, Paris, Vienna, and Philadelphia, and may have influenced the Proto-Art-Nouveau metalwork of Antonio Gaudi in Barcelona. Beginning in 1870 Jeckyll designed several rooms and the needed furniture in a new wing of a house at No. 1 Holland Park that had been acquired by Alexander Ionides; particularly successful were his floor-to-ceiling sets of shelves for the display of blue and white porcelain,

and a billiards room in which Japanese lacquered trays, color prints, and paintings on silk were inserted into a pattern of oak frames that covered the walls and the ceiling.

Whistler began his own career as a decorator in 1863 and 1864 by arranging in his first Chelsea house, at 7 Lindsey Row, his collection of blue and white Chinese porcelain, Oriental furniture, and Japanese prints, *kakemonos*, screens, fans, and lacquer work; an idea of the effect can be got from his early fancy-dress Japanese paintings, although they probably show concentrations of material usually dispersed. After 1866, at 2 Lindsey Row, he became more orderly and economical, possibly under the influence of Godwin's elegant simplicity; he painted the room normally used as a studio in gray and black, did the drawing room, where Mrs. Leyland posed, in flesh color and yellow, and substituted matting for the Oriental rugs he had previously favored. Over the years he developed a liking for stained, bare floors and the use of plain distemper, yellow and white especially, on walls; he felt that the absence of patterned wallpaper made his pictures stand out better. But he was not exclusively attached to bareness; at 2 Lindsey Row he painted a sailing ship on the wall of the entrance hall and enriched the staircase with painted flowers and a dado done in gold leaf.

His personal interiors, although they were seldom quite finished and were sometimes marred by the presence of suitcases and shipping crates, gave him a reputation as an innovating designer. In 1873 he received a commission from his friend Sir Henry Cole for a mosaic in the main gallery of the South Kensington Museum; the project got as far as a cartoon and then petered out, but left behind it a pleasant pastel of a young woman with a parasol which suggests a temporary return to his dream of combining classicism with *japonisme*. That same year Cicely Alexander's father was engaged in redecorating the recently acquired Aubrey House in Kensington, and Whistler was asked to help. He responded by doing a white drawing room which was finally altered, austerity not being what was really wanted, by the addition of a set of tapestries.

He also made some suggestions to the Alexander family for a blue and gold harmony and the use of a peacock motif; these were not adopted at Aubrey House, but were soon to prove important in another decorative context and even more so in his emotional life. There was nothing very original, to be sure, about being interested in peacocks. Rossetti had had peacocks in his backyard zoo, and they had made so much noise a special antipeacock clause was finally added to the lease for 16 Cheyne Walk. Peacocks and peacock feathers were familiar motifs to admirers of Japanese prints and silks. (A large print by Eisho, *The Courtesans Hashidate, Ayakoshe, and Hanahito in the Peacock Room*, is very close to Whistler's project, although not a demonstrable source.) In 1867 Godwin had slipped a Japanese peacock into the ornamentation of his Gothic-Revival Dromore Castle in Ireland, and during 1873 he designed some peacock wallpaper. By the end of the decade the vogue was such that a bride-to-be in a *Punch* cartoon, asked where she was going to live, could reply: "Oh, in dear old Kensington, I suppose—everything is so cheap there, you know! Peacock feathers only a penny apiece!" Vogues, however, were always something more than mere vogues to Whistler; he had a way of absorbing them and transforming them into private obsessions and eccentricities—and also, into peculiarly original artistic programs.

By the middle of the 1870s he was almost a professional decorator, confidently giving advice to friends and patrons, showing benighted house painters how to mix colors, and on occasion working closely with Godwin; some furniture and a Primrose Room—alternatively labeled Harmony in Yellow and Gold—on which the two men collaborated were exhibited successfully at the Paris international fair of 1878. Unfortunately these creations, along with the bright, relatively bare interiors of the Chelsea houses, have not survived, and so we can only imagine, with the help of a few pictures and incomplete contemporary description, the full achievement of Whistler as a pioneer of modern design. Possibly it was nearly as important, with due allowance for the differences in categories, as his achievement as a painter.

In any event there is unjust art-historical irony in the fact

that the one decorative ensemble of his that has come down to us practically complete should be a heavily eclectic, scandal-provoking, madness-tinged dining room, executed in accidental collaboration with Thomas Jeckyll for Frederick R. Leyland in 1876 and 1877, dismantled and shipped to the United States in 1904, and now installed, far from the house and the life in which it made some sort of sense, in the Freer Gallery of Art in Washington. In this enterprise Whistler exercised no control over the material components and the basic pattern of the design, and he chose to work in a lush manner quite different from the simple one he usually advocated and frequently adopted. Moreover, he was suffering from one of the worst attacks of hubris in his career.

Leyland in 1876 was a lean, sharklike man of forty-five with a grave, Piero della Francesca face and a deserved reputation as a splendid example of both the High Victorian self-made entrepreneur and the High Victorian self-taught connoisseur. Starting as a boy apprentice in the offices of the Bibby Steamship Line in Liverpool, he had become general manager in his early thirties and had finally transformed the firm into the Leyland Line, with extensive operations in the Mediterranean and ambitions in the Atlantic. He spoke French and Italian fluently, and played the piano well enough to warrant dreams of reaching the professional level. His collection of paintings included works by Botticelli, Crivelli, Filippo Lippi, Burne-Jones, Rossetti, Millais, Legros, G. F. Watts, Ford Madox Brown, and Albert Moore, plus the Whistler portraits (when delivered), a Whistler nocturne, and the *Princesse du Pays de la Porcelaine*. Among his other treasures were Renaissance bronzes, Oriental rugs, Beauvais tapestries, French desks, Chippendale chairs, German, Italian, Portuguese, and Indian inlaid cabinets, Genoese velvet curtains, and, of course, blue and white Chinese porcelain. What might be called his only eccentricities were a liking for the company of Chelsea artists, a preference for Georgian frills instead of a black Victorian cravat, and a passion for keeping track of things: he always knew exactly where each of his ships was, and exactly how much money he had advanced on a commission for a picture. His principal defects were a cold severity in his manners

and a bad temper that sometimes led him to make a scene with his wife in front of guests. He was capable, however, of long periods of patience, indulgence, and immense financial generosity, particularly with painters.

With the purchase of Speke Hall in the late 1860s he had risen from the status of a Liverpool business baron to that of a landed gentleman. To complete his ascent he had felt a need for a place in London where he could entertain during the winter social season, display his collections of pictures and furnishings, and become even more of a modern Medici than he was already; and so, after experimenting in a preliminary setting in Queen's Gate, he had bought, sometime around 1874, a large house at 49 Princes Gate, opposite Hyde Park and near the cluster of museums and mansions that had made Kensington the center of the British art establishment. The building was an undistinguished construction of the 1850s; he seems to have been anxious to avoid the external show that might have marked him as a provincial upstart. But by early 1876 the interior had been completely and sumptuously rebuilt, under the general direction of Norman Shaw, the most fashionable architect of the period. Three living rooms were separated by folding walls that could be pushed aside so as to create a baronial hall ninety-four feet long. From the recently demolished Northumberland House, the ancient town seat of the Dukes of Northumberland near Charing Cross, came a late-eighteenth-century staircase with a bronze balustrade.

The dining room, where Jeckyll was put in full charge of the designing, perhaps because of his success at the Ionides house, was particularly striking—and particularly eclectic. ("To speak most tenderly," Godwin remarked later, "it was at the best a trifle mixed.") The ceiling was strongly reminiscent of the fan-vaulted Tudor ceiling of the Watching Chamber in Hampton Court Palace, with gaslight fittings occupying the stalactite pendants. For displaying the collection of blue and white china there was a profusion of walnut shelves, with delicately carved walnut vertical supports that from a distance suggested a small forest of bamboo. The wrought-iron firedogs were sunflowers in a Japanese manner.

Above the fireplace, in a shallow recess formed by the woodwork, was *La Princesse du Pays de la Porcelaine*. The floor was covered by a large rug with a bright red border. The shelves and walls were lined with brown Cordovan leather decorated with small red flowers; according to one story the material had reached England as booty from the Spanish Armada, and according to another it had arrived in the baggage of Catherine of Aragon.

Whistler was just then on especially intimate terms with the Leyland family; he was apparently half in love with the beautiful, red-haired Mrs. Leyland, whom he often escorted about London, and for a while he was engaged to her younger sister—very quietly, one gathers, since neither Maud nor anyone else in Chelsea seems to have been informed until long afterward. So he was inevitably involved in the decoration of 49 Princes Gate. He began by painting floral motifs on some panels of the staircase and by adding some delicate cocoa color and gold to a hall. In April, 1876, Mrs. Leyland informed him that "Jeckyll writes what color to do the doors and windows in the dining room," and added: "I wish you would give him your ideas." And that, as things turned out, was the beginning of the undoing of what Jeckyll had done with walnut and old Spanish leather. Whistler suggested that the red border of the rug and the red flowers on the leather clashed with the colors in *La Princesse du Pays de la Porcelaine*. When Leyland agreed, the border was cut off and the flowers repainted in yellow and gold. But by then Whistler was inhabited by the rubbing-out and revising demons that made posing for him such martyrdom; he was shocked, he said, by the effect of the yellow and gold on the leather. Leyland, distracted by worries about his shipping line's entry into the Atlantic trade, thereupon gave permission for further adjustments of the color scheme, and before they could be carried out departed with his family for what became a stay of several months in Liverpool and at Speke Hall.

Left alone in the house in Princes Gate, Whistler was seized by his annexationist demon. Postponing a planned etching expedition to Holland, France, and Venice, he went to work. By September he had changed much of the Spanish leather into a harmony of

primrose and gold, and he felt justified in sending a letter of triumph to Leyland: "Mon cher Baron—Je suis content de moi! The dining room is really alive with beauty—brilliant and gorgeous while at the same time delicate and refined to the last degree—I have enfin managed to carry out thoroughly the plan of decoration I had formed—and I assure you, you can have no more idea of the ensemble in its perfection, gathered from what you last saw on the walls, then you could have of a complete opera judging from a third finger exercise!—Voilà—but don't come up yet—I have not yet quite done—and you mustn't see it till the last touch is on. . . . There is no room in London like it mon cher . . ." From subsequent events it is clear that Leyland was vexed to learn that what he had intended to be mere adjustments of the color clashes had turned into a complete redecoration of his already fabulously expensive dining room. But he did not have the time for an immediate inspection trip to London, and he decided that since the job was nearly finished he had little choice except to wait and see.

What happened next was described by Whistler, in one of his reports to the Pennells, as a kind of spiraling into perfection and ecstasy: "Well, you know, I just painted as I went on, without design or sketch—it grew as I painted. . . . And the harmony in blue and gold developing, you know, I forgot everything in my joy in it!" He did indeed forget many things, including notably that he was not in his own house and that he had not been authorized to do what he was doing. But that he worked "without design or sketch" was not strictly true, for shortly after writing the "cher Baron" letter he abandoned the primrose and gold idea, revived and modified the peacock scheme he had thought up for Aubrey House in 1873, and started all over again on the by now nearly unrecognizable Spanish leather. Through the autumn of 1876 and the following winter, laboring in a fever of euphoria and arrogance that sometimes kept him in Princes Gate from seven in the morning until after midnight, he changed Leyland's property and Jeckyll's creation into a Whistlerian environment, signed in four places with the butterfly and entitled, as if it were simply an-

other one of his pictures, *Harmony in Blue and Gold: The Peacock Room*. The feathers of the modish bird, and in particular the "eyes" in the feathers, were used to create decorative clouds in the small panels defined by the workwork. There were proud peacocks on the shutters of the room, and a pair of aggressive peacocks on the wall opposite *La Princesse du Pays de la Porcelaine*. The "harmony" shifted from gold on blue to blue on gold and then back to gold on blue, with an intensity that promised to kill completely the effect of any future display of blue and white porcelain.

While the patron continued to be detained in Liverpool by Atlantic affairs, the artist began to keep open house in Princes Gate so that everybody who was anybody in London might see what a dazzling masterpiece was under way; at the height of his hubris he wrote an explanatory pamphlet and left printed copies to be picked up by the customers of Liberty's and other fashionable shops. Alan Cole came and made a succinct diary entry: "W. quite mad with excitement." Lord Redesdale came, and tried to suggest a need for caution: "But what of the beautiful old Spanish leather? And Leyland? Have you consulted him?" The reply was prompt: "Why should I? I am doing the most beautiful thing that has ever been done, you know, the most beautiful room." Godwin, Poynter, and Sir Henry Cole came. So did the painter Alma-Tadema and the lovely Mrs. W. J. Stillman, née Marie Spartali. So did the Prince of Teck, of the royal house of Württemberg. Lady Ritchie, Thackeray's eldest daughter, appeared one afternoon, and the delighted Whistler grabbed her and waltzed her from one peacock to another. Queen Victoria's sculptress daughter, Princess Louise, came; so did the Duke of Westminster and scores of less notable people. Sometimes they found Whistler, his black curls and white lock sprinkled with gold, playing the busy professional with his two unpaid assistants, the Greaves brothers, but when special guests were coming he might stage a more aesthetical performance. An anonymous journalist was present one day when the guests must have been very special:

> "This is what they saw on entering—a very slim spare figure extended on a mattress in the middle of the floor: beside him

an enormous palette, paints, half a dozen long bamboo fish-poles on a line with their butts close at hand, and a very large pair of binocular glasses. Mr. Whistler, dressed wholly in black velvet, with knickerbocker pantaloons stopping just below the knees, black silk stockings, and low pointed shoes, with black silk ties more than six inches wide and diamond buckles, was flat on his back, fishing-rod in hand and an enormous eyeglass in one eye, diligently putting some finishing touches on the ceiling, his brush being on the other end of the fishpole. Occasionally he would pick up his double glasses, like some astronomer peering at the moon, and, having gained a near and better view of the effect, he would again agitate the paintbrush at the other end of the long pole."

On February 9, 1877, there was a private viewing for the press, and the result was a victory for Whistlerian publicity combined with a defeat for Leyland's hope of settling in London without looking like an attention-seeking social climber. More than a dozen papers and periodicals, including the *Times*, printed favorable notices. The critic for *London* spoke of "a paradise of peacocks, and a blending of Occidental audacity and Oriental taste . . . all the beauty that *bizarrerie* can give." The man from the *Academy* wrote: "He has worked with immense zeal and spirit, and has produced a salient triumph of artistic novelty—too uniformly gorgeous, it may readily be conceived, for some tastes, but singularly captivating . . . it will long remain to the eye and mind a type of what artistic enterprise and conception *sui generis* can effect, in combination with opulence." The elated artist wrote to his mother, who from about this time spent most of each year in Hastings for the sake of her health, that he had created a "noble work." He obviously felt no regret over having altered Jeckyll's conception and having received nearly all the credit for the final achievement, although early in the proceedings, in a letter to the *Academy*, he had been willing to acknowledge "the inspiration I may have received from the graceful proportions and lovely lines about me." In any event, Jeckyll was past caring in any rational way, for by the beginning of 1877 his peculiarities had developed

into incurable insanity. Was the Peacock Room a contributing cause? Many contemporaies thought so, and Whistler himself, on learning of the crack-up, could not resist remarking: "To be sure, that is the effect I have on people." But the only recorded direct evidence is a story that poor Jeckyll was found trying to paint the floor of his apartment gold.

Toward the end of February the overweening began to have its predictable consequences. Mrs. Leyland appeared unannounced at 49 Princes Gate and overheard the cackling voice of Whistler referring apparently to some of the furnishings: "Well, what can you expect from a parvenu?" She ordered him out of the house and then relented sufficiently to let him add the last touches to the shutters, which he did during the first week of March. By April Leyland was back in London, probably not insensible to the qualities of the Peacock Room but thoroughly determined not to put up with any more arrogance. Soon a long, violent quarrel over payment was under way. Whistler demanded two thousand guineas (the equivalent of about fifty thousand dollars in the money values of a century later). Leyland, very generously when the circumstances are considered, sent a check for a thousand pounds. Whistler then became insulting and menacing, partly because of the size of the check and partly because of the fact that, whereas English tradesmen were paid in pounds, English gentlemen were usually paid in guineas. In July Leyland replied to the insults and menaces with a letter that must have hit Whistler like a sledge-hammer blow in the belly:

> "You chose to begin an elaborate scheme of decoration without any reference to me until the work had progressed so far that I had no choice but to complete it; and it is really too absurd that you should expect me to pay the exaggerated sum your vanity dictated as its value. . . . Five months ago your insolence was so intolerable that my wife ordered you out of the house—and to anyone with an ordinary sense of dignity I should have thought this was notification sufficient. The fact is your vanity has completely blinded you to all the usages of civilized life, and your swaggering self-assertion has made you an unbearable nuisance to everyone who comes in

contact with you. There is one consideration, indeed, which should have led you to form a more modest estimate of yourself, and that is your total failure to produce any serious work for so many years. At various times during the last eight or nine years you have received from me sums amounting to one thousand guineas for pictures, not one of which has ever been delivered . . . at the time so many newspaper puffs of your work appeared, I felt deeply enough the humiliation of having my name so prominently connected with that of a man who had degenerated into nothing but an artistic Barnum."

After that the war was virtually over, although skirmishing continued until the end of the year. When Whistler denied that Mrs. Leyland had actually ordered him out of the house, Leyland returned the letter with a suggestion that it be kept "with the newspaper cuttings you are in the habit of carrying about with you." When Leyland threatened to appear on Lindsey Row with a whip to punish any inclination to see the Leyland women, who in fact kept out of the quarrel, although the engagement with Mrs. Lelland's sister was broken off, Whistler replied with a not altogether successful attempt (preserved in the undated draft of a letter) to mix dignity with wit: "It is positively sickening to think that I should have labored to build up that exquisite Peacock Room for such a man to live in. You speak of your public position before the world, and apparently forget that the world only knows you as the possessor of that work they have all admired and whose price you have refused to pay. . . . Your last incarnation with a horsewhip, I leave to you to work out. Whom the gods intend to be ridiculous they furnish with a frill."

The Debacle
1877-1879

The challenge of private enterprise to the domination of British art by the Royal Academy was strengthened in May, 1877, with the opening of the Grosvenor Gallery, a large and luxurious establishment in New Bond Street near the corner of Grosvenor Street. The founder, Sir Coutts Lindsay, was a distinguished soldier, an occasional writer on aesthetic matters, an occasional painter, and a wealthy banker. The director, J. Comyns Carr, was a competent critic and the friend of many artists; in 1875 he had amused Mayfair with the production of *A Cabinet of Secrets*, a musical play gently satirizing the craze for porcelain. The decoration of the gallery included gilded pilasters and furniture, a monumental fireplace, crimson damask and green velvet drapery, and a ceiling frieze by Whistler showing stars and some phases of the moon in silver on a blue background. There was a restaurant on the premises, and the Prince of Wales was present for the inaugural banquet.

Although the place soon acquired a reputation as a temple of the vaguely defined Aesthetic Movement, the opening group exhibition was not exactly a leap into the future; Whistler and the slightly PRB Burne-Jones were represented, but so were the classicizing Leighton, Poynter, and Alma-Tadema, and even the aca-

demic-sentimental Millais. Whistler, who in recent months had been too busy with the Peacock Room to do much easel painting, sent a selection of available work that included *The Fur Jacket*, the *Carlyle*, the *Irving*, and some nocturnes, the most important of which were *Old Battersea Bridge* and *The Falling Rocket*. The immediate critical reaction, both private and printed, was unfavorable enough to wipe out the effect of the winter triumphs in Princes Gate. Even Sir Coutts was cool concerning the nocturnes, and Millais, after peering at one of them, remarked: "It's damned clever, it's a damned sight *too* clever." The *Athenaeum* referred in passing to a "whimsical, if capable, artist and his vagaries." The *Times*, evidently determined to be unfair, found in the *Irving* "an entire absence of details, even details generally considered so important to a full-length portrait as arms and legs," and added: "In fact, Mr. Whistler's full-length arrangements suggest to us a choice between materialized spirits and figures in a London fog."

The most contemptuous reaction, however, came from John Ruskin, who was at the height of his reputation as a moralizing art critic and social reformer. He had attended the gala opening of the Grosvenor, had disliked the nocturnes intensely, and had found the price asked for *The Falling Rocket*, two hundred guineas, downright revolting. In the July issue of *Fors Clavigera* (translatable without all the connotations as "force, or fortune, the club-bearer"), his monthly "letter" to British workmen, he let himself go with a recklessness unusual even in Victorian art criticism: "For Mr. Whistler's own sake, no less than for the protection of the purchaser, Sir Coutts Lindsay ought not to have admitted works into the gallery in which the ill-educated conceit of the artist so nearly approached the aspect of wilful imposture. I have seen and heard much of Cockney impudence before now, but never expected to hear a coxcomb ask two hundred guineas for flinging a pot of paint in the public's face."

There are several explanations for the bitterness and grossness in these lines. Ruskin, although capable of provocative speculation and fine descriptive prose about art, was a very erratic judge of contemporary work; and he had fallen into the habit of substitut-

ing moralizing, or economic righteousness, or simply thunderous abuse for critical analysis and an open sensibility. Like many muddled critics, nineteenth-century ones in particular, he thought that the value of a picture was somehow related to the amount of labor put into it, and so he had long been smoldering about Whistler's lack of "finish"; in an Oxford lecture of 1873, referring apparently to work on view in the Dudley Gallery, he had launched a preliminary version of the "pot of paint" attack: "I never saw anything so impudent on the walls of any exhibition, in any country, as last year in London. It was a daub professing to be a 'harmony in pink and white' (or some such nonsense); absolute rubbish, and which had taken about a quarter of an hour to scrawl or daub—it had no pretense to be called painting. The price asked for it was two hundred and fifty guineas." Understandably, when he found the same kind of daub at the Grosvenor Gallery he was outraged. Moreover, and this is an excuse as well as an explanation, by 1877 he was already on the brink of the madness that would turn the last years of his life into an obscene nightmare. In Italy in 1874 he had had spells of being, in his own words, "fearfully despondent and confused." At Oxford in 1875, in front of his dumfounded students, he had once suddenly broken into a hopping, gesturing, gown-flapping dance. In 1876, fearful of what he might say, he had not dared to lecture. In 1878 he would go completely insane for a while and have visions of Satan, in the form of a huge black cat, leaping out from behind a bedroom mirror and ordering the commission of an unnameable sin. Possibly the incipient madness was specifically relevant in 1877, for on many occasions it manifested itself as a morbid fear of spots of light like those in *The Falling Rocket*. Possibly, too, there was some sort of doubling back in time and reversing of roles going on in the darkening mind that conceived the paragraph in *Fors Clavigera*, for in 1842 the young and lucidly poetic Ruskin had begun writing his *Modern Painters* partly because of his irritation with a magazine article that had denounced Turner for painting "as if by throwing handfuls of white, blue, and red at the canvas, and letting what would stick, stick."

Whistler, of course, could not have known all these explana-

tions, and would probably have rejected them if he had, for such words as "conceit," "imposture," and "coxcomb" were aimed with dismaying accuracy at sensitive parts of his imaginary self that had to be defended at all costs—and that were at the moment being rubbed raw by the quarrel over the Peacock Room. When he saw the article he said to a friend who happened to be with him in the smoking room of the Arts Club: "It is the most debased style of criticism I have had thrown at me yet." And on July 28, 1877, he sued Ruskin for libel.

There was a delay of sixteen months before the case was heard in court, and these months were a demonstration of what the Victorian art establishment could do to an outsider who dared to challenge it seriously. An art patron who bought a Whistler, in particular a nocturne, had always had to be willing to face a public opinion that regarded an aesthetic emphasis as immoral. As early as 1869 Tennyson had written:

> Art for Art's Sake! Hail, truest Lord of Hell!
> Hail Genius, Master of the Moral Will!
> "The filthiest of all paintings painted well
> Is mightier than the purest painted ill!"
> Yea, mightier than the purest painted well,
> So prone are we toward the broad way to Hell!

The patron also had to be willing to be made fun of; a du Maurier cartoon published by *Punch* in 1875 has a group of female aesthetes reversing Whistler's musical analogy and complimenting a pianist, Herr La Bémoiski, on the chiaroscuro in his diminuendos, and one published in February, 1877, has an Ineffable Youth with a monocle telling a Matter-of-Fact Party: "Subject in art is of no moment. The *picktchah* is beautiful." After the Ruskin attack, however, the patron had additionally to face being regarded as a fool with money, and this deterrent soon proved stronger than any of the others.

Whistler had been living for years partly on tradesmen's credit, friends' loans, and buyers' advances; now his whole rickety financial system, deprived of the willingness to bet on his future that had held it together, began to disintegrate. He had to offer

unsold pictures, including the *Mother* and the *Carlyle*, as security for small loans. Occasionally he was reduced to borrowing shillings for cab fare. He wrote bad checks and then had to scramble for the money to keep his victims from calling on the police. At one point he let Howell have the *Irving* for ten pounds and a sealskin coat. His worries were increased when, sometime in 1877, Maud gave birth to a daughter. (The child, who was christened Ione, seems to have been raised by friends or relatives; in any event she remained legally as unrecognized by the father as was her half-brother, the "infidelity to Jo.") Bigger worries came from the fact that, with truly suicidal optimism, he had committed himself to the construction of a new house in Tite Street, in the relatively modern east end of Chelsea near Wren's Royal Hospital. Godwin was the architect, and the main idea was to have a studio large enough to accommodate students and permit the creation of an *académie* like those on the Paris Left Bank.

The sale of etchings, owing largely to the efforts of the devoted and unscrupulous Howell, helped to ward off immediate disaster. In 1878, with the aid of the London lithographic printer Thomas R. Way, Whistler returned briefly to lithography, a medium he had not tried since his experiments in the United States in 1855; he produced some attractive prints and then, discouraged by the lack of public response, postponed further efforts. Among his other odd jobs during this period were nineteen drawings of blue and white porcelain done as illustrations for a catalogue of the collection of Sir Henry Thompson; in this instance the instigator was the dealer Murray Marks. Sir Henry was an outstanding example of the all-around Victorian; in addition to being a connoisseur of china, he was the best known surgeon of his day, a pioneer in cremation, an authority on diet, a student of astronomy, a novelist under the name Pen Oliver, and a painter who exhibited at the Royal Academy. In his house at 35 Wimpole Street he gave dinner parties called "octaves"; the hour was eight, the guests were eight, and the courses were eight. On other occasions he might let his pet cobra appear at his table, where it dined on mice.

Perhaps to show a proper defiance of Ruskin, Sir Coutts Lind-

say exhibited at the Grosvenor during the summer of 1878 one of the portraits of Maud, *The Young American*. The *Times* spoke of a "diet of fog" and the *Athenaeum* commented: "Last year some . . . portraits were without feet; here we have a curiously shaped young lady, ostentatiously showing her foot, which is a pretty large one." Undismayed by this reception, Whistler decided to try to get Disraeli to pose for him, and found with the help of Howell a print dealer in Pall Mall who was ready to pay a thousand pounds for the oil portrait and the engraving rights. Disraeli, in the Whistlerian version of what happened, declined the honor in a long and courteous interview: "Everything was most wonderful. We were the two artists together—recognizing each other at a glance." According to the reminiscences of Whistler's friend Graham Robertson, the aged statesman, approached by the would-be portraitist in St. James's Park, said: "Go away, go away, little man."

Somehow, to the accompaniment of an accumulating debt and quarrels with municipal officials who objected to the anti-Victorian bareness of the facade, the new place on Tite Street was finished by the autumn of 1878. Because of its white-painted brick exterior, it was named the White House. Its low, boxy, three-storied profile, oddly although functionally placed windows, unemphatic ornaments, green slate roof, and blue door made it look like an improvised cottage in comparison with the Kensington-Pompeian palaces of such crowd-pleasing painters as Alma-Tadema and Leighton. Whistler took proud possession of it at the end of October and furnished it with, among other Oriental items, a Turkish carpet, a Persian carpet, Indian matting, many Japanese hand screens, a Japanese carved armchair, a pair of Chinese clogs, and three butterfly cages. He showed visitors around with exclamations of "A gem, ha?" and "Perfect." He could not, however, have had many illusions about the length of his stay, for his creditors were already closing in. The entry for October 16 in Alan Cole's diary reads: "Poor J. turned up depressed—very hard up, and fearful of getting old."

The libel action, which asked a thousand pounds in damages, was heard on November 25 and 26, 1878, in the Court of Exchequer

Division, at that time located in a dark maze of legal chambers around the Houses of Parliament. The presiding judge was Baron Huddleston, a well-known jurist with a fondness for humorous asides and a weakness for giving strong hints to a jury on what it should think. A crowd that included some of the most prominent members of London's artistic community filled the courtroom and overflowed into the surrounding passageways. Ruskin had been pronounced too ill to appear, and he was probably as disappointed by his absence as the crowd was, for at the beginning of the suit he had said: "It's nuts and nectar to me, the notion of having to answer for myself in court, and the whole thing will enable me to assert some principles of art economy which I've never got into the public's head by writing. . ."

Whistler, called to the witness box, began by playing his Russian-princeling and military-man roles: "I am an artist and was born in St. Petersburg. I lived in that city for twelve or fourteen years. . . . After leaving Russia I went to America and was educated at West Point." But he quickly abandoned the staginess for a defense of himself as a serious painter, pointing out that he had studied under Gleyre in Paris, exhibited at the Royal Academy, won a gold medal in Holland, and enjoyed the honor of having his etchings collected for the British Museum and the Queen's library at Windsor Castle. He stressed the fact that *Nocturne in Black and Gold: The Falling Rocket*, the principal target of the *Fors Clavigera* attack, was the only picture he had offered for sale in the Grosvenor Gallery show. He went on to define his art-for-art's-sake intentions: "I have perhaps meant rather to indicate an artistic interest alone in the work, divesting the picture from any outside sort of interest which might have otherwise attached to it. It is an arrangement of line, form, and color first; and I make use of any incident of it which shall bring about a symmetrical result. Among my works are some night pieces, and I have chosen the word 'nocturne' because it generalizes and simplifies the whole set of them."

When the attorney general, Sir John Holker, acting as counsel for Ruskin, turned to cross-examination, the audience found the

trial more entertaining. "I suppose," Holker said, "you are willing to admit that your pictures exhibit some eccentricities. You have been told that over and over again?"

"Yes, very often." (Laughter.)

"You send them to the gallery to invite the admiration of the public?"

"That would be such vast absurdity on my part that I don't think I could." (Laughter.)

"Did it take you much time to paint the *Nocturne in Black and Gold?* How soon did you knock it off?" (Laughter.)

"I knocked it off possibly in a couple of days—one day to do the work, and another to finish it."

"And that was the labor for which you asked two hundred guineas?"

"No, it was for the knowledge gained through a lifetime." (Applause.)

Baron Huddleston threatened to clear the court if this manifestation of feeling was repeated. Holker then suggested that the plaintiff did not approve of art criticism, and Whistler replied: "I should not disapprove in any way of technical criticism by a man whose life is passed in the practice of the science which he criticizes, but for the opinion of a man whose life is not so passed I would have as little opinion as you would have if he expressed an opinion on law." When *Nocturne in Blue and Gold: Old Battersea Bridge* was brought out for inspection by the jury, Huddleston intervened in the questioning.

"Is this part of the picture at the top old Battersea Bridge?" (Laughter.)

"Your lordship is too close at present to the picture to perceive the effect which I intended to produce at a distance. The spectator is supposed to be looking down the river towards London."

"Are those figures on the top of the bridge intended for people?"

"They are just what you like."

"That is a barge beneath?"

"Yes. I am very much flattered at your seeing that. The thing

is intended simply as a representation of moonlight. My whole scheme was only to bring about a certain harmony of color."

William Michael Rossetti, testifying for the plaintiff although he was also a friend of the defendant, said that he had much admired, if "not without exception," the Whistler pictures in the Grosvenor Gallery show; he thought that *The Falling Rocket,* while not "a gem," was "painted with a considerable sense of the general effect of such a scene," and was worth two hundred guineas. Albert Moore was more effective: "I have seen most of the picture galleries in Europe. I have studied in Rome. . . . The two pictures produced [in court], in common with Mr. Whistler's works, have a large aim not often followed. People abroad charge us with finishing our pictures too much. In the qualities aimed at I say he has succeeded, and no living painter, I believe, could succeed in the same way in the same qualities. I consider them to be beautiful works of art. There is one extraordinary thing about them, and that is, that he has painted the air, especially in the Battersea Bridge scene. The picture in black and gold [*The Falling Rocket*] I look upon as simply marvellous." Moore was followed by Whistler's third and last witness, William Gorman Wills, a painter and dramatist who had had plays produced by Sir Henry Irving and who thought that *The Falling Rocket* and *Old Battersea Bridge* were masterpieces.

The first witness for Ruskin was Burne-Jones, who began by granting that there was good color in *Old Battersea Bridge* and then switched to condemnation: "It is . . . bewildering in form. As to composition and detail, there is none whatever. It has no finish." He declared that *The Falling Rocket* was "only one of a thousand failures that artists have made in their efforts to paint night." Asked if he thought the picture worth two hundred guineas, he said: "No, I cannot say it is, seeing how much careful work men do for much less. Mr. Whistler gave infinite promise at first, but I do not think he has fulfilled it. I think he has evaded the great difficulty of painting, and has not tested his powers by carrying it out." William Powell Frith, the painter of the enormously successful *Derby Day* and *Railway Station*, then took the stand and asserted that, while

Whistler had "very great power as an artist," *The Falling Rocket* was not a serious work and the colored moonlight of *Old Battersea Bridge* was not better than what "you could get from a bit of wallpaper or silk." The last Ruskin witness was Tom Taylor, who wielded multiple authority as a poor law commissioner, the editor of *Punch*, and an art critic for the *Times*. Much of his testimony took the form of reading allegedly relevant extracts from his published articles. "All Mr. Whistler's work," he said, "is unfinished. It is sketchy. . . . I have expressed, and still adhere to the opinion, that these pictures only come 'one step nearer pictures than a delicately tinted wallpaper'."

The judge remarked for the benefit of the jury that "there are certain words by Mr. Ruskin, about which I should think no one would entertain a doubt: those words amount to a libel." He wondered, however, if the case could not be considered one "for merely contemptuous damages to the extent of a farthing, or something of that sort, indicating that it is one which ought never to have been brought into court." The jury took the hint and after deliberating for an hour returned with a verdict for the plaintiff, damages one farthing. Baron Huddleston emphasized his view of the case by decreeing that each side should bear its own costs.

Whistler pretended to regard the verdict as a victory, although he had been awarded only token damages and now found himself with about five hundred pounds in legal fees added to his debts. Ruskin chose to regard the verdict as a defeat and reacted by resigning his Slade professorship of fine arts at Oxford, on the inflated pretext that he had "no power of expressing judgment without being taxed for it by British Law." In fact the trial had been a disappointment from every point of view. The plaintiff's counsel had failed to press vigorously enough the one point the jury and the judge might have been capable of understanding, which was that a painter's ability to earn a living had been gravely diminished by a denunciation that went far beyond the limits of legitimate art criticism. The famous defendant, whose angry eloquence, mad or not, might have lifted the crowd's mood above the level of shabby hilarity, had failed to appear. The defense witnesses

had talked feebly about finish, sketchiness, and wallpaper instead of meeting Whistler's aesthetic arguments squarely and seizing the opportunity to stage an enlightening public debate on British subject painting versus Continental painterly painting, a debate that might have anticipated twentieth-century arguments over figuration versus abstraction and thus deflected, if only slightly, the course of art history. Whistler himself, in spite of his relevant remarks about line, form, and color and about "divesting the picture of any outside sort of interest," had wandered from the central aesthetic issues into a foolishly marginal one concerning the right of nonpainters to talk about painting. And immediately after the trial, in a pamphlet entitled *Whistler v. Ruskin: Art and Art Critics*, he continued to insist on fighting on the wrong terrain; he thought that letting an apothecary run the Greenwich Observatory, or Tennyson run the College of Physicians, would not be worse than letting "gentlemen of the quill" hold forth on pictures. Tom Taylor, in better form than when testifying, replied that art criticism controlled by painters "would be a case of vivisection all round."

What the lawsuit had demonstrated principally was that the witty plaintiff was more isolated than he had suspected. In a situation that should have led artists to close ranks against the threat of critical dictatorship, the only well-known painter in all of England willing to stand up and be counted had been the normally shy Albert Moore. Such old friends as Charles Keene and Thomas Armstrong had merely expressed their sympathy in private, and Arthur Severn had taken the side of Ruskin. Frequent guests for dinner or Sunday breakfast in Lindsey Row, including Tissot, had run for cover early in the battle. William Michael Rossetti had not been an adequate substitute for Dante Gabriel. Poynter, recently elected a full member of the Royal Academy and not inclined to remember the days on the Paris Left Bank, had refused to permit the citing in court of letters he had written in praise of some of the nocturnes. Leighton, guilty of the same sort of praise in an unguarded moment, had also refused permission to be quoted. Burne-Jones, when his part of the harm was done, does seem to have felt

genuinely contrite. "I wish," he wrote to D. G. Rossetti, "all that trial-thing hadn't been; so much I wish it, and I wish Whistler knew that it made me sorry, but he would not believe." Preserved legal briefs, however, reveal that when the pressure had been strong a ruthless Burne-Jones had informed Ruskin's counsel that Whistler was to British artists "a matter of joke of long standing" and a braggart with "a perfect estimate of the value of . . . trumpeting."

By the beginning of 1879 the trumpeting was turning into attempts to blast enemies with the supposed power of Whistlerian sarcasm. Tom Taylor became a target by protesting, in a letter published in the gossipy newspaper *The World*, that his opinion of Velázquez had been deliberately garbled and misrepresented in the pamphlet *Art and Art Critics*, all of which was true. Whistler replied, also in the letters column of *The World*, with an elaborate pretense of having killed the critic, presumably by exposure in print: "Dead for a ducat, dead! my dear Tom: and the rattle has reached me by post. . . . Bah! you scream unkind threats and die badly." Taylor then tried to be quietly withering: "Pardon me, my dear Whistler, for having taken you *au sérieux* even for a moment. I ought to have remembered that your penning, like your painting, belongs to the region of chaff. I will not forget it again . . ." Whistler retaliated with more of the "dead" gag: "Why, my dear old Tom, I never *was* serious with you, even when you were among us. Indeed, I killed you quite, as who should say, without seriousness, 'A rat! A rat!' you know, rather cursorily." Meanwhile, *Vanity Fair* was opening another front by pointing out that Whistler had slipped badly in *Art and Art Critics* by referring to Balaam's ass as the first critic, for in fact the ass had been right: it really had seen the angel of the Lord. A note from the White House acknowledged the slip without letting art critics benefit: ". . . I fancy you will admit that this is the *only Ass on record* who ever *did* 'see the Angel of the Lord!' and that we are past the age of miracles."

Unfortunately, the sarcasm did not cancel debts. Creditors

who had been patient for years lost their patience and descended' on Tite Street; they appear to have been particularly alarmed by the information that, whereas loyal supporters were subscribing to a fund to pay Ruskin's costs in the trial, an attempt to do the same for Whistler had failed. Bailiffs with court writs appeared regularly at the White House, and occasionally even consented, on the basis of unkept promises of extra wages, to act as servants during Sunday breakfasts. Attempts to pay with pictures instead of money did not succeed; to one such attempt the secretary of the Arts Club replied: "It is not a Nocturne in purple or a Symphony in blue and grey that we were after, but an Arrangement in gold and silver."

Finally, on May 8, 1879, there came what Rossetti called the arrangement in black and white: a bankruptcy petition. Whistler had liabilities of 4,641 pounds (well over a hundred thousand dollars in today's values) and assets of 1,924 pounds. He owed large sums to such friends and patrons, or ex-friends and ex-patrons, as Leyland, Huth, Alexander, Jeckyll, Howell, and the lithographic printer Thomas Way, and a total of some 800 pounds to wine merchants, fish dealers, bakers, tailors, shoemakers, frame makers, and other tradesmen. The house was mortgaged and the fees for the libel suit still unpaid. The creditors proved to be good-hearted, and stipulated merely that the affairs of the debtor should be liquidated, which meant he would not have to endure the inconvenience and humilation of remaining a bankrupt until a court discharged him. Leyland, Howell, and Way were chosen to act as an examining and inventorying committee, and their activity was delayed, intentionally or not, long enough to allow the destruction or secret disposal of a number of pictures in the White House.

Whistler manifested no gratitude for the gentlemanly treatment he was receiving. The symptoms of delusions of grandeur he had exhibited during the Peacock Room crisis now became symptoms of delusions of persecution, focused on the Peacock Room as the turning point in his luck. At a meeting of the creditors in the Inns of Court Hotel he had to be called sharply to order after launching into an abusive oration about British millionaires, one in particular. He devoted part of the time he had been granted in his

studio to painting three satires against Leyland that can be fairly described as evidence of abnormality, particularly in their preoccupation with Leyland's addiction to frilled shirts. Two of the paintings, entitled *Mount Ararat* and *The Loves of the Lobsters: an Arrangement in Rats*, have been lost; the first is said to have shown Noah's ark and little figures in frills, and the second a red crustacean in a frilled shirt, while the reason for the subject matter and the ararat-rat-loves-lobsters word play remains obscure. The third picture is the Art-Nouveauish *Gold Scab*, which represents Leyland as a loathsome peacock wearing a frilled shirt, sitting on the White House, and playing a piano piece inscribed, with a stress on his initials, "The Gold Scab, Eruption in FRiLthy Lucre"; frills appear also in the creature's crest, around its claws, on the tail of a note in the score, and on some of the letters in the musical title. In addition to these three oils Whistler did an unknown number of pen and ink caricatures of his former benefactor; two of the surviving ones are marked "F.R.L. frill."

Two magazine articles, both of which appeared in August, helped to give the bitterness an anti-British flavor. In *Scribner's Monthly* an American critic, W. C. Brownell, came out strongly in Whistler's support. In *Nineteenth Century* the British critic and etching expert Frederick Wedmore published an infuriating mixture of jocular condemnation and patronizing praise. Whistler was described as "long ago an artist of high promise" who had turned into "an artist often of agreeable, though sometimes of incomplete and seemingly wayward performance." The *Irving* was a "murky caricature of Velázquez," the *Carlyle* a "doleful canvas," and other paintings "somewhat apt to be dependent on the innocent error that confuses the beginning with the end." The nocturnes were sketches with "an effect of harmonious decoration, so that a dozen of them on the upper panels of a lofty chamber would afford even to the wallpapers of William Morris a welcome and justifiable alternative," but such pictures suffered "when placed against work not, of course, of petty and mechanical finish, but of patient achievement." The etchings were often good enough to promise immortality, but "for his fame Mr. Whistler has etched too much,

or at least has published too much." The essay wound up with a hope that the future would "forget his disastrous failures, to which in the present has somehow been accorded, through the activity of friendship, or the activity of enmity, a publicity rarely bestowed upon failures at all." Wedmore henceforth occupied a prominent place in Whistler's lengthening list of unforgivably hostile "Islanders."

Obviously it was time for another trip, for a Baudelairean journey to "anywhere so long as it is out of this world." It was also the moment to return to etching, a medium in which catastrophes had been relatively infrequent. Both requirements were met by a providential commission from the Fine Art Society, whose gallery in Bond Street had recently had some commercial success with prints showing old Battersea Bridge and other sights of the Thames: Whistler was to receive a hundred and fifty pounds in expense money for three months in Venice, where he was to etch a series of twelve plates destined to be printed in an edition of a hundred impressions. Early in September he left for Italy, after making arrangements for Maud to join him and after inking a partly biblical inscription into the stone lintel over the front door of the White House: "Except the Lord build the house, they labor in vain that build it. E. W. Godwin, F. S. A., built this one." Exactly what he meant by these words is hard to fathom. Perhaps, at the moment of abandoning his dream house forever, he suddenly felt a need for some solemn, fine-sounding phrases, and did not care what they meant. The biblical verse may have drifted into his mind from a before-breakfast recitation with Anna Mathilda in New England or St. Petersburg, or it may have come to him, as it does to many Londoners, from the Latin version on the floor of the central lobby in the House of Parliament. But all this does not explain why he should have substituted "build" for the correct "keep" in the first clause and should have thus skidded into saying that Godwin had labored in vain. Could he have been reaching for an obscure joke based on "God"

and "Godwin"? Decidedly, he was not functioning with his usual lucidity during the summer of 1879.

Many of his possessions had been disposed of at an auction in Tite Street in May. On September 18, a few days after the departure for Venice, the White House itself was sold, for twenty-seven hundred pounds to Harry Quilter, a Cambridge intellectual, an amateur painter, and the art critic for *The Spectator*. Some odds and ends of household effects and some rolled-up, badly damaged paintings went with the house, but other paintings, some prints and drawings, the best pieces of blue and white Chinese porcelain, and a few unusual pieces of furniture were reserved for a sale that took place the following February 12 in the auction rooms of Sotheby's. The Dowdeswell Gallery bought the *Gold Scab* for twelve guineas, in spite of efforts by Leyland to have the picture removed before the bidding began. The Japanese screen that had served as the background for the *Princesse du Pays de la Porcelaine* went to Howell. The *Connie Gilchrist* brought only fifty guineas. Oscar Wilde, freshly down from Oxford and for the moment inclined to fall in love with actresses, paid five guineas for a drawing that was wrongly catalogued as a portrait of Sarah Bernhardt. In all the sale realized three hundred and twenty-eight pounds and nineteen shillings. If Whistler, who was probably somewhere on the Grand Canal, could have heard the low bids he might have decided that at Sotheby's he touched bottom in his humiliation.

Venetian Interlude
1879-1881

To a nineteenth-century Londoner interested in the visual arts and literature Venice was nearly as familiar as Trafalgar Square. The National Gallery was well supplied with the work of Canaletto, British tourists having been his principal buyers. Byron had galloped on the Lido beach and dallied in the palaces on the Grand Canal. Turner had used the Lagoon as important nourishment for his visions of fire and water. Ruskin had explored the city monument by monument in *The Stones of Venice* and had metamorphosed it into both a lesson for sinners and a prose nocturne, "a ghost upon the sands of the sea . . . so bereft of all but her loveliness, that we might well doubt, as we watched her faint reflection in the mirage of the lagoon, which was the City, and which the Shadow." A series of minor Victorian oil painters and watercolorists—among whom James Holland, Edward Pritchett, and J. W. Inchbold are today not quite forgotten—had made the Venetian view an expected thing in Bond Street galleries and Royal Academy shows. In short, Venice had been done. Whistler must have been slightly worried by the fact as the steam vaporetto took him and his luggage down the Grand Canal to his first lodgings. He must also have felt a twinge of the relative disappointment long

anticipation can provoke, and perhaps a twinge of the fear of getting old he had had on moving into the White House. Originally inspired by Jo's copper tresses and the water motif, the idea of going to Venice dated back at least to 1862, when it had been discarded in favor of the trip to Biarritz and the hope of getting to Madrid. He had revived it in 1876 and discarded it again, this time for the sake of the Peacock Room. Now that he was at last realizing it, he found himself suddenly forty-five.

He began by renting a room in the seventeenth-century Palazzo Rezzonico, which had not yet been converted into a museum. Soon he moved to a small house near the vast, bare, brick hulk of the Church of the Frari. Then he discovered more suitable quarters on the half-slum, but picturesque, banks of the Rio di San Barnaba, the alleylike canal that enters the Grand Canal alongside the Palazzo Rezzonico. Maud arrived in October, still styling herself Mrs. Whistler and loyally ready to share his bad luck. Little by little, although the autumn of 1879 was rainy and the following winter the coldest in thirty years, he got to know Venice and its works of art. He wrote to his mother that he liked the city best "after the wet." He went to the Scuola di San Rocco, obtained permission to climb up on a ladder for a close view of the paintings, and decided mysteriously that Tintoretto's technique was similar to his own. After attending mass at the Basilica of San Marco he decided that the Peacock Room "was more splendid in effect than the Byzantine Church with its golden domes." He admitted, however, that Titian and Veronese were "great swells," and he continued to express an admiration for Canaletto first conceived in the London National Gallery.

Weeks went by before he was able to settle down and do some work. He spent part of his time writing to England to find out what had become of pictures that had been sold or had been left as security for loans. Acquaintances remembered seeing him wandering about Venice in the bitter cold looking for subjects; he wanted to avoid as much as possible the familiar landmarks, and whenever he sat down to sketch he had a feeling, he said, that "there was something still better round the corner." When the Fine

Art Society wanted to know how he was getting on with the com-
missioned twelve etchings, he replied with a request for more ex-
pense money, and eventually succeeded in getting some two hun-
dred pounds more than what had been promised. He assured the
American consul, who seems to have wondered at the display of
insouciance by a well-known bankrupt, that idleness was a virtue
in an artist. But by the end of 1879 he was beginning to produce
some pastels, some etchings, and an occasional painting; and soon
he was back in the confident mood that usually followed one of his
spells of loafing. He told his mother that he was on the job "the
first thing at dawn and the last thing at night." Although he nor-
mally preferred to work from a window or a balcony, when the
good weather arrived he sometimes hired a gondola and floated
about town with crayons, a supply of pastel paper, and a pile of
grounded etching plates in the bottom of the boat.

Within a few months he was re-creating his old life, including
his life as a student on the Left Bank, much as if the quarrel with
Leyland, the Ruskin trial, and the bankruptcy had never occurred.
Through the American consul he met well-to-do American resi-
dents of Venice and began to dine out again. For the stovepipe hat
he had usually worn in London he substituted a soft, wide-
brimmed, Velázquez-brown creation, tilted far back on his head
so as to form a halo for his curly black hair and white lock. In the
evening he might appear in one of his white suits, or in formal dress
made singular by the absence of a necktie; in the daytime he wore
a dark sack suit and a shirt whose extremely low, turned-down
collar left most of his neck bare—an affectation which Baudelaire
had favored in the 1850s and which the Goncourts had labeled
toilette de guillotiné. For his old Paris cafés he substituted Florian's,
in the Piazzo di San Marco, or a less expensive place, the Orientale,
on the Riva degli Schiavoni. A participant in the talk, a young
American named Ralph Curtis, noticed the French slant: "Very
late, on hot sirocco nights, long after the concert crowd had dis-
persed, one little knot of men might often be seen in the deserted
Piazza, sipping refreshment in front of Florian's. You might be
sure that was Whistler in white duck, praising France, abusing

England, and thoroughly enjoying Italy. He was telling how he had seen painting in Paris revolutionized by innovators of powerful handling: Manet, Courbet. . . . To [him] it was a treat when a Frenchman arrived in Venice. If he could not like his paint, he certainly enjoyed his language. French seemed to give him extra exhilaration."

The regression to the Bohemian dandy of the Latin Quarter was encouraged by the arrival, in the spring of 1880, of the American painter Frank Duveneck, who had been teaching in Munich and who brought with him a group of students who had been following him around Europe. Whistler met Duveneck's Boys, as the students were called, through the still helpful American consul, and decided to move from the Rio di San Barnaba into their headquarters in the Casa Jankovitz, a large rooming house overlooking the Lagoon from a site on the Riva degli Schiavoni about halfway from the Doges Palace to the Public Gardens. Although he had no inclination toward the bravura style of painting favored at the moment by the Munich School, he was soon doing his best to become in other respects one of Duveneck's Boys. He went swimming with them and worried them by trying to dive as well and stay under water as long as they did. He invited them to Sunday breakfasts, substituting a local red wine for the Burgundy he had served in Lindsey Row. Forgetting his anti-British stance, he entertained them by singing the popular imperialist song of the period:

> We don't want to fight,
> But, by jingo! if we do . . .

For their benefit he performed Left Bank student pranks; one day in the Piazza di San Marco he sneaked up behind an earnest Ruskinian who was painting the basilica and pinned to a dangling coattail a card reading: "I am totally blind." Also for their benefit he kept up a patter of jokes and attempts at jokes, one of which involved using the third person instead of the first; he would say "Whistler is charmed," or "Whistler has decided . . ." Perhaps, in the midst of so much playing of roles, he felt a need for some sort

of psycho-theatrical distance between his inner "I" and the stage Whistler.

The circle of new, young friends was expanded to include artists who were not pupils of Duveneck's, and during the early phases of the camaraderie everyone seems to have been delighted; after all, to be working in Venice was already something, and to be working there in the company of the famous adversary of Ruskin was doubly something. As the summer advanced, however, the camaraderie must have often exhibited signs of strain, for Whistler became less and less excusable in his behavior. His jocular use of the third person became a reminder to Duveneck's Boys that he was to be treated as an internationally known master, as a man who had already made a name in the history of art. When the etcher Otto Bacher, one of the more experienced students, was daring enough to have a personal opinion, the call to order was brisk: "Bacher, you don't know to whom you are talking—you are talking to Whistler." If Bacher found an interesting motif, the annexationist demon was aroused: "When you find a good one like this, you should not do it, but come and tell Whistler." When there was talk about some paintings by Corot, the objection was that they had been done before. By whom? "Whistler." When Whistler was composing one of the letters he was now in the habit of sending to newspapers, everybody had to listen while Whistler read aloud and lingeringly savored his frequently labored witticisms.

Worse than the egocentrism was the fact that the return of the forty-five-year-old dandy to the *Vie de Bohème* included a return to the techniques for stealing paint that had been perfected during copying sessions in the Louvre, and also a return to Murgeresque financial sponging. Bacher appears to have been lucky; in the account he wrote of his Venetian stay he says that Whistler "rarely ever asked the other boys for money" and on one debt-paying occasion "insisted on giving me twice as much." A different picture of the situation emerges from a letter written in the fall of 1880 by Henry Woods, an English painter who had settled in Venice:

"Whistler, I hear, has been borrowing money from every-
body, and from some who can ill afford to spare it. He
shared a studio for five or six months with a young fellow
named Jobbins. Jobbins never could work there with him in
it. He (Whistler) invited people there as to his own place,
and has never paid a penny of rent. He used all the colors he
could lay his hands upon; he uses a large flat brush which he
calls 'Mathew,' and this brush is the terror of about a dozen
young Americans he is with now. Mathew takes up a whole
tube of cobalt at a lick; of course the color is somebody else's
property. There are all sorts of conspiracies against Whistler.
He is an epidemic, an old-man-of-the-sea. These young chaps
were quite flattered at first when he joined them. It made me
roar when I heard of his goings on amongst them, he evi-
dently pays for nothing. There is no mistake that he is the
cheekiest scoundrel out. . . . I am giving him a wide berth.
It's really awful. There will be *Grande Festa* if he ever goes
away."

He did go away in November; after fourteen months of Ven-
ice he felt that "Whistler must get back to the world again," and
to him the world was London. With the help of the terrible
Mathew's licks, he had managed to complete a few small oils, the
best of which is the misty, darkly luminescent night view of San
Giorgio Maggiore entitled *Nocturne in Blue and Silver: The La-
goon, Venice*. Risking comparison with Turner, he had also done
some watercolors—surprisingly, his first serious attempts to handle
a medium that was well suited to his search for atmospheric effects.
The most important results of his stay, however, were some fifty
etchings and nearly a hundred pastels; and of these he was so proud
he staged a private dinner-viewing in the Casa Jankovitz shortly
before his departure. Ralph Curtis remembered particularly the an-
ticipations of British reactions: ". . . the hour for the hors d'oeuvres,
consisting of sardines, hard-boiled eggs, fruit, cigarettes, and excel-
lent coffee prepared by the ever-admirable Maud, was arranged for
six o'clock. Effective pauses succeeded the presentation of each
masterpiece. During these entr'actes Whistler amused his guests with
witty conjectures as to the verdict of the grave critics in London

on 'these things.' One of his favorite types for sarcasm used to be the eminently respectable Londoner who is '*always* called at eight-thirty, close-shaved at a quarter to nine, and in the City at ten.' 'What will he make of *this?* Serve him right, too! Ha ha!' "

The crowing was justified. The etchings, with allowances for a few attempts to please the Londoner who was close-shaved at a quarter to nine, succeed admirably in avoiding the merely topographical category and the stereotyped panoramas of Canaletto; yet they also succeed, by use of frequently unlocalized motifs, in evoking a place and a flavor that are immediately recognizable. Such prints as *The Doorway* and *The Garden* sample a picturesque, decaying city of rusty grilles, leprous walls, and sagging, water-lapped steps—the Venice that already in 1880 was sinking, reportedly hopelessly, into the mud. Although we may not be able to specify the sites of *The Beggars* and *The Traghetto*, and although we may not find the ferry referred to in the title of the second print, there can be no mistake about the thoroughly Venetian quality of those dark passageways opening onto bright spaces at their far ends. Even the more conventional views of the Lagoon, the Rialto, and the Riva degli Schiavoni have something at once unhackneyed and essentially Venetian in their perspectives and their play of light and shade. (All these plates, incidentally, were done on the spot without reversing the scenes; hence the viewer who wants to get his bearings should look at the prints in a mirror.) Contributing to the unexpectedness of the total effect is an etching style that has come a long way, via some experiments in London in the 1870s, from the dense explicitness of the French Set and the poetic tangle of the Thames Set toward an extremely unorthodox combination of calligraphic scribbling, blank spaces, and painter's tonal values. Sometimes the scribbling and blanking out were continued during the printing—most of which was done by Whistler himself in London—to such an extent that each impression might be said to represent a different state of the plate. Sometimes the nuances in tonal values are nearly all that counts; each print of *Nocturne: Palaces*, for instance, comes close to being simply a kind of offset painting, or a monotype, so little does it owe

to etched lines and so much to the way the virtuoso artist-printer varied the quantity and distribution of ink on the plate.

The pastels are equally apt to annoy a purist, although in their subject matter they are less unexpected than the etchings. The pastel medium, after a decline in popularity during the first half of the nineteenth century, was finding new admirers in the second half; it appealed to the same sensibilities that were responding to the English Aesthetic Movement, to French Impressionism, to Japanese color prints, to eighteenth-century Rococo, and to a general brightening of European palettes. A Société des Pastellistes had been founded in Paris in 1870, and a Pastel Society in London a few years later. During the same decade Degas had begun to execute major works in pastel or in a mixture of pastel with other media. Whistler, exercising his usual ability to scent a trend, had not waited for Venice to seduce him into the movement; he had long been using pastel for preliminary portrait studies, and in the late 1860s he had used it for a fully elaborated figure piece, *Annabel Lee*, in his Greco-Japanese manner. His Venetian works, however, are special both in their European context and in the context of his previous career. They are done on a colored paper, usually brown, of which he found a good supply in an old warehouse back of the shops in the main business street of Venice, the Merceria; and most of them are too linear and too bare to be called pastels, if by "pastel" one means the traditional kind in which finger-rubbed pigment covers the entire support. In fact, most are just sketches in black chalk on a brown background, completed by the addition of thin, scattered patches of color: a scruffing of white or yellow on a wall, a scruffing of red or green on a costume, and a smudge of blue on the otherwise brown sky. The viewer is asked to regard these patches as parts that represent wholes, as instances of synecdoche in color; and the result of this do-it-yourself approach can be a summoning forth of large sections of the chromatic pattern of a city that changes constantly under the influence of water-reflected light. Once again the difference between the insistent stage Whistler and the reticent artist is striking.

It was the stage Whistler, for the most part, who returned to London and proceeded down New Bond Street to the Fine Art Society, where the director of the gallery, Ernest Brown, was busy with a group show; and it was the stage Whistler who described the event to the Pennells: "Well, you know, I was just home; nobody had seen me, and I drove up in a hansom. Nobody expected me. In one hand I held my long cane; with the other I led by a ribbon a beautiful little white Pomeranian dog; it too had turned up suddenly. As I walked in I spoke to no one, but putting up my glass I looked at the prints on the wall. 'Dear me! dear me!' I said, 'still the same old sad work! Dear me!' And Haden was there, talking hard to Brown, and laying down the law, and as he said 'Rembrandt' I said 'Ha ha!' and he vanished . . ."

The Pomeranian, the only Whistlerian dog on record, remained a part of the London act for several weeks and then it too vanished. The homeless artist, after staying for a while at his brother Willie's house in Wimpole Street, found rooms for himself and Maud at 76 Alderney Street, not far from Victoria Station. The Fine Art Society paid him a fee of twelve hundred pounds, minus the expense money advanced, for the rights to twelve selected plates, and published them in December as *Etchings of Venice*—a title later commonly altered to First Venice Set. An exhibition accompanied the publication and provoked many of the reactions that had been anticipated at the private dinner-viewing in the Casa Jankovitz; most of the potential buyers balked at the sketchiness of the prints and at the lack of familiar Venetian monuments. The critic for *Truth* spoke of "another crop of Mr. Whistler's little jokes." The *Daily News* man decided that "London fogs and the muddy old Thames supply Mr. Whistler's needle with subjects more congenial than do the Venetian palaces and lagoons." Harry Quilter, the new owner of the White House, referred in his *Spectator* article to viewers "who feel painfully the absence in these works of any feeling for the past glories of Venice."

In January, 1881, the Fine Art Society exhibited fifty-three of the pastels, and this time everything went much better. Whistler wrote a special catalogue and gave it the brown paper cover

that would henceforth be used for most of his publications. He designed new frames, redecorated his part of the gallery, supervised the hanging, and obtained from his friend Godwin an admiring article in the *British Architect*: "First, a low skirting of yellow gold, then a high dado of dull yellow-green cloth, then a moulding of green gold, and then a frieze and ceiling of pale reddish brown. The frames are arranged on the line; but here and there one is placed over another. Most of the frames and mounts are of rich yellow gold, but a dozen out of the fifty-three are in green gold, dotted about with a view of decoration, and eminently successful in attaining it." A large and fashionable crowd appeared for the opening. Millais shouted: "Magnificent, fine, very cheeky, but fine!" When somebody exclaimed that the price of one of the pastels, sixty guineas, was "enormous," Whistler was ready with a reminder of the Ruskin trial: "Ha ha! Enormous! Why, not at all! I can assure you it took me quite half an hour to do it!" The smartness, the publicity, the effrontery, and the sheer quality of the pictures themselves paid off, in spite of some grumbling from critics about transatlantic impudence. Shortly after the opening Maud wrote to Otto Bacher: "The best of it is, all the pastels are selling. Four hundred pounds' worth the first day; now over a thousand pounds' worth are sold." By the time the show closed the amount had risen to eighteen hundred pounds.

Satisfaction was shattered by the death, at Hastings, on January 31, of Anna Mathilda. She had passed her seventy-fourth birthday, her sight had begun to fail seriously, and her mind had begun to wander, but she died with the shocking suddenness of her baby Charles on the steamer to Kronstadt. Whistler went to Hastings and spent much of the time before the funeral taking long walks with Willie or Willie's wife Helen on the windy, wet cliffs above the town near the romantic ruins of William the Conqueror's castle. He said that he had not become what his mother had hoped for, that he had not been kind enough to her, and that he had not written to her often enough from Venice; one afternoon he went so far in his remorse as to say: "It would have been better had I been a parson as she wanted." She was buried in Hastings, no one

having apparently thought of sending her to the New England cemetery where the major and his four young sons lay. Later that year, however, Whistler did agree to send his portrait of her to America, and it became one of his first paintings to be seen in the United States since he had left for Paris. It was exhibited at the Pennsylvania Academy of Fine Arts in Philadelphia and a few months afterward—thanks to the insistence of the painter Julian Alden Weir, the son of the West Point drawing instructor—at the Society of American Artists in New York. Then, no buyer having come forward, it was returned to London and to a Pall Mall print dealer who had taken it as security for a loan.

Unfulfilled Promise
1881-1885

On May 26, 1881, Alan Cole noted in his diary: ". . . met Jimmie, who is taking a new studio in Tite Street, where he is going to paint all the fashionables; views of crowds competing for sittings; carriages along the streets." The reason for this burst of day-dreaming turned out to be a rented flat at No. 13, near the White House, decorated in a yellow intense enough to make Howell complain that being in it was like "standing inside an egg." Soon it contained the beginnings of another collection of blue and white Chinese porcelain, along with what paintings Whistler had been able to recover from his former creditors, thanks to his Venetian-pastel windfall and probably to a small inheritance after the death of his mother. The Sunday breakfasts were resumed, with buckwheat cakes and Burgundy. The host poured the wine with his usual dramatic pauses, told improvised versions of Poe's tales, and frequently recited what he called his favorite poem:

> Tell this soul with sorrow laden if, within the distant Aidenn,
> It shall clasp a sainted maiden whom the angels name Lenore . . .

The guests soon included as many of "the fashionables" as had appeared at 2 Lindsey Row in the good years before the attack of peacock overweening and the alleged flinging of the pot of paint.

The envisaged "crowds competing for sittings," however, did

not materialize; carriage traffic in eastern Chelsea remained normal. The Ruskinian deterrent still functioned. Nor was this the worst of the situation, for the scattered portrait commissions that did arrive were accompanied by squads of the familiar, fierce old scraping, repainting, and wiping-out demons, each capable of wrecking a canvas irreparably or of driving an exasperated client out the studio door forever. They provoked in the unhappy artist more and more of the tendency he had recently manifested in Venice, a shrinking away from the execution of works in oil that were large enough and complex enough to be regarded as "major" by the average gallery visitor. In fact, such works became infrequent enough in the years following the Venetian interlude to be regarded simply as interruptions in a long, painful demonstration of how, for a wide variety of discoverable and undiscoverable reasons, the creative energy of a gifted man may become blocked in its proper channels, or diminished when it does flow, or diverted into relatively trivial surrogate activity. From the early 1880s onward there was a stronger sting in the typical London critic's stock remarks about unfinished sketches and unfulfilled promise.

The first commission came in 1881 from the pretty, full-bosomed, quick-tempered Mrs. Henry B. Meux, who became Lady Meux two years later when her husband, a wealthy London brewer, was knighted. Whistler did a Velázquez court portrait of her in a black velvet dress and a cloak trimmed with white fur, and entitled the result *Arrangement in Black No. 5;* he followed this variation on his *Mrs. Huth* of 1873 with a warm-hued variation on his *Mrs. Leyland,* entitled *Harmony in Flesh Color and Pink: Valerie, Lady Meux.* Encouraged by these signs of a recovery of vigor, he began a third portrait of the young woman, which was paid for in advance but destroyed without being finished. Harper Pennington, a cosmopolitan artist who had been in Venice the year before, happened to be in the Tite Street studio when the final block occurred: "For some reason Jimmy became nervous, exasperated, and impertinent. Touched by something he had said,

her ladyship turned softly towards him and remarked, quite softly, 'See here, Jimmy Whistler! You keep a civil tongue in that head of yours, or I will have in some one to *finish* those portraits you have made of me!' with the faintest emphasis on 'finish.' Jimmy fairly danced with rage. He came up to Lady Meux, his long brush tightly grasped, and actually quivering in his hand, held tight against his side. He stammered, spluttered, and finally gasped out, 'How dare you? How dare you?' but that, after all, was *not* an answer, was it? Lady Meux did not sit again."

The only other important commissioned work of these years that was finished and not destroyed or lost is *Arrangement in Flesh Color and Black: Théodore Duret*, which dates from around 1883. Duret, four years younger than Whistler, was an intelligent French aristocrat who spent his money and time on journalism, left-republican politics, art collecting, dandyism, flowers, wine-growing, and the defense of vanguard painters. He had supported the anti-Bonapartists during the Second Empire, and the ruined Courbet after the Paris Commune. From 1871 to 1873, as a companion of the economist Henri Cernuschi, he had toured Japan, China, and India, buying trunkloads of art objects, some of which are today in the Musée Cernuschi, on the edge of the ultra-Parisian Parc Monceau. He had been a benefactor of the Impressionists and dissidents since 1865, when he had met Manet in Madrid; in 1878 he had published a pamphlet praising Sisley, Monet, Pissarro, Renoir, and Berthe Morisot. For years he had been coming over to London each spring to see the roses in Kew Gardens and consult his tailor in Savile Row, and during these trips he had maintained a friendship with Whistler that had begun with an introduction by Manet. (He eventually wrote biographies of both artists.) In 1879 he had written for the *Gazette des Beaux-Arts* on the Ruskin trial, and in 1881 an article for the same review on the Venice etchings in Bond Street. His good will, his patience, and his knowledge of painters' problems undoubtedly helped to make the portrait what it is—one of Whistler's strongest character-izations and most successful arrangements of figure and ground.

The sittings, however, were the usual ordeal, involving the usual repainting of the entire picture whenever a detail in the tonal relationships looked unsatisfactory.

When Duret was not available, work proceeded on an uncommissioned portrait, *Arrangement in Black: Lady in the Yellow Buskin, Lady Archibald Campbell,* in which a Velázquez background of unrealized dusky space sets off a fetching example of Late Victorian, almost Edwardian, sophistication and stylishness. Lady Archibald, who lived in Chelsea part of the year, was the wife of the second son of the eighth Duke of Argyll, and not inclined to forget that she was her ladyship. But she was also a dreaming Bohemian aesthete, an ardent experimenter in spiritualism, a friend of Godwin and Wilde, and an amateur actress who loved to disguise herself as an Arabian prince or an artist in a blue smock. Whistler made several attempts to paint her that ended in destroyed canvases, and the survival of *Lady in the Yellow Buskin* was a near thing. Walter Sickert, at that time a Whistler disciple, was present at a supposedly final session when the sitter asked if there was any need to touch up the picture. "Not touch it up," was the disconcerting reply, "give it another beautiful skin." One evening after Lady Archibald had gone home Whistler climbed up on a chair with a lighted candle and gravely examined the details of the day's work; then he started for dinner with Sickert, stopped on the pavement, and said: "You go back. I shall only be nervous and begin to doubt again. Go back and take it all out." Sickert did so, with the usual rag and benzine. On another occasion Duret found Lady Archibald in a hansom in Tite Street ready to give up definitely; leaping dramatically on the step of the cab and pleading that a masterpiece was at stake, he persuaded her to return to the studio. She remained displeased, however, and when the picture was at last pronounced finished she refused to buy it.

Early in the summer of 1884 a surge of energy and self-control resulted in the completion of another uncommissioned and unsold work, *Arrangement in Black: Pablo de Sarasate.* The famous violinist, who was at that moment particularly popular in London, had shown little interest in the project and had accepted

the invitation to pose only after his manager, looking perhaps for publicity, had insisted. Whistler also may have had publicity in mind; if so, the fact did not keep him from lavishing on the picture a remarkable distillation of his fondness for Velázquez, Spain, darkness, pensiveness, and mysterious backgrounds—possibly along with his fondness for himself, since he must have noticed a certain physical resemblance between Sarasate and himself. The size of the butterfly signature suggests a return of confidence and optimism, a new vision of crowds competing for sittings and of carriages jamming Tite Street. But once again the vision failed to materialize, and once again the scraping, repainting, and wiping-out demons appeared. Soon the number of abandoned large canvases was increasing at an alarming rate while their supposed subjects, in Sickert's words, were "getting tired, or growing up, or growing old." Soon, too, the quality of what was finished, or nearly finished, began to decline. Although Whistler went on attempting full-length studies intermittently during the remaining nineteen years of his career the *Sarasate* was the last one in which he came anywhere near the standard of the major portraits of the 1870s.

Baffled by bigness, he turned to smallness. Typical of his trend in the early 1880s is the foot-high *Arrangement in Pink and Purple*, for which Maud probably posed. Less than six inches high is *Note in Green and Brown: Orlando at Coombe*. The occasion for this second miniature was a production of *As You Like It* by Lord and Lady Archibald Campbell in the woods near their country estate at Coombe, in Surrey, with Lady Archibald herself playing Orlando. Godwin designed the costumes, and carried authenticity to the point of using honest wool and real rawhide.

The production of etchings continued, in a style that was often even less "finished" than that of the Venice plates; and the subjects reveal that during these years Whistler spent a good deal of his time wandering in the London that lay beyond the horizons of most Chelsea aesthetes—in Drury Lane, in Piccadilly, in the slums of the East End, and in the old Jewish quarter around Houndsditch and Petticoat Lane. He also resumed his travels outside London; in April, 1881, he was in Paris, late in 1883 he spent several weeks

in the Cornish fishing villages of Newlyn and St. Ives, and the next year he went to Holland, principally Dordrecht, and to the English Lake District, finding the latter a disappointing region of "little round hills with little round trees out of Noah's Ark."

Something in the process of engraving a plate, perhaps a feeling that he might save any bad situations by the mere exercise of his craftsmanship, seemed to steady his nerves; at any rate he seldom bogged down when engaged in this branch of his art. The printing process, however, often meant a return of the demons, for in his handling of the ink he tried to get tonal effects similar to those he sought in his paintings. He was capable of spending an entire day pulling proofs, only to reject the lot as unsatisfactory. In spite of what appear to have been honorable intentions, he never got around to finishing the hundred impressions of the First Venice Set he had promised the Fine Art Society.

In other enterprises his problem by the early 1880s was not so much finishing as starting. After the Venetian trip there were no more oils comparable to the marines and nocturnes of the 1860s and 1870s. Their place was taken by a growing number of watercolors and especially by on-the-spot oil sketches of daytime beaches, seas, skies, country vistas, and urban facades. Good examples of these sketches are *Grey and Silver: The Angry Sea, A Note in Blue and Opal: The Sun Cloud, A Note in Green: Wortley*, and *Chelsea Shops*, but almost equally good ones were turned out by the constantly traveling artist nearly everywhere he went. They became a habit. The best have the witty concision of Japanese poetry, and many have been praised for anticipating, in their simple patterns of rectangles and their tendency to keep everything parallel to the picture plane, the effects of modern abstract painting. Sickert went so far as to call them "masterpieces of classic painting." A less partial eye, however, may feel obliged to notice that they are, after all, merely rapid, attractive notations in thin Whistlerian "sauce" and that they are disturbingly tiny: the majority are on wood panels averaging five by nine inches, the dimensions of a small cigar-box cover. Although they are evidence of a refined sensibility and a still intact talent, they are also ground for suspecting a lack of the

afflatus and stamina needed for more complex undertakings. Viewed in the light of the psychological circumstances in which they were produced, they look like a blocked artist's substitution of aesthetic play for creative work. Whistler himself, while willing to frame and exhibit them, once referred to them in a letter as "curious little 'games'," and he must have realized, in the midst of half disowning the word by quoting it, that that was about what they were alongside such pictures as *Wapping* and the nocturnal *Old Battersea Bridge*.

He had suffered from attacks of disabling doubt since at least the Valparaiso crisis, and he had always somehow emerged from them, freshly confident and productive. But now the malady that had been at times acute was showing symptoms of becoming chronic, and like other forms of impotence it was made worse by each unsuccessful attempt to recover from it. Among its long apparent, still operative causes were his real and imagined deficiencies in academic training, especially in drawing, and the consequences of his exaggerated belief in continuity of execution, in the necessity of starting over again whenever a detail went wrong; the portrait of Duret, for example, was scrubbed out and repainted ten times. Other perceptible causes were excessive tastefulness and a marked inability or unwillingness to invent scenes and motifs; although an avowed anti-Realist in theory, he still felt that the river had to be actually there and the ribbons actually on the sitter's dress. Complicating his technical problems was a frequent yearning for effects that were impossible in the oil medium: behind many of the half-ruined landscapes there was a vision that called for watercolor, and behind many of the somber, rubbed and rerubbed portraits a vision that called for a sensitive modern camera. Complicating his execution were some peculiarly irrational work habits, based on his fits of optimism and his capacity for self-deception. Harper Pennington noted: "Whistler's habit of painting long after the hour when anybody could distinguish gradations of light and color was the cause of much unnecessary repainting. . . . The fascination

of *seeming* to have caught the values led him far into the deceiving shades of night with often disastrous results."

To all this can be added a difficulty that sprang from his aesthetic doctrines and the dynamics of his personal painting style. He had abandoned Courbet's Realism, Parisian *japonisme*, and a version of Ingres' Classicism without extracting from them much that could be called a forward-moving historical program. His art-for-art's-sake stance was mostly a set of prohibitions, extremely hard to observe in practice without drifting into mere decoration. His musical analogies were mostly just poetic conceits, useful as titles to irritate the Islanders, but not as ways of organizing pictures. He had no philosophical underpinning for his art, nothing comparable even to the puerile metaphysics of the Pre-Raphaelites and their successors. Unlike the French Impressionists, and even less like the innovating Post-Impressionists who were emerging by the mid-1880s, he had defied traditional European painting from the inside, so to speak, and by a process of elimination and simplification, not by the introduction of radically new matters and methods. He had fomented a purge, not a revolution. Forthright British storytelling, moralizing, and sentimentalizing had been discarded as claptrap and replaced by nothing more substantial than moods and allusiveness—or self-reference, the real "subject" of more than one picture having finally become the picture itself, the pure arrangement. The broad variety of imagery in academic painting had been narrowed to principally the marine view and the single human figure, the latter increasingly in empty space. The range of colors and tone values permitted in a given picture had been severely reduced, the pleasure of linear perspective and foreshortening had been largely shunned, and the paint itself had been thinned often to the consistency of a juice that let the canvas or the panel show through. Although the results of this general attack on opulence had been a number of strikingly austere or admirably insinuating works, there was evidently a point beyond which an art based on elimination could not evolve, could only become an art of repeated effects, a special kind of academicism. That by the 1880s Whistler was at least tacitly aware of being close to the danger point looks

probable. His *Sarasate* reveals a determined effort to avoid repeating the effects of his earlier arrangements in black. His failure to do anymore nocturnes suggests a realization that the formula had reached a stylistic dead end. And in this context his tiny oil sketches can be regarded not only as curious little games and substitutes for buckling down to more serious work, but also as a desperately logical development in his career, as one more attempt to continue his personal sort of artistic reductionism. They imply knowledge of a discouraging block.

He had still other, more external reasons for less than confident feelings when he prepared his palette, picked up his long brushes, and faced a large expanse of virgin canvas. There was a strong chance that the picture, if finished, would simply join *The Little White Girl*, the *Mother*, the *Carlyle*, *The Falling Rocket*, *The Fire Wheel*, *Effie Deans*, *The Lagoon*, *Lady in the Yellow Buskin*, the *Sarasate*, and the other unsold works in the Tite Street studio. Meanwhile, Millais was earning more than thirty thousand pounds a year, Poynter was a prosperous royal academician, Leighton was president of the academy, Legros was director of the Slade School of Art, Tom Armstrong was director for art at South Kensington, du Maurier was an important man on the staff of *Punch*, Burne-Jones was an associate member of the academy, and any well-known artist in England could hope to be created a baronet. Whistler could feel that he was about the only man of his generation who was not sharing in the honors and money that went with the tremendous Victorian art boom, and he came to believe that this injustice had affected the quality of his art. Looking back at 1880s, he would remark: "Poverty may induce industry, but it does not produce the fine flower of painting. The test is not poverty, it's money. . . . If I had had, say, three thousand pounds a year, what beautiful things I could have done."

Across the Channel the situation was even more disturbing, for over there the evidence was pointing increasingly and irresistibly to the conclusion that, with all his considerable merits duly weighed, he was not in the same class as his great French contemporaries, most of whom he had known for years. Between

the Ruskin trial and the middle of the 1880s Monet, who seems never to have heard of artist's block, was turning out batches of dazzling canvases, beginning with his celebrated views of the Gare Saint-Lazare. Cézanne was getting into the series of revolutionary landscapes, nudes, portraits, and still lifes that would be the point of departure for much of twentieth-century painting. Manet, although near death, painted his *Bar at the Folies-Bergère* in 1881, Renoir his *Luncheon of the Boating Party* at about the same time, Degas his *Dancers Adjusting Their Slippers* around 1883, Seurat his *Sunday Afternoon on the Island of La Grande-Jatte* between 1884 and 1886; and this list is merely a sampling of the masterpieces produced in France during these years. Whistler, naturally, never openly expressed any misgivings about being outdistanced. Toward the end of his life he was patronizing and uncomplimentary about Manet and by implication the entire Impressionist and Neo-Impressionist movement. "Manet," he said, "did very good work, of course, but then Manet was always *l'écolier*—the student with a certain sense of things in paint, and that is all!—he never understood that art is a positive science, one step in it leading to another. He painted, you know, in *la manière noire*, the dark pictures that look very well when you come to them at Durand-Ruel's, after wandering through rooms of screaming blues and violets and greens, but he was so little in earnest that midway in his career he took to the blues and violets and greens himself." The work of Cézanne was dismissed in the same scornful fashion. It is easy, however, to see in the violent unfairness of such dismissals a sign of deep feelings of insecurity, perhaps even a sign of bitter regret over what might have happened if Whistler the young Second-Empire insider, the star dissident of the Café Molière and the Salon des Refusés, had not chosen to become Whistler the Victorian outsider.

From Tite Street he made some significant efforts, for the first time in fifteen years, to escape from his London isolation and reenter the brilliant French competition; in 1882 he exhibited the black and white *Lady Meux* at the Paris Salon, in 1883 the *Mother*, in 1884 the *Carlyle* and *Cicely Alexander*, and in 1885 the *Duret*. The results were a third-class medal for the *Mother* and relatively

mild critical objections that the *Duret* looked like a sketch for a portrait, all of which, if certainly an improvement over the rough old days of rejections and guffaws, was scarcely a reason for leaving Chelesa and settling again in France. Anyway, he was beginning to be, and would remain for the rest of his career, extremely touchy about the widespread tendency in both Paris and London to prefer his earlier paintings to his more recent ones. Oblivious to the possibility that he was revealing his doubts, he finally put his views on the subject into the form of a solemnly absurd historical law: "An artist's work is never better, never worse; it must be always good, in the end as in the beginning, if he is an artist, if it is in him to do anything at all."

In 1884 there were flurries of evidence that the Islanders might one day change their minds about him: in London he was elected a member of the Society of British Artists, and in Edinburgh a public subscription was proposed for the purchase of the *Carlyle* for the Scottish National Portrait Gallery. But the election was not much of an honor, for the Society of British Artists was a half-dead organization, a sort of permanent Salon des Refusés, that existed mostly as a refuge for young or second-rate painters who could not get their work into Royal Academy shows or the Grosvenor Gallery. And his pleasure in the movement to buy the *Carlyle* turned sour when he learned that potential subscribers were being informed that in contributing to the fund they were not necessarily expressing any approval of his art, the implication being that his distinguished Scottish sitter was the real reason for the campaign. He immediately sent a telegram to Edinburgh raising his price from four hundred to a thousand guineas, and to clinch the matter he inquired, obscurely but insultingly: "Dinna ye hear the bagpipes?" The organizers of the campaign thereupon abandoned it.

As the unfinished canvases accumulated, as his unavowed despair grew, as the threat to his ideal self, to his core role as an artist, became more grave, he devoted more and more of his energy to developing and publicizing the stage Whistler. He also gave rein to his egocentrism, his aggressiveness, and his delusions of grandeur and persecution. The people for whom he reserved his charm

and his peculiar tenderness became fewer and fewer, and both his charm and his tenderness became somewhat artificial. All this did not keep him from being apparently normal much of the time, and often quite witty. But those who knew him well and wished to get along with him had to watch their step and act on the assumption that he was not actually normal, that something had gone wrong, or perhaps had simply got worse, in his sense of what other people called reality.

He was entering middle age, an embarrassing state for all dandies and Bohemians, and he was not entering it with notable Southern-cavalier dignity. His clothes were becoming more vaude-villian, his cackle more strident. Edmond de Goncourt met him in Paris in the spring of 1881, and jotted down an impression for the *Journal*: "A queer creature, this American etcher named Whistler, with his naked neck, his lifeless laugh, his white lock in the middle of his black hair, his way of looking like a weird and macabre pederast." There were indications that his years of struggle against the Victorian art establishment and against his own doubts had seriously diminished his once immense store of nervous energy; as early as 1882 he had a humiliating habit, which eventually became notorious, of suddenly dropping off to sleep, and sometimes snoring, during dinners to which he had been invited for the sake of his conversational powers. He occasionally wore pink bows on his shoes. When he went to his hairdresser's in Regent Street a small crowd might gather while he directed every detail of the cutting and shampooing and screamed for proper combs with which to arrange the feathery white lock. When he went to a newspaper office to write one of his numerous letters to editors he might be seized by the same manic meticulousness that marred his painting; he would then spend an afternoon littering the floor with first drafts of a supposedly devastating paragraph. He became a favorite subject for London caricaturists. After 1881 and the beginning of the long run of Gilbert and Sullivan's *Patience*, he became confused in the public mind with the drooping aesthetes of Kensington and Chelsea, for although the principal character in the opera, Bunthorne the Fleshly Poet, was primarily a takeoff on

Wilde, the actor who played the role in the early productions was got up to resemble Whistler.

Even his shows during this period, although generally attractive and amusing, were tinged with caricature. In 1883, for an exhibition of fifty-one etchings, mostly Venetian, he redecorated the gallery of the Fine Art Society: the walls were white with yellow drapes, the floor was covered with yellow matting, the couches were upholstered in yellow serge, and the cane-bottomed chairs were painted yellow. Yellow flowers sprouted from yellow pots, and the gallery attendant wore yellow and white livery. At the opening Whistler wore yellow socks and distributed yellow and white butterfly badges to favored viewers. The catalogue, which had the now standard brown paper cover, contained a collection of unfavorable comments by reviewers of his earlier shows, preceded by "Out of their own mouths shall ye judge them." In 1884, for an exhibition of sixty-one watercolors, pastels, and oil sketches, he redecorated the Dowdeswell Gallery: there were rose-tinted walls, a white dado, white chairs, pale azaleas in rose-flushed jars, and cards inscribed with rose-tinted butterflies. The preface to the catalogue, published later under the heading *Propositions, No. 2*, contained a defense against the familiar charge of exhibiting unfinished work. "A picture," it announced, "is finished when all trace of the means used to bring about the end has disappeared. . . . The work of the master reeks not of the sweat of the brow—suggests no effort—and is finished from its beginning." Princess Louise is said to have decided around this period that Mr. Whistler was merely a "charlatan."

His less oracular replies to the London critical corps could be funnier, but were often spoiled by overwriting and too much spite. A favorite target was Harry Quilter, who had committed the double crime of buying the White House and becoming the art critic of the *Times*. When Quilter slipped into referring to a watercolor as an oil in one of his articles, Whistler wrote to *The World*: ". . . when the art critic of the *Times*, suffering possibly from chronic catarrh, is wafted in at the Grosvenor without guide or compass, and cannot by mere sense of smell distinguish

between oil and watercolor, he ought, like Mark Twain, 'to inquire.' Had he asked the guardian or the fireman in the gallery, either might have told him . . ." When Quilter appeared one day at the Grosvenor in a rather unusual costume, Whistler protested to *The World:* "To have seen him . . . was my privilege and misery; for he stood under one of my own 'harmonies'—already with difficulty gasping its gentle breath—himself an amazing 'arrangement' in strong mustard-and-cress, with bird's-eye belcher of Reckitt's blue; and then and there destroyed absolutely, unintentionally, and once and for all, my year's work!" Tom Taylor having really died, Whistler switched the "dead" gag to Quilter, and employed it vehemently when the critic, in 1883, dared to undertake some alterations in the White House: "Shall the interloper, even after his death, prevail? Shall 'Arry, whom I have hewn down, still live among us by outrage of this kind, and impose his memory upon our pavement by the public perpetration of his posthumous philistinism? Shall the birthplace of art become the tomb of its parasite in Tite Street?"

Almost anything that happened in the private life of the artist was regarded by him as having sufficient public interest to appear in print. In 1881 three Venice etchings by Duveneck were exhibited in London and were the cause of veiled allegations by Haden and Legros that Whistler was showing his Venetian work under a false name in order to evade the terms of his exclusive contract with the Fine Art Society. The allegations, which appear to have been based on an honest suspicion, were quickly withdrawn, but the satisfactory end of the affair did not keep the indignant Whistler from publishing all the pertinent correspondence in a pamphlet he entitled *The Piker Papers,* Piker being the name of a newsvendor who was faintly involved. In 1882 another pamphlet, *The Paddon Papers: The Owl and the Cabinet,* brought to an end all relations with Howell; it consisted of letters that revealed how the unscrupulous "Owl" had hoaxed a diamond merchant named Paddon with some allegedly rare Chinese pots and how the "Owl" had managed to both sell and pawn a Japanese cabinet originally

owned by Whistler. Even the amused Alan Cole thought the story "too personal for general interest."

The friendship with Howell was not the only one that was over, or nearly so, by the mid-1880s. Relations with Fantin had long since cooled practically to zero. The Greaves brothers had been guilty of some unconsciously independent behavior, and were in any event out of place in relatively sophisticated, inland Tite Street. Links with the old Pre-Raphaelite circle had been broken by the Ruskin trial and by the death of Rossetti in 1882. There was, however, a new friend, or at least a new close acquaintance, available in Chelsea in the young, witty, fashionable, tall, flabbily handsome Oscar Wilde. Whistler, who first met him in 1878, got to know him well after 1881, when Wilde moved into rooms at 3 Tite Street. In spite of an age difference of twenty years, the two men had much in common. Wilde was a Francophile, a dandy, an admirer of blue and white pots, a convert to art for art's sake, and already an unabashed practitioner of what he would later formulate: "The first duty in life is to be as artificial as possible. What the second duty is no one has as yet discovered." Among his published poems was a mixture of Gautier and Whistler called "A Symphony in Yellow:"

> An omnibus across the bridge
> Crawls like a yellow butterfly,
> And here and there, a passer-by
> Shows like a little restless midge.
>
> Big barges full of yellow hay,
> Are moored against the shadowy wharf
> And like a yellow silken scarf,
> The thick fog hangs along the quay.
>
> The yellow leaves begin to fade,
> And flutter from the Temple elms;
> And, at my feet, the pale green Thames
> Lies like a rod of rippled jade.

Another poem in the same collection, derived partly from Verlaine, bore the Whistlerian title "Harmony in the Gold Room." And to

these marked similarities in aesthetic outlook could be added certain similarities in conversational style. Whistler, it is true, tended to be more wounding and emphatic in his attempts at humor, whereas Wilde, who was basically good-natured, tended to be more playful: one of his favorite sorts of remark was the commonplace turned upside down. But both were relentlessly self-conscious, and both enjoyed shocking listeners with bits of self-glorification that could be taken either straight or ironically. Wilde, asked by New York customs what he had to declare, answered: "Nothing but my genius." Whistler, told by a woman admirer that he and Velázquez were the greatest painters, retorted: "Why drag in Velázquez?" ("I simply wanted to take her down," he said later.)

The new friendship flourished especially in 1883 after Wilde's return from his lecture tour of the United States. (There, according to his account, he had had an awkward moment with an audience of booted, red-shirted miners in Leadville, Colorado: "I had almost won them to reverence for what is beautiful in art when unluckily I described one of Whistler's 'nocturnes in blue and gold.' Then they leapt to their feet and swore that such things should not be. Some of the younger ones pulled out their revolvers and left to see if Whistler was prowling about the saloons.") In 1884, when the poet married, the painter was still friendly enough to give the newlyweds some etchings and help Godwin with the decoration of their new home, a mid-Victorian brick structure at 16 Tite Street. But already there were indications that peaceful coexistence between a stage Jimmy and a stage Oscar was in the long run impossible. While Wilde, without doing much of anything in this part of his career except pose and talk, became more and more of a London celebrity, Whistler became more and more jealous. He lashed out at the younger man for his dandyism, accusing him of dressing "like 'Arry Quilter." He used the letters column of *The World* for ironical comments on Wilde's lectures. He decided that Wilde was a fellow "with no more sense of a picture than of the fit of a coat." Finally he became obsessed with the notion, which was not entirely mistaken, that Wilde was building a career as a leader of the Aesthetic Movement by stealing Whistlerian ideas.

When Wilde, in one of his rare moments of modesty, said he wished he had said something Whistler had said, the quickly famous (and just possibly apocryphal) reply was "You will, Oscar, you will." When Wilde held forth on art during a dinner in the studio at 13 Tite Street, his host rose and solemnly bowed as the original author of the remarks. It is apparent—although astonishing, in view of Oscar's already established reputation as a self-advertiser—that at the start of their relationship Whistler was thinking of having a properly subservient and flattering young publicity agent, not a formidable rival. He wrote later that Wilde "went forth . . . as my St. John—but, forgetting that humility should be his chief characteristic, and unable to withstand the unaccustomed respect with which his utterances were received, he not only trifled with my shoe, but bolted with the latchet!" (Mark 1:7 must have been one of the verses he had recited for Anna Mathilda.)

He had better luck with a group of young artists who gathered around him early in the 1880s and functioned for a few years as had the Greaves brothers and Duveneck's Boys: as unpaid servants, that is, and as bolsterers of an ego that had not been getting much bolstering from contemporaries. The most talented member of the group was Sickert, who became Whistler's pupil in 1881, at the age of twenty-one, after four years of training for the stage and a brief period of instruction in art under Legros at the Slade School. The second most important member was the Australian-born Mortimer Menpes, primarily an etcher, who also joined Whistler in 1881, also at the age of twenty-one, after studying for a while under Poynter at the South Kensington schools. Among the other members who drifted into and out of the group were the painters Sydney Starr and Theodore Roussel. Whistler, in the way he had of seeming to be jocular while being in fact quite serious, insisted on treating them as if they were indentured apprentices in a medieval or Early Renaissance workshop. In conversation with them he habitually referred to them as "the Followers" and, resuming his Venetian third-person trick, to himself as "the Master." Although the Followers were not allowed to paint in the Tite Street studio, they were encouraged to hang around and

make themselves useful. Menpes recalled: "We seldom asked Whistler questions about his work. . . . If we had, he would have been sure to say, 'Pshaw! You must be occupied with the Master, not with yourselves. There is plenty to be done.' If there was not, Whistler would always make a task for you—a picture to be taken into Dowdeswells', or a copper plate to have a ground put on." If a Follower found time to do something on his own, he was expected to imitate the Master's colors, the Master's tonal values, the Master's "sauce," the Master's brushwork, and the Master's composition. In short, what was wanted was total devotion and complete submission. And the surprising thing is not that all the Followers eventually broke away from such despotism, but that they put up with it as long as they did. Whistler, one must suppose, had in him something of a slightly mad dictator's ability to inspire irrational loyalty.

Preaching and Dictating
1885-1888

Tite Street by 1885 was the epitome, in both its architecture and its cultural climate, of the shift from High Victorian to Late Victorian. Most of the buildings lining its brief prospect were recent, most were in the picturesque new brick style reminiscent of the era of Queen Anne and seventeenth-century Holland, and no less than five had been designed by Godwin: the White House, the Tower House, and Nos. 29, 33, and 44. Painters and writers were prominent residents; among the regular visitors were theatrical people, art-minded aristocrats, young Liberal politicians, and more painters and writers. Whistler at No. 13 was in exactly the right spot, one might have said, for a portraitist with his feeling for stylishness. But in fact he was not prospering; there were evenings when his dinner guests felt obliged to bring their own wine and part of the food. So in 1885 he left chic Tite Street for the less expensive, more heterogeneous, western edge of Chelsea. During the next three years he spent part of his time in a studio at 454A Fulham Road, which was almost into Kensington, and part of his time in a house in The Vale, an impasse—practically a country lane —off the King's Road. The studio was a rather shabby raftered place which he brightened with whitewash for the walls, some touches of yellow in rugs and matting, and the touches of blue and white provided by his china. The house was a square little building

with a Regency balcony running across the facade; its main attractions were its wild flower garden and its leafy, rural setting.

His letters to editors, his pamphleteering against former friends, and his irritation at Wilde's success as a lecturer had led him to think about the desirability of defending himself and his aesthetic position in a relatively long public statement. He had put together some notes late in 1884, with the intention of using them in a magazine article, or perhaps in a talk to the Dublin Sketching Club, which had organized a show of twenty-five of his oils, watercolors, and pastels. When nothing had come of these projects, he had begun to think about the possibility of a lecture in London, and by early 1885 this idea was becoming a reality. Mrs. Richard D'Oyly Carte, although busy at the time with the production of Gilbert and Sullivan's *Mikado*, agreed to make the arrangements for him. Princes Hall, in Piccadilly, was engaged for the venture, possibly because that was where Wilde had scored one of his biggest triumphs. The lecture was billed as *The Ten O'Clock* in order to call attention to the hour, chosen to let the potential audience have plenty of time to finish dinner. Whistler, with his usual meticulousness, designed the tickets and posters, revised and revised his lines, tested them on the Followers, practiced his delivery by addressing the Thames from the Chelsea Embankment, and staged a rehearsal in the hall itself. On the evening of February 20, 1885, before a large and curious crowd, the awaited moment arrived. Nobody, according to one of the London papers, was quite sure if "the eccentric artist was going to sketch, to pose, to sing, or to rhapsodize."

He was dressed in unexpectedly conservative formal clothes and equipped with his monocle, an opera hat, and a long cane. After putting the hat on a table and the cane in a corner of the stage, and suffering what one of his listeners recalled as "a few minutes of very palpable stagefright," he began: "Ladies and gentlemen: It is with great hesitation and much misgiving that I appear before you, in the character of The Preacher." What followed was indeed a sermon, composed for the most part in a style that blended Anna Mathilda's biblical turns with Poe's sonorousness and all the tricks

of an American backwoods ham orator. There were archaisms, alliterations, elegant variations, battered ornaments, aesthetic inversions, purple patches, and thundering rhetorical questions. But from time to time a plain statement, a witty phrase, or some effective poeticalness emerged from the fustian, and by the end of the evening the lecturer had made his views on art, artists, culture, society, Victorians, and himself fairly clear.

He denounced current attempts to democratize art and improve taste: "Art is upon the Town!—to be chucked under the chin by the passing gallant—to be enticed within the gates of the householder. . . . The people have been harassed with Art in every guise. . . . They have been told how they shall love Art, and live with it. Their homes have been invaded, their walls covered with paper, their very dress taken to task—until, roused at last, bewildered and filled with the doubts and discomforts of senseless suggestion, they resent such intrusion, and cast forth the false prophets . . ." True art, he maintained, "has naught in common" with education: "She is a goddess of dainty thought—reticent of habit, abjuring all obtrusiveness, purposing in no way to better others." Moving insensibly from aesthetics to ethics, he condemned the notion that painting should improve conduct: "Beauty is confounded with virtue. . . . Hence it is that nobility of action, in this life, is hopelessly linked with the merit of of the work that portrays it; and thus the people have acquired the habit of looking, as who should say, not *at* a picture, but *through* it, at some human fact, that shall, or shall not, from a social point of view, better their mental or moral state."

Nineteenth-century attempts to escape from the results of the industrial revolution into some ideal, art-loving world of the past— into classical Greece, for example, or fifteenth-century Italy—were in his opinion obvious foolishness: "Useless! quite hopeless and false is the effort—built upon fable, and all because 'a wise man has uttered a vain thing and filled his belly with the East wind.'" Anyway, he argued, there was no truth at all in the widespread assumption that at some remote time there had been such a thing as "an artistic period" or "an Art-loving nation." Rapidly survey-

ing cultural history from the cave era up to presumably the late eighteenth century, he declared that the reason for so much good art in the past was simply that for centuries and centuries there had been "no meddling from the outsider" in the task of the artist: "And the people questioned not, *and had nothing to say in the matter.* . . . And the Amateur was unknown—and the Dilettante undreamed of! . . . And the customs of cultivation covered the face of the earth, so that all peoples continued to use what *the artist alone produced.*" But then one day "there arose a new class, who discovered the cheap, and foresaw fortune in the facture of the sham." Eventually the artist lost control of the situation: "And the people—this time—had much to say in the matter—and all were satisfied. And Birmingham and Manchester arose in their might—and Art was relegated to the curiosity shop."

Without transition, as if merely thinking about the philistine middle-class attitude toward painting had given him the idea, he launched into an attack on Realism: "Nature contains the elements, in color and form, of all pictures. . . . But the artist is born to pick and choose, and group with science, these elements, that the result may be beautiful—as the musician gathers his notes. . . . To say to the painter, that Nature is to be taken as she is, is to say to the player, that he may sit on the piano." Nature, he went on, although capable of producing "a very foolish sunset," seldom succeeds in turning out by herself a good picture: "The holiday-maker rejoices in the glorious day, and the painter turns aside to shut his eyes." He granted, however, at least one exception to the rule: "And when the evening mist clothes the riverside with poetry, as with a veil, and the poor buildings lose themselves in the dim sky, and the tall chimneys become campanili, and the warehouses are palaces in the night, and the whole city hangs in the heavens, and fairyland is before us—then the wayfarer hastens home; the working man and the cultured one, the wise man and the one of pleasure, cease to understand, as they have ceased to see, and Nature, who, for once, has sung in tune, sings her exquisite song to the artist alone, her son and her master—her son in that he loves her, her master in that he knows her."

The art critic was the next target: "For some time past, the unattached writer has become the middleman in this matter of Art. . . . For him a picture is more or less a hieroglyph or symbol of story. Apart from a few technical terms, for the display of which he finds an occasion, the work is considered absolutely from a literary point of view; indeed, from what other can he consider it? And in his essays he deals with it as with a novel—a history—or an anecdote. . . . All this might be brought before him, and his imagination be appealed to, by a very poor picture—indeed, I might safely say that it generally is." Grouped with the art critic for condemnation were the art expert, the art historian, and a personage referred to as the "sage" of the universities: "Filled with wrath and earnestness. . . Defiant, distressed, desperate. . . . Gentle priest of the Philistine withal, again he ambles pleasantly from all point, and through many volumes . . ."

The rest of the lecture consisted of random shots at various subjects. The public was warned against "the intoxicated mob of mediocrity" whose leaders give advice on art: "And now from their midst the Dilettante stalks abroad. The amateur is loosed. The voice of the aesthete is heard in the land, and catastrophe is upon us." Women in particular were warned against "the wearers of wardrobes" who set themselves up as professors of taste: "Haphazard from their shoulders hang the garments of the hawker—combining in their person the motley of many manners with the medley of the mummers' closet." The nation was told not to assume that there was any connection between the "grandeur of Art" and the virtues of the state: "Art, the cruel jade, cares not, and hardens her heart, and hies her off to the East, to find, among the opium-eaters of Nankin, a favorite with whom she lingers fondly—caressing his blue porcelain . . ." The painter who, like Velázquez, could make his subjects "live within their frames, and *stand upon their legs*" was pronounced a rare phenomenon. But in spite of everything The Preacher managed to wind up with a call for stout hearts and stiff upper lips: "Enough have we endured of dullness! Surely are we weary of weeping, and our tears have been cozened from us falsely, for they have called out woe! when there was no

grief. . . . We have then but to wait—until, with the mark of the Gods upon him—there come among us again the chosen—who shall continue what has gone before. Satisfied that, even were he never to appear, the story of the beautiful is already complete—hewn in the marbles of the Parthenon—and broidered, with the birds, upon the fan of Hokusai—at the foot of Fujiyama."

Many of the ideas he had expressed or implied were part of the common European stock by 1885. Gautier's theory of art for art's sake was fifty years old. Delacroix had condemned Realism as "the antipodes of art." Flaubert had felt that "hatred of the bourgeois is the beginning of virtue." Baudelaire had said that nature was simply a dictionary for an artist and had denounced "the instruction heresy" in art. Pater, among others, had developed the musical analogy. In 1868 Swinburne had written: "Art is at her peril if she tries to do good; she shall not try to do that under penalty of death and damnation. Her business is not to do good, but to be good on her own; all is well with her while she sticks to that." The tendency of art critics to translate painting into literature had been castigated by Sainte-Beuve. Many nineteenth-century painters, especially during periods when their work was not selling well, had deplored the crass commercialization of art. The ancient theory that all art was the creation exclusively of the inspired artist—of the "chosen" master working outside any historical, economic, social, political, or cultural context—had been much favored by the early Romantics. Open contempt for "the people" had long been an ingredient in dandyism. Whistler had not added anything to this list of notions. Moreover, like many of his predecessors in the same vein, he had been mostly negative. When you had made your way through all the things he was against and got down to what he seemed to favor, you found yourself in a vague region inhabited by "a goddess of dainty thought" and a "cruel jade" caressing blue porcelain, or by an undefined sort of "beauty," or simply by Art with a capital letter. When you had properly considered his references to critics, experts, historians, professors, amateurs, dilettantes, aes-

thetes, businessmen, the middle classes, the common people, and other alleged meddlers, you found yourself with what looked suspiciously like a doctrine of art for the artist's sake. When you had checked his potted history against a few of the facts he had ruled out, you were left with an unconvincing allegory.

But of course theories of art need not be correct to be effective, and so one can argue that, given the state into which British painting had declined since the death of Turner, *The Ten O'clock* was of considerable importance. It said many things that badly wanted saying at a time when a royal academician like Millais was getting rich by painting pictures of Puss in Boots and a little boy blowing soap bubbles. It countered, even if too frequently with wild logic and without supporting evidence, the tendency to put subject matter first—to look thorough pictures instead of at them. It may even have hastened, in a minor way, the advent of modern art in the British Isles.

Important or not, it must have entertained some of the more alert members of the audience in Princes Hall, for it was a remarkable demonstration of how an artist, at the cost of a few inconsistencies, could use general theory as a machine for blasting personal enemies, deflating possible rivals, and inflating himself. The "unattached" writers who knew nothing about painting were Taylor, Quilter, Wedmore, Hamerton, and any other London critic who had dared to comment adversely on Whistler's work. The "sage" who was "filled with wrath and earnestness" and beside the point "through many volumes" was Ruskin. Poynter, the Pre-Raphaelites, and Burne-Jones were among those who had fled back into a classical or medieval past. Since "the painter" shut his eyes in bright sunlight, it followed that a French Impressionist was not a true painter. Wilde was clearly meant in the references to dilettantes, amateurs, aesthetes, and "wearers of wardrobes" who set themselves up as professors of taste. Again and again the implications pointed to Whistler as the great exception. He, the audience was left to assume, was not one of the "false prophets" who had desecrated English homes with new ideas in decoration. He was not, he indicated, to be confused with anyone in the "mob of mediocrity"

that constituted the Aesthetic Movement. His own sometimes strange costumes were not to be put in the same category as those of the nondandies who combined "the motley of many manners with the medley of the mummers' closet." Nature might produce nothing except bad compositions, glaring light, and foolish sunsets for other painters, but for him, "when the evening mist clothes the riverside with poetry," she could sing in tune and produce nocturnes. He was "her son and her master." Evidently he was also to be identified, in spite of the Chinese disguise, as the favorite with whom Art lingered fondly, "caressing his blue porcelain." He was the Velázquez-like portraitist who could make his subjects "live within their frames, and *stand upon their legs.*" He was the creative artist who deserved to be left alone in a situation in which "the people questioned not, *and had nothing to say in the matter.*" Finally, although the peroration was modestly imprecise, there was little reason not to guess the name of the chosen one, the painter "with the mark of the Gods upon him," who could "continue what has gone before." All he needed for the accomplishment of his divine mission was a little less "meddling from the outsider."

Outsiders, however, continued to meddle. The *Daily Telegraph* called the lecture "the eccentric freak of an amiable, humorous, and accomplished gentleman." The *Times* said that "the audience, hoping for an hour's amusement from the eccentric genius of the artist, were not disappointed." Wilde wrote in the *Pall Mall Gazette:*

> "The scene was in every way delightful; he stood there, a miniature Mephistopheles, mocking the majority! He was like a brilliant surgeon lecturing to a class composed of subjects destined ultimately for dissection, and solemnly assuring them how valuable to science their maladies were and how absolutely uninteresting the slightest symptoms of health on their part would be. . . . Nothing could have exceeded their enthusiasm when they were told by Mr. Whistler that no matter how vulgar their dresses, or how hideous their surroundings at home, still it was possible that a great painter . . . could, by contemplating them in the twilight, and half closing his

eyes, see them under really picturesque conditions which they were not to attempt to understand, much less dare to enjoy. . . . I differ entirely from Mr. Whistler. An Artist is not an isolated fact; he is the resultant of a certain *milieu* and a certain *entourage*, and can no more be born of a nation that is devoid of any sense of beauty than a fig can grow from a thorn . . ."

The article concluded: "That Mr. Whistler is indeed one of the greatest masters of painting, is my opinion. And I may add that in this opinion Mr. Whistler himself entirely concurs."

The ensuing exchange of letters in *The World* lasted on and off until 1888, with each man straining to be witty in spite of the growing bitterness of the quarrel. Wilde spoke of painters who had "rashly lectured" on art: "As of their works nothing at all remains, I conclude that they explained themselves away. Be warned in time, James . . ." Whistler indulged his fondness for alliteration: "What has Oscar in common with Art? except that he dines at our tables and picks from our platters the plums for the pudding he peddles in the provinces." Wilde became testy: "With our James vulgarity begins at home, and should be allowed to stay there." Whistler replied: "A poor thing, Oscar!—but, for once, I suppose your own."

In spite of the criticism, *The Ten O'clock* had a fairly successful run on the local lecture circuit. Whistler repeated it at various London clubs and galleries, and also before student groups at Oxford and Cambridge. In 1888, after having had it printed privately, he had the satisfaction of finding a commercial publisher for it. Then, presumably with the idea of obtaining some favorable publicity, he made a mistake: he asked his old friend Swinburne, who was living in retirement at Putney as a reformed alcoholic and to some extent a reformed poet, to write an article on it. The result, which appeared in the *Fortnightly Review*, was much more of a shock than anything Wilde had written; in fact, it was almost a desertion to the middle-class enemy. Swinburne had many compliments for the painter, and even a few for the lecturer: "Much that Mr. Whistler has to say about the primary requisites and the

radical conditions of art is not merely sound and solid good sense as well as vivid and pointed rhetoric, it is a message very specially needed by the present generation of students in art or letters." But the compliments for the painter were turned ironically into denials of the theory of art for art's sake: "It is true . . . that Mr. Whistler's own merest 'arrangements' in color are lovely and effective; but his portraits, to speak of these alone, are liable to the damning and intolerable imputation of possessing not merely other qualities than these, but qualities which actually appeal—I blush to remember and I shudder to record it—which actually appeal to the intelligence and the emotions, to the mind and the heart of the spectator." And finally the compliments for the lecturer were spoiled by pompous abuse: "[The audience] must have remembered that they were not in a serious world; that they were in the fairyland of fans, in the paradise of pipkins, in the limbo of blue china. . . . It is a cruel but an inevitable Nemesis which reduces even a man of real genius, keen-witted and sharp-sighted, to the level . . . of the dotard and dunce, when paradox is discolored by personality and merriment is distorted by malevolence."

Whistler replied immediately with a letter, a copy of which he sent to *The World:* "Bravo! Bard! and exquisitely written. . . . Thank you, my dear! I have lost a *confrère;* but, then, I have gained an acquaintance—one Algernon Swinburne—'outsider'—Putney." He also wrote a more dignified reply, which he published two years later: "Why, O brother! did you not consult with me before printing, in the face of a ribald world, *that you also misunderstand,* and are capable of saying so. . . . Have I then left no man on his legs?—and have I shot down the singer in the far off, when I thought him safe at my side?" Swinburne responded with a poem that was found among his papers after his death:

Fly away, butterfly, back to Japan,
Tempt not a pinch at the hand of a man,
 And strive not, to sting ere you die away.
So pert and so painted, so proud and so pretty,
To brush the bright down from your wings were a pity.
 Fly away, butterfly, fly away!

He burned Whistler's letters, and tried to sell *La Mère Gérard*, which the painter had given him early in their friendship. Years later he referred to Whistler as "clever, certainly very clever, but a little viper."

While *The Ten O'Clock* was generating notoriety and wrecking new and old relationships, sitters for portraits remained as scarce in the Fulham Road studio as they had been in Tite Street. The artist went on painting his tiny oil sketches; typical ones from this period, both five inches high, are *Coast Scene: Bathers*, which may have been done at Dieppe in the summer of 1885, and *The General Dealer*, which represents a shop in Chelsea. He continued to turn out watercolors and etchings, and in 1887 he took up lithography again, this time with more perseverance than he had displayed during his experiments with the medium a decade earlier. His enthusiasm for travel did not slacken; he went to Paris in the summer of 1886, to Sandwich, Bruges, Ostend, and Brussels in 1887, and to Paris again in the spring of 1888. At one point in 1886 he even thought seriously of taking a trip to the United States, and he got as far as informing the London public through the letter column of *The World:* "They tell me that December has been fixed upon, by the Fates, for my arrival in New York—and, if I escape the Atlantic, I am to be wrecked by the reporter on the pier." His idea was "to take with me some of those works which have won for me the execration of Europe" and to "say again my *Ten O'Clock*" for the benefit of "a country in which I cannot be a prophet." But the Fates, who in this instance were probably the organizers of the projected lecture tour, decided otherwise.

Two portraits which he did manage to execute at about this time have a documentary value that takes them well out of the class of mere arrangements. One is a small study of a worried-looking Maud Franklin; the other is a full-length canvas of a radiant Mrs. Beatrix Godwin, the wife of the architect, which was exhibited in 1886 under the title *Harmony in Red: Lamplight.* Beatrix, who was usually called Trixie, was then in her early thirties and, although badly overweight, quite pretty in a wholesome, pink-cheeked, dark-eyed, dairymaid style. She was the daughter of

the sculptor John Birnie Philip, who had worked on the Albert Memorial, and she was something of an artist herself, having studied in both Paris and London long enough to be able to do decorative designs and book illustrations. People who disliked her called her "the fat thing" and found her bossy, while others were charmed by her cheerfulness, good sense, and Bohemian ways. Her marriage had ended in an amicable separation, partly because Godwin had been habitually unfaithful, and after that she had become an increasingly frequent visitor to the Fulham Road studio and the house in The Vale, at first ostensibly as a pupil of Whistler. By the time of *Harmony in Red: Lamplight* Maud had reasons for looking worried, and Trixie had reasons for looking radiant. After October 6, 1886, when Godwin died, Maud had reasons for being seriously alarmed about her future as "Mrs. Whistler."

In some ways Whistler's own future did not look very good that year. The publication of *A Set of Twenty-Six Etchings*—usually called the Second Venice Set, although five of the subjects are English—was not a resounding success, and neither was a show of watercolors, pastels, drawings, and small oils at the Dowdeswell Gallery. In April, during an auction of the William Graham collection at Christie's, the *Nocturne in Blue and Gold: Old Battersea Bridge* was greeted with angry hisses by the normally polite buyers and was sold for only sixty guineas, a ridiculous sum in contrast with the thirty-three hundred pounds paid for Burne-Jones's *Le Chant d'Amour* at the same sale. Whistler, who was now in the habit of calling public attention to every slight he received, acknowledged the hisses in a letter to *The Observer*: "It is rare that recognition, so complete, is made during the lifetime of the painter, and I would wish to have recorded my full sense of this flattering exception in my favor." He had, however, some consolations. His *Sarasate* was exhibited at the Paris Salon and then in a show organized in Brussels by the most active of the local avant-garde groups, the Société des XX. For the following season he was invited to participate in an international exhibition at the Georges Petit Gallery in Paris, along with Monet, Pissarro, Sisley, Renoir, and other rep-

resentatives of the nonacademic French school. He was beginning, it seemed, to emerge from his isolation.

In June, 1886, to the astonishment of London critics, he was elected president of the Society of British Artists. He had been maneuvered into power, according to the stories that leaked out, by reform-minded younger members, in particular the Followers, and by some of the older men who hoped that his publicity methods would bring some badly needed customers to their exhibitions. He took office in December and immediately set about changing things, as a rule without consulting anyone except his annexationist demon. At the society's gallery in Suffolk Street, near Trafalgar Square, he repainted the old blue-enamel signboard into a harmmony in gold and red, adding in the process a lion and a prominent butterfly. For the winter exhibition he covered the walls of the gallery with muslin and installed a velarium that produced a diffused, Whistlerian light; for the next show he repainted the whole place, doors and dadoes included, a bright yellow. He put an end to the practice of jamming the available space with pictures from the floor to the ceiling, and announced: "The British Artists must cease to be a shop." For the Jubilee of 1887 he secretly composed and decorated a ceremonious address to Her Majesty: bound in yellow morocco and inscribed with butterfly, it included etchings of Windsor Castle, where Queen Victoria was in residence, and the house in The Vale, where President Whistler was in residence. The Queen was pleased, or perhaps amused, enough to give permission to the society to call itself "Royal" henceforth, and its president was consequently invited to the jubilee celebration at Westminster Abbey, to a garden party at Buckingham Palace, and to a naval review off Spithead. At one of the society's shows he had the honor of welcoming the Prince of Wales (who spoiled the occasion a bit by asking one of the older painters for the name of "that funny little man we have been talking to"). But in spite of such aesthetic and social gains the conservative members became more and more restive. They pointed out that "the experiment of hanging pictures in an isolated manner" used up valuable wall space and that the income from exhibitions had been cut in half. They ob-

jected to the way their gallery was decorated; above all, they disliked the insolence and high-handedness of their new president. In June, 1888, after a series of quarrels involving lawyers and threats of injunctions, they got together a majority that favored putting an end to the dictatorship. He hung on, nominally still in office, until the end of the year and then withdrew from the society, taking with him a group of his young supporters. He explained the situation to a reporter from the *Pall Mall Gazette:* "The organization of this Royal Society of British Artists, as shown by its very name, tended perforce to this final convulsion, resulting in the separation of the elements of which it was composed. They could not remain together, and so you see the Artists have come out, and the British remain—and peace and sweet obscurity are restored to Suffolk Street! Eh? What? Ha! ha!"

His years of financial trouble had brought out his anti-Semitism; on one occasion, in the presence of Walter Greaves, he had answered a Jewish creditor's request for payment by shouting: "Are you the chap who killed our Lord?" At the Georges Petit Gallery in 1887 (most probably, although he remembered the place as Durand-Ruel's) he put on another, even less warranted, demonstration of his prejudice, his victim this time being a fellow exhibitor, the Jewish painter Jean-François Raffaëlli. The account of the incident given to the Pennells is marked by the same self-satisfaction evident in the account of the attack on the little black man on the way back from Valparaiso:

> "We were all there hanging the pictures, and had been all day, and when evening came, it was a question of dining and general gaiety. Raffaëlli appeared. And he was effusive, met me like an old and intimate friend, called me *mon cher Vistlaire, mon cher ami,* and I thought it offensive, a presumption. The next day I was again . . . in one of the rooms with a few distinguished people and critics, [Octave] Mirbeau among them. Again Raffaëlli arrived, and again was familiar with *mon cher Vistlaire* and *mon cher ami.* I put my glass in my eye, looked him up and down, let it drop, told him that I did

not know him and did not wish to, that no one had asked
him there and it would be more agreeable if he were to go
into another room. Raffaëlli was in a fury, naturally—said he
had as good right there as anybody else and would not go.
Very well, then, said I, as your company is not agreeable, I
will go; and so I did, and all the others with me . . ."

A week later Raffaëlli decided that the insult justified a duel, but
allowed himself to be persuaded by Mirbeau that a challenge after
such a long hesitation would be absurd.

In 1888 it was the turn of Mortimer Menpes to be insulted in
public, apparently partly because, although a proper gentile, he
was guilty of being an Australian. But he had also been guilty of a
number of actions that had suggested he was not the totally sub-
missive Follower he had once seemed. He had exhibited some etch-
ings in Brussels without asking the Master's permission. He had
visited Japan and had returned to England with ideas of his own
about Oriental art. He had had a fairly successful London show of
his "Japanese" works without announcing that he was one of the
Master's pupils. Seeing how things were going in the Royal Society
of British Artists, he had resigned his membership a month before
the signal for resignation had been given. Worst of all, he had
taken a house in Fulham, decorated it in a yellow Anglo-Japanese
manner, and allowed it to be publicized in the *Pall Mall Gazette*
as "The Home of Taste." He had even told an interviewer: "I
assure you the effect of a room full of people in evening dress seen
against the yellow ground is extraordinary . . ." Whistler reacted
to all this by calling Menpes a "robber" in the middle of Bond
Street, by denouncing him to the rest of the minority in the British
Artists as "the early rat who leaves the sinking ship," and by refer-
ring to him in *The World* as "an Australian immigrant of Fulham
—who, like the Kangaroo of his country, is born with a pocket and
puts everything into it . . ."

Period Figure
1888-1896

Trixie Godwin gradually became a nearly permanent presence at the Fulham Road studio and the house in The Vale, and Whistler became the butt of Chelsea jokes about his relations with "the little widdie." Maud fought hard and at times hysterically in defense of what, after fifteen years of respectable cohabitation, could have been reasonably regarded as a common-law marriage; during one of her tirades against the intruder her rage was such that she broke a blood vessel and sent her formerly devoted lover out into the night looking for medical help. But by the summer of 1888 she had lost the battle. Whistler got her out of the way by sending her to live with friends for a supposedly short while, presumably for the sake of her health, and in June he abandoned The Vale and Fulham Road for a studio flat in the recently built Tower House, in Tite Street. On August 11, in St. Mary Abbots Church in Kensington, he married Mrs. Godwin, brutally letting his ex-mistress get the news through the London papers. (The *Pall Mall Gazette* headlined its account "The Butterfly chained at last.") His behavior shocked many of his and Maud's close acquaintances, accustomed as they were to his displays of egocentricity: at the Hogarth Club he got into a scuffle and almost into a duel after being called a blackguard, and in Paris he lost for good his thirty-year friendship with George Lucas. Maud, left without money and with

her now eleven-year-old daughter to take care of, went through a period of nervous collapse and then obtained work, partly through the influence of Duret, as an artist's model in France. She continued to call herself Mrs. Whistler until the mid-1890s, when she acquired a real husband, a wealthy South American whom she seems to have met while posing in Paris.

In spite of the deplorable start the marriage of Trixie and Whistler was successful. They made a rather touchingly ludicrous couple, he with his darting leanness and she with her slow plumpness, and they had to adjust to the fact that he was moving into his late fifties while she was still a relatively young woman. But they were deeply attached to each other, and evidently determined to get the most they could out of the happiness they had long been waiting for. She mothered and managed him, called him "my own dear darling love," and tried to rid him of his remaining ties with allegedly unworthy companions—the Greaves brothers, for instance. (Walter commented afterward: "People ran him down, I know, but he was a very nice fellow. . . . Then one day he got married and vanished.") She developed the same defensive, possessive loyalty he had inspired in Jo and Maud. He responded by settling into legal domesticity as if he had never really wanted anything else; he played the role of the middle-class, manly little husband with the same meticulousness he had lavished on all his other roles. He also increased his already strenuous efforts to remain young: he began to lie about his age, and to wear white shoes and a straw hat in the summertime. One of his lawyers remembered acting as his host one evening in Antwerp: ". . . he lingered in the anteroom. The maid who had let him in returned to the living room where we were waiting and said in Flemish, with some alarm, 'Madam, it's an actor. He is doing his hair in front of the mirror, he is putting on pomade, he is rouging and powdering himself!' After quite a long delay Whistler appeared, courtly, correct, waxed, made-up, spick and span . . ."

Trixie was about as restless and rootless as her new husband. They spent the late summer of 1888 in France, visiting notably Boulogne, Chartres, Tours, Loches, Amboise, and Bourges. In 1889

they went to Dordrecht and Amsterdam. In March, 1890, they moved from Tite Street to a house with a garden at 21 Cheyne Walk, near Rossetti's old place; here Whistler could enjoy the Thames again, although it was a Thames rendered less Romantic by the construction of the Chelsea Embankment and less Japanese by the demolition, in 1885, of the wooden Battersea Bridge. In 1892 they decided to settle permanently in Paris; they lived in hotel rooms for several months, and early in 1893 took over an apartment at 110 Rue du Bac and a studio at 86 Rue Notre-Dame-des-Champs. During the summer they visited the medieval castle at Vitré and then went on to Lannion, Paimpol, and that part of the Breton coast charged for Whistler with memories of Jo's red hair, the sunny autumn of 1861, and his early attempts to paint the sea.

In the Tower House and at 21 Cheyne Walk he did little more than camp; to a guest at the latter place who stared at the bare rooms he remarked, with a ha-ha: "You see, I do not care for definitely settling down anywhere. Where there is no more space for improvement, or dreaming about improvement, where mystery is in perfect shape, it is *finis*—the end—death." In Paris, however, his interest in decorating and furnishing revived. The apartment at 110 Rue du Bac, on the ground floor of a seventeenth-century house with a courtyard in front and a shady lawn in back, had blue walls, white woodwork, blue matting on the floor, Empire chairs, an Empire couch, English silver, blue and white porcelain, a large Japanese birdcage, many bowls of flowers, and a sullen white parrot that finally escaped and starved to death in the back-yard. The studio at 86 Rue Notre-Dame-des-Champs, on the sixth floor of a modern building near the headquarters of the du Maurier gang in the 1850s, had flesh-colored walls, white woodwork, vene-tian blinds, green curtains, white Empire chairs, and a large, flower-covered balcony with a view of the Panthéon and the Luxembourg Gardens. The concierge directed visitors toward the steep stairs with the instruction "You can't go further than Monsieur Whist-ler."

As the Empire furniture can suggest, he was now quite out of the Bohemian category. In fact, he was emerging victorious, with

a rapidity he found hard to adjust to, from his years of struggle for recognition and money. At the Munich International Exhibition of 1888 he won a second-class gold medal with his *Lady in the Yellow Buskin*, and his ironical thanks for "the second-hand compliment" did not keep him from being elected an honorary member of the Royal Bavarian Academy. In 1889 his honors included the Cross of St. Michael of Bavaria, a first-class medal at Munich, a gold medal at the Amsterdam International Exhibition, and the ribbon of a chevalier of the French Legion of Honor. In March, 1891, the city corporation of Glasgow, after being petitioned by a group of local artists, bought the *Carlyle* for a thousand guineas; in November of that year the French government, under pressure from a group that included Clemenceau and Mallarmé, bought the *Mother* for four thousand francs for the Luxembourg Museum—for the Louvre, that is, eventually. In March and April of 1892 there came what Whistler often referred to as "the heroic kick in Bond Street": a retrospective exhibition of forty-three of his best oils at the Goupil Gallery. On view from the production of the 1860s were such works as *The Music Room, The Blue Wave, The Lange Lijzen, The Gold Screen, The Little White Girl,* and *Symphony in White No. 3;* from the production of the 1870s were the *Carlyle* and *Cicely Alexander*, among other portraits, and a series of nocturnes that included *The Falling Rocket* and *Old Battersea Bridge.* The pink *Lady Meux* and the *Lady in the Yellow Buskin*, both about ten years old, were the only relatively recent pictures. Almost overnight the sophisticated section of the London public decided that the thing to do was to forget the Ruskin trial and stop laughing at the eccentric Yankee "Barnum." In the United States a similar reaction was soon under way; at the Chicago World's Columbian Exposition of 1893 the *Princesse du Pays de la Porcelaine, The Fur Jacket,* the *Yellow Buskin,* and some etchings were part of a retrospective that was awarded a medal, and in 1894 the artist was given the Temple Gold Medal by the Pennsylvania Academy of Fine Arts.

A few of his countrymen were already interested in his work; Samuel P. Avery had been a collector of his etchings since 1864.

Now a number of important American buyers appeared, and a number of British collectors did not hesitate before the temptations of a rising market. Shortly after the Goupil Gallery show James Leathart of Newcastle sold *The Lange Lijzen* to John G. Johnson of Philadelphia, Mrs. Aglaia Coronio sold *Old Battersea Reach* to Mrs. Potter Palmer of Chicago, John Cavafy's son sold *The Last of Old Westminster* to Edward Kennedy of New York, and in each instance the profit was considerable. Business was good in England, too; Alecco Ionides sold both *Brown and Silver: Old Battersea Bridge* and *Arrangement in Grey: Self-Portrait*. Whistler was resentful about the money-making in which he did not share, and also about the readiness of his early patrons to part with his work. He developed a theory that a picture when sold was still somehow the property of the artist and was simply "lent"; he insisted on his right to control the public exhibition of anything he had done. But his resentment and his theorizing did not keep him from participating in the benefits of the new situation whenever he could. In the autumn of 1892 he sold *The Falling Rocket* to Samuel Untermyer of New York for eight hundred guineas and exulted that this was in Ruskinian terms the equivalent of "four pots of paint." By 1893 he could tell his friend Thomas Way that "now I fancy I see fortune looming on the horizon!—and I might really be rich! who knows!" In 1894 he met the millionaire Detroit collector Charles Lang Freer, who promptly bought thirteen thousand guineas worth of oils, pastels, and watercolors. In 1895 the *Lady in the Yellow Buskin* was bought for the W. P. Wilstach collection in Philadelphia, and in 1896 the *Sarasate* was taken by the Carnegie Institute.

Some of this success can be explained as simply a combination of a delayed recognition of quality with a delayed adjustment of the art market. Most of the pictures in the Goupil Gallery show had not been seen in public for such a long while that they came as a revelation to Londoners who thought of Whistler as a bad-tempered clown who wrote letters to newspapers; and with an occasional exception his prices had long been far out of line with

those of his English and French contemporaries. In fact, even with the adjustment the prices were relatively low; when the *Carlyle* was fetching a thousand guineas a Burne-Jones was capable of more than three thousand, and shortly before the *Mother* was bought for the Luxembourg for four thousand francs Manet's *Olympia* was bought for the same museum, by public subscription, for nearly twenty thousand. The wealthy Americans who acquired Whistlers in the early 1890s were actually getting in on a good thing: between 1892 and 1904 the *Princesse du Pays de la Porcelaine*, for example, went up from four hundred and twenty guineas to five thousand.

At the time, however, there was much more to the matter than mere recognized merit and shrewd speculation. Whistler owed his success not only to having suddenly become an excellent buy, but also to having almost as suddenly become a minor cultural hero, a supposedly representative *fin-de-siècle* man, a period figure in a decade that was variously labeled Decadent, Symbolist, yellow, and mauve. He did not, of course, think of himself as such. In his *Ten O'Clock* he had made it plain that he regarded himself as simply another incarnation of the eternal Artist, that he did not believe in stylistic periods, that he did not think modern art was decadent, that he wished to keep clear of all aesthetes and dilettantes, and that he strongly objected to literary symbolism in painting. During the 1890s he did not change his mind. At the end of the decade he could still maintain: "There is—there can be—no Art Nouveau—there is only Art." When *The Yellow Book* scored a success in 1894, he firmly disapproved. He continued to loathe anything that was faintly Wildean. After meeting Aubrey Beardsley he said: "Look at him!—he's just like his drawings—he's all hairs and peacock plumes." In general his opinion of the typical aesthete of the period was not far from that of the Kipling of "The Mary Gloster," in spite of the danger of being a fellow target:

> The things I knew was proper you wouldn't thank me to give,
> And the things I knew was rotten you said was the way to live.
> For you muddled with books & pictures, an' china, an' etchin's an' fans,

> And your rooms at college was beastly—more like a whore's
> than a man's.

Indeed, the stage Whistler who played the Southern cavalier and the West Point man had more than a little in common with the whole punctilious, jingoist, racist, protofascist, exaggeratedly masculine side of the 1890s; in Paris he made a show of accepting the code of the duel (without ever actually fighting one), and in London he dined with both Kipling and W. E. Henley ("I am the captain of my soul"). But all this did not keep him, as a personality and an artist, from fascinating the feminine—or "unisexual," a word then coming into use—side of the period, the side that muddled with books and pictures.

The synthetic aspects of his personality were undoubtedly among the reasons for the fascination. The time was one of double and triple selves, of books like *The Picture of Dorian Gray* and *Dr. Jekyll and Mr. Hyde*, of assumed names and invented life-styles, and of extravagant dandies and poseurs. The good life, many influential people felt, was to be acted, not merely lived. Wilde played Oscar of Tite Street until his fall, and then became Sebastian Melmoth of Dieppe. Arthur Symons saw his "very self" as a "painted, pathetically gay" music-hall dancer:

> I, I, this thing that turns and trips!

The young Yeats defended his own divided self on moral grounds: "If we cannot imagine ourselves as different from what we are, and try to assume that second self, we cannot impose a discipline upon ourselves though we may accept one from others. Active virtue, as distinguished from the passive acceptance of a code, is therefore theatrical, consciously dramatic, the wearing of a mask." In France such ideas, current in one form or another since the early dandyism of Baudelaire and Barbey d'Aurevilly, had recently produced such fictional characters as Huysmans' decadent Des Esseintes, who despised everything natural, and Villiers de l'Isle Adam's Count Axël, whose most famous line was "Live? The servants will do that for us." Real-life Paris could boast of scarcely less artificial characters. There was the minor writer and occultist Joséphin Péla-

dan, for instance, who became a celebrity by wearing a presumably Assyrian costume and beard, changing his name under Babylonian inspiration into Le Sâr Mérodack Péladan, writing with red or yellow ink, and founding a new version of the Rosicrucian Order. There was the strange, half-madly dandiacal Count Robert de Montesquiou, who had been a model for Des Esseintes and some of whose traits would appear in Proust's Baron de Charlus; he slept in a dragon-shaped bed, went about under various aliases, kept a gilded tortoise as a pet, always wore mauve when listening to Weber, and published some of his poetry under the title *Le Chef des Odeurs Suaves*. In short, Whistler in the 1890s was a persona who had at last found the right play and the right audience. He became, especially in Paris and French-influenced circles in London, the object of a cult which, if rather restricted and not invariably respectful, was almost embarrassingly fervent. The young Proust, who would later use him as one of the models for the painter Elstir in *A la recherche du temps perdu*, met him at a Parisian soirée and piously stole one of his gloves as a souvenir. Beardsley imitated his dress and caricatured him as the god Pan. Montesquiou called him "a rare bird, its crest his forelock." Huysmans, in 1891, was one of the few French writers willing to take a close look at the legend that was being created: "W. is always eating pickled cucumbers and butter. He is nice—almost simple in his high-falutin manner. . . . For me he doesn't put on his mincing affectations. . . . Frail, slender, keen body—a sapphire eye— there is something of a meticulous old maid about him."

In 1889 Huysmans had noticed something else about the new idol of the new aesthetes: "M. Whistler, in his harmonies of nuances, practically crosses the frontier of painting: he enters the land of literature, and advances along the melancholy shores where grow the pale flowers of M. Verlaine." This may have irritated the artist who had spent years denouncing pictorial anecdotes and "claptrap" and had recently told the British public to look at, instead of through, his works. But there was no denying the plain, if ironical, fact that much of his success in the 1890s was due to—along with his stagy personality—his *correspondances*, as Baude-

laire would have said, with the literary, in particular the poetic, temper of the period. In 1884 Verlaine had announced:

> *Rien de plus cher que la chanson grise*
> *Où l'Indécis au Précis se joint. . . .*
> *Car nous voulons la Nuance encor,*
> *Pas la Couleur, rien que la nuance!*

(Nothing more dear than the gray song/ Where the Undecided is joined to the Precise. . . ./ For we still want Shading,/ Not Color, nothing but shading!) "Satiated with light too vivid and too crude," wrote the young poet Téodor de Wyzewa, "we longed for fog." A sonnet by Albert Samain begins: *"J'adore l'indécis . . ."* Edmond de Goncourt wrote in his *Journal* on November 27, 1894: "Talking about Whistler, I said . . . that one of his great qualities was the mystery in his backgrounds, a mythological mystery that belongs to him alone. . ." Meanwhile, in London poets continued to write Whistlerian nocturnes in the manner of the young Wilde, and even Henley, moving from the masculine toward the feminine side of the period, tried his hand at the genre:

> Under a stagnant sky,
> Gloom out of gloom uncoiling into gloom,
> The River, jaded and forlorn,
> Welters and wanders wearily—wretchedly—on;
> Yet in and out among the ribs
> Of the old skeleton bridge, as in the piles
> Of some dead lake-built city, full of skulls,
> Worm-worn, rat-riddled, mouldy with memories,
> Lingers to bubble to a broken tune . . .

The painter liked the poem well enough to allow a nocturne to be reproduced as an illustration for it.

More important, however, than a shared enthusiam for tonal values, mistiness, and riverscapes was the fact that many of the poets of the period adhered to an aim or a procedure that predisposed them to see in Whistler a fellow spirit. They, too, in their various ways, were opposed to "literature" and "claptrap." They, too, as somewhat unorthodox heirs of the mid-century doctrine of art for art's sake, tended to feel that their business was more with

signifiers than with the signified. Mallarmé insisted that a poem
should be made with words, not with ideas. Verlaine urged his col-
gues to "take eloquence and wring its neck." Yeats recalled later
"the revolt against Victorianism meant to the young poet a
against irrelevant descriptions of nature, the scientific and
discursiveness of *In Memoriam* . . . the political eloquence of
rne, the psychological curiosity of Browning"—all of which
ed Whistler's revolt against foolish sunsets, moralizing, and
ntalizing. There were parallels also in the theory and tech-
Symbolism. "To *name* an object," Mallarmé remarked in
s to destroy three quarters of the enjoyment of the poem,
made to be guessed at little by little; to *suggest* is the ideal.
perfect use of this mystery that constitutes the symbol . . ."
that poets who insisted on being specific deprived readers
delicious joy of thinking that they are creating." Such no-
ted in well with Whistler's objections to counting the wires
in the canary bird's cage across the Thames and with his telling the
judge at the Ruskin trial that the figures in the nocturne *Old Bat-
tersea Bridge* were "just what you like." The ultimate intentions
of the poet and the painter were of course quite different. Mal-
larmé hoped that his manipulation of obscure language would en-
able him to suggest, or incarnate or "symbolize," a philosophical
absolute—something like the Platonic realm of ideas. Whistler was
not concerned with symbolizing anything at all; he was interested
in pattern and mood. But in practice the difference was not always
very noticeable, at least not to the more determined "readers" of
paintings. A mysterious night scene with half-identifiable forms
and without any apparent subject could easily be regarded as an
attempt to express the ineffable, or as an invitation to invent a
literary interpretation. A harmony or an arrangement that was os-
tensibly meaningless could for that very reason be charged—as
abstract paintings would be by twentieth-century critics and view-
ers—with the most exciting, magical sorts of meaning. Hence the
painter tended to become a literary Symbolist in spite of himself.

The process was helped along by his addiction to the musical
analogy, which continued to hover in vanguard imaginations. In

Huysmans' *A Rebours*, des Esseintes played alcoholiç "symphonies" and "quartets" on a "mouth organ' that consisted of little barrels of liqueurs equipped with taps: kümmel was the oboe, kirsch the trumpet, brandy the violin, rum the viola, and so on. Young poets in both England and France revived Gautier's idea and wrote "symphonies" in blue, or gray. Speaking of the situation in France, Valéry remarked later on: "What was baptized Symbolism can be summed up very simply as the intention shared by several families of poets . . . to find their good in music." In fact, artists in all fields were looking over traditional fences into neighboring fields, and the result was a confused dream of the possibility of a single all-in-one art, a sort of ideal Wagnerian *Gesamtkunstwerk*. Whistler benefited from both the confusion and the dream. Jacques-Emile Blanche, who became one of the favorite portraitists of Proustian society, remembered that in Paris at the close of the 1880s "the Whistler cult became entangled in people's minds with Symbolism, the Mallarmé and . . . the Wagner cults." Musicians also could succumb to the synesthesia epidemic, and when they did an odd circling of analogies and influences could occur. Debussy, for instance, seems to have borrowed the term "nocturne" not from Chopin but from Whistler, who had borrowed it from Chopin through Leyland. And Debussy, although often reticent about his intentions, did not conceal his debt to the Whistlerian imagination; in 1894 he wrote concerning a projected musical nocturne: "It's in sum a piece of research into the various arrangements a single color might yield, similar to what in painting, for example, a study in greys would be." A contemporary critic, Alfred Bruneau, was even more explicit after listening to the composer's *Fêtes:* "A muffled orchestra envelops in music these tableaux, which evoke the strange, delicate, and vibrant nocturnes of Whistler and which, like the canvases of the great American painter, are marked by a deeply disquieting poetry."

In such comparisons, as in French appreciations of Whistler the role-player and Whistler the supposed Symbolist fellow traveler, there were of course large amounts of faddism, snobbism, and misunderstanding. Here Blanche can be cited again: "Whistler-

Whistler, in the pages of *Truth*, renewed, violent, and rather incoherent charges of plagiarism: "Oscar, you have been down the area again, I see! I had forgotten you, and so allowed your hair to grow over the sore place. And now while I looked the other way, you have stolen *your own scalp!* and potted it in more of your pudding." The next year the news that Wilde was being invited to one of Mallarmé's Tuesday evenings elicited a cable from Cheyne Walk to the Rue de Rome: "TAKE PRECAUTIONS FAMILIARITY FATAL LOCK UP PEARLS." Shortly before these events the unfortunate Menpes had been caught taking credit in a newspaper interview for a Whistlerian way of managing a printing press. The Master sent the ex-Follower a letter, with a copy to *Truth*, alluding to the suicide in Madrid of Richard Pigott, the forger of the Parnell documents: "You will blow your brains out, of course. Pigott has shown you what to do under the circumstances, and you know your way to Spain. Good-bye!"

The years 1890 and 1892 were marked by the publication of the first and second editions of *The Gentle Art of Making Enemies*, a collection of the artist's principal writings. Included were his aesthetic "propositions," a slightly doctored account of the Ruskin trial, *Art and Art Critics*, *The Piker Papers*, *The Ten O'Clock*, two exhibition catalogues with hostile press comment, some documents concerning the final break with the Royal Society of British Artists, and a large choice of letters to newspapers and ex-friends. The aim was evidently to lend more substance to the legend, already current in certain circles, of the brilliantly eccentric butterfly whose wit knocked over everyone within range and whose attitude and work were examples of sophistication and modernism triumphing over philistinism; and this aim can scarcely be said to have been achieved: the book contained too much bitterness, too much dishonesty, too few really effective witticisms, and too little proof that "the Enemies" were always wrong. There were, however, for those readers who had come in late, some good, straight statements of doctrine: "As music is the poetry of sound, so is painting the poetry of sight, and the subject-matter has nothing to do with harmony of sound or of color. . . . The imitator is a poor

kind of creature. If the man who paints only the tree, or flower, or other surface he sees before him were an artist, the king of artists would be the photographer." There was also a prose portrait of a profoundly alienated personality. There was the dandyish appearance, quite in the Barbey d'Aurevilly mode, of the volume itself, with its half-empty pages, asymmetrical layouts, marginal comments, and swarm of butterfly signatures, many of which were equipped with the scorpion stinger Whistler had begun to fancy during his Venetian period. Finally, there was entertainment to be derived from the circumstances surrounding the publication, which were summed up by the *Sunday Times* as "Mr. Whistler's paper hunt." The book project, the catchy title, and much of the gathering of material had been due to an American journalist, Sheridan Ford, who seems to have had high hopes of glory and money from the enterprise. At a late point Whistler, apparently at Trixie's suggestion, had decided to annex the glory and money, had tried to pay off Ford with a check for ten pounds, and had taken over the task of editing and publishing. Ford, insisting that he was still the authorized editor, had gone ahead with his own version. In London he had been on the verge of printing when Whistler's lawyers had stopped him. In Antwerp he had actually brought out an edition of two thousand copies, only to have them confiscated and himself fined. In Paris he had brought out an edition of several thousand more, only to have it suppressed. And thus had ended what Whistler called "an extraordinary piratical plot."

At times his behavior seemed, even to his close acquaintances, barely on the edge of sanity. When a journal called *The Hawk* printed an unfavorable reference to Godwin, the Southern cavalier, presumably persuaded that Trixie's honor was somehow involved, waylaid the editor in the foyer of the Drury Lane Theatre and hit him in the face with a cane while screaming "Hawk! Hawk!" When the uproar over the first version of *Trilby* was at its height du Maurier wrote to Tom Armstrong: "J. W. seems to me to have gone quite crazy—however, there's nothing I can do now—and I really don't see what he's aiming at—unless it's notoriety

—an endeavor to keep his memory green in England. . . . What *does* he want? I can't very well go and call him out—fancy the roars of laughter over there! Nor can we very well have it out with fisticuffs! *à notre âge, et dans notre position!!!* I suppose he *does* mean to come and 'hit me in the eye' as he always called it—so I must look out . . ."

Early in 1894 another quarrel, which eventually led to the publication of another pamphlet, *The Baronet and the Butterfly*, got under way. The baronet in question was Sir William Eden, who was to become better known as the father of Anthony Eden. He was a large, red-cheeked, blue-eyed, bushy-browed, touchy Englishman of the hunting-squire sort, one of whose several eccentricities was a passionate love of painting. Introduced to Whistler in Paris by George Moore, he commissioned a pastel or watercolor sketch of Lady Eden, with the unfortunately vague understanding that the price would be between a hundred and a hundred and fifty pounds. Whistler liked the sitter and wound up doing a small oil portrait, which he naturally thought was worth more than a pastel or a watercolor. When he received a check for a hundred pounds he went into one of his Peacock Room rages, refused to deliver the portrait, finally wiped out the head, and twitted Eden about being a noisy Islander, all the while keeping the hundred pounds. He returned the money when Eden started legal action in a French court, but this did not avert a costly defeat: the court ruled that the portrait had to be delivered as originally painted and that in the meantime Whistler had to pay a thousand francs in damages. While the decision was being appealed everyone concerned lost control of himself, much to the delight of the Paris and London press. Eden said of Whistler: "There never was a more vulgar and indomitable cad or a more vain and vicious beast. The man thinks no one dare collar him." Whistler denounced Moore, who had become Eden's ally, as a fellow who "had made himself a spurious reputation as advanced connoisseur." Moore replied with a letter, published in the *Pall Mall Gazette* and French papers, suggesting that the butterfly was getting old. Whistler then sent Moore a challenge to a duel, which was ignored.

A supplementary reason for defensive aggressiveness during these years was the fact that most of the success that had finally been won was based on pictures that were far from recent. In 1892 Pissarro wrote to his son Lucien concerning a show in Paris: "I supposed this exhibition of Whistler would show his new works. It's strange that Whistler doesn't want to show his new canvases. Perhaps he hasn't any! For years now I have seen the same works again and again, even very early works! . . . Why?" The answer was that, while sketches, etchings, and especially lithographs were still being turned out with reasonable ease, larger works were by now almost beyond the artist's capacity and courage. Portrait after portrait was begun, only to go down to ruin under the onslaught of scraping and wiping. In 1892 he had a chance, through the American connections of Sargent, to participate in the decoration of the new Boston Public Library; he got as far as some notes and preliminary designs for a peacock ten feet high, and then gave up.

The one important portrait of this period is *Arrangement in Black and Gold: Comte Robert de Montesquiou*, which was begun in London in 1891; and it is worth attention, in its blackened, half-worked-to-death state, chiefly because of the personality of Montesquiou and his account of the sittings. Edmond de Goncourt noted in the *Journal*:

> "Montesquiou is most interesting to listen to as he explains Whistler's method of painting. . . . Apparently the first sketch . . . is a mad rush at the canvas: one or two hours of this wild fever and the thing emerges complete in its envelope. Then there are long, long sittings, when most of the time the artist brings his brush up to the canvas, does not touch it, throws the brush away and takes another, with the result that in three hours he gives no more than fifty touches to the canvas, each one, according to him, removing a veil from the sketch. Oh, sittings when it seemed to Montesquiou that Whistler's intent observation was emptying him of life, draining away something of his individuality. In the end he was so exhausted he felt as if all his being was shrinking away, but fortunately he discovered a *vin de coca* that restored him . . ."

Personal awareness of the difficulties of artistic creation may be the explanation for a couple of quite uncharacteristic Whistlerian incidents that occurred around this time. One evening the Master reduced Beardsley to tears of gratitude by looking at the young man's illustrations for *The Rape of the Lock* and suddenly saying: "Aubrey, I have made a very great mistake—you are a very great artist." In 1895 an even more surprising, and more revealing, manifestation of sympathy for fellow artists took place. Trixie, in London while he was working in the country, had just visited Streatham Town Hall, which had been decorated with about a hundred large, naïvely Whistlerian murals by the Greaves brothers. She immediately wrote to her husband: "You have no idea how dreadful it all is. . . . They have remembered anything and everything you ever did, and even to the Japanese panels in your drawing room, your brown paper sketches and the balcony, Battersea Bridge. . . . Two or three classic ladies with pots of flowers on the the floor, a travesty of *The Balcony*—two or three recollections of your peacocks in another room with an imitation of *The Fire Wheel, Chelsea in Ice*. There! I can't go on—it was like a sort of hideous Whistlerian chaos, I felt quite mad and sick—I laughed out loud at last. . . . It's frantic. My God, I could kill them—conceited, ignorant, miserable, gutter-born wretches." Whistler's reply must have startled her: "As to the work in the Hall itself—it may not be all that good. It may be absolutely wild and uncultivated as decoration—the work of peasants perhaps, but, take my word for it, there must be some stuff in all that. *To have done it* . . . when others have not *done* anything. Besides they were very intelligent and nice boys. . . . I feel kindly about them after all—Beatrice dear!"

Another of his letters of 1895 suggests that he had been going through a particularly acute phase of his self-doubt and had come out of it with a solution for the problem of working on a picture as he wished and yet managing to finish it. What this solution was is not at all clear, but it may have been nothing more than an

attempt to apply to medium-sized works the rapid, free handling he had developed in doing his tiny oil sketches. During the late summer, which he spent at the resort town of Lyme Regis on the Dorset coast of England, he painted, among other things, *Dorsetshire Landscape*, which is essentially one of his "notes" or "curious little games" elaborated on a canvas a little over two feet wide. He also did a portrait of a local girl, *Little Rose of Lyme Regis*, which on a canvas twenty inches high achieves a freshness and vividness totally lacking in the nearly life-sized portrait of Montesquiou.

Worrying over artistic problems, however, was becoming more and more incidental to worrying about Trixie, whose health had been bad since late 1894 and had recently become alarming. Whistler decided to remain with her in London for the moment in order to be near English doctors, and in December, 1895, he rented a studio at 8 Fitzroy Street, near the Euston Road and in a quarter that combined some elegant Adam facades with memories of such former residents as Constable, Verlaine, Rimbaud, and the young Rossetti. The apartment in the Rue du Bac was not abandoned, but its place was taken temporarily by rooms in the Savoy Hotel. Here, early in 1896, Whistler did eight lithographs that are by general consent among his finest: six are views of the city and the great sweep of the Thames, and the other two, *The Siesta* and *By the Balcony*, are beautifully pathetic sketches of Trixie on her sickbed. There could not be better evidence of how much the function of the stage Whistler, the aggressive Whistler, and the caddish Whistler was to shield an inner Whistler who was as sensitive and soft as the young girls he loved to paint. Nor could there be better evidence of the curious fact that his painful block with large oils never affected his powers as a graphic artist.

Last Years
1896-1903

It shortly became known that Trixie was suffering from incurable cancer: known, that is, to everyone except her distraught husband. Lacking the serene faith and cruel experience of Anna Mathilda, he refused to be docile before the ways of Providence. He became vexed when his wife frankly referred to the illness by its name. He made inconsequential plans to sail to New York and consult new specialists. Informed by his brother Willie that there was no basis for hope, he wrathfully rejected the diagnosis and broke off all relations; partly because of the quarrel, Willie then took to drinking recklessly. But by the early spring of 1896 there was no denying the facts, for the disease was in its final, ravening stage. Whistler rented a small house, St. Jude's Cottage, on Hampstead Heath, and there, on May 10, Trixie died. He spent part of the last hours aimlessly walking and half running across the heath; stopped by a sympathetic acquaintance, he shouted "Don't speak! Don't speak! It's terrible!" and stumbled on.

He buried her in the cemetery at Chiswick, near the Thames and not far from where Hogarth lies. For a while, possibly because of his belief in spiritualism, he seems to have had a frightening impression that she was still somewhere near him. An entry in the Goncourt *Journal* for May 31, 1896, remarks: "And Duret relates this singular detail about this bizarre individual: at the twilight hour,

when night falls, he has a vision of ghosts. He is afraid of being alone. On several occasions he has asked Duret not to leave him."

Duret was not the only French intimate to whom the supposedly unsentimental artist turned for affection and support. As the months went by he developed a strong desire for the intelligence and sensitivity of Mallarmé, to whom he wrote in 1897: "Mallarmé, my friend, are you in Paris? I would like to see you, I would like to grasp your hand. You, you understand everything. You understood her, who has slipped away, and you doubtlessly understand why I remain. As for me, I understand nothing . . ." An undated note, written after seeing the poet and perhaps on the train for England, continues along the same line with just a hint of role-playing: "I am crossing Paris and returning to London to find myself alone and timid with my work (which may have it in for me for having left it) and to face up, laughing and brave, to my enemies. I am, after all, always alone—as must have been Edgar Poe, to whom you have said I have a certain resemblance. But on leaving you it seemed to me that I was saying good-bye to another me—alone in your art as I am in mine—and while shaking your hand this evening I felt a need to tell you how much I feel myself drawn toward you . . ."

Among the other friends to whom he turned were the Pennells and the publisher William Heinemann, who had brought out *The Gentle Art of Making Enemies.* Joseph Pennell was an American etcher and journalist working in Europe much of the time; he and his wife Elizabeth, who was also a writer, had known Whistler since the mid-1880s and well since the early 1890s. They now, when they were in the same city with him, attached themselves to him with the enthusiasm of Boswells who at last had their great man mostly to themselves; and out of the attachment they began to draw the material for the massive biography of him which they published five years after his death. Exactly what he thought of them is hard to discern. On the one hand, he must have been occasionally astonished by their naïve, dogmatic adulation; at times he even seems to have amused himself by telling them tall stories about his career. On the other hand, he must have been grateful, after his

fashion, for their nearly unquestioning loyalty and their help in his personal publicity. In a world which he often tended to divide into Followers and Enemies, they were almost ideal Followers.

The last seven years of his life were marked by no major events and no major works. He devoted much of the period to traveling, with a compulsiveness that suggests a series of small Valparaiso crises. During the summer of 1896 he went to Rochester and Canterbury and then to the Honfleur region, where he stayed at La Ferme Saint-Siméon, an inn already historic because of its association with the early days of Impressionism. For Christmas he was in Bournemouth, where he found the hotel dinner a catastrophe and regretted not having some of "my wonderful old Pouilly" from the cellar in the Rue du Bac. The next year he went to Dieppe. Early in 1899 he visited Italy: he described Rome as "a bit of an old ruin alongside of a railway station where I saw Mrs. Potter Palmer" (the new Chicago owner of *Old Battersea Reach*), and he neglected the monuments of Florence for the sake of saluting the supposed Velázquez self-portrait in the Uffizi. That summer he was in Holland for a while and then at Pourville, near Dieppe, where he enjoyed the breakfasts. During the summer of 1900 he was in Holland again and also in Ireland, where he stayed briefly at Sutton, near Dublin. In December he left for the Mediterranean, where he toured and tried to rest until the following May. He found Gibraltar so disagreeable "I refrain from expressing myself," Tangier entirely too "Eastern," and Algiers "too cheap! like that sort of stuff you see in the small booth in . . . the Avenue de l'Opéra . . ." He liked Marseilles, and thought the garden of a hotel he found in Ajaccio "a wonderful place . . . with oranges and large white roses on the trees all about . . ." But on balance it was clear that he was not a man for the south, and so his next long excursion was to Bath, where he remained, with interruptions for trips to London, from December, 1901, until the following April. Two months later he was in Holland again.

His London base, off and on until 1902, was Heinemann's

home, first at 4 Whitehall Court and later in Norfolk Street. His
Paris base, until he disposed of it in 1901, was the apartment at 110
Rue du Bac, where he had installed his mother-in-law and Trixie's
youngest sister, Rosalind Birnie Philip, whom he had adopted as his
ward and had designated as his sole legatee (much to the later sur-
prise of those who thought he should have left something to his
children and ex-mistresses). But in London he often stayed at Gar-
land's Hotel, and in Paris at the Hotel Chatham. And he kept his
studios in Fitzroy Street and the Rue Notre-Dame-des-Champs
until nearly the end of his life. Few artists since the era of tribal mi-
grations have been so unfixed.

Impressed by the large profits other people had made out of
the rise in his reputation since the late 1880s, he attempted some
special cashing in on his own. Early in 1898, with the idea of being
his own dealer, he formed in London an agency he called the Com-
pany of the Butterfly; it got as far as having offices off Manchester
Square, near the mansion housing the Wallace Collection (only
recently given to the nation), and then gradually expired from
neglect by himself and by patrons who preferred to buy pictures
in a more traditional way. Later that year in Paris he created the
art school of which he had been thinking since at least the time of
the construction of the White House in Chelsea. Premises were
rented at 6 Passage Stanislas, near the Rue Notre-Dame-des-
Champs, and a Whistler model, Carmen Rossi, was put in charge
of the business side. Students arrived in large numbers at first and
then left in large numbers, irritated by the long absences of the
Master and by his dictatorial methods when he did appear. One of
his ideas, which cannot quite be dismissed as a joke, was to have
the woman student who normally conducted the class sign a
medieval deed of apprenticeship by which she "bound herself to
her Master to learn the Art and Craft of a painter, faithfully
to serve after the manner of an Apprentice for the full term of five
years, his secrets keep and his lawful commands obey." Another
idea was to announce that "Mr. Whistler expects, as the only
acknowledgement that can be made him, complete acquiescence in
his wishes—and complete loyalty—any doubtful hesitation being

quite out of place and impossible among the distinguished pupils it is his pleasure to meet." The Académie Carmen, as the establishment came to be called, closed in April, 1901, by which time Carmen herself had wisely switched over to the less complicated job of running a Parisian wine shop. The only truly distinguished pupil whose style Whistler can be said to have strongly influenced was Gwen John, whose work has just recently begun to get the appreciation it deserves.

There were compensations, however, for his failures as a businessman and a teacher during these years. He was still widely regarded by young painters as a symbol of modernist revolt, and in April, 1898, he was elected the first president of the recently founded International Society of Sculptors, Painters, and Gravers. As usual, his autocratic ways made cooperation with his associates difficult, but under his presidency the society organized two large exhibitions at the Princes Skating Club in Knightsbridge and gave Londoners a better idea of the achievements of such French innovators as Manet, Monet, Sisley, Rodin, Toulouse-Lautrec, Bonnard, and Vuillard.

Advancing age and international honors did not prove to be remedies for quarrelsomeness. In 1897 Sickert was banished to the category of the Enemies for the double crime of having been friendly with Sir William Eden and having written in the *Saturday Review* that some lithographs by Pennell were not true lithographs because they were done on transfer paper—which the Master also used—instead of directly on the stone. Pennell eventually brought and won a suit for libel, during which Whistler testified that Sickert was "an insignificant and irresponsible person." In December of that year the long and by then excruciatingly boring Eden affair was at last pushed to a legal conclusion, the judgment of the French appeals court being that the altered portrait need not be delivered but that the thousand francs in damages had to be paid. Whistler thereupon announced that he had "wiped up the floor" with Sir William and that thanks to the trial a new clause had been added to the Napoleonic code protecting the rights of artists to their work. He immediately began to compile and write his pamphlet on

the case, and insisted on reading what he considered choice passages
to every captive audience he could find, including the other mem-
bers of the organizing committee of the International Society of
Sculptors, Painters, and Gravers. He explained his reasons for this
to Pennell: "Well, you know, take my word for it, Joseph, the
first duty of a good general when he has won his battle is to say so,
otherwise the people, always dull—the Briton especially—fail to un-
derstand, and it is an unsettled point in history forever."

In 1898 the Spanish-American War, which he considered "a
wonderful and beautiful" conflict fought by gentlemen, provided
him with an opportunity to play the West Point man at Paris and
London dinner parties—when he was not taking one of his now
habitual dinner-table naps. In 1899 the frequently less than brilliant
performance of British forces in the Boer War gave him the same
opportunity plus a chance to get even with the Islanders for having
neglected his merits as an artist; newspaper clippings in hand, he
rejoiced over Boer victories until even his close friends begged him
to change the subject. The next year the Boxer Uprising and the
massacre of Christians suddenly made him aggressively and dandy-
ishly pro-Chinese. "Here are these people," he said, "thousands of
years older in civilization than us, with a religion thousands of
years older than ours, and our missionaries go out there and tell
them who God is. It is simply preposterous, you know, that for
what Europe and America consider a question of honor one blue
pot should be risked."

In his work he had spells of boyish optimism. "Really, you
know," he wrote to the Pennells from Paris in 1897, "I could al-
most laugh at the extraordinary progress I am making, and the
lovely things I am inventing—work beyond anything I have ever
done before." Possibly the "progress" he had in mind was a return
to the classicism he had attempted in the late 1860s, for at about
this time he was making plans, none of which was realized, for a
series of large nudes representing Eve, Bathsheba, Danaë, and an
odalisque. One of his studies in the same vein led in 1898 to the
nine-inch-high oil *Purple and Gold: Phryne the Superb, Builder
of Temples*. He was proud of this picture, although understand-

ably a little sensitive on the subject of its size. "Would she," he
asked the Pennells, "be more superb—more truly the builder of
temples—had I painted her what is called life-size by the foolish
critics who bring out their foot rule? Is it a question of feet and
inches when you look at her?" The answer, at the risk of dismay-
ing him still further, might have been yes, for the *Phryne* is very
apt to produce on viewers the effect, not of an intended miniature,
but of a sketch for a larger picture that somehow never got
painted.

As in the past, the spells of optimism were incidents in a con-
tinuing doubt. William Rothenstein—who at one point was almost
a Follower and then became an Enemy after being seen in the com-
pany of Eden—was deeply moved by a visit to the Rue Notre-
Dame-des-Champs sometime in the late 1890s:

> "Climbing the stairs we found the studio in darkness. Whis-
> tler lighted a single candle. He had been gay enough during
> dinner, but now he became very quiet and intent, as though
> he forgot me. Turning a canvas that faced the wall, he ex-
> amined it carefully, up and down, with the candle held near
> it, and then did the like with some others, peering closely
> into each. There was something tragic, almost frightening,
> as I stood and waited, in watching Whistler; he looked sud-
> denly old, as he held the candle with trembling hands, and
> stared at his work, while our shapes threw restless, fantastic
> shadows all around us. As I followed him silently down the
> stairs I realized that even Whistler must often have felt his
> heart heavy with the sense of failure."

Although "failure" was certainly too strong a word, some-
thing like "unfulfillment" was not. He had not given the full meas-
ure of his talent, and now he could not give it. He went on, of
course, being the skilled and sensitive graphic artist he had long
been. He manifested to an increasing, even slightly strange de-
gree the fondness for young girls which he had had since at least
the girlhood of Annie Haden and which he shared with such other
nineteenth-century personalities as Poe, Ruskin, and Lewis Carroll;
and he consequently produced a series of ingratiating little oil
sketches. As late as 1900, with help from memories of Hogarth, he

could capture a kind of ripe nubility in a small picture like *Dorothy Seton: A Daughter of Eve*. But when he turned to larger projects he tended either to leave them unfinished or to rework them until the life had gone out of his paint and sometimes out of the effigy. An example is the portrait of George W. Vanderbilt, which was begun in 1897 and worked on intermittently in Paris and London during the following years. Whistler liked Vanderbilt and called him the modern Philip of Spain, which carried the agreeable implication that he, Whistler, was the modern Velázquez; but liking the sitter did not keep the picture, promising in its conception, from finally becoming a half-ruin. Another, more dramatic example is *Gold and Brown: Self-Portrait*, which was under way in the studio in the Rue Notre-Dame-des-Champs early in 1898. Here the artist chose, with possibly ironical intentions, to depict himself not as a modern Velázquez but in the pose of Velázquez's Pable de Valladolid, who in real life was a buffoon and juggler at the court of Philip IV. The picture has a gloomy, histrionic intensity that approaches the tragic, partly because of the desperate expression of the face and partly because of a rubbing down of the paint surface for a repainting that was never done. In this instance one can feel that the blocked creator was lucky in his habit of wrecking and abandoning.

He continued to attract attempts to judge or portray him. In 1897 Boldini did a portrait of him as a combination of Satanic boulevardier and music-hall prestidigitator—"a wonderful presentment of him in his worst mood," the Pennells thought. At about the same period Max Beerbohm caricatured him as a belligerent ham actor. During the Boer War Henry Adams listened to one of the dinner-table tirades against the British, "witty, declamatory, extravagant, bitter, amusing, and noisy," and decided that Whistler had been "brutalized . . . by the brutalities of his world." Frank Harris came to a rather similar conclusion: "Men had treated him contemptuously for so many years, life had been so unjust to him that his temper got raw; every touch smarted, and he was up in arms and eager to fight to the death for a casual rub." Pissarro was less charitable: ". . . too much puffism in my opinion." Blanche no-

ticed that "Jimmie still wishes to be a dandy à la Barbey d'Aure-villy." Rothenstein decided: "There were limits to the price one should pay for Whistler's friendship." Arthur Symons wrote of a dinner in London in April, 1900, at which Whistler was present: "I never saw anyone so feverishly alive as this little, old man, with his bright, withered cheeks, over which the skin was drawn tightly, his darting eyes, under their prickly bushes of eyebrows, his fan-tastically creased black and white curls of hair, his bitter and sub-tle mouth, and, above all, his exquisite hands, never at rest."

"Feverishly alive" was more clinically accurate than Symons may have suspected. By 1900 the athletic Whistler who had knocked Haden through a Paris window and jumped into the ocean at Trouville in November was back in a state worse than that of the sickly boy in St. Petersburg. His heart was showing signs of serious weakness. He caught colds which he could not seem to shake off. Medical opinion, he said, was that he was "lowered in tone: probably the result of living in the midst of English pictures," but his jokes could not hide the fact that he was now half-ill much of the time and that his morale was being lowered along with his "tone." His naps during dinner became longer and sometimes alarmingly profound. In Corsica in 1901, told that he was "all nerves," he tried just sitting in the sun, with such good results that he wrote enthusiastically to his sister-in-law: ". . . for *years* I have had no *play!* . . . for years I have made for myself my own tread-mill and turned upon it in mad earnestness until I dared not stop! and the marvel is that I lived to be free in this other Island—and to learn, in my exile, that again 'Nothing matters!' " The good results, however, did not last. He was ill again that fall, and more seriously the next summer.

His traveling years were obviously over. In September, 1902, he settled down once more in what he referred to as "my" Chelsea, in a relatively new house at 72 Cheyne Walk, which he had rented the previous April. The architect and owner was C. R. Ashbee, who was a product of the arts-and-crafts movement and one of the more advanced, in theory at least, designers of the English post-Godwin generation (he became one of the earliest European sup-

porters of Frank Lloyd Wright). The house had a large studio on the ground floor done in a Whistlerian gray, a drawing room with space for blue and white porcelain, windows with small panes, and a front door of beaten copper. But the new tenant soon found reasons to be unhappy with the place. The decoration, he decided, was "a successful example of the disastrous effect of art upon the British middle classes." The windows did not afford a good view of the Thames. The bedrooms were on the top floor, and to avoid straining his heart by climbing three flights of stairs he was finally obliged to live in a small dressing room next to the studio. A building was being erected next door, and he was unsuccessful in an attempt to put a stop to the "knock, knock, knock all day."

There were days when he felt well enough to work or go for a carriage ride. He played dominoes, cheating whenever he thought he could. He continued to take an interest in the affairs of the International Society of Sculptors, Painters, and Gravers, of which he was still nominally the president. He found the energy to be at once annoyed and funny when Rodin paid him a visit and committed a social blunder: "It was all very charming. Rodin distinguished in every way—the breakfast very elegant—but—well, you know, you will understand. Before they came, naturally, I put my work out of sight, canvases up against the wall with their backs turned. And you know, never once, not even after breakfast, did Rodin ask to see anything, not that I wanted to show anything to Rodin, I needn't tell you—but in a man so distinguished it seemed a want of—well, of what West Point would have demanded under the circumstances." He also found his old capacity for abusive language when he learned that Montesquiou had sold his portrait for a thumping profit; scraps of the draft of a letter that has been lost suggest the tone of what was said to the count: ". . . the portrait acquired as the Poet, for a song, is sold again as the Jew of the Rue Lafitte for ten times that first air: felicitations."

By the spring of 1903 his heart was worse and his colds were turning into what seems to have been chronic influenza. By early summer he was spending much of his time dozing in his studio with a cat on his lap. He lost his interest in food and wine, and also in

dandyism; he began to wear a shabby old brown overcoat as a dressing gown. "To destroy is to remain," he had once written, and he now had moments of self-doubt in which he tried to raise the average level of his achievement by burning etchings he found unsatisfactory. Sometimes pictures were placed on his easels; among the unfinished works were *Portrait Sketch of a Lady* and *Portrait of Charles L. Freer*. He was visited twice by the faithful Duret at the beginning of July, and on both occasions he was too weak to talk.

He died on the afternoon of July 17, a few days after celebrating his sixty-ninth birthday. He was buried beside Trixie in the Chiswick cemetery on July 22—"amid falling rain," the parish magazine noted. During the funeral services at the Old Church long-time residents of Chelsea recognized among the mourners an elderly woman who was escorted by a man in his thirties. It was Jo, accompanied by the disowned son.

Museums and Collections

All works are by Whistler unless otherwise indicated.

Annabel Lee. Freer Gallery of Art, Washington, D. C.

Arrangement in Black and Brown: The Fur Jacket. Art Museum, Worcester, Mass.

Arrangement in Black and Brown: Rosa Corder. Frick Collection, New York.

Arrangement in Black and Gold: Comte Robert de Montesquiou. Frick Collection, New York.

Arrangement in Black and White: The Young American. Freer Gallery of Art, Washington, D. C.

Arrangement in Black: F. R. Leyland. Freer Gallery of Art, Washington, D. C.

Arrangement in Black: Lady in the Yellow Buskin, Lady Archibald Campbell. Philadelphia Museum of Art.

Arrangement in Black No. 2: Mrs. Louis Huth. Viscount Cowdray collection, Sussex, England.

Arrangement in Black No. 3: Sir Henry Irving. Metropolitan Museum of Art, New York.

Arrangement in Black No. 5: Lady Meux. Ian Gilmour collection, London.

Arrangement in Black: Pablo de Sarasate. Carnegie Institute, Pittsburgh.

Arrangement in Flesh Color and Black: Théodore Duret. Metropolitan Museum of Art, New York.

Arrangement in Grey and Black No. 1: The Artist's Mother. Louvre, Paris.

Arrangement in Grey and Black No. 2: Thomas Carlyle. Glasgow Art Gallery and Museum.

Arrangement in Grey: Self-Portrait. Detroit Institute of Arts.
Arrangement in Pink and Purple. Cincinnati Art Museum.
Arrangement in Yellow and Grey: Effie Deans. Rijksmuseum, Amsterdam.
Artist's Studio, The. Art Institute of Chicago. Municipal Gallery of Modern Art, Dublin.
At the Piano. Taft Museum, Cincinnati.
Bar at the Folies-Bergère. (Manet.) Courtauld Institute, London.
Battersea Reach. Corcoran Gallery, Washington, D. C.
Beach at Selsey Bill. Museum of American Art, New Britain, Conn.
Belle Irlandaise, La. (Courbet.) Nelson Gallery-Atkins Museum, Kansas City. Metropolitan Museum of Art, New York. Nationalmuseum, Stockholm.
Bellelli Family. (Degas.) Louvre, Paris.
Blue Wave, The. Hillstead Museum, Farmington, Conn.
Bonjour, Monsieur Courbet, or *La Rencontre.* (Courbet.) Musée Fabre, Montpellier.
Brown and Silver: Old Battersea Bridge. Addison Gallery of American Art, Andover, Mass.
Caprice in Purple and Gold No. 2: The Golden Screen. Freer Gallery of Art, Washington, D. C.
Charles L. Freer. Freer Gallery of Art, Washington, D. C.
Chelsea Shops. Freer Gallery of Art, Washington, D. C.
Coast of Brittany, The. Wadsworth Atheneum, Hartford, Conn.
Coast Scene: Bathers. Art Institute of Chicago.
Concert, The. (Vermeer.) Isabella Stewart Gardner Museum, Boston.
Cremorne Gardens No. 2. Metropolitan Museum of Art, New York.
Crepuscule in Flesh Color and Green: Valparaiso. Tate Gallery, London.
Crepuscule in Opal: Trouville. Museum of Art, Toledo, Ohio.
Dancers Adjusting Their Slippers. (Degas.) Cleveland Museum of Art.
Déjeuner sur l'herbe, Le. (Manet.) Louvre, Paris.
Derby Day. (Frith.) Tate Gallery, London.
Dorothy Seton: A Daughter of Eve. University of Glasgow.
Dorsetshire Landscape. Freer Gallery of Art, Washington, D. C.
Ecce Ancilla Domini. (Rossetti.) Tate Gallery, London.
Edge of the Sea at Palavas. (Courbet.) Musée Fabre, Montpellier.
Ex-Voto. (Legros.) Musée de Dijon.
Finding the Saviour in the Temple. (Holman Hunt.) City Museum and Art Gallery, Birmingham, England.
General Dealer, The. Rhode Island School of Design, Providence.
George W. Vanderbilt. National Gallery, Washington, D. C.
Gold and Brown: Self-Portrait. University of Glasgow.
Gold Scab, The. Mrs. A. B. Spreckels collection, Maryhill Museum, Washington, D.C.
Grey and Green: The Silver Sea. Art Institute of Chicago.
Grey and Silver: The Angry Sea. Freer Gallery of Art, Washington, D. C.

Grey and Silver: Old Battersea Reach. Art Institute of Chicago.

Guitarrero, Le. (Manet.) Metropolitan Museum of Art, New York.

Hammersmith Bridge on Boat-Race Day. (Greaves.) Tate Gallery, London.

Harmony in Blue and Gold: The Peacock Room. Freer Gallery of Art, Washington, D.C.

Harmony in Blue and Silver: Trouville. Isabella Stewart Gardner Museum, Boston.

Harmony in Flesh Color and Pink: Valerie, Lady Meux. Frick Collection, New York.

Harmony in Flesh Color and Red, or *Symphony in Red.* Museum of Fine Arts, Boston.

Harmony in Green and Rose: The Music Room. Freer Gallery of Art, Washington, D. C.

Harmony in Grey: Chelsea in Ice. Private collection, London.

Harmony in Grey and Green: Miss Cicely Alexander. Tate Gallery, London.

Harmony in Red: Lamplight: Mrs. Whistler. University of Glasgow.

Harmony in Yellow and Gold: The Gold Girl, Connie Gilchrist. Metropolitan Museum of Art, New York.

Head of an Old Man Smoking. Louvre, Paris.

Hommage à Delacroix. (Fantin-Latour.) Louvre, Paris.

Lady With a Fan. (Velázquez.) Wallace Collection, London.

Last Days of Pompeii. (Briullov.) Russian Museum, Leningrad.

Last of Old Westminster, The. Museum of Fine Arts, Boston.

Little Rose of Lyme Regis. Museum of Fine Arts, Boston.

Luncheon of the Boating Party. (Renoir.) Phillips Collection, Washington, D. C.

Meninas, Las. (Velázquez.) Prado, Madrid.

Mère Gérard, La. E. Swift Newton collection, Dublin.

Miss Maud Franklin. Fogg Museum of Art, Cambridge, Mass.

Music Lesson, The. (Leighton.) Guildhall Art Gallery, London.

Nocturne in Black and Gold: Entrance to Southampton Water. Art Institute of Chicago.

Nocturne in Black and Gold: The Falling Rocket. Detroit Institute of Arts.

Nocturne in Black and Gold: The Fire Wheel. Tate Gallery, London.

Nocturne in Blue and Gold: Old Battersea Bridge. Tate Gallery, London.

Nocturne in Blue and Gold: Valparaiso. Freer Gallery of Art, Washington, D. C.

Nocturne in Blue and Green: Chelsea. Misses Alexander Collection, London.

Nocturne in Blue and Silver: Cremorne Lights. Tate Gallery, London. Boston.

Nocturne in Blue and Silver: The Lagoon, Venice. Museum of Fine Arts,

Nocturne: The Solent. Gilcrease Institute of American History and Art, Tulsa, Oklahoma.

Nocturne: Cremorne Gardens No. 3. Freer Gallery of Art, Washington, D. C.

Note in Blue and Opal: The Sun Cloud. Freer Gallery of Art, Washington, D. C.

Note in Green: Wortley. Freer Gallery of Art, Washington, D. C.

Note in Green and Brown: Orlando at Coombe. University of Glasgow.

Portrait Sketch of a Lady. Freer Gallery of Art, Washington, D. C.

Purple and Gold: Phryne the Superb, Builder of Temples. Freer Gallery of Art, Washington, D. C.

Purple and Rose: The Lange Lijzen of the Six Marks. John G. Johnson Collection, Philadelphia.

Railway Station, The. (Frith.) Royal Holloway College, Englefield Green, Surrey.

Rose and Silver: La Princesse du Pays de la Porcelaine. Freer Gallery of Art, Washington, D. C.

Six Projects. Freer Gallery of Art, Washington, D. C.

Sommeil, Le. (Courbet.) Musée du Petit Palais, Paris.

Sunday Afternoon on the Island of La Grande-Jatte. (Seurat.) Art Institute of Chicago.

Symphony in Flesh Color and Pink: Mrs. F. R. Leyland. Frick Collection, New York.

Symphony in Grey and Green: The Ocean. Frick Collection, New York.

Symphony in White No. 1: The White Girl. National Gallery of Art, Washington, D. C.

Symphony in White No. 2: The Little White Girl. Tate Gallery, London.

Symphony in White No. 3. Barber Institute of Fine Arts, Birmingham, England.

Thames in Ice, The. Freer Gallery of Art, Washington, D. C.

Three Figures: Pink and Grey. Tate Gallery, London.

Toilet of Venus, or the Rokeby Venus. (Velázquez.) National Gallery, London.

Two Sisters. (Fantin-Latour.) City Art Museum, St. Louis.

Variations in Flesh Color and Green: The Balcony. Freer Gallery of Art, Washington, D. C.

Venus Rising From the Sea. Freer Gallery of Art, Washington, D. C.

Wapping. John Hay Whitney collection, New York.

Women of Algiers. (Delacroix.) Louvre, Paris.

There are good collections of Whistler prints in, among other places, The New York Public Library, the British Museum, and the University of Glasgow.

Notes

The page number is followed by a key word or phrase that identifies the passage, usually a quotation, being annotated. The "B" numbers refer to items in the bibliography. Thus "P. 193 ass: B. 9, p. 43" means that Whistler's comment on page 334 concerning Balaam's ass will be found on page 43 of *The Gentle Art of Making Enemies*, which is No. 9 in the bibliography. Sometimes the reference is to an author who cites the original source. The code is abandoned when unsuitable.

CHAPTER I. P. 18 Be ye also: B. 98, p. 266. P. 18 as you spend: B. 98, p. 117. P. 19 I can return: B. 98, p. 24. P. 20 I'se drawrin': B. 20, p. 6. P. 20 always doing that: B. 21, p. 171. P. 20 Jemmie asleep: B. 20, p. 5. P. 20 hand: B. 20, p. 6. P. 20 bit of color: B. 19, p. 77. P. 21 very strict: B. 20, p. 19. P. 21 like Saturday: B. 21, p. 252. P. 21 The Preacher: B. 9, p. 135. P. 22 to be shifty: Daniel J. Boorstin, *The Americans*, vol. 2, Penguin edition, 1969, p. 71; Suggs was a creation of J. J. Hooper. P. 23 so jolly: B. 98, p. 52.

CHAPTER II. P. 26 Peter the Great: B. 20, p. 10. P. 26 recite a verse: B. 20, pp. 10-11. P. 26 My dear boys: B. 20, p. 14. P. 26 drooping: B. 20, p. 15. P. 27 Jemmie's animation: B. 20, p. 7. P. 27 Jemmie's eagerness: B. 20, p. 11. P. 28 Sir William Allan: B. 20, pp. 8-9. P. 28 drawing lessons: B. 20, p. 11. P. 31 interest in portraits: B. 20, pp. 12-13. P. 32 Hogarth: B. 20, pp. 15 and 232. P. 33 Peterhof: B. 20, p. 10. P. 35 Haden patted me: B. 21, p. 182. P. 37 my choice, viz: a painter: B. 112, p. 47. P. 37 And now, Jamie: B. 112, pp. 47-48.

CHAPTER III. P. 40 little princes: B. 20, p. 18. P. 41 tall and slight: B. 20, p. 19. P. 42 He entered July 1: B. 20, p. 20. P. 42 The anecdotal history: B. 20, pp. 22-25. P. 45 forgotten your muff: B. 28, p. 24. P. 46 taint of Lowell: B. 21, pp. 3-4. P. 46 Most interesting: B. 20, p. 1. P. 46 *Who's Who:* B. 21, opposite p. 298. P. 47 loathing for niggers: B. 21, p. 168. P. 47 hated Jews: B. 21, p. 16. P. 47 Jefferson Davis: B. 21, pp. 180-81. P. 48 apt to be late: B. 20, p. 29.

CHAPTER IV. P. 51 British tendencies: B. 106, p. 94. P. 51 French easily dominated: B. 105, first chapter. P. 53 madly in love: B. 20, p. 39. P. 54 Voulez vous savoir: B. 83, p. 22. P. 55 like a trollop: see the photograph in *Horizon* magazine, autumn 1969, p. 32. P. 56 bad manners: B. 20, p. 41. P. 58 insolence of genius: B. 55, p. 153. P. 58 Le dandy ne se pare: B. 55, p. 141. P. 58 soul of old Brummell: B. 79, p. 14. P. 59 Things are beautiful: B. 119, p. 28. P. 59 Art is not a means: B. 119, p. 29. P. 59 an arrangement: B. 74, p. 392. P. 60 taught beauty: B. 105, p. 34. P. 61 It's a transformation: G. Jeanniot, "Souvenirs sur Degas," *La Revue Universelle*, October 15, 1933. P. 62 antique man: C. H. Stranahan, *A History of French Painting*, 1888, p. 287. P. 62 If a man: B. 21, p. 172. P. 64 hire the concierges: B. 20, p. 37. P. 65 during the two: B. 20, p. 36. P. 65 milk: B. 20, p. 39.

CHAPTER V. P. 66 I copied: B. 21, p. 171. P. 71 too green: *The Oxford Companion to Art*, 1970, p. 152. P. 71 Then I wrote: B. 21, p. 43. P. 75 Dutch bath: B. 87, p. 52. P. 76 bust a gut: B. 28, p. 94. P. 78 painting of democrats: M. de Fels, *La vie de Claude Monet*, Paris, 1929, p. 55. P. 78 title of Realist: B. 96, p. 33. P. 78 To the wind: Baudelaire, *Oeuvres complètes*, Pléiade edition, 1968, p. 866

CHAPTER VI. P. 86 The river sweats: *The Waste Land*, lines 266-69. P. 87 marvelous jumble: Baudelaire, *Oeuvres complètes*, Pléiade edition, p. 1148. P. 87 eccentric, uncouth: B. 20, p. 59. P. 87 recklessly bold: B. 20, p. 59. P. 87 I must now tell: B. 51, p. 4. P. 88 Jemmy . . . is working: B. 51, p. 16. P. 88 I'd like to have: B. 15, pp. 496-97. P. 89 If Velazquez: B. 32, p. 35. P. 90 scent, sound: *La Chevelure.* P. 90 left his straight: *Body's Beauty:* B. 28, p. 122. P. 90 bright golden: *Requiescat.* P. 90 And his neck: *The Host of the Air.* P. 90 Hiffernan: B. 30, p. 22. P. 91 me son-in-law: B. 21, p. 163. P. 92 huge profits: B. 88, p. 164. P. 92 Holman Hunt: B. 63, pp. 120-21. P. 93 etching sanctuary: B. 53, p. 439. P. 94 At lunch: B. 78, p. 92. P. 94 it needed God: B. 20, p. 54. P. 95 schoolboy crush: B. 51, pp. 9-16.

CHAPTER VII. P. 96 New Year's Eve: B. 51, p. 29. P. 97 towards the end: B. 20, p. 56. P. 97 one of my very best: this comment is written on a print in The New York Public Library. P. 98 powerful-toned: B. 20, p. 67. P. 98 hung over the stove: B. 20, p. 67. P. 98 James Clarke Hook: B. 106, p. 153. P. 98 Paris is liberty: B. 78, p. 23. P. 99 Whistler gone to Paris:

B. 51, p. 66. P. 101 I wrote: B. 51, p. 104. P. 101 pissed against: B. 51, p. 106. P. 102 Imagination in art: B. 96, pp. 35-36. P. 104 I note: B. 14, p. 249. P. 104 perfectly expressed: B. 20, p. 69. P. 104 It is one: B. 20, p. 70. P. 104 My painting: B. 20, p. 70. P. 105 It was the piles: B. 20, pp. 72-73. P. 105 a tropical bird: *The Education of Henry Adams*, Modern Library, 1931, p. 139. P. 105 tomb of loans: B. 61, p. 408. P. 106 going at last: B. 51, p. 160. P. 106 letters to Fantin: B. 15, pp. 501-02. P. 107 to George Lucas: B. 14, p. 250. P. 108 Now here: B. 78, pp. 176-77. P. 109 This exhibition: B. 15, pp. 403-10. P. 109 The hangers: B. 20, p. 74. P. 109 contagious hilarity: B. 132 , Chapter V. P. 110 symphony of white: B. 28, p. 40. P. 110 you are famous: B. 23, p. 36.

CHAPTER VIII. P. 113 Chelsea is a singular: Alexander Carlyle, *Carlyle's House*, 1966, p. 8. P. 115 brilliant autumn: B. 22, p. 186. P. 117 Jimmy & the Rossetti: B. 51, p. 216. P. 119 Gambart: B. 63, p. 79. P. 119 religious lady: B. 101, p. 67. P. 121 great artist: B. 20, p. 79. P. 121 slovenly scrawl: B. 28, p. 13. P. 121 putrescence: B. 20, p. 80. P. 121 I'd like: B. 15, pp. 504-05. P. 122 Jimmy: B. 51, p. 216. P. 122 artistic abode: B. 128, p. 318. P. 124 Astruc: Goncourt *Journal*, August 11, 1892. P. 125 deal of laughing: B. 23, p. 48. P. 126 so beautiful: B. 51, p. 300. P. 127 During a sharp frost: B. 128, p. 324.

CHAPTER IX. P. 130 To Mr. Whistler: B. 101, p. 81. P. 130 Portuguese person: B. 63, p. 134. P. 131 Howell: B. 21, pp. 58-70. P. 132 little Whistler: B. 28, p. 44. P. 132 remember Trouville: letter in the collection at the University of Glasgow. P. 135 I and the White Girl: B. 21, p. 157. P. 136 It was a moment: B. 20, pp. 95-96. P. 136 As for Jim: B. 51, p. 227. P. 137 Legros: B. 51, p. 248. P. 137 nigger from Haiti: B. 21, p. 43. P. 137 combative artist: B. 62, p. 47. P. 138 You lie: B. 51, p. 301; B. 21, p. 83. P. 138 to Edwin Edwards: see B. 78. P. 139 in mortal fear: B. 51, p. 227. P. 139 the kind they like: B. 60, pp. 102-09. P. 140 still living with him: B. 14, p. 252. P. 141 half a great: B. 20, p. 93. P. 141 most bizarre: B. 20, p. 93. P. 141 The enthusiasm: *Gazette des Beaux-Arts*, July, 1865. P. 141 Velazquez: Pierre Courthion, editor, *Manet raconté par lui-même*, p. 42. P. 142 falling behind: B. 15, p. 157. P. 142 His painting: B. 23, pp. 53-54. P. 143 frequently unhappy: B. 15, pp. 148, 153, and 154. P. 144 I'd like to show you: B. 15, p. 154; see also B. 28, p. 43. P. 144 not precisely: B. 9, p. 44. P. 144 Bon Dieu: B. 9, p. 45. P. 145 Ah, my dear Fantin: B. 15, pp. 232 ff. P. 146 I have a great deal: B. 14, p. 251. P. 147 I have seen: B. 20, p. 104.

CHAPTER X. P. 149 this Dandy: Robert Buchanan, "The Fleshly School of Poetry," *Contemporary Review*, October, 1871. P. 152 I'll have the portrait: B. 111, p. 507. P. 152 to render his home: B. 128, pp. 310-28. P. 153 in my Japanese bedroom: B. 128, where the letter is misdated 1866. P. 153 Art should be independent: B. 9, pp. 127-28. P. 153 we were looking: B. 20, p. 119. P. 154 he sat down: B. 21, pp. 174-75. P. 154 Carlyle

tells: B. 20, p. 120. P. 155 *La Faustin:* see Mario Praz, *The Romantic Agony,* Oxford, 1970, p. 442, P. 158 Puir lassie: B. 20, p. 120. P. 159 Manet: B. 96, p. 79. P. 160 What they like: B. 21, p. 174. P. 161 I can't thank: B. 20, p. 116. P. 164 I know: B. 9, p. 126. P. 164 This Whistler: B. 28, p. 23. P. 164 Maud: B. 21, pp. 163-67. P. 165 Dined with Jimmy: B. 20, pp. 135-36. P. 167 I was amazed: B. 21, p. 70. P. 168 quite madly: B. 20, p. 144.

CHAPTER XI. P. 169 most memorable: B. 36, p. 175. P. 169 there has assuredly: B. 36, p. 13. P. 170 chronic chinamania: Almanac, 1875. P. 170 that the painter: B. 21, pp. 209-306. P. 171 lying snob: B. 61, p. 410. P. 171 pale little man: B. 61, p. 410. P. 173 dear old Kensington: February 19, 1881. P. 175 trifle mixed: B. 61, p. 412. P. 176 Jeckyll writes: B. 61, p. 412. P. 177 Mon cher Baron: B. 61, p. 412. P. 177 Well, you know: B. 20, p. 148. P. 178 W. quite mad: B. 20, p. 149. P. 178 But what: B. 20, pp. 149-50. P. 178 This is what: B. 61, p. 412. P. 179 a paradise: B. 61, p. 413. P. 179 He has worked: B. 61, p. 413. P. 179 the inspiration: B. 61, p. 412. P. 180 To be sure: B. 61, p. 413. P. 180 Well, what can you: B. 21, p. 109. P. 180 You choose to begin: B. 61, p. 413. P. 181 positively sickening: B. 61, p. 413.

CHAPTER XII. P. 183 damned clever: B. 102, p. 111. P. 183 whimsical: B. 20, p. 154. P. 183 entire absence: B. 20, p. 154. P. 184 I never saw anything: Kenneth Clark, editor, *Ruskin Today,* 1964, pp. 205-06. P. 184 fearfully despondent: B. 108, p. 184. P. 184 throwing handfuls: Clark, *Ruskin Today,* p. 206. P. 185 most debased: B. 20, p. 155. P. 185 Tennyson: B. 119, p. 39. P. 187 diet of fog: B. 20, p. 159. P. 187 Last year: B. 20, p. 159. P. 187 Everything was most: B. 20, p. 165. P. 187 go away: B. 88, p. 214. P. 187 Poor J. turned: B. 20, p. 166. P. 188 nuts and nectar: B. 20, p. 168. P. 188 I am an artist: the account of the trial is based on B. 74, pp. 389-98; B. 9, pp. 2-18; and B. 20, pp. 166-81. P. 193 I wish: B. 28, p. 64. P. 193 matter of joke: B. 21, p. 324. P. 193 Dead for a ducat: B. 9, pp. 37-39. P. 193 ass: B. 9, p. 43. P. 194 not a Nocturne: B. 102, p. 130. P. 196 Except the Lord: B. 20, p. 187.

CHAPTER XIII. P. 198 a ghost: B. 108, p. 83. P. 199 after the wet: B. 28, p. 50. P. 199 more splendid: B. 23, p. 93. P. 199 round the corner: B. 20, p. 189. P. 200 the first thing: B. 20, p. 190. P. 200 Very late: B. 20, p. 195. P. 201 by jingo: B. 20, p. 200. P. 202 Bacher: B. 102, p. 142, and B. 19, p. 95. P. 202 Henry Woods: B. 23, p. 93. P. 203 dinner-viewing: B. 20, p. 195. P. 206 Well, you know: B. 20, p. 203. P. 207 Godwin: B. 20, p. 204. P. 207 It would have been better: B. 20, p. 206.

CHAPTER XIV. P. 209 met Jimmie: B. 20, p. 210. P. 209 Tell this soul: *The Raven,* lines 93-94. P. 210 For some reason: B. 20, p. 211. P. 212 You

go back: B. 20, p. 215. P. 214 masterpieces: B. 23, p. 105. P. 215 curious little games: B. 23, pp. 104-05. P. 215 Whistler's habit: B. 20, p. 236. P. 217 Poverty: B. 20, p. 304. P. 218 Manet: B. 20, p. 404-05. P. 219 An artist's work: B. 20, p. 405. P. 219 Dinna ye: B. 20, p. 221. P. 220 queer creature: *Journal*, April 23, 1881. P. 221 Out of their own: B. 9, pp. 91 ff. P. 221 Propositions, No. 2: B. 9, pp. 115-16. P. 221 charlatan: B. 21, p. 185. P. 221 when the art critic: B. 9, p. 69. P. 222 To have seen him: B. 9, pp. 72-73. P. 223 too personal: B. 20, p. 218. P. 223 first duty: B. 125, p. 37. P. 224 my genius: B. 73, p. 34. P. 224 Velazquez: B. 21, p. 227. P. 224 I had almost won: B. 73, p. 47. P. 224 with no more sense: B. 9, p. 164. P. 225 You will, Oscar: B. 19, p. 120. P. 225 my St. John: B. 9, p. 237. P. 226 We seldom asked: B. 20, p. 230.

CHAPTER XV. P. 228 eccentric artist: B. 20, p. 243. P. 228 stagefright: B. 20, p. 243. P. 229 Art is upon the town: the whole lecture is reprinted in B. 9, pp. 131 ff. P. 232 Delacroix, Flaubert: see Wylie Sypher, *Rococo to Cubism in Art and Literature*, 1960, p. 74. P. 232 Art is at her peril: B. 119, p. 48. P. 234 eccentric freak: B. 20, p. 246. P. 234 the audience: B. 20, p. 246. P. 234 Wilde: see B. 129 also B. 9, p. 161. P. 235 ensuing exchange of letters: B. 9, pp. 162-65. P. 235 Swinburne: B. 9, pp. 250-58. P. 236 Bravo: B. 9, p. 262. P. 226 Why, O brother: B. 9, p. 259. P. 236 Fly away, butterfly: Georges Lafourcade, *La Jeunesse de Swinburne*, 1928, vol. 1, p. 211. P. 237 little viper, B. 21, p. 247. P. 237 They tell me: B. 9, pp. 184-85. P. 238 It is rare: B. 9, p. 176. P. 239 cease to be a shop: B. 20, p. 262. P. 240 The organization of this Royal Society: B. 9, p. 210. P. 240 killed our Lord: B. 101, p. 103. P. 240 We were all there: B. 21, pp. 267-68. P. 241 Home of Taste: B. 9, pp. 230-32. P. 241 early rat: B. 20, p. 268. P. 241 an Australian immigrant: B. 9, p. 233.

CHAPTER XVI. P. 242 little widdie: B. 21, p. 166. P. 243 People ran him: B. 101, p. 125. P. 243 lingered in the anteroom: B. 20, p. 292. P. 244 You see: B. 20, p. 284. P. 245 heroic kick: B. 21, p. 10; B. 20, pp. 301-05. P. 247 no Art Nouveau: B. 21, p. 73. P. 247 Look at him: B. 21, p. 12. P. 248 I, I, this thing: B. 125, p. 43. P. 248 wearing of a mask: B. 125, p. 38. P. 248 servants will do that: B. 119, p. 90. P. 249 rare bird: B. 92, p. 37. P. 249 eating pickled cucumbers: Jonathan Mayne, "The Literature of Art," *The Burlington Magazine*, CVII, 1965, p. 325, citing B. 13. P. 249 flowers of M. Verlaine: *ibid.*, p. 324. P. 250 Rien de plus cher: *Art poétique*. P. 250 Satiated with light: B. 92, p. 52. P. 250 Under a stagnant sky: *On the Embankment*, B. 23, p. 69. P. 251 revolt against Victorianism: B. 125, pp. 185-86. P. 251 To *name* an object: B. 90, p. 869. P. 252 the Whistler cult: B. 28, p. 55. P. 252 It's in sum: B. 126, p. 206. P. 252 A muffled orchestra: B. 126, p. 215. P. 254 rare Monsieur: B. 90, pp. 531-32. P. 255 Oscar: B. 9, p. 238. P. 255 blow your brains out: B. 9, p. 235. P. 255 As music: B. 9, pp. 127-28. P. 256 to Tom Armstrong: B. 62, p. 177. P. 257 dare collar him: B. 19, p. 163. P. 257 advanced connoisseur: B. 62,

p. 178. P. 258 I supposed: B. 23, p. 129. P. 258 Montesquiou is most: *Journal*, July 7, 1891. P. 259 no idea how dreadful: B. 101, pp. 127-29.

CHAPTER XVII. P. 261 Don't speak: B. 21, p. 14. P. 262 Mallarme: B. 90, p. 1606. P. 263 bit of an old ruin: B. 21, p. 57. P. 263 I. refrain: B. 89, pp. 324-25. P. 264 bound herself: B. 20, pp. 384-85. P. 264 Mr. Whistler expects: B. 23, p. 132. P. 266 Well, you know: B. 20, p. 354. P. 266 Here are these people: B. 20, p. 401. P. 266 could almost laugh: B. 20, p. 401. P. 267 Would she be more: B. 20, p. 360. P. 267 Climbing the stairs: B. 109, vol. 1, pp. 109-10. P. 268 witty, declamatory: *The Education of Henry Adams*, Modern Library, 1931, pp. 370-71 and 386. P. 268 Men had treated him: B. 68, p. 347. P. 269 Jimmie still wishes: B. 18, p. 280. P. 269 There were limits: B. 28, p. 125. P. 269 I never saw: B. 123, p. 71. P. 269 lowered in tone: B. 20, p. 406. P. 269 for *years* I have: B. 89, p. 338. P. 270 successful example: B. 20, p. 414. P. 270 It was all very charming: B. 20, p. 415.

Bibliography

WRITINGS BY WHISTLER

1. *Harmony in Blue and Gold. The Peacock Room.* London, 1877.
2. *Whistler v. Ruskin. Art and Art Critics.* London, 1878.
3. *The Piker Papers. The Painter-Etchers' Society and Mr. Whistler.* London, 1881.
4. *Correspondence. The Paddon Papers: The Owl and the Cabinet.* London, 1882.
5. *L'Envoie in Notes—Harmonies—Nocturnes.* London, 1884. [Later called *Propositions—No. 2.*]
6. *Propositions.* London, 1886.
7. *Mr. Whistler's Ten O'Clock.* London, 1885 and 1888.
8. *A Further Proposition.* Cited in *Court and Society Review*, London, July 1, 1886.
9. *The Gentle Art of Making Enemies.* London and New York, 1890, second edition, 1892. [My notes refer to the Dover reprint of the second edition, New York, 1967.]
10. *The Gentle Art of Making Enemies*, edited by Sheridan Ford. Paris and New York, 1890. ["Pirated" editions that differ from Whistler's.]
11. *Eden versus Whistler. The Baronet and the Butterfly. A Valentine with a Verdict.* Paris and United States, 1899.
12. *Wilde v. Whistler, Being an Acrimonious Correspondence on Art between Oscar Wilde and James A. Whistler.* London, 1906.
13. *Mallarmé-Whistler Correspondence*, edited by C. P. Barbier. Paris, 1964.
14. "The Letters of James McNeill Whistler to George A. Lucas," pre-

sented by J. A. Mahey. In *The Art Bulletin*, XLIX, 1967, pp. 247–257. [The bulk of Whistler's unpublished correspondence is in the Glasgow University Library, the Library of Congress, and the Freer Gallery, Washington.]

PRINCIPAL BIOGRAPHICAL AND CRITICAL STUDIES

15. Bénédite, L., "Artistes Contemporains: Whistler." In *Gazette des Beaux-Arts*, XXXIII, 1905, pp. 403–410, 496–511; XXXIV, 1905, pp. 142–158, 231–246.
16. Duret, T., *Histoire de J. McN. Whistler et de son Oeuvre*. Paris, 1904.
17. Gregory, H., *The World of James McNeill Whistler*. New York, 1959.
18. Laver, J., *Whistler*. London, 1930, revised edition, 1951.
19. Pearson, H., *The Man Whistler*. London, 1952.
20. Pennell, E. R. and J., *The Life of James McNeill Whistler*. Philadelphia and London, 1908, sixth edition, revised, 1920. [My notes refer to the sixth edition.]
21. ———, *The Whistler Journal*. Philadelphia, 1921.
22. Sutton, D., *Nocturne: The Art of James McNeill Whistler*. London, 1963.
23. ———, *James McNeill Whistler: Paintings, Etchings, Pastels and Watercolours*. London, 1966.

CATALOGUES

24. Cary, E. L., *The Works of James McNeill Whistler: A Study, with a Tentative List of the Artist's Work*. New York, 1907.
25. Kennedy, E. G., *The Etched Work of Whistler*. New York, 1910.
26. ———, *The Lithographs by Whistler: Arranged according to the Catalogue by Thomas R. Way*. New York, 1914.
27. Mansfield, H., *A Descriptive Catalogue of the Etchings and Drypoints of James Abbott McNeill Whistler*. Chicago, 1909.
28. Stanley, A., editor, *From Realism to Symbolism: Whistler and His World*. [Catalogue of show organized in 1971 in New York and Philadelphia by the Department of Art History and Archaeology of Columbia University in cooperation with the Philadelphia Museum of Art.]
29. Sutton, D., editor, *An Exhibition of Etchings, Dry Points & Lithographs by James McNeill Whistler*. [Catalogue of show at the Colnaghi galleries in London in 1971.]
30. Sweet, F. A., editor, *James McNeill Whistler*. [Catalogue of show in Chicago and Utica, N.Y., in 1968.]
31. Way, T. R., *Mr. Whistler's Lithographs*. Second edition, London and New York, 1905.

32. Young, A. M., editor, *James McNeill Whistler, an Exhibition of Paintings and Other Works, Organized by the Arts Council of Great Britain and the English-Speaking Union of the United States.* [Catalogue of show in London and New York in 1960.]

OTHER MATERIAL

33. Amaya, M., *Art Nouveau.* London and New York, 1966.
34. Anonymous, "Mr. Whistler in Paris. With a Sketch of His New Studio." In *The Westminster Budget,* I, 1893, pp. 12–13.
35. Anonymous, "The White House." In *Vogue,* August, 1915, p. 40.
36. Aslin, E., *The Aesthetic Movement: Prelude to Art Nouveau.* London, 1969.
37. Bacher, O. H., *With Whistler in Venice.* New York, 1908.
38. Beerbohm, M., "Whistler's Writing." In *The Metropolitan Magazine,* XX, 1904, pp. 728–733.
39. Bénédite, L., *La Peinture au XIXe siècle.* Paris, 1912.
40. Bloor, A. J., "Whistler's Boyhood." In *The Critic,* XLIII, 1903, pp. 247–254.
41. ——, "The Beginnings of James McNeill Whistler." In *The Critic,* XLVIII, 1906, pp. 123–135.
42. Boughton, G. H., "A Few of the Various Whistlers I Have Known." In *The Studio,* XXX, 1903, pp. 208–218.
43. Brinton, C., *Modern Artists.* New York, 1908.
44. Brownell, W. C., "Whistler in Painting and Etching." In *Scribner's Magazine* (Old Series), XVIII, 1879, pp. 481–495.
45. Chamot, M., *Russian Painting and Sculpture.* Oxford and New York, 1963.
46. Child, T., "A Pre-Raphaelite Mansion." In *Harper's Magazine,* December, 1890.
47. Colby, R., "Whistler and 'Miss Cissie.' " In *The Quartely Review,* July, 1960.
48. Cuneo, C., "Whistler's Academy of Painting." In *The Century Magazine,* LXXIII, 1906, pp. 19–28.
49. Dempsey, A., "Whistler and Sickert: A Friendship and its End." In *Apollo,* LXXXIII, 1966, pp. 30–37.
50. Dowdeswell, W., "Whistler." In *The Art Journal,* XXXIX, 1887, pp. 97–103.
51. du Maurier, D., editor, *The Young George du Maurier. A Selection of his Letters, 1860–7.* London, 1951.
52. du Maurier, G., "*Trilby.* Part 3." In *Harper's Magazine,* LXXXVIII, 1894, pp. 567–587.
53. Duranty, E., "Edwin Edwards, peintre et aquafortiste." In *Gazette des Beaux-Arts,* XX, 1879, pp. 438–442.

54. Duret, T., "James Whistler." In *Gazette des Beaux-Arts*, XXIII, 1881, pp. 365–369.

55. Easton, M., *Artists and Writers in Paris: The Bohemian Idea, 1803–1867*. London, 1964.

56. Eddy, A. J., *Recollections and Impressions of James A. McNeill Whistler*. Philadelphia and London, 1903.

57. Eden, T., *The Tribulations of a Baronet*. London, 1933.

58. Fairman, C. E., "Whistler in Washington," in *The Lamp*, XXIX, 1904, pp. 306–308.

59. Farley, J. P., "Art in the Army—A Retrospect." In *Journal of the Military Service Institution*, XLII, 1908, pp. 32–62.

60. Fermigier, A., *Courbet*. Geneva, 1971.

61. Ferriday, P., "The Peacock Room." In *The Architectural Review*, CXXV, 1959, pp. 407–414.

62. Gaunt, W., *The Aesthetic Adventure*. Harmondsworth, Middlesex, 1957. [First edition, London, 1945.]

63. ——, *The Pre-Raphaelite Dream*. New York, 1966. [First published as *The Pre-Raphaelite Tragedy*, London, 1942.]

64. Gray, B., " 'Japonisme' and Whistler." In *The Burlington Magazine*, CVII, 1965, p. 324.

65. Grieve, A., "Whistler and the Pre-Raphaelites." In *The Art Quarterly*, XXXIV, No. 2, 1971, pp. 219–228.

66. Hadley, F. A., "Whistler the Man as Told in Anecdote." In *Brush and Pencil*, XII, 1903, pp. 334–359.

67. Harbron, D., *The Conscious Stone. The Life of Edward William Godwin*. London, 1949.

68. Harris, F., "Whistler—Artist and Bantam." In *Forum*, LII, 1914, pp. 338–355.

69. Hartmann, S., *The Whistler Book*. Boston, 1910.

70. Hilton, T., *The Pre-Raphaelites*. London, 1970.

71. Hind, A. M., *A History of Engraving and Etching*. New York, 1963. [A reprint of the third edition of 1923.]

72. Holden, D., *Whistler Landscapes and Seascapes*. London, 1969.

73. Holland, V., *Oscar Wilde*. London, 1966.

74. Holt, E. G., editor, *From the Classicists to the Impressionists*. Volume III of *A Documentary History of Art*. Garden City, N.Y., 1966.

75. Huysmans, J. K., *Certains*. Paris, 1889.

76. Ionides, L., "Memories I, Whistler in the Quartier Latin." In *Transatlantic Review*, I, 1924, pp. 37–52.

77. Jullian, P., *Oscar Wilde*. London, 1969.

78. Jullien, A., *Fantin-Latour, sa vie et ses amitiés*. Paris, 1909.

79. Kempf, R., *Sur le dandysme*. Paris, 1971. [includes essays by Balzac, Baudelaire, and Barbey d'Aurevilly.]

80. Keppel, F., *One Day with Whistler*. New York, 1904.

81. Key, J. R., "Recollections of Whistler while in the Office of the

United States Coast Survey." In *The Century Magazine*, LXXV, 1908, pp. 928–932.

82. Kobbe, G., "Whistler at West Point." In *The Chap-book*, VIII, 1898, pp. 439–442.
83. Lamont, L. M., *Thomas Armstrong, C. B.: A Memoir*. London, 1912.
84. Lane, J. W., *Whistler*. New York, 1942.
85. Laughton, B., "British and American Contributions to Les XX, 1884–1893." In *Apollo*, LXXXVI, 1967, pp. 372–379.
86. Lecoq de Boisbaudran, H., *Education de la mémoire pittoresque*. Paris, 1848.
87. Lumsden, E. S., *The Art of Etching*. New York, 1962. [Reprint of first edition, 1924.]
88. Maas, J., *Victorian Painters*. London, 1969.
89. MacInnes, M. F., "Whistler's Last Years: Spring 1901—Algiers and Corsica." In *Gazette des Beaux-Arts*, LXXIII, 1969, pp. 323–342.
90. Mallarmé, S., *Oeuvres complètes*. Paris, 1945. [The standard Pléaide edition.]
91. Menpes, M., *Whistler as I Knew Him*. London, 1904.
92. Milner, J., *Symbolists and Decadents*. London and New York, 1971.
93. Mumford, E., *Whistler's Mother*. Boston, 1939.
94. Munhall, E., "Whistler's Portrait of Robert de Montesquiou." In *Gazette des Beaux-Arts*, LXXI, 1968, pp. 231–242.
95. Nochlin, L., *Realism*. Harmondsworth, Middlesex, 1971.
96. ——, editor, *Realism and Tradition in Art, 1848–1900. Sources and Documents*. Englewood Cliffs, N.J., 1966.
97. Ormond, L., *George Du Maurier*. London, 1969.
98. Parry, A., *Whistler's Father*. New York, 1939.
99. Pennington, H., "The Whistler I Knew." In *The International Quarterly*, X, 1904, pp. 156–164.
100. Piper, D., *Painting in England 1500–1880*. Harmondsworth, Middlesex, 1965.
101. Pocock, T., *Chelsea Reach: The Brutal Friendship of Whistler and Walter Greaves*. London, 1970.
102. Prideaux, T., *The World of Whistler: 1834–1903*. New York, 1970.
103. Quilter, H., "J. A. McNeill Whistler, a Memory and a Criticism." In *Chamber's Journal*, VI, 1903, pp. 691–696.
104. Reitlinger, G., *The Economics of Taste*. London, 1961–1963.
105. Rewald, J., *The History of Impressionism*. Revised and enlarged edition, New York, 1961.
106. Reynolds, G., *Victorian Painting*. London, 1966.
107. Robertson, W. G., *Time Was*. London, 1931.
108. Rosenberg, J. D., *The Darkening Glass: A Portrait of Ruskin's Genius*. New York, 1961.
109. Rothenstein, W., *Men and Memories*. Three volumes, New York, 1931, 1932, and 1938.

110. Rutter, F., *James McNeill Whistler. An Estimate and a Biography*. London, 1911.

111. Sandberg, J., " 'Japonisme' and Whistler." In *The Burlington Magazine*, CVI, 1964, pp. 500–507.

112. ——, "Whistler's Early Work in America, 1834–1855." In *The Art Quarterly*, XXIX, 1966, pp. 46–59.

113. ——, "Whistler Studies." In *The Art Bulletin*, L, 1968, pp. 59–64.

114. Seitz, D. C., *Whistler Stories, Collected and Arranged by D. C. S.* New York and London, 1913.

115. Sickert, B., *Whistler*. London and New York, 1908.

116. Sickert, W., *A Free House! or the Artist as Craftsman: Being the Writings of Walter Richard Sickert*. Edited by Osbort Sitwell. London, 1947.

117. Sloane, J. C., *French Painting between the Past and the Present: Artists, Critics and Traditions from 1848 to 1870*. Princeton, 1951.

118. Staley, A., "The Condition of Music." In *Art News Annual*, XXXIII, 1967, pp. 80–87.

119. Starkie, E., *From Gautier to Eliot*. London, 1960.

120. Starr, S., "Personal Recollections of Whistler." In *Atlantic Monthly*, CI, 1908, pp. 528–537.

121. Stubbs, B. A., *James McNeill Whistler, a Biographical Outline, Illustrated from the Collections of the Freer Gallery of Art*. Washington, Freer Gallery, Occasional Papers, I, No. 4, 1950.

122. Swinburne, A. C., "Mr. Whistler's Lecture on Art." In *The Fortnightly Review*, XLIX, 1888, pp. 745–751.

123. Symons, A., *Studies in Seven Arts*. New York and London, 1906.

124. Tabarant, A., *La Vie artistique au temps de Baudelaire*. Paris, 1942.

125. Thornton, R. K. R., editor, *Poetry of the 'Nineties*. Harmondsworth, Middlesex, 1970.

126. Vallas, L., *Claude Debussy et son temps*. Paris, 1958.

127. Way, T. R., *Memories of James McNeill Whistler, the Artist*. London and New York, 1912.

128. Whistler, A. M., "The Lady of the Portrait. Letters of Whistler's Mother." In *The Atlantic Monthly*, CXXXVI, 1925, pp. 310–328.

129. Wilde, O., *The Artist as Critic*. Edited by Richard Ellmann. New York, 1968.

130. Williamson, G. C., *Murray Marks and his Friends*. London and New York, 1919.

131. Young, A. McLaren, *Whistler*. London, 1967.

132. Zola, E., *L'Oeuvre*. Paris, 1886.

Index

Scotland, National Portrait Gallery of, 219
Scott, Sir Walter, 30, 164
Scribner's Monthly, 195
Scuola di San Rocco, Venice, 199
seascapes, 107, 132, 144, 145, 160
"Second Venice Set" (etchings), 238
Selsey, 166
Set of Twenty-six Etchings, A ("Second Venice Set"), 238
Seton, Dorothy, portrait of, 268, 274
Seurat, Georges, 218, 253, 276
Severn, Arthur, 97, 104–05, 192
Shaw, Norman, 175
Sickert, Walter, 212, 213, 214, 225, 265
Siesta, The (lithograph), 260
Sisley, Alfred, 62, 85, 211, 238, 265
Six Projects (oil), 147
Skye, Isle of, 17
Slade School of Art, 217, 225
Smoke Nuisance Act, 86
Smollett, Tobias, 113
Société des Pastellistes, 205
Société des Trois, 77, 83, 94, 98, 120, 122, 138, 142, 144
Société des XX, 238
Society of American Artists, 208
Society of British Artists, 219, 239
Society of French Artists, 163
Sommeil, Le (Paresse et Luxure, Courbet), 139–40, 276
Sotheby's, 197
Southampton, 133
South Carolina, 135
South Kensington Museum, 63, 172, 217. *See also* Victoria and Albert Museum
Spain, 133; art of, 67, 68–69, 75, 76, 82, 106, 141, 151; JAMW in, 107
Spanish-American War, 266
Spartali, Christine, 92, 126
Spartali, Marie, 126, 178
Spartali family, 92
Spectator, The (periodical), 197
Speke Hall, 157, 175, 176

spiritualism, 135, 166, 212, 261
Starr, Sydney, 225
Steele, Richard, 113
Stephens, F. G., 104
Stevens, Alfred, 111, 124
Stillman, Marie Spartali, 126, 178
Stockholm, 274
Stones of Venice (Ruskin), 198
Stonington, Conn., 16, 18–19, 22, 23, 39, 40, 55, 71
Stothard, Thomas, 38
Streatham Town Hall, 259
Street at Saverne (etching), 73, 74
Suggs, Simon, 22
Sunbury-on-Thames, 93, 94, 96, 122, 138
Sunday Afternoon on the Island of La Grande-Jatte (Seurat), 218, 276
Sunday Times, London, 256
Sutherland, Duchess of, 87
Swedenborg, Emanuel, 143
Swinburne, Algernon Charles, 91, 105, 108, 117, 119–20, 126, 131, 149, 251; on *Arrangement in Grey and Black*, 153; on art for art's sake, 142, 232; *Before the Mirror*, 128; quarrel with JAMW, 235–37
Switzerland, 35, 61
Symbolism, 247, 251–53, 254
Symons, Arthur, 248, 254, 269
Symphony in Flesh Color and Pink: Mrs. F. R. Leyland (oil), 107, 210, 276
Symphony in Grey and Green: The Ocean (oil), 144, 276
Symphony in Red (oil), 147, 275
Symphony in White Major (Gautier), 143
Symphony in White No. 1 (oil), see *White Girl, The*
Symphony in White No. 2 (oil), see *Little White Girl*
Symphony in White No. 3 (oil), 144, 145, 245
"Symphony in Yellow" (Wilde), 223